W9-CHP-557

ANIMALS IN AFRICAN ART
FROM THE FAMILIAR TO THE MARVELOUS

ANIMALS IN AFRICAN ART
FROM THE FAMILIAR TO THE MARVELOUS

Allen F. Roberts
The University of Iowa

With a Foreword by James Fernandez

Exhibition and Catalogue by
Carol A. Thompson

Photographs by Jerry L. Thompson
unless otherwise noted

The Museum for African Art, New York
Prestel, Munich

Tabwa proverbs:

In unfamiliar places, the dog
puts its tail between its legs

If a baboon can't eat there,
the slope must be very steep

If the bushbuck's horns spiral, it is because
the bushbuck dares sleep in very dark places

S/he is a monitor lizard,
with two tongues

If a young snake begins to sleep in the pathway,
it is because its tail has grown thick and firm

If the hyena's hair turns white the night that an
old man disappears, it is because the old man
has been eaten by the hyena

ANIMALS IN AFRICAN ART: From the Familiar to the Marvelous is published in conjunction with an exhibition of the same title organized and presented by The Museum for African Art, New York.

Text Editor: Henrietta Cosentino
Design: Linda Florio Design
Publication Coordinator: Carol Thompson

Copyright 1995 © The Museum for African Art. All rights reserved. No part of this publication may be reproduced without written permission from The Museum for African Art, 593 Broadway, New York, NY 10012. Tel. (212)966-1313, fax (212)966-1432.

Front cover: Scepter; Fon, Republic of Benin, brass and wood, h. 21 in., Shelly and Norman Dinhofer Collection

Back Cover: Scorpion mask; Bwa or Nunuma(?), Burkina Faso. Wood, paint, seeds; H. 17 1/4 in. Thomas G.B. Wheelock.

Trade edition distributed by Prestel-Verlag, Mandlstrasse 26, 80802 Munich, Germany, Tel. (89)381709-0; Fax (89)381709-35 and 16 West 22nd Street, New York, NY 10010, USA, Tel. (212)627-8199; Fax (212)627-9866.

Prestel books are available worldwide. Please contact your nearest bookseller or write to either of the above addresses for information concerning your local distributor.

Printed and bound in Japan.

Library of Congress catalogue card no. 94-73442
Paperbound ISBN 0-945802-17-X
Hardbound ISBN 3-7913-1455-6

Contents

Preface

A few months ago, when the photographs for this catalogue were being taken, a Museum staff member was crossing lower Broadway in New York City, helping to transport a nine-foot tall Bozo antelope sculpture made of wood, covered with red cloth and metal sheeting (cat. no. 1) from a nearby art gallery to the Museum. As he walked across the street, a passerby approached and asked, "What's that?" Preparing himself to provide a quick answer concerning African geography, he replied, "An antelope from Mali." The passerby responded, "What's an antelope?"

In an American urban environment where it becomes increasingly difficult to find remnants of nature and non-domesticated animals, it is perhaps not surprising that many wild animals, once common on this continent, are now virtually unknown. At the same time, a study of urban school children between the ages of five and a half and fourteen revealed that these young people are not afraid of the things they have been taught to be careful about but fear, instead, wild animals (Mundkur in Ingold 1988: 157).

A fascination with both wild and domesticated animals and their behavior is widely evident in Africa. Praise-poems sing of them; traditional sculpture portrays them; myths and fables chronicle their actions and adventures. They are mocked for their shortcomings, teased for their quirkiness, and, above all, honored for their strengths. A closer look at the way these animals are depicted reveals that the animals' behavior can be seen as metaphors for human experience, a symbolic language for conceptualizing human lives.

Throughout this volume and the related exhibition and public programs, we will explore over 125 artistic representations of animals, primarily from Western and Central Africa, in a wide range of media and of exceptional aesthetic quality. The animals depicted make up an eclectic and diverse menagerie: aardvarks, antelopes, chameleons, hornbills, hyenas, pangolins and warthogs, to name just a few. And as we hope to demonstrate, these creatures—all remarkable for how they look or act—are ultimately not the subjects here. We will show instead how they are useful metaphors for people's predicaments and, as such, mirror human qualities.

As a museum without a permanent collection, we are especially grateful to the many people and institutions who helped see this project through to fruition. We thank William Siegmann, Vicki Rovine, and Guillermo Ovalle of The Brooklyn Museum; Kevin Smith of the Buffalo Museum of Science; Maggy Willard and Deborah Leveton of the Des Moines Art Center; Kathleen Berrin and Mary Haas of The Fine Arts Museum of San Francisco; Lella F. Smith of Walt Disney's Tishman African Art Collection; Janice B. Klein, Chapurukha M. Kusimba, and Nina Cummings of The Field Museum; Doran Ross of the Fowler Museum of Cultural History, UCLA; Valerie Mercer of The Studio Museum in Harlem; Stephen Prokypoff, Jeff Martin, and Karen Milbourne of The University of Iowa Museum of Art; R.M.A. Bedaux of Rijksmuseum voor Volkenkunde; Julie Jones and Kathleen Bickford of The Metropolitan Museum of Art; William J. Hennessey of The University of Michigan Museum of Art; Louise Lincoln of The Minneapolis Institute of Arts; Anne Spencer of The Newark Museum; and Rebecca Buck, Charles Klein, and Sylvia S. Duggan of The University Museum of Archaeology and Anthropology, University of Pennsylvania. For agreeing to lend works of art from their personal collections, we thank all those whose names are listed within the catalogue, anonymous lenders, and the many knowledgeable people who helped us in our search for loans.

"Animals in African Art: From the Familiar to the Marvelous" was conceived as part of a collaborative project initiated by The New School for Social Research and involving The Asia Society, The Jewish Museum, the Pierpont Morgan Library, and The Academy of American Poets. We are proud to be a part of this major effort, bringing our unique perspective to bear on "In the Company of Animals," a cross-cultural exploration of the relationship of humans and animals.

This project is the culmination of the work of many individuals. Arian Mack of The New School for Social Research spearheaded the collaborative project of which the exhibition and catalogue are a part. The National Endowment for the Humanities generously supported the creation of both the exhibition and this publication. The Museum was fortunate once again to work with the creative talents of Linda Florio Design and Jerry Thompson on the catalogue and Christopher Müller on the exhibition. They have each made a significant contribution to this project's success. Our publicist Paula Webster and co-publisher Prestel-Verlag help ensure that our efforts are known by the broadest possible audience. Of course, none of this would be possible without the untiring efforts of the whole of the Museum's staff. To all of them, we give our sincerest thanks.

Sally Yerkovich

Author's Acknowledgments

Like most people, I was fascinated by animals as a child; unlike some adults, I still am. My lifelong interest was shaped by my parents. My mother grew up in the 1920s on a farm in upper New York State that has been in our family for two centuries, and my childhood was animated by her folktales (most of her own invention) and stories of working with farm animals. My dad came from a family of outdoorsmen; he contracted polio as a child, but although he could not get around as he might have otherwise, his love of nature informed all he did. My uncle William Fennell, godfather Allen Parrette, and great aunt Rose Losee took me birding and to natural history museums, and conveyed to me the excitement one can find, even in the smallest corner of one's backyard. It is in loving memory of all these, and for my mother, that I write this book.

My writing about Tabwa people of southeastern Zaire is based upon 45 consecutive months of predoctoral anthropological fieldwork (1974–7) generously funded of the U.S. National Institute of Mental Health (grant-in-aid #1-F01-MH-55251-01-CUAN); the Committee on African Studies and the Edson-Keith Fund of the University of Chicago; and Sigma Xi, the Scientific Research Society. Subsequent archival and museum studies have been supported by tenure in the Michigan Society of Fellows (1980–1, 1984–5) and grants from the National Endowment for the Humanities (1984–6); the Mellon Foundation via Albion College (1983, 1985); and the Stanley/University of Iowa Foundation Support Organization that funds The Project for Advanced Study of Art and Life in Africa (PASALA). A year's leave from teaching (1994) as a University of Iowa Faculty Scholar has permitted me to bring this project to fruition.

Thanks are extended to Herbert Cole, William Dewey, Henry Drewal, James Fernandez, Manuel Jordán, Stuart Marks, Don Merten, William Murphy, Yoshinobu Ota, Christopher Roy, Dana Rush, Roy Willis, and Edgar Winans for intellectual guidance in the course of this project; and to Christopher Davis, Luc de Heusch, Anita Jacobson-Widding, Mumbyoto Lubeni, Daniel Moerman, the late Kaloko Mpala, Marselena Mumba, Falansowa Muzame, Nzwiba Muzombwe, Geneviéve Nagant, Rodney Needham, and the late Victor Turner, earlier on. Friends at The Museum for African Art have been exciting to work with; thanks are extended to Susan Vogel for proposing the project, Sally Yerkovich for seeing it through, Troy Browne and Chris Müller for early discussions, Patricia Blanchet and Sarah Ariel Bennett for securing funding for the exhibition, Linda Florio, for the graphic design of the catalogue, Carol Braide for seeing to myriad details, Robert Rubin for his vision and support, and Marjorie Ransom, Lubangi Muniania, Lisa Hamilton, C. Daniel Dawson, and volunteers, for presenting the exhibition to broad audiences in the museum's education and public programs. It has been a great pleasure to work with Carol Thompson as co-curator, and with Mary Nooter Roberts, who has helped at every step of the way. Very special thanks are extended to Henrietta Cosentino for her copy-editing, done so gently yet with such good sense. Despite the generosity of these agencies and individuals, I alone am responsible for the present text. Like all my writing, I dedicate this book to Avery, Seth, and Polly; and to the memory of Mary Kujawski Roberts.

Allen F. Roberts
Iowa City
1994

Meditating on Animals — Figuring Out Humans!

Of all the kinds of human pensiveness, meditating on animals and our relations to them must be very nearly the oldest and most persistent. It is doubtful that we could ever really adequately know our own identity as humans if we did not have the "other animals" as a frame for our own activity and reflectivity. Just as we have long been predatory on animals—as they on us—and hence attendant to them and dependent upon them for our physical survival and well-being, so our reflections upon them have, in a more lofty sense, been central to our cerebral survival and well-being. As the current phrase goes in anthropology: animals are as "good to think" as they are "good to eat." Proverbial wisdom, which is the earliest, and in many cultures still a flourishing formulation of human pensiveness, is predominantly a wisdom derived from meditating upon animals: from ants to elephants, with a "bird in the hand" along the way. And folklore—the oldest, but also in many cultures a still prosperous compendium of instructive amusement—is richly "peopled" with animal presences. In contemporary societies, this survives in children's books, which are apparently inconceivable without human-like animals acting out the failures, foibles, and fantasies of both our humanity and inhumanity. The truly great books of European children's literature, Grahame's *The Wind in the Willows*, or Lindgren's *Hans Holgerson* or Jimenez' *Platero and I* just to name three, are all meditations on the human by means of animals.

We have here a very ancient wisdom. In the cave art of the Upper Paleolithic of Europe and Africa, we have evidence of a mysterious figure, half-human and half-animal, called the "Master of Animals." For those ancient hunting societies, survival depended upon the mastery over animal nature which he or, perhaps, she provided. But the figure also artfully shows a melding of the human and the animal. It shows a mastery achieved by an identification of the one with the other. Over time, of course, that, at once predatory mastery of and mysterious identification with the animal world and its denizens—creatures who were provocative and mysterious because of their elusive and dangerous powers—passed over into the domestication of animals, easier mastery over them and greater familiarity with them.

Domestication has acted to make our relations with animals more matter-of-fact and less mysterious, but by no means have the domesticated animals become less the subject of our meditations. Because of their inclusion in our social circles, as it were, domesticated animals have become more human-like and provocative, the more present in our folklore in human guise. And we have become, perhaps, more dependent upon them, not only for their fur, hides, and flesh but—in a deeper sense—for their companionship. For we have become **inter**dependent, responsive and responsible to the domesticated animals in a way that we have never been with those of the wild. The domesticates are never very far from our thoughts.

Some would suggest that our preoccupation with the animals we have domesticated has caused us to lose our identification with, and feelings of responsibility towards, the animal world in the wild. Thus, we have become more dangerous to wild animals than we ever were. For while we can take for granted our exploitation of domestic animals, we put wild animals at great risk with our extreme exploitativeness of the natural environment. We suddenly recognize that we are faced with their extinction and disappearance from our environment, if not from our awareness entirely. But that very awareness and its urgency would seem to suggest that the ancient identification still survives, and that we feel ourselves faced with the loss of an important "affecting presence."

Any effort, such as this richly documented and rewarding monograph on the "thinking of animals" in Africa, which serves to bring us back into touch with the multiplicity of ways that both wild and domestic animals are woven into human lives, is, therefore, both welcome and very necessary. It reminds us of what their absence would mean and how, in their endangered state, they must be actively protected. It cannot be that thinking devices such as computers and the intricate dependencies and interdependencies they create might come to preoccupy us entirely. The virtual realities of the cybernetic age are, as this compendium makes clear, no substitute for the lived reality of animal-human relationships.

In this book, Allen Roberts brings us back from Africa a multitude, a veritable menagerie, of vivid instances of that reality both directly lived and as reflected in African proverbial wisdom, lore, and, above all, art. His menagerie is also salutary in a second sense. Africa, in European and American public imagination created by popular nineteenth-and-twentieth century geographies, frequently suffered—and still suffers in some quarters—from a divided, almost schizophrenic appraisal. It became known on the one hand for the panoply of its marvelously diverse wildlife. On the other hand, it also became known for its diverse tribal life, often featured and too readily apprehended in Euro-American circles, as bizarre and savage in nature. Rarely was the wisdom which Africans derived from their hunting and meditating over the variegated wild and domestic animals of their surroundings brought to our attention. Rarely were the many ways that African wildlife and livestock related to the understandings of their human co-occupants made clear. It is the additional virtue of this compendium to

have made just this connection with admirable corroborative detail. The age-old productive and intellective interaction of humans and animals in Africa is presented to us in the most satisfying detail in this volume.

To have made such connections would be a sufficient value, but the author has additional, deeper interests, of which the reader will become aware. He asks, "Why it is that our ideas of the animal, perhaps more than any other set of ideas, enable us to frame and express ideas of human identity?" That is, why is it that animal identity such as we understand it enables us to speak about human identity? By such questions, Roberts is also inquiring into intellectual processes in general. He is asking how it is that we at once categorize ourselves in or on top of the animal kingdom and how, at the same time, we both use and yet escape these categories in identifying ourselves with animals or them with us. The constancy not only of categories but, at the same time, the escape from categories is seen in the persistent dynamic processes of anthropomorphism and zoomorphism. These are the processes of seeing ourselves in animals, and/or seeing animals in us.

Is there not something paradoxical in this dynamic? Roberts does not hesitate to evoke the "contrariety" by which we both categorize the world, and yet by metaphor and other figurative uses of language, shift our classifications and ourselves from category to category. One consequence of reading this book is an emerging conviction that to be human is to be a categorizing animal with the capacity to, if not escape entirely, at least recurrently shift or collapse our own categories.

One might say, then, that to be human is to be constantly engaged with the "dynamic of the categorical." From the materials gathered from his own fieldwork among Tabwa and other ethnographic sources, Roberts shows that to be human is to be constantly struggling with the meaning of categories. To be human is to be constantly struggling to figure out one's place in what Linneaus, the forefather of botanical, biological, and zoological classification called the "system of nature." This is a system that, paradoxically, although conceived by humans is never fully set in concrete, never fully, completely and finally understood.

So we are endlessly engaged in the struggle to find, as it were, our branch in the phylogenetic tree. We do this by entertaining—through various forms of imaginative shape-shifting, by the "acting out" of the animal or through the animal—the similarities and differences in our "animal natures." In part, it is the struggle to understand what it means to have—and how it puts an obligation on us to have—in the biblical phrase, "dominion over the animals." It is a struggle to come to terms with the animal within us, with our own animal natures as it were. It is a struggle to find ourselves in The Great Chain of Being in such a way that neither we nor the other animals are permanently chained to narrow, abusive, and sorrowful categories. These are deep, age-old, persistent questions, and the volume the reader has here in hand returns us to instructive meditation about them.

Of course, in the final analysis, this is not a book of philosophy—whatever the philosophical rabbits it subtly starts up. It is a book, after all, about "Animals in African Art." But here we ought to say that it is often in art—perhaps only in art—that some of the deeper paradoxes of the human condition can be most profoundly explored and offered up for meditation. That is surely the case in African art which comes from a continent where the deeper problems and paradoxes of the human condition have been so artfully explored in sculpture, song, and story-telling. Above all, since the plastic arts are a shaping of the raw material of life into visual representation, it may well be, as I think this monograph demonstrates effectively, one of the most affective mediums for that difficult and enduring exploration.

James W. Fernandez
University of Chicago
1994

LENDERS LIST

Lucille and Arnold J. Alderman
Ernst Anspach
Mr. and Mrs. Armand Arman
Dr. Michael Berger
Nancy and Richard Bloch
William W. Brill
The Brooklyn Museum
Buffalo Museum of Science
Mr. and Mrs. Benton Case, Jr.
Pamela and Oliver E. Cobb
Margaret and Al Coudron
Gerald and Lila Dannenberg
The Fine Arts Museum of San
 Francisco
Margaret H. Demant
Des Moines Art Center
Shelly and Norman Dinhofer
Walt Disney's Tishman African
 Art Collection
Mei Li Dong
Drs. Jean and Noble Endicott
Marc Felix
The Field Museum
Fowler Museum of Cultural
 History, UCLA
The Graham Collection
Toby and Barry Hecht
Regina and Stephen Humanitzki
The University of Iowa Museum
 of Art
Julian Kaplin
Carol and Jerome Kenney
Joseph and Margaret
 Knopfelmacher
Mauricio and Emilia B. Lasansky
Rosemary and George Lois
The Metropolitan Museum of Art
University of Michigan Museum of
 Art
Peter and Nancy Mickelsen
The Minneapolis Institute of Arts
Donald Morris Gallery
Florence and Donald Morris
The Newark Museum
Robert and Nancy Nooter
David T. Owsley
The University Museum of
 Archaeology and Anthropology,
 University of Pennsylvania
Susan and John Picton
Phyllis and Stuart Plattner
The Regis Collection,
 Minneapolis, MN
Doris Rief
Rijksmuseum voor Volkenkunde,
 Leiden
Eric D. Robertson
Sydney L. Shaper
Merton D. Simpson Gallery
Joyce Marie Sims
Cecilia and Irwin Smiley
The Studio Museum in Harlem
Farid Tawa Collection
Lucien Van de Velde, Antwerp
Dr. and Mrs. Bernard Wagner
Stewart J. Warkow

The May Weber Museum of
 Cultural Arts, Chicago
Thomas G.B. Wheelock
Ernie Wolfe, III and Diane
 Steinmatz Wolfe
William Wright
Maureen Zarember

and anonymous lenders

CURRENT DONORS

Mr. & Mrs. Herbert L. Abrons
Charles B. Benenson
Bernice & Sidney Clyman
Mr. & Mrs. Richard Faletti
Lawrence Gussman
Lofton P. Holder, Jr.
Jane & Gerald Katcher
Drs. Marian & Daniel Malcolm
Adriana & Robert Mnuchin
Don H. Nelson
Susan Vogel & Kenneth Prewitt
Mr. & Mrs. James J. Ross
Lynne & Robert Rubin
Daniel Shapiro & Agnes Gund
Cecilia & Irwin Smiley
Henry Van Ameringen
Jason H. Wright

Charles & Kent Davis
Lance Entwistle
Roberta Entwistle
Irwin & Madeline Ginsburg
George Gund
William H. Hayden
Helene & Philippe Leloup
Mr. & Mrs. Sydney Lewis
Mr. & Mrs. Lee Lorenz
Peter Norton
Richard Parsons
Mr. & Mrs. Morris Pinto
James Taylor

S. Thomas Alexander, III
Joan Barist
Michael Berger, M.D.
Sherry Bronfman
Leo Castelli
Howard Chenkin
Mr. & Mrs. Gustavo Cisneros
Mr. & Mrs. Marshall Cogan
Mary Cronson
Gabriella de Ferrari
Mr. & Mrs. Francois de Menil
Alain de Monbrison
Drs. John & Nicole Dintenfass
Denyse & Marc Ginzberg
Marilyn Holifield
Daniel Hourde
Regina & Stephen Humanitzki
Richard Kahan
Naomi Kaldor
Mr. & Mrs. Jerome Kenney
Mr. & Mrs. Martin Kimmel
Lincoln Kirstein
Mr. & Mrs. Jay Last
Mr. & Mrs. Roy Lichtenstein
Mr. & Mrs. Jason McCoy
Mr. & Mrs. Robert Menschel
Nancy & Robert Nooter
Michael Oliver
Arthur G. Rosen
Clifford Ross
Mrs. Harry Rubin
Mr. & Mrs. Robert E. Rubin
Laura L. Scheuer
Edwin & Cherie Silver
Marsha & Saul Stanoff
Dr. Martin Trepel
Maureen Zarember
Mr. & Mrs. William Ziff

Bette Alexander
Ernst Anspach
Mr. & Mrs. Jonathan Bell
Mr. & Mrs. Jerry Blickman
Alan Brandt
Damon Brandt
CDS Gallery
Mr. & Mrs. Carroll Cline
Pam & Oliver Cobb
Frederick Cohen & Diane Feldman
Kevin Connru
Charles Cowles Gallery
Mr. & Mrs. Lewis Cullman
Gerald & Lila Dannenberg
Mr. & Mrs. Jeff Dell
Barbaralee Diamonstein & Carl
 Spielvogel
Lisa Ely
Richard Feigen
Mr. & Mrs. Arthur Fleischer, Jr.
Larry Gagosian
Mrs. Victor Ganz
Barbara Gladstone Gallery
Mr. & Mrs. Arthur Goldberg
Hubert Goldet
Mr. & Mrs. John Grunwald
Esther J. Gushner
Brigitte Guttstadt
Mr. & Mrs. Edward P. Harding
Mr. & Mrs. Jacques Hautelet
Steven M. Hayes
Mr. & Mrs. Evan Heller
Michael Herring
Udo Horstmann
Linda Barth Janovic & William
 Goldstein
Judith & Harmer Johnson
Mr. & Mrs. Charles Jones
Leonard Kahan
Oumar Keinde
Jill & Barry Kitnick
Dr. & Mrs. Samuel Klagsbrun
Mrs. Estelle M. Konheim
Mr. & Mrs. Arthur Kramer
Mr. & Mrs. Frank Y. Larkin
Mr. & Mrs. Leonard Lauder
Lawrence Lederman
Stanley Lederman
Ray L. LeFlore
Mr. & Mrs. Sol Levitt
Mr. & Mrs. Brian Leyden
Mr. & Mrs. Robert Lifton
Earle Mack
Mr. & Mrs. Thomas Marill
Matthew Marks
Mary Boone Gallery
Barry Maurer
Sally Mayer
Steve Mazoh & Martin Klein
Mr. & Mrs. David McKee
Mr. & Mrs. Richard L. Menschel
Mr. & Mrs. Robert Miller
Rodney Miller
Milos-Atherstone African Arts
Mrs. Kendall Mix
Mr. & Mrs. Steven Mnuchin
Florence & Donald Morris
Mr. & Mrs. Herbert Neuwalder
Maggie Nimkins & David Balsley
Marie Nugent-Head
Kathy van der Pas &
 Steven van der Raadt

Mr. & Mrs. Guy Peyrelongue
Mr. & Mrs. Leon Polsky
Mr. & Mrs. Benjamin Richman
Fred & Rita Richman
Eric Robertson
Mr. & Mrs. Milton Rosenthal
Elsa & Marvin Ross-Greifinger
Salander-O'Reilly Galleries
Arthur & Joan Sarnoff
Sydney Shaper
Mr. & Mrs. Robert Shapiro
Dr. & Mrs. Jerome Siegel
Marty Silverman
Merton Simpson
Mr. & Mrs. Anthony Solomon
Sonnabend Gallery
Mr. & Mrs. Morton Sosland
Sperone Westwater
Jerry I. Speyer
Isabel C. Stewart
Nils von der Heyde
Jerome Vogel
Dr. & Mrs. Bernard Wagner
Mr. & Mrs. George Wein
Thomas G.B. Wheelock
James Willis
William Wright

Mr. & Mrs. Barry Adams
Marcelle S. Akwei
Lucille & Arnold J. Alderman
Susan Allen
Pierre Amrouche
Gillian Attfield
Audrey Augustine
Neal Ball
Walter Bareiss
Saretta & Howard Barnet
Thomas F. Barton
Mr. & Mrs. Armand Bartos
Douglas Baxter
Tony Bechara
Sallie & Robert Benton
Lynn & Samuel Berkowitz
Sid & Gay Berman
Mary & Darrel Bigham
Mr. & Mrs. Joseph S. Blank
Dr. & Mrs. Claude Bloch
Jean Borgatti & Donald Morrison
Louise Bourgeois
Peter M. Boyd
Ed Bradley
Mimi Braun & Andrew Frackman
Martin & Shirley Bresler
The Reverend &
 Mrs. Raymond E. Britt, Jr.
Christine Burgin & Bill Wegman
Antoinette Cook Bush
Catherine Cahill & William
 Bernhard
Mr. & Mrs. Robert Carey
Janet & Ronald Carter
Mr. & Mrs. James Cash
Joyce Chorbajian
Jane Forbes Clark
Joan Hardy Clark
Jeffrey Cohen & Nancy Seiser
Eileen & Michael Cohen
Betsy & Alan Cohn
Anita Contini & Stephen
 Van Anden

Paula Cooper & Jack McCrae
Herman Copen
Lisa Cortes
Jan Cowles
Berry A. Creighton
Catherine Curran
Mr. & Mrs. Thomas D'Agostino
Farah Damji
Rodger Dashow
Carl A. De Brito
Laurent de Brunhoff
Mr. & Mrs. Edward De Carbo
Count & Countess Bernard de
 Grunne
Carl A. DeBrito, Esq.
Mr. & Mrs. Kurt Delbanco
Jill & Ray Dempsey
Dr. D. David Dershaw
Sulaiman Diane
Morton Dimondstein
Alan & Suzanne Dworsky
Mr. & Mrs. Daniel Ehrlich
Ms. Barbara Eisold
Drs. Jean & Noble Endicott
Dr. & Mrs. Aaron H. Esman
John Falcon
George & Gail Feher
Mr. & Mrs. Ronald Feldman
Mr. & Mrs. Lincoln Field
Stella Fischbach
Charles Flowers
Jeremiah Fogelson
Gordon Foster
Mr. & Mrs. Marc Franklin
Michele Friman
Jean Fritts
Dr. & Mrs. Murray B. Frum
Mr. & Mrs. Richard Furman
Dr. & Mrs. Joel D. Fyvolent
Robert A. Gerard
Emily G. Gittens
Mr. & Mrs. Joseph Goldenberg
Mr. & Mrs. Harold Gootrad
Susan Gordy
Mr. & Mrs. Paul Gottlieb
Denise Green & Frank Claps
Stuart Greenspon
Dr. & Mrs. Irwin E. Gross
Mr. & Mrs. Geoffrey Gund
Mr. & Mrs. William Harrop
John W. Hawkins
Stephen Heard
Nancy Herstand
Patricia Hewitt & Dale Christensen
Mr. & Mrs. Karl M. von der Heyden
Janine & Michael Heymann
Mr. & Mrs. Gregory Hines
Elizabeth Hird
Mr. & Mrs. Ethan Hitchcock
Paul Hoffman
Mr. & Mrs. Donald C. Hofstadter
David Holbrook
David Hotson
Mr. & Mrs. Edward Hoyt
Bernard & Fern Jaffe
Barbara Jakobson
Mr. & Mrs. Christo Javacheff
Mr. Lloyd Sheldon Johnson
Lucy Johnson
Philip Johnson & David Whitney
Jerome Joss
Margaret Kaplan

Blanche Katcher
Paul Katcher
June Kelly
Mr. & Mrs. Roderick Kennedy
Mr. & Mrs. Robert Kiley
Linda J. King
Jacqueline Knights
Joseph & Margaret Knopfelmacher
Mr. & Mrs. Hugh Kohlmeyer
Werner Kramarsky
John Kunstadter
Carolyn Lanchner
Emily Fisher Landau
Terese & Alvin Lane
Mr. & Mrs. Guy Lanquetot
Mr. & Mrs. Elliot Lawrence
Mr. & Mrs. Seymor Lazar
Jay C. Leff
Mr. & Mrs. Gerson Leiber
Maya Lin
Arthur Littwin
Gabrielle & Samuel Lurie
Miki Marcu
Vivione Marshall
Dr. Margaret McEvoy
Raymond J. McGuire
The Honorable John A. McKesson
Genevieve McMillan
Kynaston McShine
Mr. & Mrs. Gregor Medinger
Piet Meyer
Mr. & Mrs. Robert E. Meyerhoff
Thando Mhlambiso
Marguerite Michaels
Sam Scott Miller
Elaine Mintzer
Rt. Rev. & Mrs. Paul Moore, Jr.
Dr. Werner Muensterberger
Mr. & Mrs. Daniel Murnick
Thomas Murray
Charles J. Mus
Judith Nash
Mr. & Mrs. Milford Nemer
Roy R. & Marie S. Neuberger
Mr. & Mrs. Ronald Nicholson
Michael Ovitz
Carolyn Owerka & Alyasha
 Owerka-Moore
David Owsley
Meredith Palmer
Mr. & Mrs. John Parkinson III
Professor & Mrs. John Pemberton III
Paul Peralta-Ramos
Klaus Perls
Linda C. Phillips
E. Anne Pidgeon
Max Pine
Mr. & Mrs. Robert Pittman
Mr. & Mrs. Jonathan Plutzik
Mr. & Mrs. Stephen Posen
Mr. & Mrs. Joseph Pulitzer, Jr.
Carol L. Putzel
Michael Rhodes
Beatrice Riese
Mr. & Mrs. Clifton S. Robbins
Flavia Robinson
Constance Rogers Roosevelt
William Jay Roseman
Audrey Rosenman
Ana Roth & Abraham Vorster
William & Joan Roth
Philip & Marcia Rothblum

Mrs. Stephen Rubin
William Rubin
Mr. & Mrs. Ira Sahlman
Melissa Salten-Rothman
Phoebe Salten & Merril Weingrod
Michael Sand
Mr. & Mrs. Andrew Saul
Mr. & Mrs. Robert H. Schaffer
Stephen K. Scher
Enid Schildkrout
Franyo Schindler
Eleanor & Herbert Schorr
Mr. & Mrs. Eugene Schwartz
Mr. & Mrs. Martin Segal
Mr. & Mrs. Ralph Shapiro
Henry Shawah
Dr. & Mrs. Robert S. Siffert
Beverly Sills & Peter Greenough
Mr. & Mrs. Henricus Simonis
Patterson Sims & Katie Homans
Ingrid Sischy
Kenneth & Katherine Snelson
Joan Snyder & Maggie Camner
Jill Spalding
Keith Spears & Carolyn Johnson
Mr. & Mrs. Paul Sperry
Mr. & Mrs. Jerry Spiegel
Carol Spindel & Tom Bassett
Barbara H. Stanton
Joanne Stern
Mr. & Mrs. Oscar Sternbach
Mr. & Mrs. Allan Stone
Arthur Sulzberger & Gail Gregg
Jay Swanson
Mr. & Mrs. Anselm Talalay
Naomi & John Tamerin
Howard Tanenbaum
Mr. & Mrs. Mark Tansey
Ellen & Bill Taubman
Farid Tawa
Mrs. Walter N. Thayer
Franklin Thomas
Diane G. Tichell
Emily Todd
Barbara Toll
Helaine Topple
Helen Tucker
Gloria P. Turner
Kirk T. Varnedoe & Elyn
 Zimmerman
Lucien van de Velde
Carolyn Carter Verleur
Anthony & Margo Viscusi
Adrienne & Gianluigi Vittadini
Lucille & Fred Wallace
Dr. & Mrs. Leon Wallace
Stewart Warkow
Jennifer C. Warren
Mr. & Mrs. Abraham Weiss
Barbara & Michael Welch
Mr. & Mrs. Gregory Wells
Eric White
Mr. & Mrs. Christian Wijnberg
Lynn Williams
Mr. & Mrs. Oswald Williams
Peter Wolff
George Woodman
Emma Lee Yu
Shelly Zegart
Mr. & Mrs. Aristide Zolberg

Institutional Donors

National Endowment for the Arts
National Endowment for the
 Humanities
Rockefeller Foundation

Frances & Benjamin Benenson
 Foundation
Dade Community Foundation
Aaron Diamond Foundation

Louis & Anne Abrons Foundation
City of New York Department of
 Cultural Affairs
Charles E. Culpeper Foundation
New York Council for the
 Humanities
New York State Council on the Arts
Puget Sound Fund of the Tides
 Foundation
Noah-Sadie K. Watchel
 Foundation, Inc.

The Max & Victoria Dreyfus
 Foundation
Gulton Foundation, Inc.
The Helen & Martin Kimmel
 Foundation
Joseph & Ceil Mazer Foundation
Peter Norton Family Foundation
Arthur Ross Foundation
The Travelers Foundation
Tribune New York Foundation
H. van Ameringen Foundation

Alconda-Owsley Foundation
The Kitnick/Alexander Family
 Foundation
Sydney & Frances Lewis Foundation
The Evelyn Sharp Foundation

Corporate Donors

Aetna Life & Casualty Co.
Goldman Sachs & Company
J.P. Morgan & Company, Inc.
R J R Nabisco

Chemical Bank
Citibank
Con Edison
Dime Savings Bank
Joseph E. Seagram & Sons, Inc.
United Technologies

Arthur Andersen & Co.
Black Entertainment Television
CBS Broadcast Group
Creative Artists Agency, Inc.
IBM Corporation
Meredien International Bank, Ltd.
Merrill Lynch & Co.
Sotheby's

Donaldson, Lufkin & Jenrette, Inc.
Herbert Construction Company
Chubb Life America

Bronx Community College
Carroll, McEntee & McGinley, Inc.
Christie's
Huntington T. Block Insurance
Philip Morris Companies, Inc.
NYNEX Philanthropy
Saturn Corporation
Sterling Winthrop, Inc.

Current as of December 31, 1994

BOARD OF TRUSTEES

Co-Chairpersons
Jane Frank Katcher
Irwin Smiley

Acting Director
Sally Yerkovich

Vice Chairman
Robert Nooter

Secretary
Richard Faletti

Treasurer
Robert Rubin

Assistant Treasurer
Lofton P. Holder, Jr.

Trustees
Corice Canton Arman
Charles B. Benenson
Sherry Bronfman
Allison Davis
Lawrence Gussman
William H. Hayden
Barry Lites
Lee Lorenz
Kathryn McAuliffe
John Morning
Don H. Nelson
James J. Ross
Daniel Shapiro
Marianne C. Spraggins
Jason Wright

STAFF

Executive

Sally Yerkovich
Acting Director

Curatorial

Carol Thompson
Associate Curator

Elizabeth Bigham
Assistant Curator

Carol Braide
*Executive Assistant/
Publications Coordinator*

Registration

Erica Blumenfeld
Curator of Exhibitions

Eliot Hoyt
Assistant Registrar

Development and Membership

Patricia Blanchet
Director of Development

Sarah Ariel Bennett
Development Associate

Tajudeen Raji (T.J.)
*Membership Coordinator/
Accounting*

Sarah Jane Stratford
Administrative Assistant

Education

C. Daniel Dawson
Interim Curator for Education

Muniania Lubangi
Education Assistant

Lisa Hamilton
School Programs Consultant

Accounting

Patrice Cochran
Controller

Operations

Mayumi Fujitani
Reception

Debra Whitfield
Building Manager

Bernard Saunders
Chief of Security

Kwabena Antwi
Siedwass Arjoonsingh
Tammy Farmer
Lawrence Kendle, Jr.
Lear Riojas
Security

Retail and Admissions

Regina Humanitzki
Manager, Retail Operations

Carolyn Evans
Barbara Field
Frank Lewis
Robert Reynolds
Admissions

VOLUNTEERS

Johanna Cooper
Events Coordinator

Marjorie Ransom
Director of Volunteers

Yumiko Ito
Curatorial Research Assistant

Deborah Collingwood
Events Volunteer

Claude De Backer
Norma Berk
Ethel Brill
Nicole Richards
Membership Volunteers

Vita Dalrymple
Betty Gubert
Mary Ann Jung
Rita Kuoh
Yasmine Limage
Zahera Saed
Nicole Scheps
Barbara Welch
Juanita Wimberly
Museum Store Volunteers

Gail Ahye
Kira Bond
Laverne Bruce
Marylis Cisek
Deborah Collingwood
Claudia Danies
Dedra Diggs
David Doris
Ayana Duckett
Pamela Ford
Jacques Frazier
Marva Gonda
Natasha Gordon
Lisa Hammel
Lois Henderson
Michele James

Michelle Johnson
Lee Krueckeberg
Ferman Lee
Frank Lewis
Lillian Lowy
Shana Mathur
Jennifer McShane
Elizabeth Moran
Xavier Rivera
Aielianna Ross
Helene Tissieres
Maria Vecchion
Charlene Whitmore
Barbara Welch
Museum Educators

Artists are above all
men who want to become inhuman.
Guillaume Apollinaire, 1913

Hitching Up the Horse

Group of Bwa animal masks
entering the village square,
followed by uniformed members of
each of the men's age-grades, at
a harvest celebration in the
village of Pa, Burkina Faso. The
performance celebrated the arrival
in the mail of the checks for the
individual cotton harvest from the
mill in Koudougou. Photo:
Christopher D. Roy, 1984,.

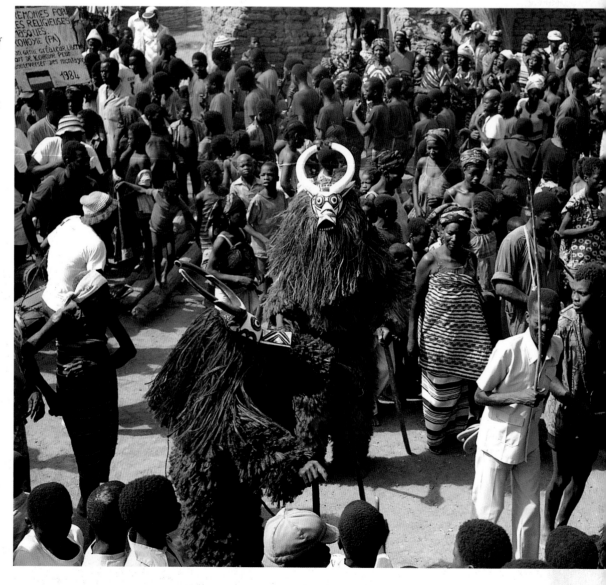

L ike most American parents with a preschooler at home, my wife and I are surrounded by "animals." Seth has stuffed animals ranging from a favorite rabbit to a cloth aardvark to Buster Bear, who was once my own. Dinosaurs of every sort lie underfoot. Books and magazines teach the wild lives of wildlife. There are tapes with tunes like "Tiiiiii-ran-o-saurus, Tyrannosaurus Rex" and videos like "Winnie-the-Pooh." Drawings hung on the icebox door portray epic confrontations between fantasy animals and stick-figure people. A Disney movie sends Seth into lion imitations. For bedtime stories his parents recount animal allegories.[1]

African children are similarly inspired. In her wonderful book L'Enfant africain et ses jeux (1963), T. H. Centner records a wide variety of games focused on animals. Lullabies sung to babies tell of parents dressed in antelope skins. Boys dance as leopard cubs, lions, and ground hornbills, or hunters. Girls dance as swallows, partridges, and army ants. Clay and fiber masks represent elephants or ferocious lions in imitation of men's sacred paraphernalia. There are clay bird and animal dolls, and bead games about bushbucks and chickens scratching in the sand. There are cat's-cradle configurations portraying butterflies or buffalo.[2] Significantly, African children's preoccupation with animals persists even where big game was eliminated generations ago, as is now the case for most of the continent.

Animals are also among the most common subjects of African art made for adult contemplation and use.[3] Africans are by no means unusual in this regard: other traditions, ancient and modern, suggest how often through art "humans take animal shape and enact nature."[4] In Africa, this is true even today, when large mammals exist only in a few far-flung reserves (especially in west and much of central Africa).[5] Zoomorphic imagery still appears in a great many contexts of leadership, healing, divination, problem-solving, rites of passage, and rituals. Animal allusions are woven or dyed into the patterns of women's fabrics (cat. no. 84), incised on pots, scarified on bodies, braided into hair, and painted on houses.

In many ways, human identity is still defined against an animal foil—through juxtaposition with significant animal-others, somehow different, yet hauntingly the same. Animals are a distorting mirror, but a mirror nonetheless.[6] "This becoming an object, this taking the other . . . is a process that has for millennia turned to the animal world,"[7] for through animal symbolism human creativity is provoked, thought is organized, and meaning made.[8] How and why are the questions we shall pursue here.

Common Misperceptions

That animals are essential to African life may seem so self-evident as to lead to some very common misperceptions. Most Americans imagine Africa as "jungle," complete with shrieking monkeys and fierce felines. Package tours to the continent almost always use a lion, giraffe, or some other big-game beast as their logo: such an animal *is* Africa for those who have never visited the continent.[9] Common themes of African art are the elegant antelopes of *chiwara* headdresses made by Bamana people of Mali; the pachyderms of countless masks, stools, combs, and such; or the leopards that lurk and leap across a wide spectrum of art. Even the best-versed Western connoisseurs may assume that the reasons for such thematic promi-

nence are self-evident: living in a place so "filled" with wildlife, and being so "close to nature" themselves, Africans must consider animals to be as important as they are to many of the rest of us.

Lost in such idle imagining are questions about why Africans depict animals so frequently in arts that ostensibly dramatize human issues and problems. Indeed, while animals certainly are important to Africans in some of the same ways they are to people elsewhere—say, as used in allegories to chasten children—recent studies make clear how superficial it would be to assume that African and non-African reasons for such interests are always similar or, perhaps, even alike in any way at all,[10] and suggest why people outside of Africa might arrive at such misleading conclusions.

Basic Questions

If "what does it mean to be human?" is the most primordial of questions, then "what is an animal?" must follow. Questions like these, however, simply do not occur to most people, because such matters tend to be taken for granted.

In the industrialized West, animals have gradually disappeared from everyday life over the past century or so; and, excluding pets, for the most part "today we live without them."[11] An ideological shift away from animals began even earlier, when Descartes portrayed animals as machines without souls, and French naturalists asserted that animals had no experience or secrets, which had been sources of their previous power. Instead, as the Industrial Revolution gained momentum, animals became commodities and raw material for capitalist endeavor.[12] Because of these developments, social analysts like Tim Ingold ponder questions such as: does Darwinist evolutionary theory preclude understanding African definitions of "human" and "animal" in their own terms? If not, "how can we reach a comparative understanding of human cultural attitudes toward animals if the very

Safari lions. Kenya, 1981.
Photo: Allen F. Roberts.

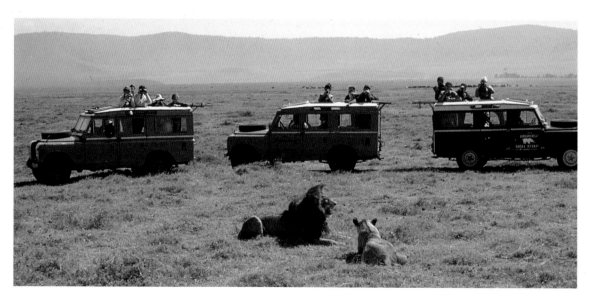

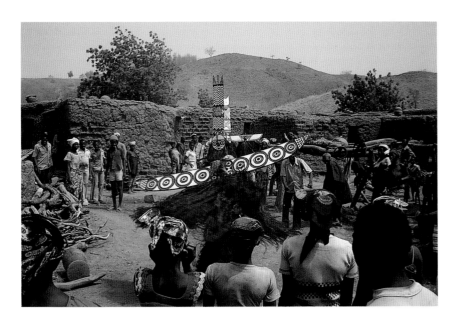

Bwa butterfly, hawk, and plank masks parade throught the village of Boni, Burkina Faso, greeting each household during initiation ceremonies for members of the Gnoumou family. Photo: Christopher D. Roy, 1984.

conception of what an animal might be, and by implication of what it means to be human, is itself culturally relative?" Furthermore, he questions: "does not the anthropological project of cross-cultural comparison rest upon an implicit assumption of human uniqueness vis-à-vis other animals that is fundamentally anthropocentric?"[13] These biases may be so deeply seated that they are altogether unconscious, like so much of one's own culture. Nature is usually presumed to be an objective given, and humanity a species with biological commonalities greatly outweighing cultural diversity.[14]

Any postmodern project to decenter the human subject is threatening, since many people flinch at the suggestion that "the individual is not a free agent in the cultural space of representation"; that no particular "I" or "we" has an edge on truth; and that no position is of greater value or takes precedence over others.[15] A conference on the theme of "what is an animal?" held in Southampton, England, in 1986 proved surprisingly passionate.[16] Those asserting that a species is not a natural kind but a cultural construction[17] were particularly controversial. Instead, we can take another tack. We can stress *relationships* among beings, human and animal.

African animal imagery challenges common Western views that culture and nature exist in stark, Manichaean opposition. A Western perspective may be that "every attribute that it is claimed we uniquely have, the animal is consequently supposed to lack; thus, the generic concept of 'animal' is negatively constituted by the sum of these deficiencies."[18] Animals cannot feel, reason, or do: they can only react instinctively. Personhood is for persons, not animals. Instead, animals are antihumans outside moral community, and the "notion of the species-barrier . . . is inevitably linked with that of the border of value."[19] Nature is a frontier to be mastered (with an androcentric bias), for as the first chapter of the book of Genesis tells us, "God created man in his own image, ... and said ... 'Fill the earth and subdue it; and have dominion over the fish of the sea and over the birds of the air and over every living thing that moves upon the earth.'"[20]

By contrast, many African philosophies posit a culture-to-nature continuum, with interlacing instances of nature-within-culture and culture-within-nature. Animals may have souls, be devious, and know magic; they both deserve and require sacred attention from humans who interfere with them. As Roy Willis (1990) notes, underlying the disjunction through which Africans define differences between human culture and nature is a commonality between the parties: opposition coexists with unity in logical, generative contradiction. Humans and animals dance in "complementary duality," and indeterminacy, irony, and paradox result.

From such a viewpoint, there is a beast in the best of us.[21] In African cultures, human/animal commonalities are not frightful (although they can be), nor are they necessarily to be repressed. Distinctions between humans and animals may sometimes be quite fuzzy, as studies of African origin myths, totemism, food prohibitions, animal husbandry, spirit-mediumship, witchcraft, blood sacrifice, and other social processes suggest. Shape-shifting can occur, and Africans may coexist, integrate, and identify with animals in ways disconcertingly difficult for many Western observers to comprehend, let alone accept. If the human/animal dialectic is up for grabs, so may be other seemingly "natural" oppositions between matter and spirit, male and female, and time and space. African zoomorphic arts such as masked performances, carved and cast figures, and petroglyphs, often capture this very ambiguity with all its potential.

Why *These* Animals?

Recognition of differences between African and Western views of culture and nature leads to questions about iconography. For instance, popular safari images almost always portray Africa as a vast zoo in which African people are either effaced and invisible, or poachers obstructing wildlife conservation. Contrary to Western expectations, however, zebras, giraffes, rhinos, and lions—though emblematic of tourist Africa—are rarely if ever depicted in African art.[22] Indeed, very few animals from the continent's great diversity of life forms are chosen for artistic representation. While African artists portray some familiar animals (e.g., dogs, horses, rams), they tend to concentrate on a curious menagerie of aardvarks and antelopes, bats and buffalo, pangolins, snakes, spiders, spotted cats, and a few others deemed meaningful in appearance and behavior.

One may ask the structuralist's first question:

The late Dominique Zahan standing between a Bamana Chiwara headdress and a large photograph of two headdresses in performance taken in Mali by Pascal James Imperato, both displayed at the University of Iowa Museum of Art.

Why are *these* "signifying animals," as Roy Willis calls them, so exceptionally "good to *think*" (in the famous phrase of Claude Lévi-Strauss)?[23] It is their salient characteristics that Africans have recognized: the singular cunning of bush pigs, the greed of hyenas, and the rapaciousness of sharks. Even though significance is a cultural construction subject to variation, these are what Mary Douglas has called "natural symbols" (1970). They allow one to begin cross-cultural analysis of animal imagery. Natural symbols leap to the eyes; but they are also "core clichés"—"[images] in suspension needing the context of details supplied in performance to give . . . form and substance."[24]

Some animals effect miraculous transformations: chameleons change color, snakes shed their skins and thus live forever. Other creatures may be wise and know things humans yearn to but cannot (certain small antelopes seem able to evade human capture miraculously). Still others defy expectations of what an animal should be or do: bushbucks are spotted when other antelopes are not, and their truculence in invading human space is cause for both irritation and alarm.

In African zoomorphic art, the reasons for choosing subjects are not always so obvious as these. African artists often focus on creatures deemed *preposterous* (literally "before-after-ness") because they defy and cross categories. Animals that live in and out of water are notable: Nile monitor lizards, bichir fish with their primitive lungs and stout front fins, crocodiles, and pangolins. So are owls that fly at the cusp of night and "birds" that are not birds at all (bats). Also preposterous are creatures forever between one place and another (spiders spinning webs); those so ferocious that they hunt hunters (leopards); and the embarrassingly "human" (chimpanzees). Often the more anomalous the beast (as defined by the contingencies of a specific culture), the more essential its role in African systems of

thought. It follows that the better an animal is in stimulating thought, the more frequently it appears in visual arts.[25]

All these and many other characteristics lead to comparisons between humans and animals. Animals may be like humans, but they are not humans. Why, then, are they so important to African art concerned with human drama? This is the subject of the chapters to follow. First, though, a suggestion of how these images work.

A Conceptual Tool Kit

We must ask the basic questions: what are animal images for, and how do they work? Over the past twenty-five years or so, anthropologists and art historians have become increasingly interested in the ways that thought is organized, expressed, and activated through tropes.[26] Tropes are often called "figures of speech," but it is useful to consider them as organizational forms for visual and performative as well as verbal expression. Following David Sapir (1977), we shall limit our inquiry to the four "master tropes": metaphor, metonymy, synecdoche, and irony.

Metaphor is essential to African expression and is its most significant device as, for example, when people "become" animals in masquerades. When the performer dons a mask, he recognizes that "I am not myself,"[27] but a monkey or bush pig; yet at the same time, everyone, masker included, must know that the person is not a monkey or bush pig, but a human being in that guise or transformative state. The "am" here suggests predication (that is, implication, affirmation, or manifestation) rather than strict identity.[28] Irony and paradox result as intended, and apparent meanings clash.[29] Still, the bridge of metaphor allows one to learn something about what it means to be a human, by the theater of becoming someone or something else.

Metaphor cannot exist without other organizational principles, and in particular, metonymy and synecdoche. An understanding of metonymy helps resolve one of the common questions about African art: how can objects that look so different be called the same thing and used in the same way? *Chiwara* headdresses are a good example of this (cat. nos. 49, 50, 96, and 97). All of these objects differ in some ways, yet each is a *chiwara*. What do these objects have in common? What are the limits of difference allowed within this commonality? That is, how different can an object be from others called *chiwara*, and still be a *chiwara*?

Metonymy refers to the relationship of a shared domain. At issue is the relationship between a conceptual whole and its parts. As such, metonymy is the "logical inverse of metaphor. Rather than the relationship of two terms from separate domains that

share overlapping features," as is the case of metaphor, metonymy "is the relationship of two [or more] terms that occupy a common domain but do not share common features,"[30] except those features necessary for inclusion in the conceptual set itself.

Metonymy is the organizational principle through which group identity and classification are determined. Dominique Zahan presented drawings of over five hundred different *chiwara* headdresses in *Les antilopes du soleil* (1980), yet even this remarkable study is far from exhaustive. Other, slightly different *chiwara* that have been collected or observed, or that are in use by Bamana today or will be in the future could be added to Zahan's list. In other words, in all likelihood there have been and are thousands of *chiwara*, each more or less different from the others. Zahan's *catalogue raisonné* of *chiwara* is so valuable, though, because by looking at hundreds of *chiwara*, one gains a sense of what the boundaries of the metonym called *chiwara* may be, for despite the differences, an object must respond to certain criteria to be classed, called, and used as a *chiwara*, after all. A metonym, then, is a "constrained diversity," as Daniel Biebuyck would have it, with the "constraint" defined by particular cultural and formalistic criteria.[31]

Once the constraint of a metonym is defined and a sense of classification gained, one can concentrate on the particular members of the conceptual set. This, the process of synecdoche, allows one to propose that a part stands for the whole. Synecdoche "foreground[s] those aspects of the whole that are not only distinctive but are also taken as essential or directly relevant to the topic" at hand.[32] One *chiwara* may stand for all *chiwara*.[33] Furthermore, as we shall see, *chiwara* are what I call "collage sculpture," incorporating bits and pieces of animals, some of them readily identifiable, others not so easily recognized. Each *chiwara* is a metonym, then, combining animal parts into a sculptural whole. Looking at a compendium of *chiwara* allows one to speculate (or perhaps "know") what each part does represent, because other examples of *chiwara* make the reference more obvious.[34] Synecdoche and metonymy are in kinetic tension, moving back and forth from part to whole to part; binding any two parts together within the whole is the bridge of metaphor.

Metaphor will be further discussed in this introduction. Metonymy forms the basis for animal classifications presented in our first three chapters. Synecdoche and irony prove important to an understanding of the composite and collage zoomorphic art considered in chapter four. As an epilogue, a study of leopards brings all four master tropes to bear on the question of why leopards appear so frequently in African arts concerned with political legitimacy. To understand the impact on Africans' lives of zoomorphic art objects and their contexts—how these are vehicles for ideas, how they foster creativity, and how they often provoke innovative response—we must begin with a basic understanding of how thought is organized through metaphor and other tropes as Africans seek to make sense of their world.

Of Turkeys and Aardvarks

The way the world works is explained to children and contemplated by adults through oral narratives and dramatic performances, often using art objects as props and vehicles for ideas. In what James Fernandez calls a person's "quest for identity," "primordial metaphors" are proposed that establish the boundaries between divinity and humanity, nature and culture; often they play upon "mankind's ancient, virtually universal, and inveterate interest in animals." Such metaphors are a strategy—they have purpose, and rather than being concrete and objectively "true," they depend upon paradox and irony, as they "locate the movements . . . [of] desire."[35]

Animals are portrayed in African art for human purposes: they help make sense of the human condition, as amorphous a proposition as that may be. First formulations of sense and order must be intuitive, and as Fernandez suggests, "intuitions of inchoate matters must be . . . expressed in metaphor."[36] Intuition suggests perceptive insight, scrutiny, and contemplation; while that which is inchoate is a beginning or something incipient, hence that which is elementary, imperfect, or undeveloped. "Inchoate" is from the Latin root *incohare*, to harness or hitch up a plow to a draft animal[37]: as the farmer readies his beast, the plowing of a new or fallow field is anticipated but not yet begun. The imposition of orderly furrows upon weedy chaos is an intention to be realized. Metaphor provides the active means to achieve the cognitive intentions implicit to the inchoate.[38] One is reminded of the Yoruba saying, "proverbs are the horses of speech"[39]; as metaphors that extend toward parable, proverbs carry meaning. And on the backs of robust African-animal metaphors, a good ride it is!

"Tropes [like metaphor] always define a relationship between terms."[40] The word "metaphor," for instance, is the joining of two Greek roots: *meta-* refers to "sharing action in common, pursuit or quest, and especially change of place, order, condition, or nature"; while *-phor* is from a Greek verb meaning "to bear, to carry."[41] "Metaphor" implies, then, a carrying across or a bridging between two disparate things, states, or persons. Metaphor demonstrates or, in some cases, proposes and creates a link, an affinity, or an otherwise unrecognized commonality.

Metaphors have two parts: a subject is linked to a predicate, suggesting they share some quality. This can be illustrated through the Venn diagrams of sym-

(LEFT) Mother of the performer giving instructions and encouragement to her son, speaking to him through the mouth of the Gnoumou family plank mask, in the Bwa village of Boni, Burkina Faso. Photo: Christopher D. Roy, 1984.

(RIGHT) The Catholic church at Boni in the form of a Bwa plank mask. Photo: Christopher D. Roy, 1984.

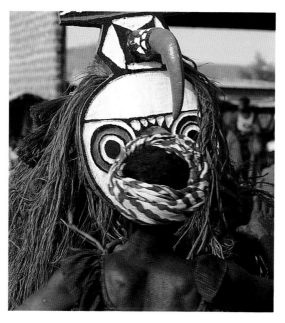

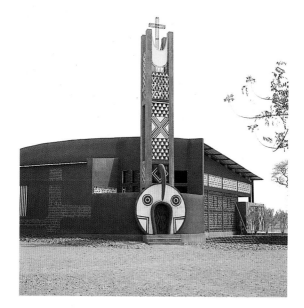

bolic logic, in which A and B share some quality at area C (see fig. 1). Most of the attributes of A and B are not shared, and yet a possible relationship, no matter how remote or unlikely, exists between any attribute of A and any attribute of B through the bridge at C. The result of the metaphorical relationship proposed between A and B is a figurative image, a *sense* of the subject that is interpretive and hypothetical rather than "direct," "natural," or "objective," as might be the use of an adjective or other modifier of the subject. These last terms are placed in quotation marks because they are by no means absolute; instead, they are contingent upon the particularities of cultural and historical context.

A simple example from American popular speech, such as "Dan is a turkey," makes the bridging relationship of metaphor clear. A speaker and his or her audience will know that Dan is a human and not a bird, of course, and they will know that a turkey is not a person named Dan. Yet there is something about Dan that is turkey-like, and vice versa. In order to "get" the metaphor—that is, in order to understand its allusion and its intent—one must know something about both Dan and turkeys, as well as about the intentions of the narrator in proposing the metaphor in the first place. The root of the metaphor probably lies in the seeming mindlessness of turkeys, who gobble at the slightest provocation and whose heads are so small in proportion to their ungainly bodies. Many Americans, especially urban ones, may have no direct knowledge of turkeys, however; yet they use the metaphor because it is in common parlance. Some Americans do raise turkeys, and it may have been they who originated the metaphor; it is also said that "animals of the mind remain with us, while real animals have become marginalized."[42] The bridge effect of metaphor is possible even without direct knowledge, if people using the metaphor share

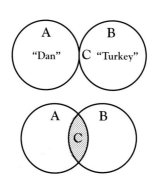

Fig. 11: The bridging of metaphor A and B are metonymic totalities, C a synedcochal part-for-whole that they share.

the basic assumptions and expressive forms of a common culture.

If, however, a different metaphorical relationship were suggested, between, say, Dan and an aardvark, few if any Americans would "get it." Not many Americans know anything about aardvarks, and even if they are seen occasionally in a zoo or in a photograph, the animals are so remote from American life that the proposition of such a metaphor would be considered nonsensical. The audience would refuse to cross the metaphoric bridge between humans and aardvarks.[43]

A person in the parts of Africa where aardvarks are found, however, might think very differently. If one were to propose this metaphor to a Tabwa hunter from southeastern Zaire, he would probably laugh uproariously at the impertinent suggestion that Dan has a head as oddly phallic as an aardvark's! To my knowledge, Tabwa do not use this particular metaphor—but they might, say, to describe a womanizer. Such potential is another aspect of metaphor: possible bridges exist that may not have been crossed, but that could be. Speech is generative, and eloquent speakers are always proposing new twists.

Metaphor, then, is a relationship posited between two domains, and if an audience is to cross the bridge and "get" the metaphor suggested by the individual proposing the relationship, the audience must share certain information, attitudes, and intentions. People of different nationalities and ethnic groups have different information at hand: Americans know about turkeys, Tabwa do not. Similarly, at least some Tabwa know about aardvarks, but most Americans do not.

Within a given culture, information necessary to "get" a metaphor may be group-specific as well. In America, inner-city dwellers generate and use metaphors that have little significance to rural people, and vice versa. In the 1990s, rap music has popularized

urban American expression, but a rural person is unlikely to understand or appreciate its nuances. Among Tabwa of Zaire, men know about aardvarks while women allegedly do not, because it is men who do the hunting and encounter the reclusive animals. Hunters who catch an aardvark cut its phallic snout into tiny pieces before they bring the carcass into the presence of women. They fear that, were they not to do this, women might cry "So that is what it is like!" and break into such hilarity that the men's hunting "luck" would be ruined![44]

Some groups of people may be deliberately denied the knowledge necessary to "get" a metaphor. That is, the allusion made through metaphor may be based upon secret or arcane information, proposed specifically to mystify all but those few who know the secrets. The joy with which adolescent Americans befuddle their parents with slang is one instance of this; the use of metaphor by initiates of African secret societies or in circumstances of political tension are others.[45] Metaphor can be important as a strategy for creating or maintaining a sense of group identity (Us versus Them) and often implies secrecy, separation, and the power that is possessed by those who know something that others do not.[46] Metaphor is an expressive device of great political significance, then. Multireferential animals serve such purposes especially well, for a simple dog or ram to outsiders may have great significance to those who share access to esoterica.

People propose metaphors when they wish to explain or add nuance to an understanding of some subject. Often the subject is divine or magical, and so it is ineffable—that is, both impossible and sometimes improper to describe by ordinary verbal means. One can think of a conundrum shared by African and Judeo-Christian traditions: how does one describe divinity if God is Almighty? How can one describe anything that is infinite? One cannot, and to say that one can is a contradiction in terms. Description itself

is the recognition or declaration of something as finite and tangible. Metaphor allows one to overcome this conceptual dead end. In Christian art, for instance, God may be portrayed as a kindly old man with a flowing beard, as on the ceiling of the Sistine Chapel. Elderly men with long beards are by no means "almighty," nor would everyone agree that God is male; but this is clearly not the point. Rather, the wisdom and warmth of the elderly are qualities so closely associated with God the Father that, for many Christians, an old man with a flowing beard is an appropriate metaphor for God himself.

Africans, too, represent the ineffable through visual arts that often play upon useful animal metaphors. A theranthropic aardvark (that is, one with some human characteristics and some bestial) is the culture hero in a series of important origin stories collected among Tabwa around the turn of the century, for example. As will be discussed in chapter four, this preposterous animal is "overdetermined" in its being and behavior, and presents so much information about the way the world is (or is not) organized, that such a hero proves to be both an especially economic narrative device and one that is comical to audiences aware of just how absurd it is to have an *aardvark*, of all things, as the originator of human culture as they know it.

An important aspect of animals' utility in this regard is that they are once-removed from humanity. What people are unable or loath to put into words may more easily or appropriately be represented in visual and other expressive forms. Through the "parallel discourse" of animal allegory, relationships can be posited, sense made, and critique delivered from an intellectually and politically safe distance. In other words, metaphor is still only that: hypothetical, and basically untrue. The man wearing a bush pig mask is still a man, despite his convincing performance. The irony is conscious, but it works. Although he and his audience may be intellectually and spiritually transformed by the insight and drama of his performance, he can and will take the mask off again.[47] Metaphor proves especially appropriate in circumstances of ambiguity, tension, or conflict as a means to prod and provoke from a distance.[48] Indeed, animal metaphors are often employed to express indelicate, controversial, or confrontational subjects with the wise indirection (and humor) that characterizes so much of African discourse.

Proposing a metaphor can bring a better understanding of a subject that otherwise defies definition, but only if the audience agrees that the metaphor is apt.[49] In such a transaction, the audience must see the metaphor as logical or at least useful. They must be willing to recognize and cross over the bridge pro-

Drawing of Mtumbi, the aardvark [Orycteropus afer (Pallas)] by Allen F. Roberts, 1978.

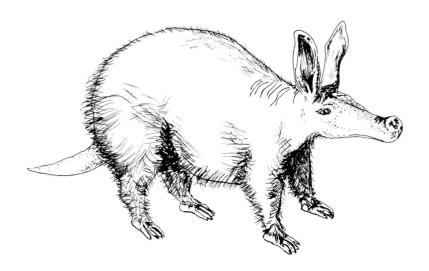

posed by the metaphor, linking an old man with God or an aardvark as culture hero.

Alternatively, though, the audience may reject the metaphor as inappropriate and refuse to "get" it.[50] Some metaphors are so provocative that they have caused great controversy. In the early 1990s, a photograph by the Afro-Cuban artist Andres Serrano of a crucifix partially immersed in the artist's urine was described by one reviewer as an "industrial-strength sacramental" and "an altarpiece for a cathedral no one is building"[51]; yet it so infuriated ultraconservative members of the U.S. Congress that they threatened to eliminate the entire National Endowment for the Arts, which had partially funded the artist's work.[52] In other words, "getting" a metaphor, like "getting" a joke, depends upon more than a sharing of sufficient information for the bridging effect to be recognized, for even when the audience "gets" it, the metaphor may be deemed inappropriate because of the provocation of its juxtaposed subject and predicate. Instead, the sharing of metaphor implies negotiation and a "bargaining for reality"[53] that makes metaphors "aspects of more complex, pragmatically oriented forms of discourse or activity"[54] based upon the contingencies of local-level politics and history.

All said, and following others' lead, I would suggest that metaphor is *the* organizational principle for expressive culture in Africa and elsewhere.[55] Indeed, if Western observers admit that they do not "get" African art, this may well be because they cannot or will not cross the metaphoric bridges that African artists propose, or because many of the metaphors are meant to deliberately exclude outsiders to African cultures and circumstances.[56] Even if Western observers do possess sufficient information to "get" the metaphors of African art, as in the case of some missionaries who have spent many years in Africa, Western observers may be unwilling to accept the conceptual relationships that African art suggests for reasons specific to their own ideologies.

Riffing with the Buffalo

An example will make evident the role of metaphor as the master trope of African art. What seems, at least at first glance, to be a readily accessible[57] example is the buffalo masks made by Tabwa people of southeastern Zaire (cat. no. 64). An obvious first question would be: why is this animal chosen for what are almost the only carvings that represent animals known to have been made by Tabwa?[58] There are several hundred mammals indigenous to Tabwa territory, including some of the most striking carnivores such as lions and leopards. Why is the buffalo (*Syncerus caffer*) so important, and what is implied by its metaphor? What does "buffaloness" have in common with humanity? Why should this relationship or

bridge between buffalo and people be so important that the metaphor is enacted in dance and performance? To answer such questions necessitates an ethnographic riff—a jazzy excursion through Tabwa culture.

Several traits of buffalo anatomy and behavior described by Western naturalists are also important to Tabwa reckoning. Buffalo are found in "herds in which red and black buffalo live all together" in the forested savanna of Zaire.[59] Often, buffalo cows are "sorrel-colored" while bulls are "almost coal black."[60] Buffalo cows usually bear single young.[61] Although ordinarily as docile as cattle, buffalo are notorious for their "deliberate savagery" when provoked. Prehistorian Louis Leakey, for instance, wrote that "a wounded buffalo is the most cunning and most dangerous of all animals I know,"[62] yet buffalo may not be as "diabolically clever as hunters claim," except when persistently harassed. Instead, they are "really more cow than killer."[63]

Buffalo are "mostly nocturnal" or crepuscular (that is, active at dusk and dawn); and, although enormous animals, they are able to virtually disappear during the daytime, seeking refuge in thickets around sources of water.[64] Part of Tabwa people's fear of buffalo is due to their apparent invisibility: they are there but not seen, and so doubly dangerous. The animals are also fond of mud wallows, in which they may submerge themselves almost completely,[65] and they seem to swim in rivers and lakes for the pleasure of it.[66] Yaka hunters in west-central Zaire have noticed these unusual traits, and have coined proverbs that refer to "the buffalo's capacity for disappearing when surprised or wounded. The animal hides and then surprises the hunter who, thinking it is front, finds the animal attacking from behind. In such manner, the animal is likened to a witch preying upon an unsuspecting foe." Southern Suku buffalo masks are worn in the morning or evening, but never during full daylight, again reflecting the animal's distinctively crepuscular behavior.[67]

Buffalo, then, possess opposed traits either alternatively or, what is even more paradoxical, seemingly at the same time: they are red and black, docile and aggressive, visible and invisible, in water or mud and out, active at dusk or dawn. They present a divided or dichotomous nature, subsuming opposed categories of color and behavior that are separate in most other animals. It is such paradoxes of buffalo anatomy and behavior, observed by Tabwa hunters, that are the basis for a metaphoric bridge between buffalo and human beings. In particular, buffalo are associated with chiefs and culture heroes for Tabwa and related peoples of southern Zaire.

Buffalo are still found in Tabwa lands, although they are far less common than they were prior to the

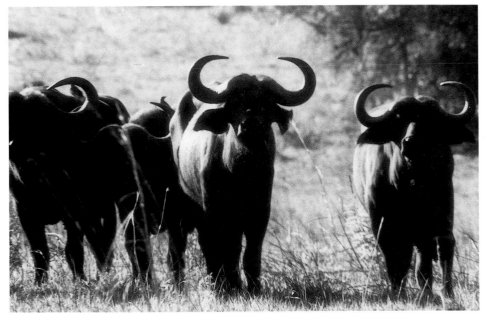

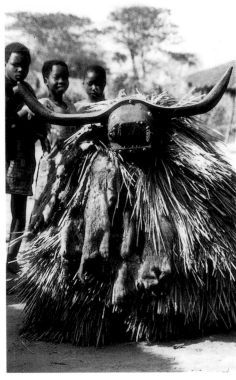

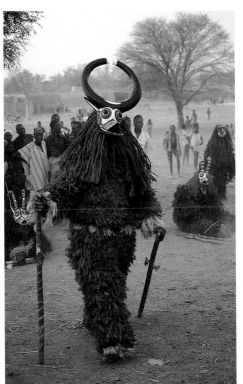

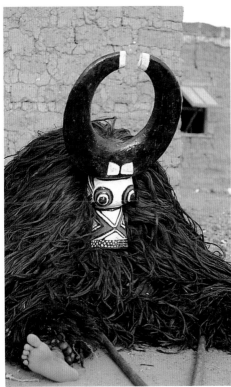

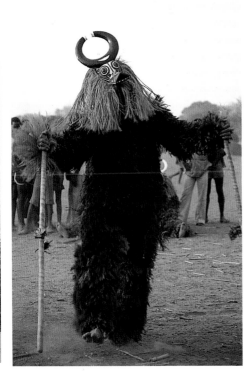

(TOP LEFT) Buffalo in Zaire. Photo: Allen F. Roberts/ Christopher Davis-Roberts, 1976.

(TOP RIGHT) Tabwa buffalo mask in performance, Zaire/Zambia. Photo: Marc Félix, 1973.

(BOTTOM LEFT) Nunuma buffalo mask arriving at a funeral performance in the village of Tisse, Burkina Faso. Photo: Christopher D. Roy, 1984.

(BOTTOM CENTER) A Bwa buffalo mask waits its turn to perform at a Gnoumou family funeral. Photo: Christopher D. Roy, 1984.

(BOTTOM RIGHT) A Nunuma male buffalo dancing at a funeral in the Bano neighborhood in the village of Tisse, Burkina Faso. Photo:Christopher D. Roy, 1985.

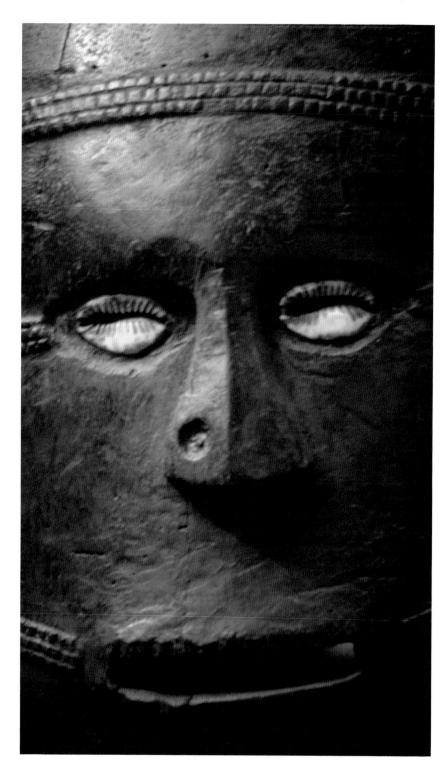

Detail of a Tabwa female mask from a private collection. Photo: Allen F. Roberts, 1993.

ate buffalo and buffalo masks with male initiation.[73] Furthermore, Mbidi Kiluwe, the Luba culture hero, was praised as being "shiningly black like the buffalo."[74] Two field collectors of Tabwa art have been told that the name for Tabwa buffalo masks is Kiyunde, and that this buffalo dances with another mask representing a human woman.[75] Although the etymology of "Kiyunde" remains obscure, it may be derived from a root meaning "to heal" or that is associated with the smelting of iron, activities associated with local culture heroes among Tabwa and their Luba neighbors.[76]

Luba and some western Tabwa possess a secret society called Mbudye, the purposes of which include extolling Mbidi Kiluwe, the culture hero who founded the Luba state.[77] The central figure of Mbudye is Lolo Inang'ombe, said to have been the offspring of a woman and a buffalo, a woman married to a buffalo, or, as in a Mbudye wall painting seen once by W. F. P. Burton, a dichotomous being that had the body of an animal (a buffalo?) and the torso and head of a woman.[78] Tabwa buffalo masks dancing with those portraying human women may represent this couple or at least refer to the same play of metaphors. Perhaps the buffalo mask was danced to dramatize the bestial excess of the earliest humans, who, like Lolo Inang'ombe, coupled with buffalo. As Burton suggests, "within the sect [of Mbudye] promiscuity is practiced" and there are "sensual displays of dancing, where every sexual action and gesture is exploited to the full,"[79] probably for the same symbolic purposes.

Why, though, should an animal that exhibits such paradoxical behavior be associated with heroes and chiefs? What is it about political power that finds apt expression in dichotomy and its mediation, as represented by buffalo masks?

Tabwa chiefs are the "fathers of their people," and as such, they are expected to give their followers whatever support, guidance, and protection they may need.[80] At the same time, Tabwa chiefs are feared as the greatest sorcerers of the land, sharing in the evil rewards of human misfortune suffered by their "children." This is to say that political power for Tabwa is considered inherently ambiguous and accepted with palpable ambivalence. Those enlightened leaders have a dark, maleficent, potentially despotic side, marked by the pursuit of their own selfish interests.[81] Evil does exist. As the personification of social order, chiefs must be responsible for evil as well as good and must tread a fine line between positive and negative action (as defined situationally through ego-defined local-level politics). They are forever betwixt and between crosscutting social forces.[82] Everyday social life entails the difficulties of decision making and divided loyalties—the "matrilineal puzzle" (in which

introduction of gun hunting.[68] The strength and violent nature of the buffalo are played upon in Tabwa ritual and magic. Magical whisks made from buffalo tails are used to keep at bay smallpox, *visanguka* lion-man terrorists, sorcerers, or other agents of destruction.[69] The name of such a whisk, *mpunga*, is from a verb meaning "to stay awake and vigilant all night."[70] These whisks are still used in magic and as signs of political status, as they were by earlier Tabwa chiefs.[71]

Turn-of-the-century Eastern Luba found the same metaphors apposite. A boy leaving the initiation camp was greeted with the cry, "Here is the buffalo, here is the buffalo!"[72] Yaka, Suku, Pende, and perhaps other groups from west-central Zaire similarly associ-

the demands of a man's own biological children are set against those of his sisters' sons, who will be his heirs) and many other conundra. A conundrum, by definition, is a riddle admitting no final or absolute solution. Such puzzlements of society are recognized and personified in the very beings of their dichotomous chiefs.[83]

Tabwa chiefs are ambiguous creatures, then, and their two faces reflect the reality of a world in which people strive to be generous and good, that is also a world in which misfortune ultimately prevails.[84] A Tabwa chief's house is ideally located at the head of the central avenue of his village. As he sits on his porch, the chief sees everything that happens in his village. He must see both sides of any contentious issue, intervene, show pity, and offer refuge. When he does so, not everyone will be pleased, though, as self-interest on one side of the line will cause suspicion of collusion with the chief on the other.

Luc de Heusch points to the dichotomous dilemma inherent in the Bantu conception of political power when he writes of the newly invested Tetela king as someone who rules society, but who is also intimately associated with the dangerous, bestial power of raw Nature. As de Heusch notes, the Bantu king is "an ambivalent creature, at once beneficent and dangerous: a sacred monster."[85] This, quite clearly, is what Tabwa have sought to contemplate through their buffalo masks, reflecting as they do, a chief's incarnation of the contradictions, paradoxes, and other ambiguities of daily social life.

Buffalo applique as emblem of kingship, Ouidah, Benin. Photo: Allen F. Roberts/Mary Kujawski Roberts, 1984.

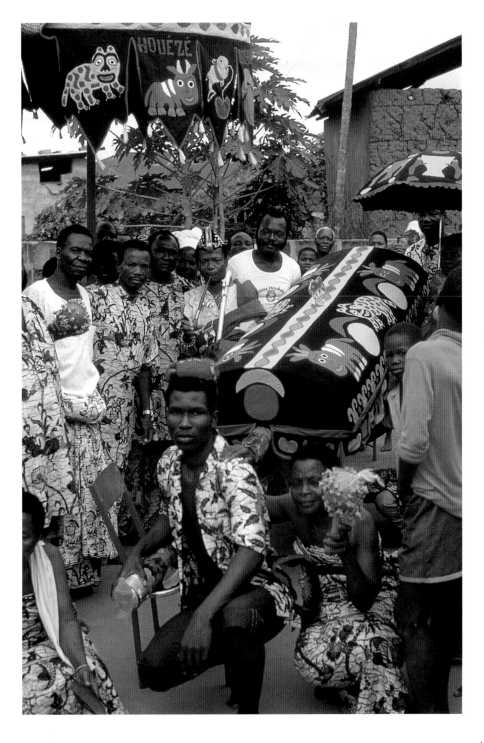

When a man bites a dog, that is news.
Charles Dana, 1882

Familiar Friends

Matakam household showing cow in subterranean pen, Cameroon. Photo: Allen F. Roberts, 1965.

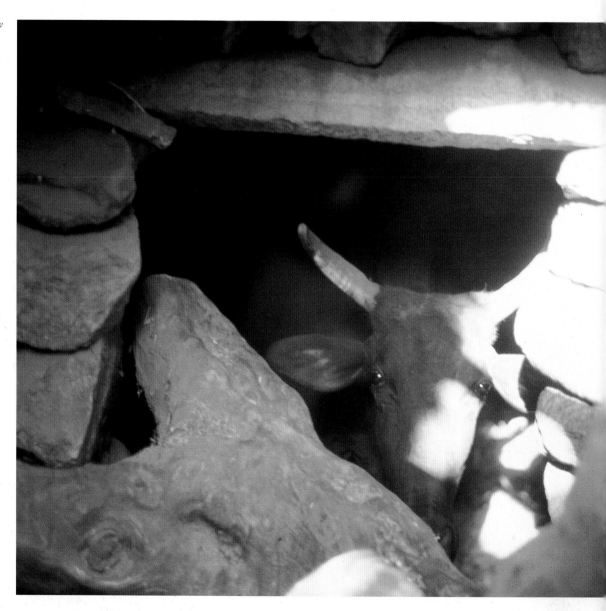

*T*hings and circumstances do not make sense—people make sense of them. Aristotle remarked that "men create the gods after their own image."[1] As Zora Neale Hurston would add, "gods always behave like the people who make them," not the opposite, despite the book of Genesis.[2] Moreover, "nature is, by nature, undifferentiated and unclassified. It is man who, in his social behavior and his language, distinguishes fish from fowl, man from god."[3] And it is humans who proceed from there to differentiate among animals in a classification system. But what is so fascinating is how human *the purposes are for doing so.* "We need to become objects to ourselves, and others need to become objects to us as well."[4] Animals are just the device to allow people to accomplish this task easily, so that they may put into some once-removed context who and what they are all about.

Religion, or its near synonym "cosmology," can be thought of as a system of classifications that explains how the world works and why it sometimes does not. According to the Oxford English Dictionary, cosmology "deals with the idea of the world as a totality of all phenomena in space and time."[5] Defining the rules and norms of the totality provides a secure sense of human place and purpose. This "ought-to-be" permits people to exploit the regularities of the universe—the monotony that Durkheim saw as the basis of "the religious sentiment"—while coping with the "surprises" of misfortune.[6]

First formulations of sense and order must be intuitive. The goal is to establish order in chaos, or to *recognize* it.[7] Tabwa and other Bantu-speaking peoples (like Durkheim) would say that the order is there, divinely inspired or divinity itself, waiting for perspicacious people to notice, comprehend, and put it to use. Anthropologists would contend this achievement of knowledge is a social process,[8] and not once-and-for-all. One must first know the monotonous regularities in order to recognize the dialectics of order and disorder, stability and change. But there must also be a continual and dynamic struggle to keep one's knowledge current, as the rules are put to the test by the "surprises" of conflict, misfortune, and sometimes radical upheaval.

Metaphor's intuitive process of carrying across from one domain to another is especially apposite to such unending needs. To pursue the matter of the inchoate, at the end of the harvest, once orderly fields revert to disorder, the farmer must be prepared to cinch his harness and plow anew. Growing conditions may change, though, due to variables such as weather, animal pests, human competition for land, or other factors. The farmer will have to adapt to meet these new circumstances, if he is to be successful in the coming season. The inchoate is a permanent aspect of understanding that is always changing and challenging.

Naming Names

If cosmology is "a totality of all phenomena in space and time," there must be a logic of distinction through which one thing is differentiated from another. Making sense begins with naming and proceeds through classification. A primordial goal of any such system must be to differentiate between people and animals, human culture and nature. Tabwa say that before infants acquire human speech, they converse with animals; but once they begin to "talk," they lose this capacity.[9] Enter culture. Anthropologist Edmund Leach has proposed a straightforward scheme for understanding how the transition to humanity occurs, beginning with how children first learn to identify and interpret their world in ways consistent with their culture. "The child's first and continuing problem is to determine the initial boundary. 'What am I, as against the world?' 'Where is the edge of me?'"[10] Leach suggests that physical and social environments for newborn infants are "perceived as a continuum" that "does not contain any intrinsically separate 'things.'" Such cognition can be represented by a solid line. As the child learns, and especially as language is acquired, names of separate things and discriminating among them are introduced to the child's cognitive repertoire. The solid line of perception becomes divided as vocabulary and other sensory and intellectual experiences are gained. As an indi-

Dogon granaries, Mali. Photo: Allen F. Roberts/Mary Kujawski Roberts, 1986.

Yona, "ritual thief" holding yo domolo crook on shoulder, Mali. Photo: Allen F. Roberts/Mary Kujawski Roberts, 1986.

vidual grows more mentally sophisticated, these perceptive bits ("line segments") become smaller and smaller with precision of reference.[11]

Such a model for cognition depends upon clarity of discrimination: ambiguity is to be eschewed, and "there must be absolutely no doubt about the difference between *me* and *it*, or between *we* and *they*."[12] This is a logical requirement if one is to make sense of existence. Yet the disjunction itself—the space between the line segments—is also a thing. If the sides of a yin-yang symbol form a dialectical opposition, the threshold line between the two also has significance: the figure is of three parts rather than two, then.[13] Leach calls such disjunctive interstices "nonthings" and "tabooed ambiguity."

Taboo is a recognition of this odd, betwixt-and-between status that is often dramatized through prohibitions and ritualized avoidances: "whatever is taboo is sacred, valuable, important, powerful, dangerous, untouchable, filthy, unmentionable"[14]—and, more fascinating than almost anything else. The buffalo is one such paradox, as understood by Tabwa. Subsequent chapters are devoted to anomalous animals represented in African art that are taboo in this manner. In this chapter, we consider the familiar structuring of thought and experience as the regularity against which tabooed oddity is defined.

Constructing the Familiar

Cosmogonic myths set forth a world known or knowable to a narrator's audience. A first task of such stories is to create a system of knowledge by which the world can be understood, as in the first verses of Genesis. Typically, a supreme being gives individual

and family names to plants and animals and determines their distribution; this is the achievement of taxonomy—"the classification of organisms in an ordered system that indicates natural relationships."[15] One of the clearest delineations of such divine order in the literature of African peoples appears in *Conversations with Ogotemmeli*, recorded by French anthropologist Marcel Griaule in 1946 after fifteen-years' work among Dogon people of Mali in and around Ogotemmeli's village.[16]

According to Ogotemmeli, the Supreme Divinity Amma first created beings called *nommo*, whose unarticulated limbs and undifferentiated gender characterized their inchoate nature. One *nommo* rebelled against Amma and decided to leave heaven, taking with it whatever might be useful to life on earth. It constructed an ark in a form replicated by contemporary Dogon granaries (silos). The circular base of the ark represented the sun, the square top the sky, and a circle within that square, the moon. Stairways led down each side. The rise of each step was male, the tread female, and the four stairways of ten steps prefigured the number of great families born from the original beings. Each stairway was occupied by a different sort of creature under the ægis of a particular constellation of stars. To the north, was the way of the Pleiades, for men and fish; to the south, that of Orion's Belt, for domestic animals; to the east with Venus, the birds; and in the west, the "long-tailed star" shone over all wild animals, insects, and plants.[17] Each stairway was also a hierarchy. Descending the first six steps of the west, for instance, were antelopes, hyenas, felines, reptiles, monkeys, gazelles, marmots, lions, and elephants; after which came trees and plants, and the insects associated with them. The southern stairway began with chickens, then sheep, goats, cattle, horses, dogs, and cats. On the eighth and ninth steps were the great tortoises—still kept in Dogon households to take the place of watchful and wise heads of household, should these be absent for some reason—and smaller turtles used in important sacrifices. The tenth step of the southern staircase, for domestic animals, was occupied by mice and rats. The various birds on the eastern stairway were matched by people and fish to the north. The humans were Bozo, deemed by Dogon to be the original inhabitants of the Inner Delta of the Niger River, which they now share. The inside of the ark (like that of a contemporary granary) was divided into compartments associated with human organs; nowadays, particular grains and other foodstuffs, as well as sacred materials, are kept in these.

When the ark was completed, one of the *nommo* stole a piece of the sun to provide fire for blacksmithing, and thus for life itself, on earth. This Promethean act was the origin of human culture, but would also

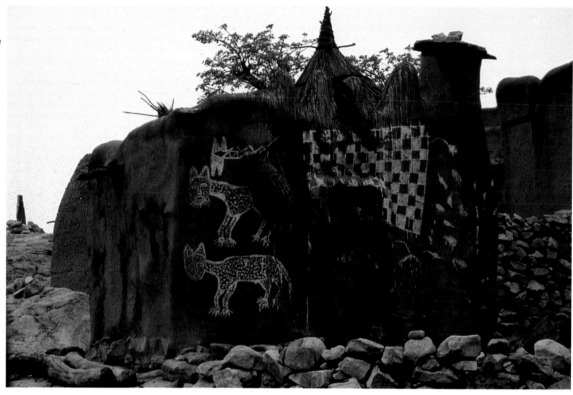

lead to the introduction of loss, death, and grieving to the human world.[18] The *nommo's* theft was accomplished using what Dogon call a *yo domolo*—a "robber's crook" with an animal head, still worn over the shoulders of members of the Yona Society when they ritually reenact the creation myth.[19] Amma (God) was furious at the *nommo* for this defiance, and as the being began to ride the ark down the rainbow to Earth, Amma hurled lightning bolts after it. The *nommo* shielded itself with the skin of its blacksmith's bellows, and the deflected lightning became known as *bazu*, still replicated in carved, wooden posts placed near fruit trees or other precious resources to warn would-be thieves of the wrath of God. The bolts accelerated the ark so that it crashed onto the surface of the earth. The impact broke the *nommo's* arms and legs at the points of articulation (wrists, elbows, shoulders; ankles, knees, hips) necessary for agriculture and the other life-sustaining, hard work of humans. At the same time, the plants, animals, and people on the ark's staircases were flung in a wide circle, to occupy their places known to Dogon today.

Several points are of particular interest in this account. The classification by stairway does not strictly follow Western taxonomy. Tortoises and rats are "domestic animals," because they live in human space, while fish are so intimately associated with Bozo people living along the Niger River that they appear together. Dogon consider Bozo to be autochthonous to the lands they now share, and a Dogon name for Bozo means "that which has not completely passed," suggesting their primitive nature from a Dogon-centric viewpoint. Furthermore, all Bozo but one woman on the lowest step of the stairway are

attached at the navel to fish. This suggests both the way that Bozo are identified with their fishing lifestyle, and, again, their not-quite-yet-human nature, for Dogon consider fish (and especially certain catfish) to be fetal beings, close to *nommo* in their inchoate nature.[20]

The vertical hierarchy of the stairways suggests that animals closer to the bottom of the ark are closer to humans on earth, in a life to be dominated by the sun (the circle forming the bottom of the ark). Of domestic animals, mice and rats share the most intimate household spaces with people, and moving up the stairway, one encounters animals with which Dogon identify less and less. Ogotemmeli's account, then, explains the way things are, not only how one sort of animal is related to another, but how non-human life and other ethnic groups like the Bozo are distributed outward from the point of the ark's impact. The center of Dogon life, household and village, is thus defined.

Familiar Animals

In many (or all?) African societies, social space is constructed outward from the center of everyday life, just as Ogotemmeli's story suggests. Familiarity begins at home. As Gaston Bachelard has written, "Our house is our corner of the world . . . a real cosmos in every sense of the word." One's home is closed and protecting, the site of original values, fondest dreams, and elemental memories. "The house we were born in is physically inscribed in us. It is a group of organic habits." Furthermore, as a place of secure sheltering, "the house thrusts aside contingencies, its councils of continuity are unceasing. . . . It appeals to our con-

sciousness of centrality."[21] Villages of such homes are "the focus of the many euphorias of . . . social life," where family and women's activities predominate.[22] It is here that one is anchored at and to the center of life—the refuge that is mother, the bosom that is home.

Several sorts of domesticated animals found in the rural African home are often portrayed in visual arts and enacted in performance. The layout of the household itself may incorporate relationships between human and animal inhabitants. For Dogon, the idealized home compound takes the form of a man lying on his right side in a fetal position, with the various bedroom and kitchen houses, stables, granaries, and other buildings, workspaces, and passages corresponding to points of significance and articulation of the physical and social body. Goats are penned in the chest, for instance, and horses stabled in the legs. In the semi-subterranean households of Matakam people of northern Cameroon, cattle and horses occupy buildings adjacent to the headman's central granary, calves are stabled near sons' quarters, and oxen near the first wife's; while for Mousgoum, who also live in northern Cameroon and northwestern Chad, cows and goats share space with the first and later wives, respectively. In such instances, African households recapitulate aspects of the greater social universe, stressing how nature and culture stand opposed and yet intersect.[23]

Animals sharing the domestic space of African homes may be more than domesticated animals: their places, lives, and behavior may overlap with that of humans to the extent that they are no longer strictly "animal." This is most obvious in the case of dogs, which are presented in detail here. It is curious that some equally common domestic animals (e.g. cats, donkeys, pigs, goats, ducks) rarely appear in visual arts.[24] Apparently, these animals are so mundane that at least some are better to eat than to think! Certain

others—horses, cattle, sheep, chickens—are portrayed in African arts, and these are discussed at the end of this chapter.

Of Wagging Tails

Throughout Africa, dogs are kept as helpmates in herding and hunting, and to watch over the household.[25] Sometimes, as among Tabwa people of Zaire, they may be cherished pets with endearing praise names, who sometimes share or clean up after human meals. Yoruba, too, sometimes give fanciful pet names to their dogs, such as Lekewogbe, "He who drives away liars into the bush."[26] Among Kongo, running over a dog with a vehicle is considered nearly as serious an offense as striking a person.[27] Minyanka of Mali become so attached to dogs that when such a companion dies, a funeral and burial may be offered following the same practices as those used for people.[28] For other African peoples, though, dogs are barely tolerated pests, more likely to attract stone-throwing than a pat on the head.

In many African societies, dogs are felt to possess an extended ken that allows them to see what humans cannot. For Tabwa, dogs, like spotted hyenas, side-striped jackals, bushpigs, and bateleur eagles, have *malosi*, a prophetic vision that permits them to penetrate the obscurity of darkness, distance, or tangled vegetation in their quests for prey or plunder. If a Tabwa person dreams about dogs, it is a sign that Kabwangozi, a personal spirit, has come to council the dreamer. An amulet (*erizi*) will be made that includes red and black *minkinke* seeds (*Abrus precatorius*) or tiny glass beads of the same colors, which Tabwa refer to as "eyes of the dog." The seeds or beads contrast the "red" of violent transformation with the "black" of arcane knowledge.[29] Honored, engaged, and empowered by the amulet, Kabwangozi will "see" and help avoid adversity.

Like many central African peoples, Tabwa further assert that the *malosi* of dogs allows them to see through the veils of secrecy to the odious activities of witches and sorcerers invisible to ordinary eyes. The iron bells that Tabwa hunters fasten to their hunting dogs' collars, so that the dogs' progress can be tracked even in the densest thickets, are also attached to the medicine horns of the most powerful shamanistic healers, to point toward sorcerers attacking them or their clients.[30] For similar reasons, in many parts of Africa dogs are associated with divination, again because they can "track" the source of difficulty and despair.[31] Kuba wooden rubbing oracles may take a dog's form, for example,[32] because of that animal's "ability to negotiate the dark recesses of the forest and find hidden prey" in a manner deemed "analogous to the role of the diviner seeking truth."[33] Among some Nigerian peoples, dogs' eyes are roasted,

Matakam household, Cameroon. Photo: Allen F. Roberts, 1965.

(LEFT) *Abrus precatoria seeds, "eyes of the dog."* Photo: Allen F. Roberts, 1992.

(RIGHT) *A Tabwa man holding a kabwangozi magical amulet he is making with abrus precatoria seeds, Zaire.* Photo: Allen F. Roberts/ Christopher Davis-Roberts.

ground, and mixed with other ingredients, to be swallowed by someone wishing to see more clearly; spirit mediums and nightwatchmen are said to partake of such a preparation.[34]

Among Kongo peoples, dogs are at home in the most private parts of village compounds, and so are an ordinary feature of everyday life; yet they seem equally at ease in the forest, the residence of the dead (cat. no. 11). Wyatt MacGaffey reports that some Kongo say that "on the way to the village of the dead, a traveler passes through a village of dogs"[35] who presumably watch over the threshold as did three-headed Cerberus of ancient Greek and Roman lore. Kongo hold that dogs possess two sets of eyes, one for this world, the other for the other. As "seers extraordinaires," dogs may carry messages back and forth between the living and the dead.[36] This may explain why some wooden *nkisi* figures studded with iron "messages" to the spirits represent two-headed dogs facing opposite directions, with a bundle of powerful magic at the threshold between them.[37] Such bundles are often closed with a mirror, representing the reflective division between the living and the dead that may be traversed by a piercing gaze.[38] The Kongo writer Fu-Kiau Bunseki suggests that the "mirror (*talatala*) and dog (*mbwa*) symbolize the same thing among Bakongo," underscoring the animal's dualistic ambiguities.[39]

In Africa, then, dogs may be "man's best friend," and sleep at one's feet; but the same animals are subjects of ambivalence, even among those like Tabwa, who generally hold them in high esteem. As intermediaries between this world and that, or between moral and malicious actors, dogs partake of both sides. Such ambiguity is expressed by Lega of Zaire through carved quadrupeds that may be interpreted as dogs, more anomalous beasts such as pangolins, or dogs and other animals at the same time.[40] Sukuma of Tanzania make a magically charged dog so expressive as to seem anthropomorphic.[41] Dogon sculptures portray dogs gagging on their own tongues in thirst; and as

they become encrusted with sacrificial materials they take on an earthy appearance.[42]

The ambiguity of dogs is underscored by other traits of their behavior.[43] In parts of southern Nigeria, dogs are "nursemaids," acting as "four-footed diapers" to clean up after infants. They are also thought to have such exaggerated sexual appetites that they assume human shape in order to couple with women. For this reason, promiscuous men are called "dogs."[44] Similarly, Lele people of Zaire find dogs "the most shameless animals."[45] So it is thought elsewhere in Africa; in southeastern Chad I heard rumors that when an adulterous human couple had been discovered *in flagrante delicto* by the cuckold, the lovers became stuck together as dogs sometimes do.[46] Dogs' sexual exuberance is more positively interpreted in the context of fertility cults such as Mbenza, in nineteenth-century Kongo, which used stone figures of dogs.[47]

Such ambiguity is especially clear among west African peoples who eat dog meat, either as a ritual activity during sacred dramas, or as a much more common, and even prized, fare. Kabré people of central Togo, for instance, observe a set of age grades, each with its own initiation. For that of the youngest boys leaving the shelter of their mothers' warmth, eating dog meat is an act of separation. Dogs are scorned as polluted because they eat feces and commit "incest." Male infants, too, are unclean and must be purified by ritual if they are to become boys. Dog meat is repulsive, but its consumption nullifies the impure status of the initiands.[48] Among southwestern Nigerian peoples, dog meat is sometimes consumed or used in the preparation of healing magic, as when dog fat is used to treat fever or syphilis.[49] Elsewhere in Africa, dogs may be the subject of dances highlighting some of these same characteristics and purposes.[50]

Dog meat is also relished by some Igbo, Ibibio, Yoruba, and other peoples in southern Nigeria.[51] At work is such an intimacy between people and their "best friends" that those who do eat dog meat often disguise the fact, presumably to avoid a sense of can-

nibalism and the scorn of those in the same community who are repulsed by such a viand. Ojoade cites a case in which different cuts of dog are referred to as parts of a Peugeot pick-up truck, as subterfuge.[52] It would be difficult to imagine a better example of euphemistic metaphor.

Dogs are sometimes sacrificed to African gods, spirits, or ancestors. Offering the life of a dog "occupies a singular place in the sacrificial system" of African religions, and is either strictly prohibited as sorcery tantamount to murder, or is practiced at very particular moments of social transformation, as when marking the death of renowned warriors or hunters, or entry to the deepest secrets of societies like Komo and Nama among peoples of central Mali.[53]

To the great derision of their neighbors, Minyanka people of Mali sacrifice dogs much more frequently to punctuate far less significant moments of social life, although they try to spare their own favorite companion dogs. The blood of dogs is deemed "bitter" like that of humans, and the "exceptionally vengeful capacity" of dogs, likened to that of human victims of war or hunting, is such that whereas the unleashed force of dog-sacrifice may be directed to protect the living, the greatest care must be taken during sacrifice to avoid revenge being taken upon the sacrificer. When parts of the dog carcass are removed for use in powerful medicine bundles (as, in the past, when human enemies were killed), the "male" left side of the dog's face is removed, creating a divided "monster" that incorporates the opposition of life (red from the rufous pelt preferred in dogs for sacrifice) and death (white of exposed bone). In such a way, ambivalence is incarnated.[54]

Yoruba also sacrifice dogs, to honor Ogun, "Lord of the Cutting Edge" and god of iron, transformation, and the recycling of scrap metal. Ogun can be fierce: he is praised as "the enraged *orisa* [god] who bites himself," and it is fitting that the Orisa who bites with iron teeth should eat biting dogs, mad or otherwise, that are sacrificed to him. Indeed, it is said that a dog once bit off the tip of Ogun's penis, and the god immediately severed the animal's head to prevent it from swallowing. For this reason, when a dog is sacrificed to Ogun—as, say, when a new car is purchased and an offering is made to enlist Ogun's help in protecting it from thieves—it is decapitated and its head hung in Ogun's shrine while a prayer is offered entreating the god to leave people in peace.[55]

In all these cases, dogs are so intimate with humans that a dog can stand in and take a human's place. Among Fipa of southwestern Tanzania, for instance, the *mwavi* poison oracle was administered when someone was strongly suspected of evil sorcery. An innocent person would vomit and so be proven innocent of the accusation, while those who perished from the virulent poison were guilty. At the turn of the century, when German colonizers outlawed this practice, Fipa allowed the accused person to substitute a cherished dog to receive *mwavi* in his or her place.[56] In such instances, people and dogs are so closely associated that metaphor may not be as appropriate a description of the relationship between them as simile.[57]

So interrelated are people and dogs that Mary Douglas wonders, "do dogs laugh?"[58] Perhaps so, but the animals would not be so amused to know how they are referenced in choice epithets. Among Lele of Zaire, calling a man a "dog" is bad enough, but should one wish to incite the argument further, "to tell him to go and eat excrement like a dog, that is a deadly insult, for which a man will try to kill his defamer." As Mary Douglas adds, though, such an outrageous antagonism would be "between men. A man can with impunity, and regularly does, call his wives 'beasts, dogs.'"[59] Knowing the forcefulness of central African women in conjugal relations, I doubt that such insult occurs as regularly as Professor Douglas implies; yet the clear parallel to use of the word "bitch" in English cannot be denied.[60] As Edmund Leach has suggested, "when an animal name is used ... as an imprecation, it indicates that the name itself is credited with potency. It clearly signifies that the animal category is in some way taboo or sacred."[61] As we have seen, dogs present just such ambiguities to African observers; but what of other familiar animals?

Horses, Heifers, and Hosts

Horses, and especially mounted horsemen, are so important to African visual arts that Herbert Cole considers them one of the perduring icons of African expression (cat. nos. 17–22, 24, 25). "A mounted horseman fuses human intelligence with animal strength, creating an awesome presence far greater than the sum of its parts."[62] It is no wonder that horses are so frequently associated with African royalty, for riders are the essence of forcefulness, and "the mounted man generally outranks the unmounted."[63] The truth of this assertion was brought home to me as a young teacher in southwestern Chad, where Fulani pastoralists live interspersed with Tupuri, Mundang, and other agriculturalists. One day, when I was out riding my moped in a T-shirt and shorts, two Fulani men in full regalia charged their richly caparisoned horses toward me, rearing up in a toweringly tall, two-legged salute within inches of a collision. Petrified and irritated, I wondered just how aggressive this challenge was meant to be. But their smiles and later discussion with Chadian friends suggested that they were paying me the greatest honor.

Sometimes the horse rides the rider, as in the transformative inversions of Vodun spirit possession

Matakam girl wearing dogtooth necklace, Cameroon. Photo: Allen F. Roberts, 1965.

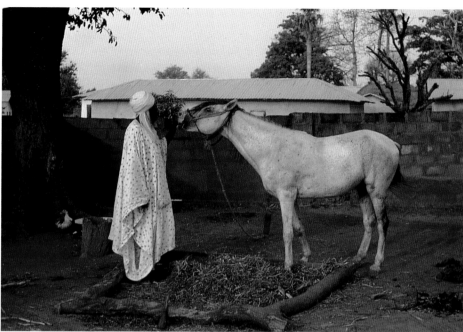

(LEFT) Yoruba drums with carving of horse and rider, Cové, Benin. Photo: Allen F. Roberts/ Mary Kujawski Roberts, 1987.

(RIGHT) King of Nikki and his horse, Nikki, Benin. Photo: Allen F. Roberts/Mary Kujawski Roberts, 1984.

among Fon-related people in Bénin and the African-Americas.[64] In other circumstances, horses are sacrificed or ritually buried to honor someone very special.[65] In still others, they are simply beasts of burden, their bony sides attesting to the rigors of making a living in contemporary Africa.[66] In all cases, horses, like cattle, are so important for their powers to provide and protect, that they are considered the essence of value itself. Because Herbert Cole has recently described the imagery of African horse and riders so admirably (1989), we turn to the somewhat related representation of cattle in African thought, practice, and art.

Cattle are the livelihood of many African groups. A few are still nomadic or transhumant, but most have settled in particular lands free of tsetse-fly infestation and appropriate for grazing. The classic portrait of African pastoralists remains Edward Evans-Pritchard's studies of the Nuer of southern Sudan.[67] Nuer are herdsmen through and through, "and the only labor in which they delight is care of cattle.... Cattle are their dearest possession and they gladly risk their lives to defend their herds or to pillage those of their neighbors. Most of their social activities concern cattle, and *chercher la vache* is the best advice that can be given to those who desire to understand Nuer behavior."[68] Kinship and inheritance are organized to control and protect cattle ownership, and cattle constitute the major gift of bridewealth. Nuer are often given or take names referring to the scores of color patterns Nuer identify, or the form taken by ox horns, and a Nuer genealogy sounds like a cattle inventory. Children play with cattle-dolls crafted of clay, songs are sung to praise cows, God is poetically called "Tutger" after the most powerful and visually magnificent of oxen, cattle products are eaten and

worn, wealth and well-being are gauged by herds, and Evans-Pritchard concludes that the Nuer "social idiom is a bovine idiom," to the degree that such pastoralists might be considered "parasites of the cow."[69]

People identify with their cattle, as the Nuer case suggests. A basketry hat worn by an Antandroy herdsman in Madagascar is surmounted by an origami-like woven image of an ox; other hats made from the tail-hair of cattle or leather from the hump of zebu oxen make clear the degree to which the "bovine idiom" may be lived by African pastoralists. Similarly, silver charms in the form of long-horned zebu are used by Merina and other peoples of the plateau region of Madagascar to attract wealth, but also to reflect social status through reference to royal herds.[70] Indeed, Ndagara, a mid-nineteenth-century "blacksmith-king" of the Karagwe people of Tanzania, is said to have fashioned iron "cow" figures himself (although others contend it was the royal smithies who did so, in the king's name). These robust but animated figures are assumed to have had magical powers to protect and assure the fecundity of the king's herds, and by extension, those of his subjects (cat. no. 16). Other iron objects, and especially "pillar-anvils" with one or more sets of crescent-shaped horns, were used in succession and other rituals at the court related to practices observed in other kingdoms of Tanzania, Rwanda, and Burundi.[71]

Several of the Karagwe iron cows represent animals whose horns have been patiently trained to curve downward rather than up, perfecting them, by local estimation, for important sacrifice.[72] As one might expect, so important are cattle for Nuer that "the sacrificial animal *par excellence* is the ox" to celebrate weddings, honor the dead, settle feuds, and implore God when there is a grave illness or natural

calamity. When one is too poor or it is otherwise impossible to sacrifice cattle, a gelded ram, castrated goat, or even a wild cucumber (*Cucumis prophetarum*) may be offered in its place; but the victim is always referred to as a cow, nonetheless.[73] "Sacrifice" is from Latin roots meaning "to make sacred,"[74] and the act of choosing an animal or plant for sacrifice removes it from ordinary considerations and circumstances.[75] Cattle are value itself, and giving them up is a true gift and real loss, endured in the expectation of greater good and gain.

This is undoubtedly the reasoning behind the use of cattle in the funereal arts of Mahafaly and other peoples of Madagascar. The scimitar horns of zebu cattle-sacrifice are placed around tombs, suggesting the weight of the loved one's loss; and carvings of cattle adorn the tops of grave posts, celebrating the wealth and status of the defunct. Such offerings stress the promise of ongoing contact with the ancestors, for through sacrifice, "cattle are ... converted from mere beasts into channels of communication with the ancestors."[76]

Cattle are sacrificed to mark other important circumstances, such as boys' initiation. In 1965, a bull was offered to celebrate the initiation of five boys in the Casamance (Senegal). After the sacrifice, the skull was covered with holy verses in Arabic and its openings were stuffed with paper upon which Koranic scriptures and prophetic squares were written. Instructions about proper use of "the sacrificial artifact" were added to these documents, as were references to totemic animals such as crocodiles and lions. The bull's decorated skull stood as a channel for communication, both to the world of Islam and to the institutions of pre-Islamic culture.[77]

In precolonial times and in many parts of Africa on into the first decades of this century, cattle and horses were so important as measures of value that they were often kept in a restricted sphere of exchange and only used for the most important social transactions. Tiv people of central Nigeria included slaves, important ritual offices, and the secrets of the most powerful magic in this sphere.[78] Ransoming war captives and making death payments for witchcraft were among the few contexts for exchange of such goods, but by far, bridewealth was the most common and regular.

Bridewealth cements relations between in-laws, and is often used as a political device to create alliances between families for reasons beyond the marriage itself. From a materialist viewpoint, bridewealth is offered in exchange for the labor and offspring a woman can be expected to bring to her husband's lineage. The number of cattle and other goods agreed upon often exceeds what any father-of-the-groom can afford, so he borrows from his kins-men. The father-of-the-bride then redistributes the bridewealth to his own kin from whom he has borrowed in the past for his sons' bridewealth. Such debt, incurred or repaid, reinforces group solidarity.[79]

Bridewealth is a negotiated process. In the old days when Gusii elders met to decide the terms of their children's marriage, there would be a great deal of haggling about how many cattle and other livestock would be offered and what their various qualities would be. Once the exchange was begun and marriage rituals were performed, the children born would be of the husband's lineage. Several cattle and goats were sacrificed, with meat sent to both sides of the family; and to emphasize the young couple's joy, one of these was designated "the goat of laughter" and given to the bride and her girlfriends to enjoy in the groom's village.[80] These solid family values are conveyed through art works representing cattle, such as Bidjogo (Guinea-Bissau) masks, bowls, and related objects. The ox supporting a container used in initiation to serve ritual meals stands for tamed and directed strength, as opposed to a crocodile on the bowl lid, that reflects the pre-initiates' lack of discipline.[81]

Not Necessarily Sheepish Sheep

Sheep, and especially rams, appear quite frequently in African visual arts. The key metaphor of rams is derived from the dramatic way they butt heads as they vie for a ewe's attentions during mating. Among Yoruba around Owo, Nigeria, *osanmasinmi* altarpieces are in the form of rams' heads slightly tilted as though ready to clash in battle. The ivory attachments to some Orufanran costumes, worn by illustrious high chiefs and warriors among Yoruba, also take the form of rams' heads, in head-on profile. Their foreheads and muzzles are decorated with potent numerical symbols underscoring their mystical strengths of protection, and in defeating adversaries.[82] The kings of Benin wore ram-head hip pendants as "emblems of their own ramlike qualities—virility, aggressiveness, courage—or their dominance over their enemies."[83] Also in Nigeria, sculptures representing stalwart ram heads are central to Edo (Bini) chiefs' altars; sacrifices are made to them to assure bountiful yam harvests.[84]

Following the same imagery, *ikenga* shrine sculptures made by Igbo people of southern Nigeria incorporate ram horns on an anthropomorphic head. *Ikenga* shrines combine the powers of a man's ancestral guardians with those of his right hand or arm. They are carved of "male" hardwoods, and stand as the strong center of a man's social life. The ram's horns are symbols of aggression, determination, stoicism, and perseverance in repeatedly attacking an adversary or other problem. But rams only fight occasionally, and do not often grievously wound or kill;

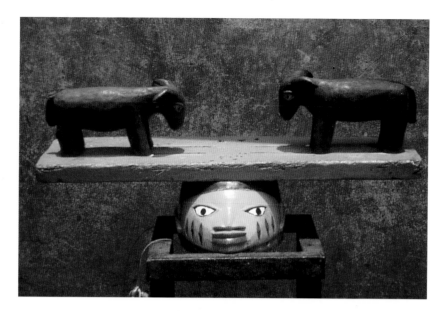

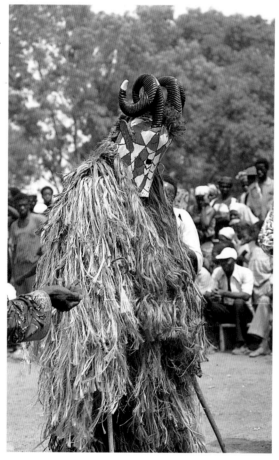

(ABOVE) *Articulated gelede mask with rams butting heads when string is pulled, Cové, Benin. Photo: Allen F. Roberts, 1994.*

(RIGHT) *A Bobo ram mask performing at a sacrifice held once a year for all of the ancestors of the community in the village of Dofigso, Burkina Faso. The mask performer spent most of the day trying to butt anyone who came too close. Photo: Christopher D. Roy, 1984.*

and so an *ikenga*'s horns also encourage a man's restraint and stress his spiritually inspired psychic powers in the heat of passion.[85]

Among many groups in central Africa, the ram finds a prominent place in cosmology and occasionally appears as masks or through ram horns added to composite sculpture.[86] For Tabwa and related peoples, Nkuba is a jet-black ram with wings of fire from which lightning flashes.[87] Nkuba is felt to protect the wet season from the rigors of the dry in an underground lair that Tabwa describe as being like that of a lungfish. Nkuba also brings forth the rains as the seasons change. Nkuba's fiercely sharp teeth can eat

through the hardest wood (as trees are struck by lightning), and God can send the monstrous ram to punish transgressors, as in the following account told to me by Kalulu:[88]

> Two thieves were sitting with other people in a house during a thunderstorm, when through the torrents they saw a small animal coming toward them, walking in the water. Suku-suku-suku-suku [a sloshing sound] it came toward them, suku-suku-suku-suku it came toward them, until it was right in the house with the people; then POO-BOO-Boo-Boo-boo! [a great, downward-directed noise]. Those in the house were terrified, and when they looked about, they saw that the thieves had been "carried away"—they were dead, while the others remained uninjured. God had sent Nkuba to punish the thieves.

Tabwa assert that in olden times, great practitioners of magic (*ng'anga*) could catch and secure a piece of Nkuba to use as the activating agent (*kizimba*) for protective and vengeful medicines. Neighboring Luba direct such magic against enemies, so that they will be struck by lightning or gunshots, or attacked by leopards,[89] while Bemba (Zambia) use a similar element in medicines given to puppies, so that they will thrive and learn to seek out even the best-hidden game in river thickets.[90] Lightning magic is still associated with Tabwa chiefs, and Nkuba is structurally related to the culture hero who introduced refined but ruthless court behavior to Tabwa, Luba, and other central Bantu peoples.[91]

Similar associations between rams and thunder are found elsewhere in Africa. A bas-relief on the wall of King Ghèzô's palace in Abomey, Bénin, portrays the god Hevioso (Hébyosô) as a seated anthropomorphic ram holding an axe in its mouth with a semi-circular blade representing the "cutting edge" of lightning.[92] The axe form is reproduced from scrap metal and sold by the thousands in Béninese markets, to be placed on shrines and at portals to gain Hevioso's protection from both lightning and "lightning"—sacred or sorcerers' attacks.[93] The bas-relief ram "is" Ghèzô, who made a pact with the priests of Hevioso's cult and who, "himself as king, was of inexhaustible energy, always in movement and ready to react at the slightest provocation."[94]

Sheep, both rams and ewes, provide another ready metaphor for African artists. Except when in rut, sheep are generally docile animals, known for their mindlessly following a lead animal. One of the ironies of contemporary American political terminology plays upon this tendency, for "bellwether," usually employed with reference to "trend-setting" (as in,

"Iowa is a bellwether state for national primaries"), literally refers to a bell-wearing castrated ram that leads a flock, often up the ramp to the slaughterhouse where the ram—and not the flock—will be spared to do the gruesome job again and again.[95] A Yoruba sculpture portraying a woman respectfully offering a submissive ram (cat. no. 2), presumably in sacrifice,[96] may reflect this aspect of sheep behavior, as does the common sacrifice of sheep by west African Muslims to celebrate Tabaski or "the Feast of Sheep" (*Fête de moutons*) that falls on the twelfth day of the Islamic month of pilgrimage. Homage to chiefs and kings is commonly offered at Tabaski, again reinforced by the subservient nature of sheep.[97] A Yoruba (Bénin/Nigeria) Gelede mask shows the refined head of a Muslim with a pair of rams on his turban, probably in reference to the sacrifices of Tabaski.[98]

Sheep are a gift of God to Bamana and Malinke peoples of Mali, for whom God created a ram as the "perfect sacrifice" (*sòoni*) with which people might purify their hearts and submit (*sòon*) to Him. God struck the first ram He had created with lightning; its blood cleansed and revived the world theretofore polluted by incest, and, by cutting up and distributing the carcass, God created signs differentiating genders and affinal groups.[99] A Yoruba (Nigeria) *olumeye* shrine figure representing "the one who knows honor," portrays a woman kneeling and offering one bowl in her hands, while carrying another on her head from which the head of a sacrificed sheep protrudes. The figure shows the respect offered a god, and implies that the god will bring fertility to those who recognize it through offerings.[100] Perhaps these same qualities of rams inform the use of their effigies in puppetry

among Bamana and neighboring Bozo.[101] For Lugbara of Uganda, the sheep is a "thing of God" and so distinct from all other animals. Its slaughter or other use in ritual brings people into direct contact with God; and sheep blood, deemed to contain the beast's soul, is used to mark people's bodies and the thresholds of their homes with "the words of God." Offerings of sheep are not considered a sacrifice, however, because Lubgara say they do not give food to God. Instead, sheep are killed to nullify critical discord among kin, bled along the periphery of the community to close it to the ravages of a meningitis epidemic, or banished to alleviate severe drought.[102] For Zaose and other Mossi-related people of Burkina Faso, sheep are solar animals associated with God and kings; as such, they are not to be sacrificed or eaten by the women of royal lineages.[103]

Tabwa use the metaphor of the docile sheep in the preparation of magic to neutralize their enemies—extortion-bent soldiers at a roadblock, for instance. For this, they use a *kizimba* activating agent taken from the back of a sheep's neck, bowed in submission, which adds the nuance that the enemy will not notice what the person is doing, any more than sheep pay attention to much of anything but that upon which they are browsing. Abyssinian Christians of central Ethiopia sacrifice sheep and use their skins in healing, perhaps with reference to the imagery of submissive "lambs of God."[104] A healer (*dabtara*) becomes entranced so as to be able to identify the source of illness and prescribe the color of pelt for the sheep to be sacrificed. Evil spirits must be exorcized, and the patient participates in the sacrifice, drinking blood or performing other medicinal functions. The

(LEFT) Restaurant in Dakar with sheep and other wall-painting advertisements. Photo: Allen F. Roberts/Mary Nooter Roberts, 1994.

(RIGHT) Gelede efe mask showing ram, Cové, Benin. Photo: Allen F. Roberts, 1994.

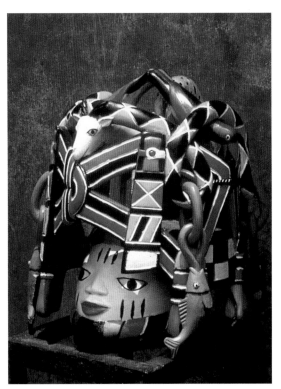

skin is then dried and prepared as parchment, cut into three strips and sewn together end-to-end to match the patient's height, affording divine protection from head to foot. Prayers such as *The Net of Solomon* and paintings of saints defeating satanic forces are inscribed on the sheepskin parchment, to ward off the evil eye and other attacks. In illness or times of menace, scrolls are kept close at hand, worn in leather containers, or unrolled so that the afflicted person may gaze at the holy words and images, engaging them in the struggle against evil.[105]

A final example of the potency of the metaphor of the ram as harmony and harmonizing comes from Kwele people of Gabon and the Congo. I suspect that Kwele wooden face masks representing rams and Kwele iron currency tokens used in precolonial times shared both an æsthetic and commonality of meaning.[106] Kwele currency tokens, called *mezong* or *mandjong*, were used to acquire certain important masks and other ritual objects, to pay damages in adultery litigation, and, most especially, in bridewealth exchanges.[107] While information such as this tells us something of how *mezong* were used, the question remains: why were they made in this particular form? Kwele society is characterized by "informality and impermanence of status," and is stateless. That is, political functions are provided by men who lead by wisdom and example rather than by rule. Kwele society is also marked by a "volatile quality of life" that runs "counter to their view of an ideal society," and several devices and institutions exist to assure harmony, to the extent it is possible. Until the 1920s, Kwele had a politico-religious cult called Beete that provided them with an overarching set of principles and activities that held society together and helped people cope with crises. Masked performances were instrumental to the realization of this important goal. "When the prospect of confrontation and violence seemed close at hand, the main leaders of the village.... usually favored performing beete." Masked dancers representing spirit animals danced while various magical materials were combined into a stew with the flesh and chyme of an antelope, to be consumed by the entire village. The "intense and harmonious interaction" of such a feast underscored community values and commonality of purpose, undoubtedly as symbolized by consumption of the antelope's stomach contents and the various magical elements of the stew.

Some *ekuk* masks such as one in the Stanley Collection at The University of Iowa Museum of Art[108] represent rams, and the shape of the horns may allude to a precolonial women's coiffure.[109] More broadly, *ekuk* masks refer to a combination of other animal metaphors, and bring to mind the fellowship of the community feast and its attendant symbolism.

The composite nature of well-known Kwele masks that portray smaller faces on the horns framing the central face, might find an explanation in such a sense of referential collectivity. That the horns of the *mezong* tokens have flattened barbs at their ends may refer to these secondary faces, as well. The bilateral symmetry of these horns and of the heart-shaped face may well be an artistic statement of the harmony and balance that Kwele recognize in nature and hope to achieve in social life, despite the dissonance that they recognize and, indeed, give a place in their lives. In such an expressive interplay between æsthetics and social structure, Kwele are like their Fang neighbors as described by anthropologist James Fernandez.[110] Fang ancestral figures reflect an attention to "opposition and vitality," hence to the balance and negotiation seen in village organization and the "complementary opposition" of lineage segments and social relations. In equal likelihood, the symmetrical form of the Kwele currency token refers to the quest for and contemplation of these same goals, for it links the social values of agricultural work symbolized by the hoe shape from which it may be derived, the *ekuk* masked performances of the Beete Cult that it echoes, and the exchange, reciprocity, and mutual responsibility for which it was used and that it would engender.

Tracking the Cosmic Chicken

The last domestic animal to be considered here is the chicken (hen and rooster). Other domestic birds are common to African households, such as guinea fowl, ducks, and, more rarely, geese and turkeys; but while these may occasionally appear in African art, the frequency for such expression is far less than the representation of chickens (cat. no. 5).[111]

Chickens are everywhere in Africa: scratching

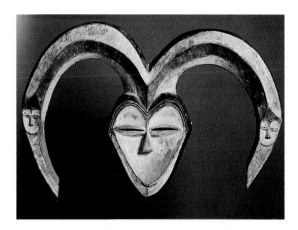
Kwele mask with extra faces on horns. Photo: Courtesy Musée Barbier-Müller.

(ABOVE) *Chickens and pot with tortoise design in Zaose household, Burkina Faso. Photo: Allen F. Roberts, 1989.*

(RIGHT) *Woman brewing beer with chicken eggs in nest in her kitchen space, Tangaye, Burkina Faso. Photo: Allen F. Roberts, 1986.*

about rural yards, dashing across the busiest roads, wandering in the fringes of field and forest, and crowing in the hearts of the most cosmopolitan cities. Western varieties such as the stalwart Rhode Island Reds were introduced to coastal Africa many years ago, but in places like central Africa, earlier species related to sleek Indonesian jungle fowl are found. Their astounding plumes, vibrant colors, and regal beauty are hardly conveyed by the humble word "chicken" (*kuku* in Swahili, for instance). With regard to sacrifice and spheres of transaction, chickens are small change, so common and taken for granted that they form a constant currency of interaction. In many places they are still traded in barter for other foodstuffs, and everywhere, they are offered to honored guests.

Most visitors to Africa have experienced the warm generosity characterizing all of the continent's many peoples: arriving at a friend's home unannounced, one is seated in the shade and given a cool drink. Suddenly, there is a flurry of activity as boys and girls careen through the yard, chasing a rooster. In southeastern Zaire, when the cock is finally apprehended, it is presented to the guest who receives it, holds it respectfully, and praises its strength, size, and plumage. The chicken is slaughtered, bled, plucked, butchered, and slowly cooked with savory sauces. You may have only stopped in to say hello, but two hours later, you are offered a repast fit for royalty. In southeastern Chad, to complete the compliment, the guest is offered the heart of the chicken, in assurance that it has not been taken to use in malicious medicines of harm rather than welcome. The association between chickens and hospitality probably informs the carving of kola-nut containers by Yoruba (Nigeria): as a sign of welcome, a guest may lift off the upper part of the wooden hen, to remove a kola nut.[112]

Chickens are carefully kept as both choice food and capital for future exchange. Despite their plentifulness and the dire need for protein, however, women in some societies do not eat chicken. Among Lele of Zaire, "poultry is unsuitable food for women," and "a woman is expected to feel disgust at the thought of eating chicken.... The wife feeds the hens, and calls them into her hut at night. She should feel too strong sympathy to be capable of eating them."[113] Women in southwestern Chad avoid eating eggs because of their reference to fertility.

Mothering by hens is a metaphor that appears frequently in African arts. The finial of an Asante spokesman's staff from Ghana depicting a hen surrounded by four chicks was used when the paramount Asantehene was "trying to achieve a peaceful settlement of a dispute arising among chiefs or between a chief and his subjects; for the mother hen, it is said, steps on her chicks not to kill them but to put them

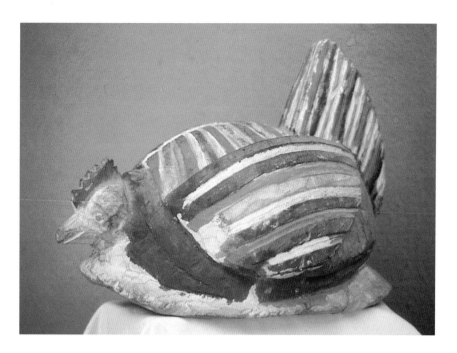

Gelede mask with hen, Porto-Novo Ethnographic Museum, with permission. Photo: Allen F. Roberts/Mary Kujawski Roberts, 1987.

on the right path—in other words, the purpose of punishment is to correct, not to harm miscreants."[114] A Yoruba Gelede mask at the Alexandre Adande Ethnographic Museum in Porto Novo, Bénin, enriches the same allusion. A hen replaces the serene female face ordinarily occupying the lower portion of Gelede masks, and there is no upper register. The hen's outstretched wings that provide safe haven for chicks when a hawk is in the air, its upraised tail, and the polychrome striations for feathers all mimic a popular women's hairdo of the 1940s, when the mask was carved. The mask was danced with a song alluding to the improper behavior of a mother of young children, who, rather than seeing to her charges, was flirtatious or committed adultery—an act placing the infants at direct risk from sorcery and divine retribution.[115] In a more positive vein, hens carved in wood (with supports to hold small ivory tusks) and roosters cast in brass adorn the shrines of mothers of chiefs and kings in Benin (Nigeria), perhaps as a symbol of femininity and nurturance,[116] but perhaps also as something else. The king's senior wife is praised as "the cock that crows at the head of the harem," suggesting her dominant position and strong character; and given the unusual privileges such a queen-mother shares with men, "it is not surprising that a male symbol, the rooster, should be used to honor her."[117]

In Africa, the chicken is the "universal sacrificial animal, for it is used as much by nomadic as by sedentary peoples, by farmers as by pastoralists, in the savanna as in the forest." There are obvious practical reasons for this, because of how easily chickens are raised and how easily they reproduce; but, as Dominique Zahan wrote, "bodily peculiarities, coloration, voice, laying, and disposition vary so greatly from one [chicken] to another that there are hardly two that resemble each other."[118] The appropriate

victim can be chosen from this diversity through divination, and Zahan found criteria for defining more than seventy kinds of chicken kept by a single African ethnic group. Among Minyanka of Mali, forty sorts of chicken are differentiated and when they are sacrificed, the "cosmological correspondences" of each kind helps determine what more elaborate offerings might be made to the great spirits that decide the course of life. As Luc de Heusch notes, Minyanka differentiation of chickens appears to be an attempt to "render most meaningful the seemingly banal domestic species to which other African cultures (the Thonga, for instance) pay little attention, or none at all."[119] As with Nuer cattle, the choice of a distinctive feature, as arbitrary as such a decision may be, is practically limitless, and depends upon the observational skill and intellectual needs of those using chicken-sacrifice for sacred work, far more than zoology.[120]

Rather than hens, it is usually roosters that are sacrificed (or caught to cook for honored guests), in large part because it is the hens that produce both eggs (which are often eaten with relish), and more chicks to replenish the flock. A common metaphysical explanation for sacrifice of roosters must be the association between them and the sun. Roosters greet the sun and announce the day. According to a Ghanaian aphorism portrayed by a modern Asante spokeman's staff, "the hen knows when dawn will break but leaves it to the cock to make all the noise."[121]

Bobo and related peoples of western Burkina Faso don rooster masks during initiation, for the rooster, given the onomatopœic name Kokoro, "'is the sage of initiation, praise poems, songs, and esoteric metaphorical phrases in the initiatory language [called] Luo," as well as "the first carver, the introducer of intensive education, and an important culture hero'" (cat. no. 7).[122] Similar masks are danced at funerals, especially for elders of the Dwo Society, that provide social cohesion for Mande-speaking peoples throughout the area. Masks are felt to "embody the spirit of Dwo," and chickens may be sacrificed upon them, as an altar to the other world. Elsewhere in the same culture area, Bwa blacksmiths use stylized rooster masks as sacrifices are made to the spirits protecting those of their profession.[123]

Because cocks crow at dawn, they are associated with time itself. Asafo battle flags made by Fante people of Ghana may depict the saying "we control the cock and the clock-bird," to warn rivals that a faction is so powerful, it controls the rising sun and even time itself.[124] To offer a rooster in sacrifice is "to present oneself before the Invisible and to demonstrate the desire to match one's 'time' with the rhythms of the cosmos."[125] Yoruba of Bénin believe

A *Tabwa spirit medium's beaded
headband showing the rooster that
signals enlightenment, decorated
with rooster feathers. Photo: Allen
F. Roberts/Christopher Davis-
Roberts, 1977.*

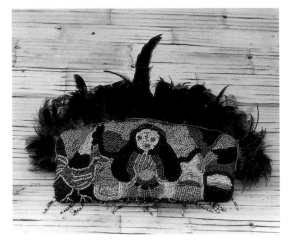

that, by sacrificing a chicken, they assure their own
"sunlight perception," and commemorative shrine
sculpture depicting them may affirm such a relation-
ship.[126] Yet in some African societies, even the
return of the sun—one of Durkheim's "monotonies"
if there ever was one—is too important to take for
granted. As the Zairian writer Mudiji Malamba has it,
"intriguing and reassuring for its time-telling song as
night ends, the rooster seems to be in permanent res-
onance with the sun. It incarnates vigilance to ...
people who have impotently watched the descent of
the sun (*astre de jour*) and are awaiting its return with
hope mixed with anxiety." Mudiji describes a Pende
(Zaire) initiation mask called Kolombolo that por-
trays the rooster as a symbol of people's lurking incer-
titude, even when regularity ought to prevail.[127]

Reflecting the practical side of these same ambi-
guities, Tabwa mediums of the Bulumbu possession
cult wear rooster feathers stuck into the tops of their
beaded headbands. Part of a cock's head is among the
activating agents of a magic bundle sewn into the
center of the headband, over the point on the fore-
head that Tabwa point to as the seat of intellect,
dreams, and prophesy;[128] and, although Tabwa rarely
engage in animal sacrifice per se, Bulumbu mediums
occasionally offer roosters to their spirits. When they
do, they stuff white chalk (*npemba*) down the roost-
er's throat until it suffocates, and they take care not
to break any of its bones, for to do so might "inter-
rupt" the benefits of their action. The word *npemba* is
from a root meaning "east," where the sun dawns, life
begins, and the words of wise elders go when such a
person passes away, to become light in the east and
"enlightenment" for those surviving. Chalk is "light."
Its whiteness stands for and its application brings
about auspicious and harmonious contact with the
other world. Just as a rooster announces the coming
of dawn, so it is hoped that spirits speaking through
the medium will bring "enlightenment" (a poetic
metaphor Tabwa themselves propose) to those
afflicted with the "dark obscurity" of ignorance about
how to solve their problems.[129]

*Dogon family shrine with animal
skulls as hunter's trophies to
honor ancestors, Sanga, Mali.
Photo: Allen F. Roberts/Mary
Kujawski Roberts, 1986.*

A final word may be said about chicken sacrifice.
Among Bamana of Mali, the point where a path splits
into three others is called a "chicken-foot crossroad."
Chicken tracks may add a dimension to the meta-
phor, then, at least for some Africans.[130] Because
Bamana associate the chicken with dawn and tempo-
ral rhythms more generally, a "chicken-foot cross-
road" is where prayers and chicken-sacrifices are
made during rites of renewal for the new year.[131] Yet
crossroads are also the epitome of indeterminacy; as
Dominique Zahan put it, "a crossroad is above all a
place that no one has expected to be *there*."[132] At a
crossroad, one is forced to ponder: why does my path
cross this other one *here*, rather than somewhere else?
How can convergence immediately lead to diver-
gence? Why such an unexpected convergence, *now*?
Why such sudden discontinuity, complete disjunc-
tion, a necessity to choose, an obligation to turn, a
possibility to change? What should I do next?[133]
In "Crossroad of Being, Crossroad of Life," Zahan
addressed life's greatest conundrum: the difference
between the ways things ought to be and the way
they are, that is, between what is ideal and what
really happens. He asserted that at the "crossroad" of
the wished-for and the tolerated, one is forever struck
by how infrequently (if ever) such expectations are
met, despite notions of what ideally ought to happen
in life.[134] At such a tangibly intangible "non-place" in
African life, it is somehow fitting that the humble
chicken should be the most common sacrifice, its
life's blood an opening to the other world and a plea

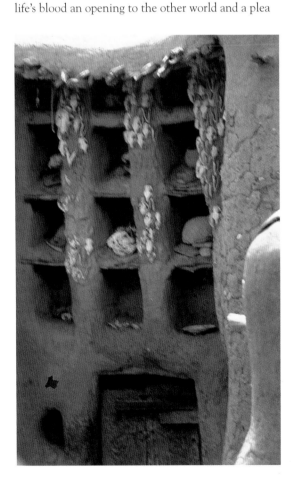

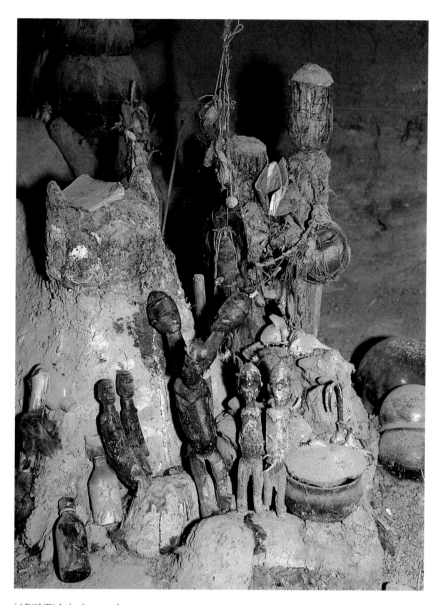

(ABOVE) *Lobi shrine in the village of Dako, Burkina Faso, showing sacrificial materials offered to boteba figures representing spirits, wathil. Photo: Christopher D. Roy, 1984.*

(RIGHT) *Dogon house with sacrificial material, Sanga, Mali. Photo: Allen F. Roberts/Mary Kujawski, 1986.*

for the clemency and succor that is all too often lost in the arid wind.

The Play of Death

To complete this chapter on the place of domestic animals in African expressive culture, let us briefly reconsider the nature of sacrifice. Domestic animals may be close to home, and play their parts in the theater of memory inspired and inscribed there; they may be helpmates and pets that accompany one through the day's chores and watch over the night's terrors, but they may also be eaten. When they are, they may be dispatched with the utmost impunity, and when the killing is for sacred purposes, their deaths can appear to be ghastly affairs of brutality and mutilation. Understanding sacrifice of animals so valuable to human life in Africa will lead us further toward an understanding of why it is that some animals are depicted in African arts, while others are ignored.[135]

The nature of sacrifice has been the subject of hoary academic debates, and still raises the hackles of adversaries squared off in the lists. Earlier analysts such as Hubert and Mauss wondered why sacrifice should prove to be the most common means of establishing communication between this profane world, and the sacred beyond.[136] Luc de Heusch contends that the sacred/profane dichotomy is inappropriately applied to non-Western cosmologies, as it is biased by concepts derived from peculiarly Indo-European notions of sin, pollution, and exculpation.[137] Rather, in Africa, sacrifice is often performed to restore or insure one's physical and social status, in transaction with divinity. But this "game of death," as de Heusch puts it, *produces* life, even as life is taken.[138]

Dismissed are the popular theories that sacrifice is scapegoating through which humans kill animals to avoid killing each other, out of inveterate bloodlust.[139] Rather, de Heusch cajoles us to listen to what *Africans* say of their own practices, rather than judging them from afar. In many instances, there is a sense of sublime trade, of life for LIFE: the tiny gift of a chicken's last breath can ensure the rising of tomorrow's sun.[140] That which is sublime is transcendent and amazing, but also causes some anxiety, because of its awesome power that is ultimately beyond human understanding. So it is with sacrifice: one is aware that through the game of death and its gift of life, one is terrifyingly close to the verge of divine province.

Sacrifice is not like other killing then, in war or the hunt. Instead, "the annihilation of life nourishes the phantasmagoria of want. A want that all the victims in the world would not fulfill.... It is impossible to penetrate this existential emptiness (or to artificially fill it with violence...) ... [for] sacrifice burrows into the deepest part of the animal to extract some

meaning." Sacrifice makes sense, quite literally. It sketches out or reconfirms cosmology. "To perform a sacrifice is, primarily, to try to outwit death,"[141] if for only an instant. The critical point is that the instant is created in the life taken; that is, as Zahan suggests, sacrifice affirms life's rhythm, in a contract with time. Blood itself "is above all intimately tied to rhythm. Blood is the sustainer of the body's life-movement and reflects the allotment of time to each being, a little like drum music which in a series of intervals sends naked time to the ear enriched by this new dimension, 'rhythm.' Indeed, man could not find a more proper element to inscribe his 'prayer' upon the life of the world" than through blood sacrifice[142]— even, or especially, that of the humble chicken.

What a wonderful bird
the frog are.[1]

Into the Garden

Laka village showing mountains in background, from familiar toward edge of knowledge, near Baïbokoum, Chad. Photo: Allen F. Roberts, 1969.

"*F*amiliar" *space is a cultural construct; so is the category of animals considered domestic—the ones people allow in that space. Through taxonomies, the inchoate is given form: categories are created, perhaps when God names them or, in the case of the Dogon, when they find their places on the stairways of the celestial ark. Before proceeding further, it is useful to understand what animal categories are, how they are created, and what they can do for people seeking to make sense of the world.*

"Category" is a very interesting word. Its prefix derives from the Greek root kata-, *"down or against"; while the "-gory" part is from the Greek verb* agorein, *"to speak in public" (from* agora, *marketplace, assembly).[2] The original sense of "category," then, was to speak out or against, and so accuse or allege something about someone else at the market forum, where value was negotiated and deliberation encouraged. Many African markets serve this same purpose today as in the past.[3] However muted it may be in current usage, the word "category" implies a sense of indeterminacy as to what is included within its definitional boundary. This is an important point, for ideologies—whether African or Western—assert that categories delineating the classification of nature are true, natural, and set in stone. This is simply not the case, as we shall see through the cases of animal categories to be discussed below.*

Categories are created by deciding that certain groups of animals, plants, people, or phenomena have some significant distinctive feature or features in common that are not shared by other groups. This first formulation of sense is achieved through the bridging of metaphor, and extends to the organizational process of metonym, as discussed in our introduction. Choice of distinctive features (a synecdochic process of part-for-whole) is arbitrary, however, and just the sort of artificial device described by Jean-Baptiste Lamarck, the great eighteenth-century French naturalist.[4]

The surreal passage from Jorge Luis Borges that prompted Michel Foucault to write *The Order of Things* makes the point brilliantly. "A certain Chinese encyclopedia" is said to have divided animals as follows:

> (a) belonging to the Emperor, (b) embalmed, (c) tame, (d) suckling pigs, (e) sirens, (f) fabulous, (g) stray dogs, (h) included in the present classification, (i) frenzied, (j) innumerable, (k) drawn with a very fine camel hair brush, (l) *et cetera*, (m) having just broken the water pitcher, [and] (n) that from a long way off look like flies.[5]

Whether this description responds to reality, as recognizable now or at the time the encyclopedia was (allegedly) written is irrelevant. Far more important is its challenge to a Western sense of logical categories.[6] If one is prepared to accept the relativist challenge that such a taxonomy is perfectly logical, then one may perceive the more subtle, yet equally dramatic, differences between Western animal taxonomies and those of African societies.

An exercise I conducted with Tabwa friends illustrates the principles involved (see Table, p.56). When presented with animal names written on notecards in their language, three men divided them into what they alternatively described as *kundi* "groups," a term often used with reference to people of similar interest or pursuit; *fungo* "a closing" or something bounded, and so defined; *jamaa* "families" with reference to human families, lineages, or religious congregations; or *bundugu* "brotherhoods," referring loosely to kinship or other social proximity.[7] Some of these groupings follow Western taxonomy, however roughly (e.g. "rodents" in the first *kundi* include mice); but others do not: galagos or bush babies, which are primates, are also placed with mice and elephant shrews. Instead, the categories possess their own logic.

Arguing About Order

In each of these Tabwa cases, a metonym is being created—that is, a conceptual set of commonalities and contingencies, bounded by one or more overarching criteria. The terms with which Tabwa describe the units of such a taxonomy ("group," "closing," "family," or "brotherhood") suggest the degree to which the men were aware of and accustomed to classification in other contexts.[8] When Tabwa friends were given the task of defining an animal taxonomy, however, there was nearly as much disagreement as agreement about what went where.[9]

Kalulu proposed that cane rats, porcupines, and moles should be in their own category, separate from that of mice, flying squirrels, galagos, and others, mostly because the former are nocturnal. Kalulu and Mumbyoto both placed the aardvark ("earth pig" in Afrikaans) in a category with warthogs and bush pigs, because of similarities in body shape; and pangolins with turtles, primarily "because of their scales." Another hunter heartily disagreed, contending that aardvarks and pangolins occupy their own category, as "people of the night." Kalulu placed *kenge*, the Nile monitor lizard, with *mamba wa maji*, the crocodile; whereas Luvunzo differentiated between *kenge*, as a large lizard inhabiting the "bush," and *mbulu* as an equally large lizard found in the water. Kalulu argued that these were both the same, as would Western naturalists.[10] This led to further dissention. Luvunzo placed *sokosoko*, the very common little orange-headed agama lizard (*Agama agama*) found throughout Africa, with crocodiles and water monitors; whereupon Kalulu shot back that *sokosoko* was not an "animal" (*nyama*) at all, but a *kidudu*, like a snake.[11] The Tabwa category *wadudu*, occupied by many insects but also by freshwater crabs (*nkala*), lake jellyfish (*tombotombo*), and other small creatures, is perhaps the fuzziest of all, loosely defined as "living things no one likes to look at."[12] The banter took another turn, as Luvunzo said that since a *nyama* is "given a birth in its belly" (*nyama anapewa nzazi wa tumbo*), a crocodile is not a *nyama*, because it lays eggs. Kalulu laughed uproariously and said that a crocodile is a *nyama*, even though the "form of its birthing" (*umbo la kizazi*) is different, and that it is a *nyama* of both land and water. *Nyama* is not strictly "mammal," then; nor can it more generally be classified as "animal" or "creature," since birds—*ndege*, which includes airplanes and a few other non-animal members—are categorized separately.[13]

Arguing about animal categories is a beloved pastime among Tabwa men.[14] Time and again, as they paddle along the shores of Lake Tanganyika, hike over the mountains to the next village, venture into the woods to hunt and gather medicinal plants, or sit together at funeral wakes, men indulge in the same debates: is a crocodile a fish because of its scales and the way it swims, a *nyama* because of its legs, or an *ndege* because it lays eggs?[15] Is a bat (*popo-ndege*) an

ndege because it flies, or a *nyama* because it gives birth, rather than laying eggs and has hair, rather than feathers?

These are conundra—riddles with no definite solution. Like Tabwa dilemma tales, such irresolute questions spark spirited, hilarious discussion,[16] savored, no doubt, largely because if they *could* be solved, the fun would be lost. I have witnessed the very same individual argue both sides of the bat riddle, showing equal comedic brilliance. If, as Hegel said, "contradiction is the principle that moves the world" and if, as Bachelard remarked, "everything comes alive when contradictions accumulate," then *not* finding a solution to the riddles of animal classification is the point, rather than an intellectual mishap or flaw of reasoning.[17]

Classification may also be situationally defined: differences may result from the divergent purposes of speakers on a given occasion.[18] It is most useful,

though, to think of classification systems as "fuzzy sets," and their various members as polythetic.[19] That which is polythetic, according to Rodney Needham, is "a common repository of factors to which men [and women] resort in the construction and the interpretation of social reality," and a "concatenation" of "sporadic conjunctions ... contingently generated," rather than a discrete system of defined elements.[20] Studying this phenomenon requires appreciating the potential of the fuzziness, rather than trying to avoid or solve its perplexities. Puzzlement may be positively edifying.[21] Furthermore, consideration of conjunctions as sporadic and contingently generated proves important to establishing an understanding of how different African animal categories can be from Western ones. In particular, it helps us to reconsider the "familiar" and every step beyond it in social space, as well as the singularities and anomalies of animal classification encountered along the way.

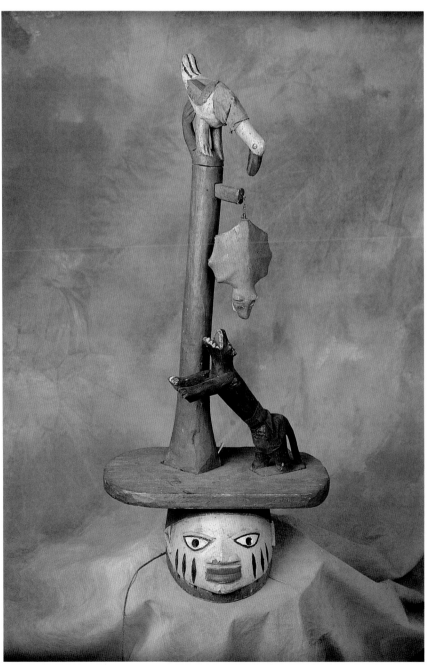

A gelede mask articulated so that a bird pecks and a dog tries to bite a bat, used to taunt a rival dance society as being neither fowl nor mammal. Private collection. Photo: Allen F. Roberts.

Beyond the Familiar

"Familiar" social space is the first metonym we have considered, to be defined against a "wilderness" encircling and extending outward from it. As a category, though, the familiar is by no means as fixed and static as it might seem. Home and village may be set against the outside world—for instance, when it is a question of defining human civilization.[22] But, as Michel Cartry suggests, "'it is not the boundaries that define the village,' but 'the village that engenders the boundary.'" In this manner, home becomes the center of "projective space" extending outward to the bush. For the Gurmanché people of eastern Burkina Faso, about whom Cartry has written so evocatively, the bush (*fuali*) is "a space with moveable and moving boundaries," varying through time and season. "*Fuali* implies indistinction, absence of differentiated form, [and] a fading of boundaries." During the night, the *fuali* draws up to the outer limits of the village, penetrates the spaces between and among habitations, and, presumably, even lurks in the darkest corners of one's home; but when the sun is high, the *fuali* changes to islets of obscurity where it is considered dangerous to go, in otherwise safe, sunlit expanses.[23]

The familiar is the primary locus for everything that gives people a sense of security. As one might expect, the contingencies of local-level political economy play a role in determining its boundaries, and they are decided situationally. For Fang people of Gabon, as for many others, social and physical space is defined by a linear progression from village to near gardens, farther fields, edges of surrounding rainforest, and on into the most frighteningly unfamiliar reaches of the outback. Mediating between the village and the forest are two rings of cultivation, the nearest composed of kitchen gardens, banana groves, and important cash crops, the second of corn, peanut, and manioc plantations. Before the introduction of logging and other latterday economic activities, Fang saw themselves as locked in struggle with the engulfing forest; they regarded their homesteads, hamlets, and surrounding gardens as "portions of warmth and light that they had succeeded in chopping out of the pervading rainforest, cold and obscure." Fang contrast the "pleasurable activity" of home life with the terrifyingly "cold" solitude of the surrounding, swallowing forest, and in the early 1960s, they often spoke to anthropologist James Fernandez of "their struggle with the forest and [they] employed an imagery of conflict." Yet the forest was and still is an ambivalent place for Fang, at once the abode of ferocious animals, fierce ghosts, malevolent spirits, and ne'er-do-well neighbors; and the source of pleasure, excitement, and distinct gain through ritual, hunting, fishing, and gathering wild foods and medicines.[24]

Other African peoples living in different ecotopes nonetheless share a similar sense of social space as an extension of physical space outward from home and village. Lugbara of Uganda project a horizontal plane from normal ("just like us") members of the community, to "quasi" members of society who are "more-or-less like us" but possess some amoral or suspicious supernatural qualities and abilities and onward to horrific people who are hardly human at all. At the farthest edge of a Lugbara person's direct knowledge, there reside ethnic groups such as Mangbetu and Azande whom Lugbara "know" walk on their heads, eat each other as well as repulsive things like snakes and hyenas, and possess the most fearsome powers of sorcery.[25] People walking upside-down or eating nasty things invert that which is "normal"—what "we" do and are. As one travels from the security of home, terror mounts.[26]

African animal taxonomies are often human-centered in this same way. They extend outward in conceptual and physical space, from the familiarity of one's secure inner circle of home and closest family, toward the unknown.[27] Different animals are encountered in each segment of this trajectory. Chadian peoples of the Sara language family, such as Laka and Mbaï, construct their worlds in a fashion similar to that of Lugbara, for example, with signposts of distance recognized in animal and plant species, as well as categories of human existence. Such distinctions form the structure of Orphic myths, in which an attempt is made to retrieve a loved one from the far-off village of the dead. There reigns a demiurge named Gaji-girgu, whose name means "horned buttocks" in reference to his ghastly skeletal appearance.[28] The protagonist passes successively through significant stations, marked by mourning and hideously corrupting disease.[29] On reaching the village of the dead, Gaji-Girgu is found walking on his head: it is he who can reverse expectation to raise the dead. Other Sara stories work within the same structure, with the stations occupied by people of different ethnicity, animals, or tree species:

Versions of Sara myths demonstrating the differentiation of social space, outward from ego

nuclear family >> same ethnic group or ones related to ego's >>Muslims and Europeans >> half-beings

◊◊◊

nuclear family >> Africans >> Europeans >> wild animals

◊◊◊

nuclear family >> anomalous animals >> trickster animals >> natural boundary mountains

◊◊◊

nuclear family >> thorn trees >> wild fruit trees >> rare but prized wild fruit trees

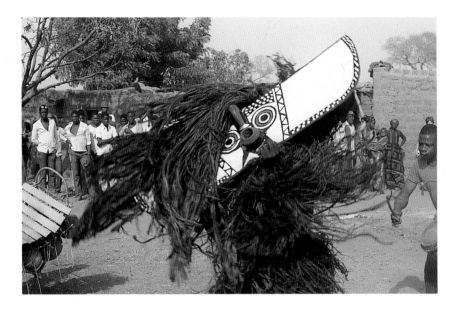

Bwa hawk mask at funeral, Boni, Burkina Faso. Photo: Christopher D. Roy, 1985.

Still other Sara stories extend this same concentric structure vertically, in a quest to regain the heavenly domain of Loa, the Supreme Being and master of agriculture. The intrepid voyager first traverses an ambiguous area associated with the troublesome trickster spider, Su; then passes successively through the domains of hawks, crows, and vultures before reaching Loa's. Each of these three sorts of bird wheels about in the air, riding updrafts; but each most frequently does so at a different altitude. Hawks, especially common African kites (*Milvus migrans*), circle the edges of bushfires, watching for hapless rodents fleeing the blaze. Carrion crows and vultures circle about higher than hawks, vultures sometimes so high as to disappear from human sight. By wheeling in the air at their different levels, the birds define a series of distinct planes, much the way that Laka determine land rights by walking in concentric circles of increasing radius until a neighbor's marker is discovered. The passage to God passes these "planes" in the sky.[30]

Along such paths, one moves from the familiar to the marvelous.[31] Such a centrifugal model applies to economic exchange and political transaction, as one moves from the pooling, sharing, generalized reciprocity, and solidarity of the nuclear group, to the more carefully crafted exchange of balanced reciprocity between groups different from but dependent upon each other; and finally on to the unsociable extreme of negative reciprocity—the cut-throat politics of barter, through which each party attempts to get the best of the other.[32] Making a "killing," as the most aggressive capitalists strive to do, falls within this last social perimeter. Time, like space, is conceived concentrically as well. Moving back from the present, through immediate history to that of more obscure ancestors, and from there to culture heroes, one eventually reaches God.[33] Finally, the same model is often deployed to understand kinship and

other social relationships. As Evans-Pritchard wrote, Nuer "speak of natural species, on analogy with their own social segments," and vice-versa.[34] In such instances, "taxonomy organizes nature *so that* the categories of animals mirror and reinforce the social rules about marriage and residence."[35] In other words, some observers reasonably ascribe functional purpose to the ordering of nature, so that such classifications can assist people in thinking through the thorniest of their own social relations. It is not so much that one is the model of and for the other, but that both domains are understood via a common logic.[36]

Animals in the Garden

Certain animals seem to belong in gardens and other lands lying nearest home and village. Some may be pests, others potential game; in any case they appear rarely if ever in African art. This class of animal comprises almost all of what Tabwa would call *wadudu* (insects, worms, and other tiny animals). It also includes mice, moles, squirrels, cane rats, jackals, foxes, and other small mammals; lizards, many sorts of snake, toads, and frogs; and certain birds. Animals normally encountered in gardens seem of little intellectual—that is, metaphorical—interest. They are expected to be found in gardens, and they are.[37]

Other creatures do not "belong" in gardens, but venture into them. Such animals do appear in African visual arts; they include spiders, chameleons, small antelopes, baboons, bush pigs, and warthogs. Forest animals for the most part, they are often so dangerous and destructive that people are sorry and angry when they find them there. Some of these creatures stray even further from their normal domains to invade the most familiar crannies of human space. They are all the more problematic for so doing. Though it is difficult to generalize as to why these animals, and not others, are represented in visual arts, it is striking that each animal in this group seems singular or anomalous in significant ways.

Mary Douglas has written extensively on animals deemed anomalous in Africa, stressing that "there are obviously as many kinds of anomaly as there are criteria for classifying."[38] Classification depends upon things fitting into proposed categories, but, logically speaking, proposing that some things do fit implies that others must not, hence the suggestion that animals falling between categories possess what Leach called "tabooed ambiguity" (discussed in the previous chapter). One can agree with Douglas that, "by focusing on how anomalous beings may be treated in different systems of classification, we make a frontal attack on the question of how thought, words and the real world are related." While other writers have challenged Douglas' position,[39] one must still accept certain animals as anomalous, whether negatively or

Female (five inches from tip to tip) and male spider, Zaire. Photo: Allen F. Roberts/Christopher Davis-Roberts, 1974.

positively so, since Africans themselves assert that this is the case. Let us consider some of the garden animals that appear in African art.

Several of these animals serve as the protagonists of trickster stories. Tricksters subvert expectations, fool the pompous, and turn life upside-down. Trickster tales are hilarious, and, as Mary Douglas suggests, laughter-producing humor affords the "opportunity for realizing that an accepted pattern has no necessity."[40] A trickster's joke is "an attack on control" that reveals conflicts and contradictions in social structure. Paradoxically, tricksters put the "ought-to-be" into relief, thereby confirming the relevance of rules to everyday affairs, even as they subvert the very same expectations. Trickster stories usually concern "the most obsessive, complex, and problematic situations and relations of the social order,"[41] such as the universal tensions between in-laws. This is because "the trickster is a mediator," as Claude Lévi-Strauss has written, and "an ambiguous and equivocal character."[42] Of African tricksters, spiders may be the best-known in Africa and the African-Americas.

Ethereal Thresholds

Most spiders live "in the nooks and crannies of social life," where they construct their webs in the interstices forming the most ethereal of thresholds.[43] For Ashanti and other Akan-speakers of Ghana and adjacent countries, Ananse is a "spinner of doubleness" embodying the paradox of the threshold, as that which is "neither this nor that, and yet is both."[44] "Trouble spiders" such as Su and Yanzele, as recognized by Sara and Mbum peoples of southeastern Chad, animate other trickster tales.[45] Rather than

web-spinners, though, Su and Yanzele are large, red, hairy hunting spiders that madly dash from place to place. They are never any one place, always rushing here and there, somewhere in between.[46]

The curious liminality of the spider finds a place in African cosmology and art. A series of Dogon (Mali) wall drawings and paintings on shrines depict the spider spinning its web, ephemerally objectifying the words of God. It also seeks to spin the signs that the trickster "pale fox" stole from God (in a version of the Promethean tale) so that in giving them form, it might gain their control. In a complex story explaining the origins of agriculture, the spider contends with the fox, trying to give place to the seeds and plants necessary to human life; but ultimately, the fox cannot be controlled, and the scorching principle it has stolen (in its piece of the sun) continues to desiccate Dogon fields.[47] One is reminded of Marcel Mauss's assertion, that "myth is a mesh of a spider's web, and not a definition in the dictionary."[48] Meaning is spun, but is also easily and regularly blown away by the harsh winds of change.

Still, spiders do not appear frequently in African visual arts, except in the kingdoms of the Cameroon Grassfields. There, as Paul Gebauer has described, terrestrial hunting spiders are the subject of motifs used by leaders and the people and circumstances associated with them, but they might also adorn the sculpted doorways, or appear as scarification patterns for commoners. Terracotta and cast-brass pipe bowls sometimes depict spiders, and were used as important regalia by kings of Bamum and Fumban, as were thrones and footrests. It was in these open-work sculptures that Grasslands art reached its zenith.

The hunting spider was among the more common heraldics of Grasslands kingdoms. Royal stools were ritually bathed and oiled, and because they were believed to bear the life force of their possessors, when the king perished, so did the stool. The spider was seen as "the mediator between gods and men," and so a symbol fit for sacred rule.[49] As such, spiders are also used in divination by some Grasslands peoples. Specially marked wooden cards are placed next to the entrance of a spider burrow, and after it has emerged and "arranged" the cards by rushing through them, they are interpreted by the diviner as messages from the underworld.[50] Web-weaving spiders were also occasionally portrayed in royal arts of the Grassfields, for such a creature is "welcome in any home as a symbol of peace and protection."[51]

The Spiral of Time

The chameleon, another little animal sometimes encountered in kitchen gardens, appears more frequently and in many more sorts of African art than the spider. Chameleons are perhaps best known as

the central motifs of brass pendants, rings, and other small sculptures from west African peoples (cat. nos. 79-81). Among Winiama of Burkina Faso, chameleons are feared for their ability to change color and so "disappear," and metaphorically suggest magical transformation. They are also associated with fertility. If a Winiama elder chances upon chameleons copulating, he pulls them apart and removes them to the bush, far from one another. From the place where he found them he takes some of the earth for his family shrine, to bring fertility and many offspring to his household. Brass pendants depicting chameleons are worn by children among Winiama, Senufo, Lobi, and other peoples of the region, to protect and bring them health and strength. Nuna make chameleon face masks, following the same associations.[52]

Chameleons seize attention by other physical and behavioral traits. Their oddly cone-shaped eye sockets, located on the sides of the head, turn separately, and one can look forward while the other looks back. This and their slow, quavering gait—undoubtedly an evolutionary ploy to deceive predators into thinking

Three views of a chameleon, Baïbokoum, Chad. Photo: Allen F. Roberts, 1969.

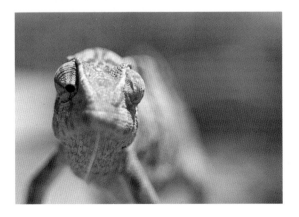

that the animal is part of a breeze-blown tree—are traits that play upon a sense of time. Among Senufo people of Ivory Coast, Mali, and Burkina Faso, chameleons are considered "beings created in primordial times," associated with "supernatural powers of transformation, sorcery, and primal knowledge." An oral narrative describes the chameleon as the "horse" ridden by bush spirits as they convey messages to God, and it commonly appears on protective rings and amulets, masks, and other Senufo art forms for this reason(cat. no. 98).[53]

In a related vein, Susan Vogel has noticed that the tails of chameleons portrayed in African art almost always curl up on the tops of the animals' hindquarters, rather than downward and below the body, as in nature(see, for example cat. no. 84).[54] In a left-side view, the upward roll of its tail (as depicted in art) is counterclockwise, while the downward roll (in the actual animal) is clockwise. When seen from alternate sides, whether in art or in nature, the spiral is clockwise from one side or counterclockwise from the other. One can speculate that such reversals (up/down, right/left, clockwise/counterclockwise) are so dramatic that they have been seen to symbolize the defiance of death and time.

At least in precolonial days, many African groups conceptualized time as a spiral. For Kongo peoples of Zaire, time was a "non-reversible ... spiral" marked by "a sense of the dead as moving, by a series of transformation[s] in the afterlife, through a hierarchy of increasingly remote but also more powerful and functionally less specific positions in the other world."[55] Earlier Tabwa also considered time a spiral, and still figure their genealogies and inheritance by the same principle, using cone-shell disks as a convenient emblem for such relationships.[56] The spirals of the shells provide the same useful paradox as a chameleon's tail: when viewed from the inside (exposed by cutting the blunt end to produce a disk), they are clockwise, while from the outside, they are counterclockwise. Like the cone-shell disk, a chameleon's rolled-up tail may play upon the paradox of time run backwards. If so, such traits may help explain why the chameleon appears so often in African folklore as the animal that introduces death to humanity.

Where time is not viewed as linear, death and eternity have different meanings too. In Africa, death may not be "punctual" nor eternity a "forever" enjoyed by the dead in strict seclusion from the living.[57] Rather, ancestral spirits may return to guide and protect their loved ones, and be reincarnated in grandchildren named after them. The afterlife may be accessible to the living, often through the services of a shamanistic spirit medium. For Sara peoples of southern Chad, the dead reside beneath rivers and lakes, in an inverted mirror-world. Tabwa ancestors

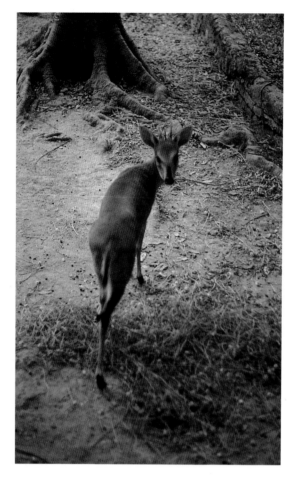

Duiker, zoo in Parakou, Benin. Photo: Allen F. Roberts, Mary Kujawski, 1984.

reside in a deep cavern once visited as an oracle where the voices of the dead could be heard and cases of serious litigation settled.[58]

Thus, ancestors are deemed present in everyday affairs, even though the names of all but the most famous may be forgotten over the generations. Time may be rolled up like a chameleon's tail and it may be reversed as one obtains contact with lost loved ones through spiritualist rituals. Perhaps this explains why in west Africa chameleons are so frequently associated with the ancestors, and so revered that if a chameleon is killed by mistake, a funeral ritual may

Mbote pictograph from a gourd quiver portraying a human couple and a reedbuck, Zaire. Photo: Allen F. Roberts/Christopher Davis-Roberts, 1976.

be offered—for example, among Kabré people of northern Togo.

Antelope Freeway

Small antelopes appear in African art even more commonly than the chameleon. Duikers, bushbucks, and a few other small antelopes are sometimes directly depicted in masks, figures, paintings, and patterns (cat. nos. 51–53); but even more frequently, their horns are combined in composite and collage sculptures, often as a bestial reference that skews an otherwise anthropomorphic representation, adding a "horned embodiment of power," and sometimes a sense of "dynamism and growth"(cat. no. 54).[59]

Although they are supposed to inhabit woods and other areas uninhabited by people, small antelopes often invade people's fields and kitchen gardens, where they can cause a good deal of damage to crops. Their trickster trait of being out of place is linked to their cleverness in avoiding traps and hunting dogs. Furthermore, even in areas where bigger game has long since been eliminated by over-hunting and habitat destruction, small antelopes still manage to thrive, seemingly against all odds. Because of this, duikers, in particular, provide game meat to people who have no other. All this no doubt adds to an African sense of why these animals are so important symbolically.

The average duiker (*Cephalophinæ*) stands two or so feet tall at the shoulder, and weighs about forty pounds.[60] Some are much smaller, with the blue duiker (*C. monticola*), common to forested areas of central Africa, only half that size. Duikers are found in both forest and savanna; those of the forest are rather squat and have a hunched back with front legs shorter than back, while savanna varieties are generally sleeker and longer-legged. Grimm's duiker (*Sylvicapra grimmia*) has the widest range of all, inhabiting far more open spaces than other species. All duikers have small, straight, sharply pointed black horns. Though they very common, duikers are shy and seldom seen.[61]

Of all these little animals, Grimm's duikers seem the best able to adapt to the changing ecology of Africa. They are found in areas of dense settlement, and are notorious for invading people's gardens, especially at dawn and dusk, and on into the night. On those rare occasions when they are startled, they emit a "'sniffy' sort of snort." Usually, though, people know their gardens have been visited at night by the destruction they find the next day.[62]

Duikers (and most probably Grimm's) are the subject of trickster tales in central Africa,[63] and while they do not seem to appear directly in African art as masks or zoomorphic figures, their straight little horns are used in a great many circumstances. For example, based upon their size and straightness, it is likely that

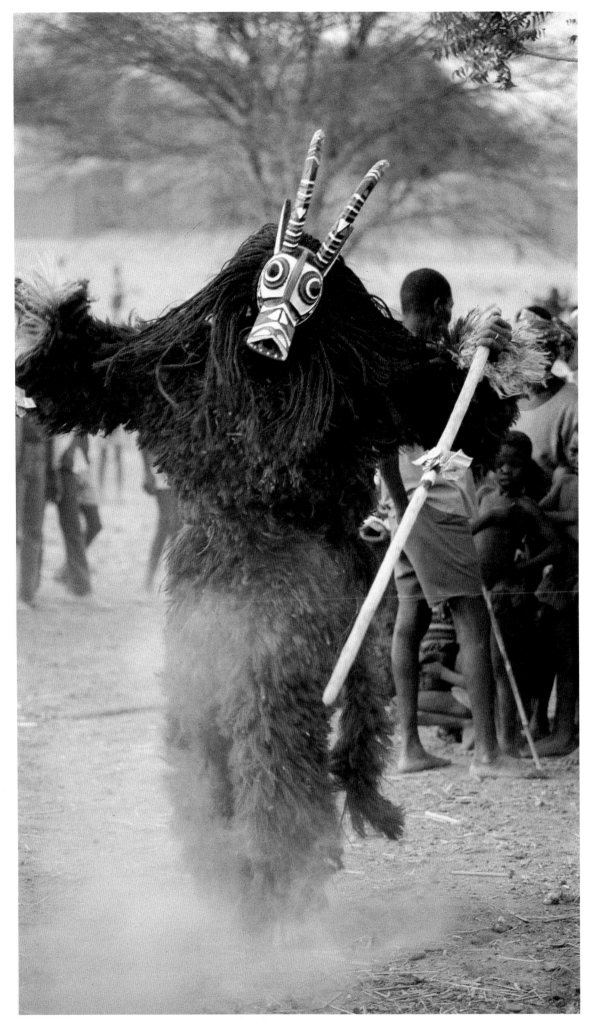

A Nunuma mask representing a roan antelope (gazella rifrons) performs holding the batons that represent its forelegs, Tisse, Burkina Faso. Photo: Christopher D. Roy, 1985.

Pictograph from a Mbote gourd quiver portraying a bushbuck, Zaire. Photo: Allen F. Roberts /Christopher Davis-Roberts, 1976.

the horns on "anthropo-zoomorphic" masks made by the Tabwa and also by Bafo people (Cameroon) are those of a Grimm's duiker; while the more squat horns of a Nyindu (Zaire) mask may depict those of a different, forest duiker.[64] The shape and use of horned *kayamba* masks by Lega (Zaire) also suggest reference to the trickster behavior of Grimm's duikers. *Kayamba* are rare and carefully kept in special baskets for use during *yananio* rituals of the Bwami Society; they represent "a clever and shrewd person," and when used in pairs, they may act out dramatic confrontation between "Kabimbi, the Clever-One, and Kalulungula, the Liar."[65]

Small, hollow, black duiker horns are also used as containers for magic. Their convenience and attractiveness is more than matched by the symbolic significance of the horns, which stand synecdochically for the entirety of the animal's physical and behavioral attributes.[66] Often, such horns are worn as amulets around the neck or upper arm, or they may be secreted above or under a threshold to close and so protect a household. In other instances, they may be placed upon or stuck into wooden sculpture,[67] or carved into the objects themselves. They appear in the headdresses of some wooden masks of the Sande Society, for example, that are made for and danced by women of Mende and adjacent groups of Sierra Leone and southern Liberia;[68] and in carved figures, as among Tabwa.[69] In other words, the magical charge empowering the object may be real, in that the substances are placed in an actual horn, or they may be carvings of such amulets, communicating an intention to protect (usually both a defensive and offensive proposition).

An even more intriguing little antelope is the bushbuck (*Tragelaphus scriptus*). This robust animal stands about three feet tall at the shoulder, and weighs up to 175 pounds. Its undercoat is chestnut-to-brown, with black bellies on males. What African observers seem to find most significant about its coat are the several light-colored stripes that "harness" the back, and the spots that mark the chest and rump. Males have horns that are "strongly keeled, forming the first loop of a spiral," while females have none.[70]

Bushbucks are "very nocturnal," and "seldom seen, even where fairly plentiful." They "haunt the neighborhood of rivers and streams which are usually bordered by marginal 'forest,'" or thickly wooded ravines. The bushbuck's "harsh, rather hollow 'bogh' ... is a common nocturnal sound," uttered in communication, challenge, or alarm. If a leopard or other predator is perceived, bushbucks will signal its movements to each other so accurately that a human hunter can trace the cat's path.[71] As the Luba say, "in the forest of the leopard, the bushbuck already wanders:"[72] the little antelope is afraid of nothing. Tabwa

speak of how a person may be in the garden farming in the late afternoon, and look up to find that a bushbuck has slipped into the very same garden, unperceived. It barks "insults" (*matusi*) at the farmer, and Tabwa associate such impertinence with the way a thief is said to mock his victim by shouting out, "If you were smarter, you would catch me!" The animal becomes truculent if threatened, and may even charge, driving the hapless farmer out of the garden. Tabwa say that the bushbuck derives its fierceness (*makali*) from the habit—shared with certain snakes and bushpigs—of eating marijuana (*Cannibis sativa*).[73] Its eyes glow red because of this, and one hunter told me that the bushbuck is a "sorcerer" (*mulozi*). Bushbucks are also said to bark at the moon in surprise and "arrogance" (*kiburi*), and when a full moon looms just over the horizon during the dry season, made red and immense from dust and smoke in the air, it is poetically called "the bushbuck's bark."[74]

Tabwa and neighboring groups associate the bushbuck's markings with the ashen spots seen at the onset of leprosy. Many Tabwa, and especially pregnant women, refuse to eat bushbuck meat for fear of contracting the illness. Impugning a person's skin with the insult, "the spots of the bushbuck" (*nkulungu ya mabela*) is likely to provoke a fight.[75] Bushbuck meat is never presented to Tabwa or Bisa chiefs, at least openly, for it is considered light (*mwepesi*) and without substance, and such a disrespectful act would be tantamount to wishing leprosy upon the chief.[76]

Because of its associations with leprosy (a dangerously "hot" illness), the effrontery of its opposition to the moon, and its "sorcery," the bushbuck is a solar animal for Tabwa, despite—and, indeed, paradoxically because of—its being so very nocturnal. As one whose being and behavior challenge taxonomic and socio-political categories, it also typifies Leach's "tabooed ambiguity." It is no surprise that throughout central Africa, "unclean" and "polluted" young people who have yet to be circumcised or brought into initiatory societies are mockingly called "bushbucks."[77] In Zaire, when a Luba person is being initiated to the Mbudye Society through which royal bearing and prerogatives are extolled, for instance, the initiand is shown the "bushbuck's heart" extracted from his or her chest (actually the bleeding liver of a chicken), to indicate that the disharmonious element has been removed.[78]

In central Africa, horns of the dangerously antisocial bushbuck are used to contain the most powerful and often the most aggressive forms of magic such as those associated with *nzunzi*, the wooden figures made by Tabwa and their neighbors that can be animated and sent to do a sorcerer's evil errands.[79] Similarly, bushbuck horns are fitted into the tops of the heads of *ilande* and *eki* power figures made by

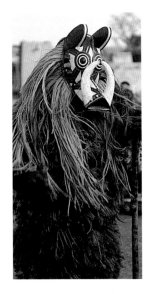

Nunuma warthog masks perform in the village of Tierko, Burkina Faso. Photo: Christopher D. Roy, 1984 and 1985.

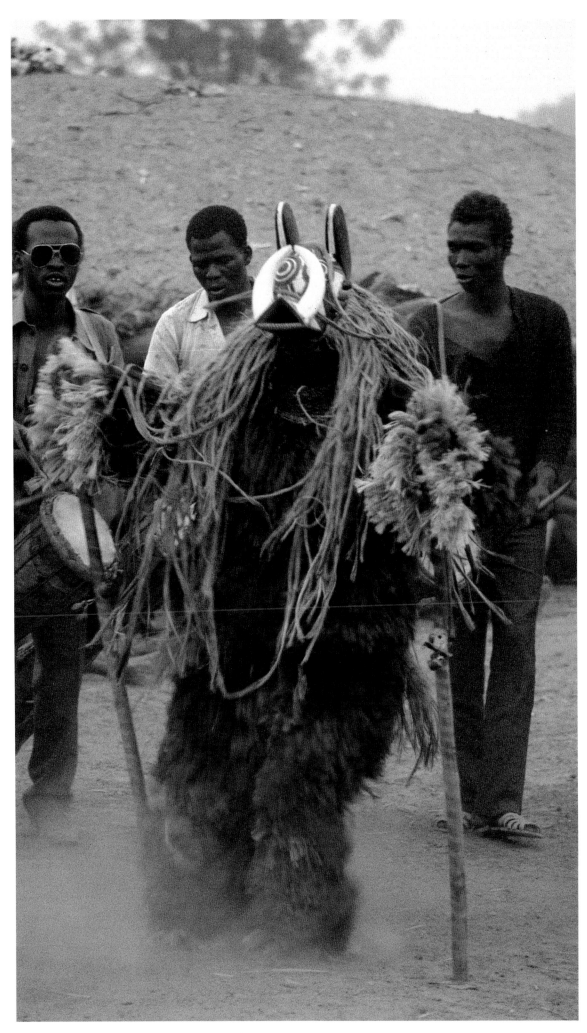

Elements of Tabwa Animal Taxonomy

The following taxonomic categories are examples of those suggested by a hunter who is also an important shamanistic healer, an elderly farmer/fisherman, and a young man with primary-school education who also farmed and fished. Eighty-five names of animals in the Tabwa language were placed on notecards, and these were read by the third man to help the other two decide how to organize the animals into categories. Asterisks mark those entries about which there was lack of agreement.

1. Animals "following the example of mice"
"They all eat in the same way, and they sleep in tunnels; and when they walk about, it is especially at night or in the early morning and late afternoon, not in the bright sunlight. Their teeth and the shapes of their heads are similar."

panya	mouse and rat
kansense	squirrel (Sciuridae spp.)
membe	flying squirrel (Anomaluridae)
ntondo	elephant shrew (Rhynchocyon cirnel)
kianga	thick-tailed galago (Galago crassicaudatus)
kabundi	lesser galago (Galago senegalensis)
ngezi	*cane rate (Thrynomys spp.)
nfuko	*mole
kinungi	*crested porcupine (Hystrix spp.)
mtumbi	*aardvark (Orycteropus afer)

2. Animals with "long tails, pointy heads, and long bodies"
"They have claws on their feet and no hooves; they catch chickens or small animals to eat."

nzenzekala	mongoose (Herpestinae; species?)
mukala	another mongoose
kitotoma	another mongoose
kasama	zorilla (Ictonyx striata)
kansimba	*genet (Genetta genetta)
kazamba	*servaline cat, smaller "red" spots (Leptailurus serval)
libalabala	*serval, "ordinary" serval; note that the melanistic serval is placed in following category (also Leptailurus serval)

3. Animals that "walk close to the earth and go about at night"
"They are not seen often, and are "black" in color. They have claws that are short like a dog's, but they eat different things: the ratel eats honey, the civet eats palm nuts, and the melanistic serval eats mice."

kibulibuli	ratel or honey badger (Mellivora capensis)
liobo	civet (Viverra civetta)
nzima	melanistic serval (Leptailurus serval)

Songye people of Zaire, and such sculptures were so powerful in their ability to protect a village (probably by reflecting evil back on its perpetrators) that Kuba kings and other neighboring leaders sought and used them.[80]

In west Africa, the bushbuck is also thought to be troublesome. Among Guro (and neighboring peoples who have adopted some of their art forms), well-known Zamblé masks portray the bushbuck as "'the one who ate his master'—it killed its own mother."[81] Zamblé is the "prohibition ancestor (interdit-ancêtre), [and] doubly metaphorical: with its open mouth [and] protruding tongue, the mask evokes the leopard goli, whose skin covers the dancer, and at another register, the odor of bushbuck meat reminds one of that of humans." Women may look at but not touch Zamblé,[82] presumably because the animal and its mask are too anomalous, too "human."

In a kinder light, it is likely that the Karipko antelope masks worn by Ogoni people of Nigeria to honor their founding ancestors during agricultural ceremonies[83] also portray bushbucks or perhaps their close cousin, the somewhat larger, longer-horned sitatunga (Tragelaphus spekei). Sitatunga are aquatic antelopes whose long, splayed hooves are adapted to walking on the matted papyrus and reeds of swamps. They "slink through reed beds with great agility and swim very well. When surprised, they immerse themselves in the water and submerge entirely, with only the tip of the snout protruding above the surface." Furthermore, sitatunga spend the hot hours of the day in the water, and are clumsy on land.[84] Although their particular attributes accommodate different ecologies, sitatunga and bushbuck are as similar in their nature as true beasts of the between.

A Shrewdness of Baboons

Gardeners do not stand a chance if baboons live nearby. On a visit to a friend's village along the shore of Lake Tanganyika, I once watched a "shrewdness" of yellow baboons (Papio cynocephalus) completely hoodwink the boys trying to chase them from a manioc field.[85] The village sat at the edge of a very steep mountain, and fields were cultivated up the precarious slope. Because of the lay of the land, we could stand in the village and see what was happening in the gardens above us, even though we were far enough away so that boys guarding their manioc could not hear our shouts of warning as we noticed baboons coming down from the forested top of the mountain to enter the field. As we watched, the boys became aware of the baboons and ran to chase them away; but the baboons circled around behind the boys in a most comical fashion, and began breaking down and eating the manioc canes, even as the boys continued to whoop and holler in the opposite direction. We could do nothing but laugh. It may have been just as well that the boys' actions were so futile, for baboons can be "fierce fighters, able to inflict serious wounds with their powerful canines. Their collective defence makes them much more dangerous and many predators keep well away from them."[86]

Another experience made me aware of baboon affrontery. I was swimming with some friends in a deep stream in southwestern Chad when a troop of Anubis baboons (Papio anubis) decided it was their turn to take a drink and enjoy the place. They began screaming at the tops of the rocks overlooking the swimming hole, and when we took little notice, threw sticks and stones at us!

Baboons are portrayed in masks, figures, and paintings by a number of African peoples. Best known are large sculptures made by Baule of Ivory Coast (cat. nos. 70-72).[87] The figure of a male baboon (mbotumbo) standing in an anthropomorphic stance with knees bent, its hands cupped or holding a bowl, represents a divinity of forest and field, whose power is deemed to be like baboons—able to devastate, and so by extension, to protect the village with equal force from its supernatural enemies. Such a figure is kept outside the village in a sanctified place, and at the rising of a new moon or when planting is to begin, the priest overseeing its cult offers eggs and the blood and meat of a chicken or even a cow, along with a gruel of foodstuffs such as yams and locally brewed beer. The spirit becomes more powerful as sacrifices are given, and the crusty patina of such figures is explained by the many offerings made in this way, to gain the spirit's assistance in warding off the attacks of those who would thwart the village's harvests or otherwise menace its people.[88] The same figures may also be used in divination to determine the cause of a drought or epidemic, in male organizations that protect people from witches, and to promote human fertility.[89]

Baboons make "baboons" of people by invading their gardens at will, but in turn, they may be scorned as gluttonous. This message is given a political twist in a Fon (Bénin) bas relief on the wall of King Ghézô's palace at Abomey. A baboon sitting in profile, a maize cob in its hand, reflects the ironic response of Guézô's predecessor, Adanzan (1797–1818), to the excessive requests for tribute from the Yoruba or Nago King of Oyo (now in Nigeria). Adanzan sent the king a parasol with the same motif attached in appliqué, showing the baboon eating one ear of corn and reaching for another. The King of Oyo sent back a hoe with the message, "So, are you so poor nowadays? Farm [with this hoe and then] you will be able to pay my tribute."[90] A more bluntly antagonistic baboon image appears on a Yoruba Gelede mask in the collection of the Alexandre Adande Ethnographic Museum of Porto-Novo, Bénin. A smirking baboon stands atop the mask, its testicles grotesquely swollen from elephantiasis, as a taunt to a rival Gelede society to which the baboon is meant to allude.[91]

Finally, as with chimps and some other animals to be discussed in the next chapter, baboons may be considered human. To help celebrate the "festival of life," Owerri Igbo people in Nigeria make sculptures of baboons (or other apes) and place them in their Mbari houses; the spirits of old men are deemed to reside in these creatures and care is taken not to kill one, for that would be tantamount to murdering an old man.[92] Chokwe (Angola/Zambia/Zaire) occasionally make baboon masks[93] to be danced in boys' initiation rituals, where they refer to the "human-ness" of the families of baboons, and especially the mother-infant relationship. Some Chokwe thrones are also decorated with lines of tiny baboon figures, and the association between them and chiefs may be via the Mungonge initiation society that stresses the place of transformative magic in human society.[94] Senufo (Ivory Coast) baboon helmet masks called korubla are danced during the initiations and funerals for members of the Lô Society. The performer wears a "cyno-cephalic mane" of fiber about his neck and carries a double-membrane drum on his chest, decorated with feathers, porcupine quills, and other animal remains. These are evocative masks and, as Robert Goldwater suggests, "a human face has, as it were, been laid over the animal muzzle."[95] Baboons also sometimes appear in rock art, for instance in paintings from shelters and caves in South Africa.[96] These latter, as recent research suggests, might portray the sort of merging and shifting between people and animals that takes place during trance healing and related rituals, as documented among hunter-gathering peoples of Botswana, Namibia, and South Africa.

Sounders and Singulars

Warthogs (Phacochœrus æthiopicus) and bushpigs (Potamochœrus porcus) are two quite different wild pigs (Suidæ). Although their ranges overlap in some places, warthogs live primarily in open savanna grasslands, bushpigs in woodlands and forests. Both are depicted in the masks of several African peoples and their tusks[97] add ferocity to other conglomerate works.

Warthogs are odd animals: even naturalists call them ugly.[98] Warthogs can weigh up to three hundred pounds, and their enormous heads are "much flattened, with an expanded muzzle and two pairs of large 'warts,' the upper immediately below the eye, the lower between the eyes and the tusks." Warthogs are gregarious and sounders of several litters live together. They favor aardvark burrows, which they widen, line with grass, and enter backwards so as to face outward. Their eyesight is poor but their hearing and sense of smell acute; they are usually silent, but grunt when alarmed. While warthogs generally keep to wildlands, they enjoy many of the fruits prized by humans, and they will sometimes root about in gardens and become pests. Like the other animals we have considered, they are "out of place" when they do so.

A number of African peoples perform warthog masquerades, with a concentration in western Burkina Faso. For Mossi, (cat. nos. 60-61) warthog masks are danced as a clan emblem. Among Bwa, they are decorated with geometrical color-contrasts, including an X-shape on the muzzle that may refer to

the scarification pattern deeply cut into the dancers' foreheads. The masks are performed in dramatizations of family myths, initiation, funerals, and other key moments in community life. Nunuma people also make warthog masks representing bush spirits; the dance step is very distinctive, for the performer rushes headlong through the dust he has kicked up, probably in imitation of the juggernaut-run of the warthog.[99]

Little information is available to explain why warthogs are the subject of masks used in such contexts. It may be that their gregarious nature, the way they enter burrows backwards (an intriguing reversal), and other noticeable attributes make them apt vehicles for spiritual encounter. Other groups making warthog masks, such as Ligbi people of the Ivory Coast and Ghana, stress the warthog's great strength and "beauty"[100]—despite the judgment of some Western naturalists. Ligbi warthog masks used to be performed in the sacred dramas of the Do Society, but nowadays they are danced in theatrical performances to mark important Muslim holidays or similar events. Their entertainment value is derived from the animal's wily nature and dangerous strength, and in a set piece, a hunter tries to shoot the "warthog," fails, and is set upon by the beast, much to the audience's delight.[101]

Warthogs have another unmistakable trait that proves important to African thinking: when they run from danger (or just to get from one place to another), they do so in single file, their tails raised vertically, as straight as flagpoles. So pronounced is this posture that warthog-tail is often an element of amulets and medicinal preparations to treat male impotence or to assure success in courtship, as among Laka and related peoples of southwestern Chad and Bemba of Zambia.[102] African artists creating and performing warthog masks very likely have this attribute in mind; the comedy of the Bwa masquerader's dance may well be derived from such a once-removed reference to male sexual exuberance.

If warthogs and baboons sometimes lay waste to gardens, the depredations of bush pigs can be far worse. Bush pigs are the bane of African farmers living within their range. Unlike baboons, they not only break down plants to get at fruits and vegetables, they also root around and dig up tubers. They almost seem to prefer the ease of eating in people's gardens to scrounging about to find wild foods in the bush. A "singular" of bush pigs may number more than three dozen members of several generations, and when they flood into a garden, they leave it utterly devastated.[103] Indeed, Tabwa describe the destruction wrought by bush pigs using the Swahili verb *kuteketeza*, a word more frequently used to describe the ravages of warfare. The Sanga, a Tabwa clan, have chosen the bushpig as one of their emblems for this reason: while the primary analogy is between their own farming proficiency and the way that bushpigs "cultivate" with their tusks as they root about,[104] the bush pig emblem warns of the ruthlessness with which Sanga warriors will lay waste their adversaries, should they be antagonized.

The Banyang people of Cameroon extend the sense of the bush pig's ravages to explain certain forms of human misfortune. Seeking the causes of misfortune through introspection, they find that the quirks of their lives are due to the influences of an assortment of were-animals, who lead lives that are parallel but intimately connected to those of humans. A were-animal's being, behavior, and health influences a person's. This can explain ugly actions or awful accidents, although some were-animals are "little more than metaphorical descriptions of a person's individual talents." A were-bushpig is deemed responsible for multiple miscarriages, for example, and for other difficulties in conception and giving birth. In one case mentioned by Malcolm Ruel, when a bush pig was caught in a trap set in a frequently invaded garden, a woman sharing its meat died soon afterwards, for the bushpig had been her own were-animal.[105]

Another dimension to bushpig behavior is pertinent. To Tabwa, bush pigs seem altogether uncanny in the way they avoid the best-laid traps, skirt or dig under the thickest thorn hedges, and otherwise plunder gardens if and when they choose. Tabwa assert that they possess *malosi*, a faculty shared with dogs, side-striped jackals, hyenas, and bateleur eagles—each in its own right an intelligent and wily kind of animal. *Malosi*, or prophetic insight and keenly projective eyesight, is the source of a bushpig's cunning. Tabwa say that bush pigs (like bushbucks) eat marijuana (*Cannibis sativa*), which makes their eyes glow red with malicious intent. Nzwiba, a hunter and shamanistic healer with whom I worked closely, described bush pigs' acuity with words that connote such craftiness (*mayele* and *werevu*) as to imply the illicit advantage of sorcery. He said that if a bush pig finds owners guarding their crops from night attack, it will perform a special dance that sends the farmers into a deep sleep. After eating its fill and in all likelihood ruining more than it can eat, the bush pig dances again or defecates as it leaves the field, whereupon the farmers are startled to wakefulness but ignorant of what has happened until dawn breaks and they see how their crops have been destroyed. Nzwiba compared the bushpig's cleverness to a magical bundle called *kabwalala* ("the little dog sleeps"), used by thieves to send their victims into such sound slumber that they can be robbed without the least protest. A Tabwa adage has it that "theft and sorcery are of one path." As a chief once told me, the bushpig is a

shetani—a "devil"—and chiefs should not eat bush-pig meat because of this, although (he added wryly) they might do so privately, because the meat is such a succulent treat.

Bush pigs are singular, no doubt about it; but there is even more to their story, as suggested in a narrative explaining the origin of Bulumbu, the possession cult of diviner-healers found among Tabwa and their Luba or Luba-ized neighbors.[106] A hunter wounded a bush pig, which then fled into a cavern. As the hunter pursued the beast, the floor of the cavern gave way and the hunter fell into utter darkness. Stumbling on, he was suddenly confronted by a long-deceased brother who explained that the bush pig the hunter had wounded was a spirit guide (mutumbe), who would thereafter mediate among the hunter, and ancestors, and other spirits.[107] The man returned to his village and became a Bulumbu medium, helping others solve their problems through divine intervention.[108]

The image of the bushpig as a mediator and guide to the underworld is related to a broader complex of cosmogonic narratives found throughout central Africa. The term for bush pig in Swahili and other central Bantu languages is nguruwe, the last particle of which (-ruwe or -luwe) appears over and over in the names and attributes of culture heroes such as Mbidi Kiluwe of Luba fame, who introduce civilized behavior and sacred rule to an inchoate world.[109] Mbidi and his fellows are dichotomous beings, divided vertically down the body midline and often half-human, half-beeswax. As such, they incarnate the paradox of asymmetry, for right-versus-left is always assigned social symbolism, with right usually being correct male, and auspicious, while left is the opposite.[110]

It is likely that African art portraying bushpigs is based upon these same associations. A Makonde girls' initiation mask (Tanzania/Mozambique) depicts a bush pig as a symbol of transition.[111] A Gelede mask in the collection of the Institute of African Studies at the University of Ibadan (Nigeria) depicts a bush pig that has seized a monkey in its maw, that in turn is eating an ear of corn. On its head the bush pig bears a snake that is attempting to swallow a tortoise. It is possible that the sculpture "conveys a pecking order and symbolizes the competing forces in the Yoruba cosmos," as Drewal and Drewal have suggested,[112] but I imagine another factor is at play. Like the mask of a hen described in the last chapter, this one lacks the placid female face that forms the lower tier of most Gelede masks. Instead, the bush pig sits squarely on the masker's head, and one is left to assume that, as with the hen, the bush pig "is" the woman usually portrayed. The overall message, then, directed to someone or a faction in the community that the

Gelede society members deem in need of "subtle" correction, might be one of mystically compounded, consuming avarice. Alternatively, Gelede bushpig masks and their accompanying songs and dances may refer to the sexual potency of "our mothers," as a general female principle,[113] or to the profligacy of someone in the community, at whom the performance is being directed.

Peoples in the area where Angola, Zambia, and Zaire converge, also make bush pig masks.[114] A Yaka initiation mask in the collection of the National Museum of Zaire (Kinshasa) portrays a bush pig surmounted by a crown-like coiffure upon which a bird perches. The bird is said to be "a symbol of fecundity,"[115] as is, in all probability, the pig. The large corpus of Chokwe boys' initiation masks also includes one called Ngulu that may either be a domestic pig, a bushpig, or both at the same time (cat. nos. 54, 62). The Ngulu performer enlivens his audience with humorous steps as he grunts, roots about, and dances on all fours.[116] Ngulu is sometimes danced as a counterpoint to another mask, a graciously beautiful ancestress named Mwana Pwo, in the kind of raucous drama of gender that Chokwe so greatly enjoy.[117] Ngulu is said to display swinish sexual excess; a monkey pelt is attached to the mask and draped over the dancer's head, because, it is said, "monkeys behave like pigs—they are uncontrollable and unpredictable."[118] While some observers report that an Ngulu performance underscores "the difficulties men have controlling women,"[119] it is as likely that the opposite is true as well: that Ngulu pokes fun at male sexuality, especially through the masker's pas-de-deux with the dignified and lovely Mwana Pwo.

Manuel Jordán notes another interesting aspect of Ngulu masks: most are divided down the middle of the muzzle, either by a carved ridge or a painted line, to symbolize "the tension between the sexes."[120] While this may be true, it is probable that at a deeper level the dividing line alludes to the paradoxically dichotomous nature of the bush pig, for the word "Ngulu" is a version of nguluwe, "bush pig" for other Bantu-speakers. In such a case, in its dance with Mwana Pwo, Ngulu stands in for Mwana's more usual partner, Chihongo, "the spirit of power and wealth" and archetypal chief.[121] Both Ngulu and Chihongo present aspects of the Chokwe culture hero, Chibinda Ilunga, who, in turn, is a member of the conceptual set of dichotomous beings that bring civilization to many Bantu-speaking peoples. These stories and performances suggest that for Chokwe, bush pigs are heroic beasts and Chibinda Ilunga and his fellows truly beastly heroes.[122]

Don't mock the croc
till you've crossed the river.
A Cameroonian proverb[1]

Out on the Edge

*Luba spirit medium using owl head
in divination as bird of prophesy that
sees sorcery, Zaire (detail). Photo:
Mary Nooter Roberts, 1990.*

L ife makes most sense closest to home, according to a taxonomy of fixed categories. Of course, these are not really fixed, as we have seen; but people choose to believe that their cosmology works and that there is an explanation for whatever happens in life, no matter how unexpected.[2] Out on the edge of direct knowledge, though, explanations unravel. In the twilight, odd things happen. "People are fooled by the moonlight," say the Tabwa—as if in a midsummer night's dream. Over the last hill ever visited by anyone you know, gaping jaws may await.[3]

Following a linear trajectory, beyond the gardens lie more and more endless expanses of scrubland, deeper, darker, and danker forests, and muckier marshes. It is here at the edge of the known and knowable that one may encounter fabulous phenomena. Fearsome animals slink, lurk, and leap out of bushes. Such beasts are often rare, but they are always noticed and reported by those who live to tell the tale. A disproportionate number of African zoomorphic art forms depict just such animals.

It would be bad enough if frightening animals stayed out at the edge, where they belong; one could avoid them by staying home. But the world does not work that way. There is too much to be gained from the outback, and sometimes the most fearsome of beasts provide the most valuable benefits to human enterprise. The forest may be a frightening place but for many, such as Fang (Gabon), it is also

Wall painting of wild cat and snake, Baïbokoum, Chad. Photo: Allen F. Roberts, 1969.

exhilarating and full of positive surprises. Furthermore, strange denizens of the edge are forever getting "out-of-place" in the course of their own peregrinations, or sometimes by the design of blasted kith and kin, who may shift to animal shape in their furtive schemes for wrongdoing.[4]

In this chapter, we consider two categories of out-on-the-edge animals: those that for the most part stay where they belong, and those that don't. Certain of these have been discussed recently elsewhere and will not be considered here. These include buffalo, contemplated in the introduction to this book, and the elephant, subject of a mammoth anthology edited by Doran Ross. Approaching the edge of the known world, it becomes more and more difficult to discern what is an animal, and what is a human. In one sense, there is no question at all; yet in another, this most basic of distinctions can and does become blurred, which may be both alarming and charming.

The Subtlest Beast

The serpent is a common out-on-the edge animal. Snakes are so conceptually important that they are one of the most frequent themes of zoomorphic art. Indeed, a number of authors have suggested that "the snake was the first, and remains the most fundamental, of all animal symbols."[5]

The linear extension of social and physical space outward from the familiar finds its reflection in ser-

Mbote pictograph from a gourd quiver portraying a human face and a snake pattern, Zaire. Photo: Allen F. Roberts/Christopher Davis-Roberts, 1976.

pent physiology. Snakes are "endless," both physically and chronologically, for it is hard to tell head from tail, and as they shed their skins they are "eternally" reborn. Indeed, the serpent may be seen as "a straight line with one extremity lost in the infinity of the past, and the other in the infinity of the present.... They are as cold as eternity, and as horizontal as we are vertical: the serpent is the exact opposite of living man" and woman.[6] As Mercea Eliade has commented, snakes are all that is "amorphous and virtual, ... everything that has not yet acquired form."[7] Serpents are intimately associated with and, indeed, incarnate the inchoate itself.

Some African snakes like the Gaboon adder generally stay where they belong, out in the woods, and they present little danger elsewhere. Others, such as mambas, do not know their "proper" place, and intrude into the most intimate spaces of human habitation. The most remarkable snakes, which Western naturalists would call mythical, are to be found so far beyond the last known landmark that they are encountered only by the greatest shamans who can go there by mystical means.

In many cases, although acutely aware of how lethal some snakes can be, people are not so much afraid as in awe of them, and may even seek, rather than avoid, them. Of all the snakes in Africa, pythons (*Python sebæ*) and Gaboon adders (*Bitis gabonica*) are two of the ones most frequently represented in art, either directly, as an architectural element or subject of masks, or more indirectly as motifs incised or burned into pots and gourds, woven into mats and textiles, used in scarification, and the like.[8] Both are certainly dangerous, but both also have transcendent meanings for Africans. Tabwa and other

(LEFT) *Wall painting from Dangbe python shrine, Ouidah, Benin. Photo: Allen F. Roberts/Mary Kujawski Roberts, 1987.*

(RIGHT) *Wall painting of a serpent on an Egungun house near Porto-Novo, Benin. Photo: Allen F. Roberts/Mary Kujawski Roberts, 1987.*

Tabwa highbacked stool with serpent representing earth spirit. Courtesy: Linden Museum.

central African peoples associate large serpents with the earth spirits that were once the center of important ecological or territorial cults practiced to assure continued access to important natural resources such as spawning runs of fish, or success in hunting. J. M. Schoffeleers has suggested that "snake deities" of this sort "are probably part of the oldest identifiable cult strata" among the several in central Africa for which he provides a useful typology.[9] The same could be said for the association between pythons and the gods of Yoruba, Fon, and related west African peoples.

Pythons are the largest African snakes (discounting those that Western naturalists identify as mythical), and although they occasionally reach a length of fifteen to eighteen feet and are dangerous to those foolish enough to mistreat them, they are easily avoided. In fact, they are widely venerated as manifestations of earth spirits or other divinities, and may be caught, kept, and manipulated, as in the serpent cult of Dan Aïdo-Huédô or Dangbe, the rainbow deity of Fon and related people in southwestern Bénin. Many Igbo people (Nigeria) "claim safety in their presence," and will carefully remove a python to the woods, should one mistakenly enter human space.[10]

Many staffs and canes from Zairian peoples portray pythons and other serpents slithering up the shaft. In so doing, they follow the staff's path upward from the earth and bring to bear its powerful forces upon the hand of the leader grasping the grip. Giant python figures are said to have decorated all manner of regalia and the palace roofs of the kings of old Benin, demonstrating similar relationships (cat. no. 27).[11] The serpent's mediation between divinity and sacred rule is nowhere better demonstrated than on the backs of three Tabwa stools. The snake mounts from right to left, diagonally across the backs, and is framed by blocks and registers of isoceles triangles and diamonds, in the "rising-of-the-new-moon" (*balamwezi*) motif. Models of duiker horns and weevil (*Brachycerus apterus*) carapaces are carved as protec-

tive amulets, on either side of two of the snakes. Best of all, on one stool, the irregular play of the *balamwezi* pattern—achieved by tilting some lines of triangles and opening or squeezing shut others—makes the snake come uncannily to life. Surely, this tour de force is one of the best examples of what Robert Farris Thompson calls "African art in motion."[12]

Pythons are patient hunters. The hilt of an *afenatene* ceremonial sword made by Baule for Akan royalty in Ivory Coast shows a python seizing the wing of a fowl, recalling a proverb about a python that captured a swift bird by waiting until the last waterhole dried up (cat. no. 136). An Asafo battle flag of Fante people (Ghana) tells a variant of the same tale in which the bird was a hornbill who had borrowed from the python, and refused to repay his debt. The python waited patiently until the last waterhole dried up, and then promptly caught and ate the hornbill.[13] Pythons devouring or being devoured by other animals may also refer to a political arena of competing factions or powers.[14] A Gelede mask in the Béninese national collection depicts pythons coiled on either side of a turtle, but facing toward the back of a dancer, while the turtle marches forward between them, unscathed and unfazed. The message is that one must have the patience and fortitude to resist the destructive forces that surround us all, and the courage to "keep on keepin' on." Alternatively, the same imagery may refer to the nefarious activities of witchcraft, as among Banyang of Cameroon; a beaded headpiece in the form of a big-eyed python made by Bamileke, also of Cameroon, has a place in activities that are generally auspicious, yet it "resonates with an honorific rendering of a reptile of dark capabilities."[15]

The sense that snakes incarnate inchoate possibility is captured in the imagery and performance of many ophidian objects. Among Fon-speaking peoples of southwestern Bénin, a horned serpent is associated with continuity between this world and that of the ancestors, and suggests the umbilicus that unites

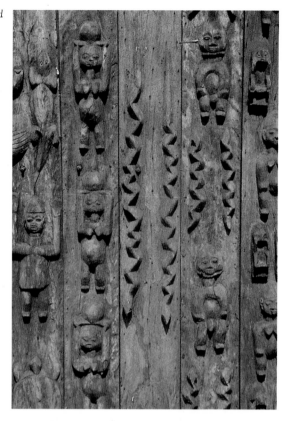

Snakes carved on palace compound door, Honme Palace Museum, Porto-Novo, with permission. Photo: Allen F. Roberts/Mary Kujawski Roberts, 1987.

mother and child, and the act of creation itself. A bas-relief on the palace wall of King Ghèzô shows the serpent catching its own tail, an act that transforms the serpent's linearity into an active assertion of unity, harmony, mediation, and rhythms that hold the universe together. Little snakes of scrap iron and brass are placed on family shrines in the same region, to assure fertility, "great abundance, creativity, and wealth." [16] Somewhat similar iron sculptures find a place on Dogon (Mali) shrines, and refer to Lebe, the serpent whose zigzags refer both to the descent of the primordial ark to earth and to sinuous rivulets of rainwater on sun-baked ground.[17] Chewa women in Zambia and Malawi make clay models of pythons, which they paint red, white, and black with termitary earth, chalk, and soot; these are used during girls' initiation as the most important visual teaching devices.

Songs and dances mention the "serpent" that controls women's sexuality and fecundity.[18]

In Guinea, Baga and Nalu serpent sculptures called *bansonyi* are used for rituals that "entrap and destroy sorcerers, cure sterility, end droughts, and protect their villages from malevolent forces."[19] They are also used in the contexts of initiation rituals. At the end of initiation, male and female *bansonyi* figures emerge from fields surrounding a village and each is surrounded by a moiety. Half the village is "male," half "female," and as the villagers engage in mock combat centered around the *bansonyi*, they dramatize gender conflict. An illustration of six of these animated figures presented by Warren Robbins and Nancy Nooter shows the serpents wriggling and writhing upward, perhaps in a dance toward divinity.[20]

In a similar play on verticality, Bwa serpent masks stand twelve to more than sixteen feet above the dancer's head (cat. nos. 30, 33, 34). The strength and agility needed to perform them gracefully and with vigor nearly defy the imagination. A story has it that such masks were first made as a token of gratitude when a man whose village was being raided by enemy warriors was given refuge in the burrow of a python. The serpent protected and fed the man for two whole market weeks, and when he finally returned to his village, a diviner instructed the man in how to create and perform the tall masted mask, to dance in celebration of family and clan histories.[21]

Other snake masks convey less convivial messages. When they do, there is often a sense of the inchoate and the insecurity of that which is not yet decided, because the imagery itself proposes alternative explanations for what the sculpture presents to an audience. For example, Gelede masks made by Yoruba peoples of Bénin and Nigeria often depict pythons, either individually or in compositions with other animals as visual puns or proverbs. One mask at the Alexandre Adande Ethnographic Museum of Porto-Novo, Bénin, shows a version of the placid

(LEFT) Sign advertising insurance, using motif of rainbow snake biting its own tail, taken from bas relief at Abomey Palace Museum, Benin. Photo: Allen F. Roberts/Mary Kujawski Roberts, 1987.

(RIGHT) Postcard showing bas relief of Abomey Palace Museum, Benin.

(OPPOSITE PAGE) Bwa snake mask waits its turn to perform at market day dance in the village of Dossi, 1985 (detail). Photo: Christopher D. Roy.

female face typical of Gelede masks, on which the woman's head scarf is replaced by a python, whose every life-like twist and coil suggests the elegance of the woman's stylish wrap. This may be a reference to the python's association with Yoruba gods, for through costuming and paraphernalia, Gelede masquerades often refer to Ogun, god of iron and innovation. Ogun controls snakes and his adepts sometimes dance with them. As mentioned in the context of dog sacrifice, Ogun embodies the perplexities of change, which may lead to innovation but also to violence; one should be wary of the god's fury. In a similar vein, Yoruba men associate snakes with the awesome powers of women, and perform Gelede masquerades to both celebrate and keep in check the "concentration of vital force in women [which] creates extraordinary potential that can manifest itself in both positive and negative ways." According to Yoruba men, women nurture with love but destroy through witchcraft, and certain women can turn themselves into snakes in the course of their fell deeds.[22]

Snakes in Yoruba art may also refer to or stand for the god Osùmàrè, the rainbow divinity known as Dan Aïdo-Huèdo by Fon-speaking peoples of southwestern Bénin. An association between serpents and the rainbow is found in the cosmologies of people around the world.[23] A Gelede mask from the Ketu region of Bénin shows two royal python/rainbows arching over the head of a small female figure, in turn standing on the placid woman's head of the lower register; the two snakes face in opposite directions.[24] A similar opposition is suggested in a remarkable composite sculpture from Nigeria, in which a man stands in a threshold, defined on either side by snakes (probably pythons) (cat. no. 148). The snakes, rising from the tips of their tails, reach up to a lintel formed by an antelope with a leopard on its back, which in turn stands over the man's head and echoes a line of scarification across his own brow and the slope of his shoulders. The man faces outward, so that his right, and presumably "male" side, joins a python grasping the antelope's front hoof in its mouth; the man's left, "female" side, is in conjunction with a python seizing the antelope's hind leg.[25] Were the pythons to complete the arch of the doorway themselves, they would be facing in opposite directions (with the "female" side likely being lower).

Tabwa say the rainbow emanates from a hole in a natural clearing or from a termitary, and is the breath of the great (and Western naturalists would say mythical) serpent Nfwimina. Luc de Heusch has plausibly linked a similar phenomenon, recognized among eastern Luba, to nuptial swarms of termites that emerge after rains like "'black smoke rising from the nest.'"[26] Neighboring Luba say that the rainbow is composed of "two serpents, a male and a female, each staying in a different stream. From time to time they unite over our heads, their union appearing to the eyes of men in the most vivid colors: it is the rainbow."[27] The image is the same as that of the reversed pythons arching over the head of the figure on the Gelede mask from Ketu, or the sides of the Esan threshold. The serpent "wife," closer to the ground, represents a secondary rainbow caused by double refraction that reverses the color sequence of the primary rainbow. The two rainbows lie "belly-to-belly," with their violet registers facing each other like two serpents engaged in sexual union.[28]

Snakes as lines of demarcation are thresholds of becoming rather than being. The hypothesis and necessity of choice they embody present what Turner called "pure possibility whence novel configurations or ideas and relations may arise." To return to the Esan threshold, the image of the man framed by pythons reaching upward and animals arching over his head may represent indecision and choice; but it may also signal the wild possibility of transforming the communal life at which he stares, as violent as such social processes must sometimes be.

Never Smile at a Crocodile

If snakes are the essence of ambivalence, other animals spell out a complementary message. Among Tabwa, one of the animals that is the subject of unending debate is the Nile monitor (*Varanus niloticus*). These largest of African lizards may be ten feet long, although most are half that size; they are "extremely fast, voracious creatures eating eggs and any animals they are able to overcome."[29] Their bite is said to be excruciating and risks dangerous infection; Tabwa take care to keep away from them. For Bisa of Zambia, coming upon a live monitor in the bush is considered auspicious; if it is dead and uneaten, however, it is a sign of impending trouble.[30] My one encounter with a monitor revealed another dimension of the animal's anomaly. I was walking in woods by Lake Tanganyika (Zaire), preceded by my dog, who flushed up a six-foot-long Nile monitor from the bushes. The lizard and I were equally frightened, but my dog took off after the monitor. As it vanished over the tops of scrub brush, the animal literally appeared to fly.

Tabwa and a great many other African peoples use monitor skin for drum heads because it stretches well, is remarkably strong, and is so very thin that no other skin can match its vibration.[31] Other attributes of the monitor lizard were explained to me by Tohoessou Sourou, an Aja blacksmith in Gbakpo, Bénin, from whom I commissioned an *assanyin* tomb ornament made of recycled car bumper and brass pipe.[32] The *assanyin* has three tiers, the topmost of

which is surmounted by a two-dimensional chrome Nile monitor lizard, its head tilting upwards. Surrounding the lizard are four bird silhouettes in chrome, while the lower disk sports four brass roosters. As explained by the blacksmiths, the *assanyin*

> is a face, this is life, and what would life be without birds and animals? Animals are signs (*signes*), and different animals tell people different things. We chose the lizard because we had an eye for the beauty of the object, but also because the monitor lizard is above other animals. It is a *reptile* as is a snake, and you with your science may have heard the call of a snake, but we here have not. It is difficult to know a snake's voice. The monitor is like this too, and cannot be heard, but it is a powerful animal and it has a forked tongue, as well, which people feel is a *bizarrerie*. It goes on land and in the water, and so is above other animals.[33]

I was told that people in Gbakpo sometimes use monitor skin for drum heads; Mr. Tohoessou suggested that perhaps this is how the monitor finds its voice. Hearing the story of how the monitor "flew" when my dog spooked it, Mr. Tohoessou said that this, as well as the way it lives on both land and in water, is why the lizard is "above other animals." In other words, its oddity is a positive virtue.

The "flying" monitor may appear in other African arts. A Nuna mask from Burkina Faso portrays a ground hornbill surmounted by a reptile that has been identified as a crocodile, but because of its pointed snout, may be a monitor lizard.[34] The mask represents a bush spirit and would be danced at initiations, funerals, and for the health, prosperity, and moral strength of the village. The eyes of the hornbill look upward, as they do on other masks depicting the bird alone; but in this case, they seem to be looking at the lizard which is mounted on a pedestal attached to the back of the mask, in such a way that the monitor seems to be leaping over the top of the hornbill's head.[35] The combination of these two animals increases the expression of power, and it is conceivable that the mask plays additionally on an odd reversal of animal taxonomy, through the fact that the large hornbill bird is a ground-dweller, while the monitor appears to fly over its head. A monitor on a Yaka (Zaire) *mbala* initiation mask may depict the same sort of "flight," as the lizard seems to plummet down the cone-shaped, three-tiered headdress, that may represent a descent from the heavens to humanity.[36] A related message may be conveyed on a Dogon granary door in the Wunderman collection, upon which a monitor is carved in relief, its limbs decorated with

zigzags that suggest the plummeting celestial ark or granary, and the sinuous movement of rainwater on sun-parched earth.[37] Certain Senufo *dagu* headpieces (in Ivory Coast, Mali, Burkina Faso) that bear a stylistically similar monitor design, danced in transformative dramas of Poro Society rituals, may hold a comparable message.[38]

Monitor lizards find other meanings and purposes too. A Tabwa high-backed stool depicts one climbing up from the ground to support the leader whose seat of power this was. A hunting cult called *buyubwanga* or *mbuimang*—"the magic of the monitor lizard"—was once practiced by Luba, Tabwa, and Mbote hunter-gatherers living in the hills among them, and perhaps by some Hemba and other groups north of the Lukuga River.[39] For this, an unfired clay figure is prepared, roughly in the shape of a monitor, although Luba ones illustrated by W. F. P. Burton have a mask-like human face depicted wearing a headdress of the sort worn by possession-cult adepts.[40] The figure was given blood offerings to protect the village and bring success in the hunt. In the mid-1970s, I watched Abunamboka, an Mbote headman, make a much smaller version of a monitor lizard from clay taken from termitaries. The creation was his response to a long stretch of failure to catch any game, made even more embarrassing by his responsibility to provide me with hospitality.[41] The monitor is an emblem for the Tabwa clan that uses the bushpig for the same purposes. One can assume that they, like the Aja of Bénin, deem the lizard "above" other animals because of its curious—if not anomalous—being and behavior.

Crocodiles are peculiar for some of the same reasons. Tabwa argue endlessly about whether a crocodile is an animal (legs, lives out of water) or a fish

(scales, lives in water), and some even jokingly throw in that it might be a bird because it is egg-laying. Crocs are dangerous characters, and even in lakes and waterways where one *thinks* they are not to be found, there is always the possibility that a crocodile is lurking in the weeds, waiting for your foot! I used to bathe in Lake Tanganyika at the foot of the bluff below my house, until the day that I noticed a fourteen-foot crocodile lolling in the waves, just where I liked to swim. Thereafter, I lugged a bucket up the hill.

Tabwa call crocodiles "lions of the water," and for good reason. Like lions (discussed in the epilogue), their behavior is marked by intermittence: they seem so docile, lazy, and lifeless. Watching a treasured dog get snatched under water, right where women come to wash clothes, will change one's opinion in a hurry. The protean nature of crocodiles, at once land and water animals, "docile" yet vicious, lends itself to a sense that they must be able to change their form in other ways. A Dogon (Mali) iron figure in the Wunderman collection captures this sentiment, as it portrays the instant of metamorphosis of a Nommo primordial being, bending over to become a crocodile.[42] A pair of Gelede masks from Nigeria bear crocodiles above the usual female face, suggesting women's dangerous powers of witchcraft. Crocodiles are sometimes Yoruba witches' familiars, and Shango, the dangerous god of thunder, is so intimately associated with the animal that some Yoruba keep live crocodiles to protect their households from lightning.[43]

Crocodiles are also creatures associated with sacred rule, and for the Edo kings of Benin (Nigeria), they are associated with Olokun, son of the Creator God Osanobua, who is a spiritual "pillar" of the monarchy. The king could "send" crocodiles to punish those who would thwart his intentions, and people might shift their shapes to crocodiles to do this, as well. Stories of the gods and of the passage of souls across the waters also imply taking the form of crocodiles as an "intermediary state" between that which is and is not fully human.[44] Many Benin plaques, carved tusks, pieces of warriors' equipment, and other objects are decorated with images of the whole crocodile or just its head, as it lurks on the surface of the water, waiting for the foolish misstep of its next meal. Dogon crocodile masks from Mali, such as one at the Virginia Museum of Fine Arts, or Kalabari Ijo ones from Nigeria, presenting the crocodile as a water spirit that is "half-human and half-animal,"[45] are among the many objects inspired by the animal's sudden, deadly voracity. To bring harmony to local-level politics, they may suggest the menace reflected in a Lega aphorism: "who does not stop arguing will quarrel with what has the mouth widely distended."[46] The Fante of Ghana give the metaphor a taunting twist on their Asafo battle flags: "fish grow fat for the benefit of the crocodile."[47]

Obdurate Sentinels

A far more benign subject of African art, but one that is not a bit less singular, is the hornbill.[48] Although there are a number of species, several of which are very common throughout the continent, it is the

Lizard motifs on rock shelter wall, for Dogon boys' initiation, Songo, Mali. Photo: Allen F. Roberts/ Mary Kujawski Roberts, 1986.

(LEFT TO RIGHT) Mbote elder, Abunamboka, making a clay figure of a Nile monitor lizard for his Mbuymang spirit shrine to bring hunting success, Zaire. Mbote boys leave duiker carcass at Abunamboka's shrine, then butcher it to honor the Nile monitor lizard spirit after successful hunt, Zaire. Photo: Allen F. Roberts/Christoher D. Roberts, 1976.

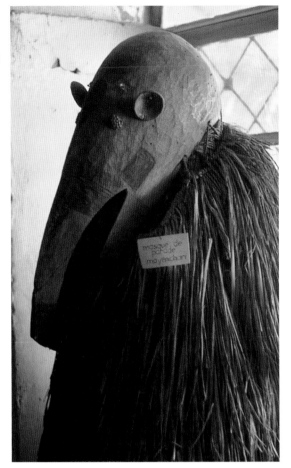

Sara hornbill mask from Moyen-Chari, one of the few objects left when the Chadian National Museum (N'Djamena) was sacked by the Libyans in 1984, with permission. Photo: Allen F. Roberts, 1985.

ground hornbill that is usually the subject of African art.

The ground hornbill (*Bucorvus leadbeateri*) stands anywhere from three to four feet tall. Its black plumage includes white primary feathers seen only when the bird is in flight, and it has a heavy bill surmounted by a "casque-like structure on the culmen" or upper ridge. It has oddly large eyes and an unfeathered, bright crimson face, throat, and wattle.[49] Hornbills are said to demonstrate remarkable diligence and intelligence in hunting, for they will follow a band of monkeys or other animals, catching insects and little creatures they disturb.[50]

There is something bizarrely human about the ground hornbill as it strides about open woods, and stranger still when it utters its uncanny "deep lion-like grunts" that can be heard over great distances.[51] Once, while walking through a remote area of open woods in a southeastern Zairian game reserve, I heard the spooky call somewhere nearby and wondered what sort of beast was watching me, and from what proximity! Adepts of certain initiatory societies imitate these cries with a bullroarer, as a central mystery. The same sounds may suggest the leopard's growl, increasing the insecurity of those who hear it as members of the performers' unknowing audience.[52] During certain funerals among Bobo people of Burkina Faso, the hornbill's grunts are also replicated by a bullroarer, while a nude dancer wearing a horn-

bill mask imitates the bird's odd gait in a drama re-creating both the origin and finality of death.[53] Among Mano of Liberia, a hornbill mask may be danced during Poro Society rituals, as a manifestation of "the spiritual forces behind this brotherhood and ... guardians of its deepest secrets." One such mask illustrated by René Bravmann has Koranic verses and Cabbalistic signs inscribed upon its inside surface that denounce and actively curse treachery; "whatever else is expected of this Poro mask, it surely stands as an obdurate sentinel ever ready to defend the organization and its members against treason."[54]

Ground hornbills and/or related species are also an emblem of religious societies often called Mungonge among Pende and other Lunda-related peoples of Zaire, Angola, and Zambia.[55] "Mungonge" is the name of the bird itself in a number of central Bantu languages, and an entire bestiary comes into play through the rituals and performances of the society. As masked dancers on stilts perform the actions of Mungonge, these birds and animals bring strength to emotionally and physically difficult circumstances such as funerals and the hunt, and Pende refer to such beasts as "animals with eyes of night."[56] Luc de Heusch describes the way that the society enacts the tensions and confrontations spelled out in cosmology, as initiands to Mungonge are brought into circles of knowledge that prepare them to cope with the contradictions of everyday social life.

Some of the best known sculptures of hornbills are made by Senufo people of Ivory Coast, Mali, and Burkina Faso. Hornbills are one of the the the first five living animal species, and the first killed for food; the bird's frequent use in Senufo art suggests "the continuity of the whole community or 'the constituent elements of the collectivity.'"[57] Large hornbill figures called "birds of Poro" (*pohdjo sedjihin*) are carried as headpieces by dancers,[58] and may be immense, heavy wooden affairs, standing five or six feet above the performer's head (cat. no. 39). The curving beak is said to be phallic, and the bulging belly to reflect human pregnancy; such a "bold synthesis of forms" stands for the dialectics of gender. Less obviously, the ground hornbill stands for the convergence of physical and intellectual powers: "fecundity and increase" on the one hand, and the "knowledge and skills" necessary to reproduce society on the other. The outspread wings are often decorated with geometrical patterns[59] that are didactic symbols for monitor lizards, pythons, and tortoises, used to teach initiates the esoterica of Poro as, through ritual performance, the "living forces of the universe" are enacted.[60] A name associated with the figures is *Gahariga*, which Senufo say is "master among birds." They stress the intellectual acuity of

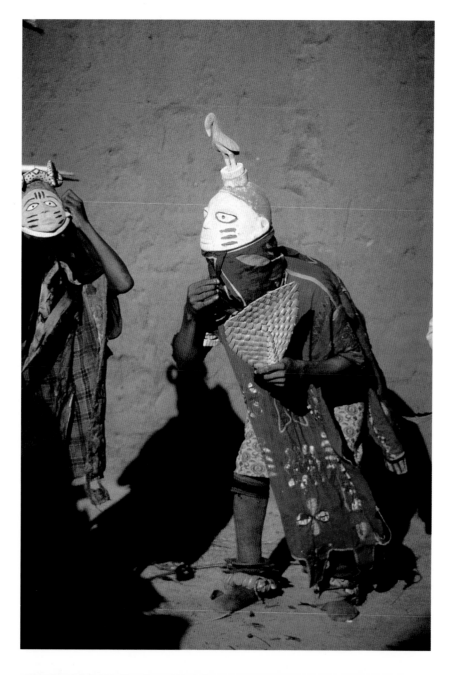

the bird, and by extension metaphorically, those associated with it.[61]

Echoes of the ground hornbill are found in other Senufo objects, such as helmet masks (*kponyugu*) danced by Poro members at important funerals; or as elements of *kpeli-yëhë* masks portraying the essence of a beautiful woman, danced in commemorative funerals for blacksmiths.[62] In these last, added reference may be made to the odd nesting habits of many hornbills: a nest is built inside a hollow tree, and the female literally walls herself up inside it using mud, resins, and saliva, to be fed by the male who passes insects to her through the tiny opening left open to the outside world.[63] Tabwa allude to this trait when they take a *kizimba* activating agent from a hornbill and use it to protect a pregnant woman from miscarriage, through the synecdochic reduction of magic. A Bemba woman in a polygamous household may put the same hornbill *kizimba* in her husband's food, so that he will be "closed up," and thus sleep with her and not his other wives.[64]

The head and beak of hornbills are alluded to in many other sorts of objects, such as hook-shaped diviners' wands made by Bwa, Bobo, Lobi, and other peoples of Burkina Faso. The bird is felt to have "great magical power"[65] and its uncanny qualities most likely provide a link to the other world that is useful when diviners seek spiritual inspiration. In a related play upon the arcane, Mossi of Burkina Faso carve standing figures of hornbills that suggest a chief's "knowledge of secrets and hidden things."[66] Dried hornbill heads are fitted to caps and worn in boys' initiation ceremonies among Tupuri people of Chad; similar headdresses made by Hausa (Nigeria) are often said to be "hunters' decoys,"[67] and in Mali, wooden carvings of hornbill heads worn the same way by Bamana people refer to the way this "wisest of birds" can control the rains.[68] Heddle pulleys made by Senufo and related peoples often imitate the crook of the hornbill's beak as the hook by which they are attached to the loom.[69]

The Owl's Scowl

If people are ambivalent about hornbills, they are less so about owls. Ranging in size from the tiny Scops

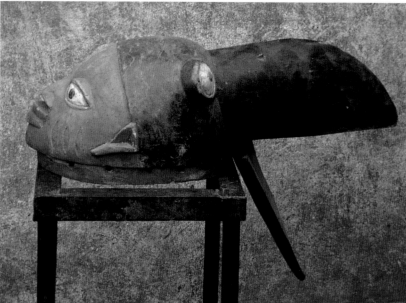

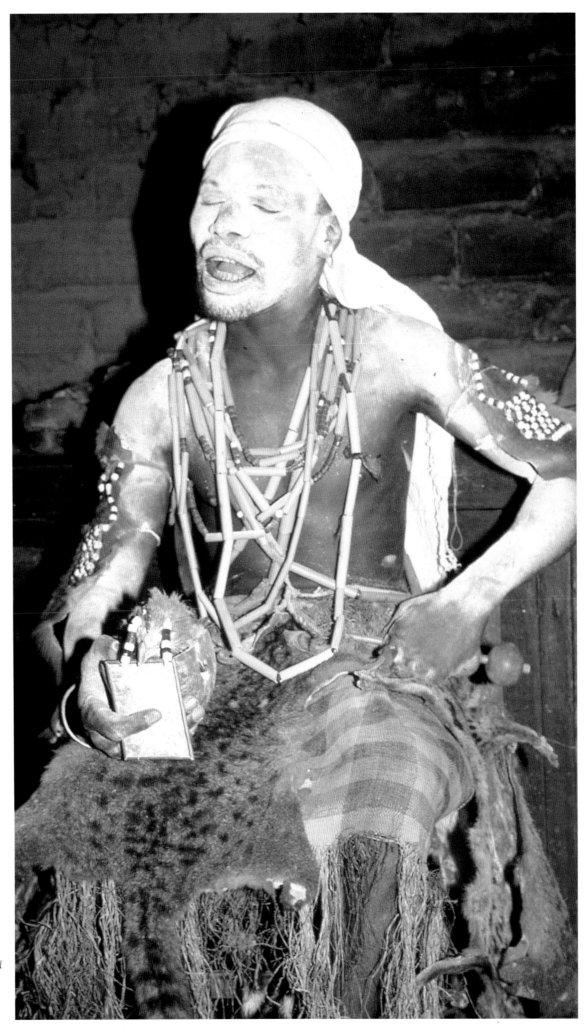

*(TOP RIGHT) Aja/Nago/Yoruba
assanyin tomb ornaments in
market display, showing bird-of-
the-night or bird-of-the-mind,
Ajara, Bénin. Photo: Allen F.
Roberts, 1994.*

*(TOP LEFT) Gelede bird mask
danced near Porto-Novo, Bénin.
Photo: Allen F. Roberts/Mary
Kujawski Roberts, 1987.*

*(BOTTOM LEFT) Gelede
mask, bird-of-the-night Janus with
articulated beak, Cové, Bénin.
Photo: Allen F. Roberts, 1994.*

*Luba spirit medium using owl head
in divination as bird of prophesy
that sees sorcery, Zaire. Photo:
Mary Nooter Roberts, 1990.*

Two inverted clay pots painted with white kaolin, black ash, and pulverized camwood with representations of an owl, a female figure, and the moon, images associated with mystery, female menstruation, supernatural power, and witchcraft, among the Mbamga and Mambilla of northern Nigeria. The hooting owl forebodes evil, i.e. the death of prominent persons. To hear the soft flight sounds of an owl striking its prey and the death cry of the victim are tabooed topics of conversation. Photo: Gilbert D. Schneider, 1960.

owl (*Otus scops*) standing only six or seven inches tall, to the huge Verreaux's eagle owl (*Bubo lacteus*) at over two feet, owls haunt African nights. Their "mournful hooting"[70] raises goosebumps for its portentousness, as an owl's nocturnal habits and uncanny eyesight are almost always associated with death, and, very frequently, with the heinous devices of witchcraft and sorcery. Indeed, the Tabwa and Bemba name for owl is *fwifwi*,[71] from the Bantu verb "to die" (*kufwa*). Given these dire associations, it is no surprise that the clandestine killers who protect President Mobutu's interests are called "the Owls"; nor, given what people universally seem to think of politicians, that a fifteenth-century English collective term of venery is a "parliament of owls!"[72]

Badyaranké people of Senegal, Guinea, and Guinea Bissau "believe that misfortune is the unavoidable consequence of human collision with the nocturnal world," and that most illnesses and accidents are caused by witches, who eat people's souls. If a village is visited by an owl at night, a witch must be on the prowl, and someone is likely to die. Witches invert normal social and physical behavior; "they defy physical constraints, they contradict basic categories . . . and they act in ways that men should not act," but do anyway, all the time.[73] Banyang people of Cameroon also fear the owl, for it is said to be the "'leader of the were-animals'" that eats the flesh of children. When an autopsy finds blood clots in the heart, it is known that the deceased has trafficked in the maleficent world, for these are the vestiges of the individuals consumed by the were-owl's "owner."[74]

Owls occasionally appear in African visual arts. *'Alunga* masks made by Bembe people of Zaire are associated with owls,[75] and it is quite likely that the huge, white-ringed, deeply set eyes of these and other masks and figures representing "bush spirits" refer to or are those of the owl (cat. no. 112).[76] *'Alunga* masks were danced to assert authority in circumstances requiring solidarity and cooperation, for the *'alunga* spirit "has a destructive power" that can be activated or placated.[77] Contemporary eastern Luba make an owl mask that is "male" and "very fierce" (*méchant*). If someone laughs as it is danced in a village, the person's mouth will remain wide open until a goat is given to beg pardon.[78] Among Mambila of Cameroon, owls are associated with women's "spirituality and the pollution" of menstruation. Figures portraying wide-eyed owls are made from inverted, broken pots, one painted in red, white, and black as the head, the other as the torso of the owl. Women are the potters of Mambila society, and two large white circles on the lower pot—echoing those of the eyes on the upper one—are breasts. The sculptures are put under the storage places of ritual materials, presumably to keep them free from female influence.[79] The dried heads of owls are kept in some Luba diviners' baskets, too, as "the bird of prophesy" that increases perception and assists in seeing sorcerers who pass invisibly in the obscurity of everyday life. Owls "mourn" as they hoot, announcing someone's demise; they fly at dusk and in tenebrous night, guided by their giant, luminous eyes which Badyaranké say are reminiscent of people's.[80] Like the next animals to be considered, owls are just *too* human for anyone's good.

Too Human for Comfort

Chimpanzees once lived in two broad areas of tropical Africa, from the Casamance in Senegal through the southward bend of West Africa to Ivory Coast, and from southeastern Nigeria down and across to the Congo and the forests between the Central African Republic and Zaire. Smaller, isolated populations were/are to be found across West Africa and either side of Lake Tanganyika, in Zaire and Tanzania.[81] African peoples living within their range rarely represent them in art—perhaps, as Tabwa say, because chimpanzees are better ignored and avoided as too human for comfort. Chimps do live in the montane forests of peaks in Tabwa lands, but hunters and others take pains to keep away. Tabwa recount misadventures with chimps (that overlap with Yeti-like stories of even larger ape-beings), and in particular, say that women are at risk of being raped and kidnapped by them.[82] Hemba people living in southeastern Zaire just northwest of Tabwa share some of these same misgivings.

Hemba make chimpanzee masks called *mwisi gwa so'o*, which Pamela and Thomas Blakely explain as a "spirit-invested object of the chimpanzee-human" (cat. no. 69).[83] Such masks are well known from Western museum collections, and Western viewers are likely to find their clownishly broad grins comical, especially when several masks of the same genre are shown together.[84] Hemba apparently feel the opposite emotion, for the "terrifying 'mouth'" is by no means a "smile," but rather "an inappropriately stretching, gaping opening."[85] The facial expression is antithetical to how calm and cool Hemba wish to present themselves, and instead, the combination of open mouth and raised eyebrows in the *so'o* mask is not only impolite, it suggests "drunken anger," insanity, or "having just seen an apparition."[86]

So'o masks may be kept inside houses as protective devices that also assist human fertility,[87] and that of crops. But the *so'o* "chimpanzee-human" masker is a frightening forest creature; therefore a safe place to which to escape is a garden or field.[88] One of the principal contexts of *so'o* performance, however, is during funerals. The masker scatters mourners with a wildly active dance, and mocks human convention: "anomalous, category-confusing characteristics of the *so'o* parallel Hemba conceptions of the afterworld, where categories of things that are clearly distinct in the world of the living become muddled and mixed." It is the "awful reality of death" that is expressed by "the mask's grotesquely open mouth;" and the Blakelys note that Hemba take great care to bind shut the mouths of the deceased "to keep the dead from talking," and the "'soul-essence'" from escaping prematurely. In the *danse macabre* of the *so'o*, death is given a leering face.[89]

Dan people of Liberia also make chimpanzee masks, which are blockish and crude in contrast to the smooth, even-featured masks usually associated with Dan æsthetics. Such masks are performed to instruct young people in proper behavior through the maskers' hilariously improper acts. Chimps represent uninitiated and antisocial members of the community. The dancer carries a bundle of hooked sticks which he throws, or uses to catch people in the audience and thrash them if he can.[90] As he rushes about, knocking things over and making a mess, he demonstrates the destructive behavior of those who are not cooperative or who are uninitiated to community responsibilities,[91] in what is no doubt a hilarious bit of

Monkey or chimpanzee skull over Dioula door, Casamance, Senegal. Photo: Allen F. Roberts/Mary Nooter Roberts, 1994.

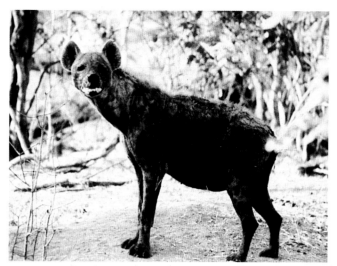

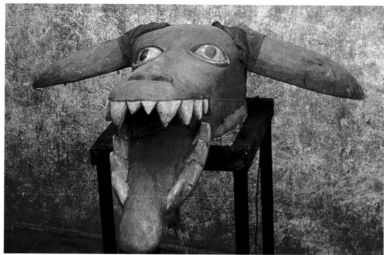

(LEFT) *Spotted hyena, Zimbabwe game park. Photo: Manuel Jordân, 1992.*

(RIGHT) *Gelede hyena mask seen at Cové, Bénin. Photo: Allen F. Roberts, 1994.*

theater, for all but those whose clean clothes have been trampled!

The same sense of unrestrained chimpanzee behavior may be reversed by other African groups. René Bravmann illustrates a nineteenth-century charm made from a chimpanzee skull, inscribed with a checkerboard of numerals and Arabic inscriptions by Mandingo people of Liberia or an adjacent country, perhaps to protect a house from witchcraft.[92] If this was the object's purpose, one can suppose that "God's secrets" were given direction and thrust by the paradoxes of the chimpanzee's almost- human inverted-human behavior.

Gorillas are also represented in African art, but only rarely, undoubtedly in large part because their range is limited to the most remote lowland forests of Equatorial Guinea, Gabon, Cameroon, Congo, and Central African Republic, and the mountain highlands of Zaire, Rwanda, and Uganda. The animals have always been few in number and live in small, dispersed bands; and of course in our days their numbers have dwindled distressingly. Still, gorilla masks once made by Kwele of the Gabon/Congo border region, and others that are being danced nowadays in certain Yoruba (Nigeria) Gelede performances, are of interest as examples of how imagery depicting an animal that is shockingly "human" can be put to political use in a manner different from what we have seen in the representation of chimpanzees.

Kwele live in small hamlets carved from very dense rainforests. In this they are rather like their Fang neighbors as described by Fernandez (1982); but if anything, the Kwele part of the forest is even less easily penetrated and conquered. As Leon Siroto has written, precolonial Kwele leadership was "diffuse and transitory," and war leaders, called *begen*, often used their bravado and martial skills to manipulate community affairs. Lineages contended with each other for status and wealth, with *begen* at the forefront. Among the strategies of the *begen* was a rela-

tively peaceful contest, through which people might "fight with art."[93] Performing with masks called *gon* that represent stylized gorilla skulls was one such device.

The *gon* dance was violent. As he entered a village clothed only in a mongoose-skin loincloth, his body blackened with soot, a *gon* performer waved short spears and threatened all he encountered.[94] Any domestic animals would be speared, and occasionally people might be struck as well. The purpose was intimidation, and through the performance, one lineage would be forced to become the submissive clients of another. Open conflict was usually avoided. One just does not mess with a "gorilla."

This Kwele example suggests how art is used to manipulate individuals and factions. Such a strategy may meet the contingencies of certain circumstances but not others, for sooner or later, any metaphor is likely to become what Fernandez calls a "vitiated abstraction" and will be abandoned in favor of one deemed more appropriate.[95] Art is forever on the move. One case in point is that of Yoruba Gelede masks representing gorillas, illustrated by Margaret and Henry Drewal.[96] Instead of the usual placid female face surmounted by an active tier of figurative sculpture, the gorilla mask is a large structure made from a hollowed-out tree trunk that fits like a sheath over the head and torso of the performer, who peeks out of slits cut into the trunk. The head of the "gorilla" sits on the dancer's head, and its enormously long arms reach out to either side, threatening to seize people in the audience. The gorilla is said to be associated with Odua, the Earth Goddess, and the mask is performed in a theater of opposing forces and factions, perhaps to make a statement about the power of women, or to mock a rival Gelede society. What is most interesting, however, is how highly unlikely it is that any Yoruba have seen a gorilla, except in books, movies, or perhaps at a zoo. Instead, it is the idea that matters the most, and that has

brought an animal image foreign to Yoruba into their *dramatis personnæ*. One of the masks the Drewals illustrate wears a necklace and bracelet and has bared, pendulous breasts; the imagery is utterly contemporary. Whatever the particular sense of the mask, it is not difficult to imagine the delighted shrieks as the dancer runs toward a crowd!

All Too Familiar

Several of the animals mentioned so far are known or suspected to be vehicles for shape-shifting: crocodiles are one such beast, dogs are another.[97] In some of the societies we have discussed, people may become were-crocodiles, and as such attack their adversaries; in others, dogs may become people, to achieve their lusty goal of coupling with women. One of the most common culprits of this sort is the spotted hyena, a singular beast that is portrayed in many forms of African art, but especially as masks through which people can "become" hyenas to play dramatic roles that usually run counter to social harmony or the tenets of human civilization.

The spotted hyena (*Crocuta crocuta*) is a peculiar animal if ever there was one.[98] It has an odd posture and gait, with front legs longer than the back ones; its "grotesque and somewhat humanoid calls [have been] described by some writers as 'demonic'"; it "pastes" an odoriferous substance from anal glands to mark its territory; and it chews up and digests bones left as refuse by other predators, so that its droppings may be white from calcium[99] and "hot," as Tabwa say. A skulk of spotted hyenas may clean up after other animals, but they are terribly ferocious predators as well.[100] They sometimes invade villages, and their favorite morsel may be what was once your favorite dog. When I first got to my Peace Corps assignment in Baïbokoum, Chad, hyenas had a habit of visiting the town during the night, and I heard one outside my yard on the very first night I spent by myself in my house. It did not help matters to have my landlord recount how hyenas sometimes sneak up and bite off someone's face while they sleep!

What is most unusual about the spotted hyena, however, is its apparent lack of sexual dimorphism, suggesting hermaphroditism. Females have an elongated clitoris visually identical to a male's penis, and a sham scrotum as well; the clitoris becomes erect during the animal's greeting behavior, as does the male's penis,[101] and field zoologist Hans Kruuk admits that he can only distinguish between the sexes of adolescent hyenas through close anatomical inspection.[102] Observers as early as Aristotle commented upon this "bizarrerie," and the twelfth-century *Bestiary* noted that the spotted hyena's "nature is that at one moment it is masculine and at another moment feminine, and hence it is a dirty brute."[103]

These qualities, "unique among carnivorous mammals," are remarked and commented upon by Africans as well.[104]

Tabwa say that the spotted hyena brought the sun to heat the earth, which was until then cold and desolate,[105] and as a solar animal, they use its hair in some of their most powerful magic of sorcery. "Hyenas" of the Kazanzi anti-witchcraft society, which Tabwa share with Luba, see to the bloody business of executing sorcerers and other ne'er-do-wells, and then, again as "hyenas," exhume them to distribute their bones for use in magic. Among Giriama people of Kenya, Vaya witch-hunters are "hyenas" who operate on the edge of society; people are as ambivalent about their powers as they are about that of the necrophagous hyena, considered the vilest of beasts.[106] Senufo (Mali/Burkina Faso/Ivory Coast) dance with hyena masks during funerals—but also, it seems, in performances targeting the "soul-eaters" hiding in the community.[107] This, too, makes reference to the behavior of hyenas in nature, that wantonly disturb human graves. Like Tabwa, Dogon consider the hyena to be a "hot" animal, and the zoomorphic head of the *yo domolo* "robber's crook," used to steal a piece of the sun and so bring fire to earth, may be that of a hyena.[108]

For the Beng people of Ivory Coast, the hyena stands for "all that is immoral to humans, symbolizing a range of negative character traits from avarice to malice to stupidity" that may be comical, but also menacing. Hyenas and dogs seem to dance an odd duet of familiarity for Beng, and perhaps a touch too much of it. The hyena is a "night walker," a grave-robber, and dangerous in every way. If one finds a dead hyena in the bush and fails to plug its anus with a maize cob, the person making the discovery will be stricken with fits of laughter for the rest of his or her life, according to Alma Gottlieb.[109] In many parts of Africa, witches ride on hyenas, or use them as familiars. Indeed, for Kaguru of Tanzania, spotted hyenas are the "witches of the animal world," and human witches hug hyenas "by the belly as they race through the sky" on their maleficent errands.[110]

Hyena masks and other visual representations must bear some of these same references to inverted anatomy and behavior. Members of the Kore Society among Bamana (Mali) wear hyena masks in dramas filled with physical stress and painful trials (cat. no. 90). Initiation to Kore brings a Bamana man to complete moral formation, intellectual freedom, and spiritual harmony, reintegrating his maleness with the female principles that were abandoned when he was circumcised.[111] The hyena mask's role in this transformation must surely refer to the animal's seeming lack of sexual dimorphism, while referring to the "foolishness, incredulity and naïveté" of those Bamana who

have not reached Kore's inner circles of knowledge, or, perhaps, who fail to recognize the inevitably incomplete nature of their wisdom, when compared to God's.[112] Still, Kore is a triumph over death, if only for an ephemeral moment, and it celebrates "human perfectibility. Man is raised above material contingencies so that he may fully enjoy the pleasures offered by sovereign knowledge,"[113] and in this vital theatre, "hyenas" guard the secrets of Kore.

In Burkina Faso, Bwa hyena masks are danced in harvest festivals. Christopher Roy recounts how the first hyena mask was made to commemorate an incident of mystical encounter between a man and the animal. Hyena masks made by nearby Nuna are always danced separately, to suggest how people "despise it for its dirty habits;" while those made and performed by Nunuma have a snarling maw full of pointed teeth and their eyes are sometimes studded with red seeds to further emphasize the animal's nastiness (cat. no. 91).[114] During initiation rituals of Luvale and Chokwe of Zambia and Zaire, hyena dancers physically torment the neophytes, for they represent beings come back from the dead who bring the stark messages of life to bear on the transformation of boys into men.[115] Yoruba people in Bénin and Nigeria carve hyena masks for the Gelede Society that are frightening things: I saw one in Cové, Bénin with articulated ears that could flap and a toothy jaw that could snap. Stilted hyena masqueraders called koriko provide an important service during the nocturnal portion of Gelede performance, for they divert the crowd's attention and allow the important Oro Efe mask to return to the "mouth of authority," bringing a close to the evening's events. Interestingly, the koriko hyena masker is sometimes replaced by one representing the tricker Esu/Elegba, another master of the in-between.[116]

The Dance of Spirit-Elands

The eland is a far more benign animal, and both a source of human sustenance and, especially for Bushmen of southern Africa, an important vehicle for thought and accomplishment.[117] Giant and Cape elands (Taurotragus derbianus and T. oryx, respectively) once had a wide range across west and central/southern Africa; nowadays they are soon to be extinct from many places where they once roamed, due to over-hunting, habitat reduction, and rinderpest epizootic. Each is "a very large antelope, with ox-like massiveness and 'bovine' appearance," that gregariously gathers in herds of a few to many dozens, to browse on leaves and grass. Elands have an odd ability to leap up to eight feet in the air from a standstill, highly surprising in such a ponderous animal. They are "exceedingly shy," demonstrate a remarkable "lack of aggressiveness," are readily tamed, and

have been semi-domesticated in southern Africa.[118]

The great cow-like Cape eland is a subject of some of the most renowned rock art of southern Africa—paintings and etchings that may be centuries or many millennia in age. David Lewis-Williams and Thomas Dowson offer a pathbreaking reinterpretation of these, in a radical departure from the simplistic explanation that the art works were created through "sympathetic magic" to somehow control, and therefore more easily slaughter, the animals depicted.[119] Instead, they combine ethnoarchæological and neuropsychological research to suggest that the twentieth-century religious practices of Bushmen, and especially those associated with trance and shamanistic healing, may inform an understanding of the ancient petroglyphs.

The eland is nearly as important to Bushmen as cattle are to Nuer. Praying Mantis, the Supreme Being, created the eland before all other animals, and it remains God's favorite among beasts. This sacred relationship is affirmed through ritual. A boy's initiation to manhood includes killing his first eland. The boy is seated on the skin, scarified, and the animal's fat rubbed into the wounds to "create a new hunter." Other aspects of the ritual may explain some theriomorphic rock paintings, such as one showing a half human/half eland, surrounded by hoofprints like those made around the boy seated on his first eland pelt, undergoing his social and spiritual transformation. The eland is also a dominant symbol of girls' puberty rituals. In a girl's honor, women perform the Bull Eland Dance, which simulates elands mating; and the girl is metaphorically associated with the animal's fat, which a man will later give to his future mother-in-law to gain a girl's hand. A praise name for eland is "dance," because of the importance of these activities and contexts.

It is through shamanism that elands become most cognitively significant for Bushmen.[120] Male and female shamans heal illness of the physical sort, but they also heal social illness such as when something in the relationship between humans and divinity has become inharmonious; and, as a result, hunting or other critical pursuits fail, or accidents happen. Illness may be caused by malevolent shamans, shooting the "arrows of sickness" at a victim. Some rock paintings appear to portray the complexities of shamanistic healing, showing dancing, the fending off of medicine arrows, and various degrees of trance as blood flows from the noses of the shamans (like those of wounded elands). It is when this latter state is depicted that the paintings are their most remarkable.

Trance is an ineffable state of altered consciousness—that is, it cannot be put into words easily, if at all. Bushman rock-art depiction of trance is of Einsteinian brilliance. Some images are of the

"death" shamans experience as they cross to the other world. One shows a dying eland lowering its head, just before sagging to its knees; around it are four shamans who have been transformed by trance to share attributes of the dying eland. The multi-dimensional reality of Bushmen includes such experience, rather than sequestering it in categories of the non-rational like dream or hallucination, as would be done in the West. The eland is like a shaman and vice-versa, but the metaphorical bridge between the two is real, not imagined: shamans become elands, elands can be shamans. As elands, shamans may fight other shamans to win the life-battles of their people; or they may interact with the rain, a fierce bull animal that can assume various shapes.

Aside from the results of trance, seen in the fruition of such interactions in healing or rain-making, the experience of trance itself follows a course that is also depicted in rock art. Basing their thesis on neurological research that probably holds true for all human societies, Lewis-Williams and Thomas identify three stages of dissociation, each with its sensations and artistic representation. The first is characterized by seeing "entoptics"—luminous pinpoints, zigzags, and other patterns. The frequency and intensity of these increase as the mind loses direct control; on the conscious level, such release may cause panic, while at the neurological one, the brain seeks to make sense of the visions through the second-stage phenomenon called "construals." Something that looks like X must be an X. In stage three, memory takes over and gives elaborated, narrative form to the sensory experience. In Apostolic and other Charismatic churches across the United States, the swoon into deep trance is exegetically situated as "receiving the Holy Spirit;" for Bushmen, it is to become an eland or one of several other spirit-animals.

Lewis-Williams and Dowson illustrate a number of paintings that show the transformation of the shaman into an eland, through these three stages. To my mind, the most remarkable imagery from the first two steps of trance experience, however, depict giraffes.[121] At one site near Kamanjab in Namibia and another in Driekopseiland, South Africa, shaman-artists have engraved a rock surface with entoptic patterns of loosely fused, irregular circles. The Kamanjab etching includes several smaller clusters and then a much larger one with two lobes, between which a giraffe is outlined, "its body marking echoing the grids. An entoptically experienced grid seems to have reminded the artist of a giraffe." At Driekopseiland, the thought process seems even more obvious, for the grid flows into what becomes the spots and shape of a giraffe—as though part-way through the etching, the artist's memory took control and imposed sense on the flashingly luminous, dancing patterns he was seeing. The mind was shifting to see, and then become, an animal.

All is real and verges on banality;
all is unreal and verges—on what?
Octavio Paz, 1973

Beyond the Pale

Ng'ombo divination basket showing
aardvark claw among sculptures
and other objects, near Kabompo,
Zambia. Photo: Manuel Jordân,
1993.

I f our last chapter took us out to the edge of knowledge and understanding, this one

takes us "beyond the pale." The phrase derives from an old English expression

originally connoting "the medieval dominions of the English in Ireland." It refers

literally to whatever is encountered on the other side of secure familiarity and,

figuratively, to that which is "irrevocably unacceptable or unreasonable"—such as

the behavior of Irish people, from a less-than-generous medieval English viewpoint.[1]

African systems of thought define a "pale," as we have described the

organization of social and physical space, outward from home to the edge of the

known. Beyond the pale, imagination reigns. Some animals incarnate the pale

itself, as threshold beings incorporating physical parts and behavioral attributes of

other animals in a preposterous pastiche,[2] marvelous and sometimes terrifying.

Surrealist writing and art of the 1930s favored pastiche and valued "fragments,

curious collections, [and] unexpected juxtapositions" so as to "provoke

manifestations of extraordinary realities" through "sensual derangements," the

"instability of appearances," "analytic decomposition of reality," and "aggressive

incongruity."[3] For Africans, as for Surrealists, the ironies of pastiche lead to a

consideration of the marvelous.

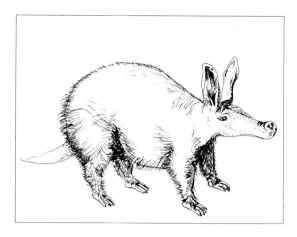

Africans have their own words for "marvelous." Tabwa, speaking a mix of Swahili and their own dialect, refer to the astonishment of the marvelous as *ajabu* (a word derived from Arabic), while a "thing of wonder" is a *mwigiza*, a term referring to the blackness of night.[4] The symbolic sense of "black" is arcane potential, and as the "eldest of things," "sable-vested night" (to borrow from Milton) both conceals and reveals the most elemental and awesome of creatures.[5] As William Murphy tells us, Mende people of Sierra Leone use the word *kabânde* "to express appreciation for the mystery and wonder" of that which is deemed extraordinary.[6] Things, phenomena, and beings which are *ajabu* or *kabânde* are out there, beyond the pale; but as the Surrealist author Pierre Mabille wrote, the marvelous is also everywhere around us, penetrating every corner of our existence, and most especially "between things, between beings, in that space in which our senses perceive nothing directly but which is filled to overflowing with energies, oceans, [and] forces ceaselessly in motion; where ephemeral equilibria are elaborated, [and] all transformations take form."[7] In other words, in "the coupling of two realities, irreconcilable in appearance, upon a plane which apparently does not suit them,"[8] one is bound to encounter that which is *ajabu* or *kabânde*. Such insight returns us to the question of what religion is in the first place.

"He who would know must first believe," Clifford Geertz has observed.[9] The extension of belief begins outward, from what people know about themselves, and implies a dialectic of this world and some other, beyond the pale of humanity. As Edmund Leach suggests, this might mean that "the category 'god' is thus constructed as the binary antithesis of man. But this is inconvenient. A remote god in another world may be logically sensible, but it is emotionally unsatisfying." Instead,

> to be useful, gods must be near at hand, so religion sets about reconstructing a continuum between this world and the other world. But note how it is done. The gap between the two logically distinct categories, this world/other world, ... is bridged by supernatural beings of a highly ambiguous kind—incarnate deities, virgin mothers, supernatural monsters which are half man/half beast. These marginal, ambiguous creatures are specifically credited with the power of mediating between gods and men.[10]

"Mankind cannot remain indifferent to its monsters," wrote Georges Bataille.[11] It is to just such pastiche-creatures that we shall turn, for they are interpreted from nature or "manufactured [through culture] precisely to teach [people] to distinguish between the different factors of reality, as it is conceived in their culture." Through such marvelous beings—whether found in nature or created by culture—people are startled into thinking about how the world does work, as well as how it might.[12]

The Wonders of Nature

Nature is full of oddities, some so strange that it is hard to imagine that they really do exist at all. It was not until just after 1900, for instance, that the okapi (*Okapia johnstoni*) was described in scientific literature.[13] Even then, the existence of this "very peculiar," "extremely wary" animal from the deepest rainforest of what is now Zaire seemed hard to believe, with its "sloping back like the giraffe" (to which the animal is indeed related), "ill-defined mane," and mix of striped legs and "dark chestnut, almost purplish black" body.[14] Naturalists scrambled to obtain specimens for their museums, and at the same time, the West learned a great deal about African people living in the more remote parts of the continent, who had long known all about okapis.[15] Even when told of what is a real animal, it is sometimes hard to accept what one is told: Mary Douglas recounts that when Lele people of Zaire first told her of the pangolin, she assumed that it was mythical because she had never heard of such a bizarre creature —Lele must be making it up.[16]

Tabwa people told me of a "blood-red, wrinkled" animal that looks rather like a human fetus. Like Douglas, I assumed my friends must be describing a mythical animal, but now that naked mole rats (*Heterocephalus glaber*) have come to scientific attention,[17] I wonder if these are not the creatures in question. Naked mole rats are "neither moles nor rats," and may be "more peculiar perhaps than any other [mammal] on earth. More peculiar, in fact, than the wild imaginings of Maurice Sendak or the conjurers of other-worldly visitors." Naked rats are "fetal-looking" and live in "insectlike" eusocial colonies of a fecund queen and non-reproducing worker.[18] If a naked mole rat exists, then perhaps the fabled "Nandi

bear," *Mngwa* "the Strange One," "Kongamato, the last flying dragon," Mokele-Mbembe, "the last living dinosaur," and other African "not-Yetis" will someday prove real, as well.[19]

Here are several animals that do exist, that are as odd as any on earth. But even as they *are* odd, they are so peculiarly human in some of their attributes or behavior that they instigate thought. They are so very absurd that they antagonize one's rationality. These last verbs are important, for funny little animals like aardvarks, pangolins, and a few others that are so innocuous in their habits, nonetheless challenge any sense that nature is reasonable, and threaten to undermine any security in one's sense of the order of things. Instead, as Georges Bataille points out, they are "freaks" of nature that, though defined by the eye of the beholder,

> provoke a positive impression of aggressive incongruity, a little comic, but much more a source of malaise. This malaise is, in an obscure way, tied to a profound seductiveness. And, if one can speak of a *dialectic of forms*, it is ... essential to take into account deviations for which nature—even if they are most often determined to be against nature—is incontestably responsible.[20]

As Susan Stewart suggests, "through the freak we derive an image of the normal; to know an age's [or a culture's] typical freaks is, in fact, to know its points of standardization."[21] And this is what makes such strange beasts so very "good to think."

Consider the Aardvark

Judging from Tabwa ethnography, the aardvark (*Orycteropus afer*) is flat-out preposterous—thus, according to Oxford English Dictionary, "monstrous, irrational, perverse, foolish, nonsensical" or "utterly absurd."[22] That is the aardvark, to a tee. Tabwa describe the aardvark as an odd assortment of other animals' parts: it has legs that are "thin like a goat's," ears that are "long like a rabbit's," a back that is humped and sparsely covered with reddish hair something like that of a bushpig, and a long snout and a tongue that is much longer still, with which it eats termites and ants. As for the aardvark's long and peniform snout, Tabwa men find it so fundamentally comical that before bringing one home they cut its snout into pieces, lest women see it and laugh, as mentioned in the introductory chapter. The genitalia of female aardvarks are treated in the same way, for it is said that they too closely resemble those of a woman. In this respect, according to Tabwa, the aardvark is similar to the zebra, an animal once (but no longer) found on the grassy plateaux of the Marungu

Massif in the center of Tabwaland.[23] Tabwa also say that, like a human being, the aardvark usually bears one offspring at a time and that it sleeps on its back, deep within its burrow.[24] The greatest Tabwa hunters of the old days are said to have entered aardvark tunnels to confront the beast in its own sanctum, and the contest was so fiercely fought that the hunter was not always the victor. In this and other accounts, it is clear that Tabwa identify with aardvarks.

The aardvark is unusual in many significant ways. Although not in the least a rare animal throughout sub-Saharan Africa, aardvarks are "almost blinded by daylight" and hardly ever seen.[25] As an early missionary among Zambian Tabwa wrote, "so sly are these curious sloths that many a native the wrong side of forty has lived his life without seeing one."[26] If the aardvark is rarely seen, its distinctive three-toed tracks are often found in the savanna grasslands and light forests of Africa. Its burrows, too, are frequently encountered. These may plunge abruptly and "endlessly" as Tabwa say, or they may wander in a "network of subterranean subtlety,"[27] surfacing repeatedly over a wide area.[28] The aardvark can dig into the soil so rapidly as to be out of sight when a pursuer approaches. Yet Tabwa say that aardvarks are occasionally "caught by sunrise" and quickly dig shallow holes where they hide their heads, leaving their hindquarters exposed to human hunters and other predators.

As if to underscore their reclusiveness, aardvarks carefully bury their droppings.[29] When I asked for an explanation of this, the rhetorical response was, "Isn't the aardvark a sorcerer?" Nzwiba, a renowned Tabwa shamanistic healer, triumphantly said that he *had* found aardvark scat, despite the animal's attempts to hide it, and that he uses it in magic to render one "invisible." To Tabwa, the aardvark is known as "a person of the night," *mutu wa busiku*, as much for its mystical powers as for its nocturnal habits.

The aardvark offers "numerous contradictory formal properties," and the resulting ambiguity is one of overdetermination. That is, the aardvark is so useful because it seems to present too much information. The aardvark's "contradictory formal properties"[30] include a "penis" in the wrong place, before rather than behind. The penile snout would not be so comical, though, if it looked like an aardvark penis. Instead, it is like a *human* one—even more disconcerting on a female aardvark, whose actual genitalia, though in the right place, are also alarmingly and amusingly "human." Such a monstrous juxtaposition makes especially evident the opposition of head and loins, hence intelligence and sexuality, maleness and femaleness.[31]

However preposterous, though, aardvarks *are* animals. They are "only human between quotation

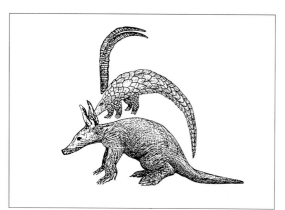

Drawings by Dominique Zahan from Les antelopes du soleil, showing relationship between Chiwara headdress and aardvark, pangolin, and antelopes in collage.

marks," in the words of Dan Sperber. Animals of this sort do not defy classification, as Mary Douglas once suggested, but they do "put in question the encyclopedic knowledge on which [classification] is founded." Sperber asserts that "the symbolic representation of animals does not have as its function to correct a taxonomic system that is [logically and by definition] adequate. On the contrary, one must know the world to desire it different," and this presupposes "a rational description to formulate a symbolic representation that modifies it."[32] The aardvark, for Tabwa, provides just such a possibility for contemplating both a rational description of natural and (by extension) social worlds, and the provocative possibility of modifying them.

It should come as no surprise that an aardvark is the protagonist of a Tabwa origin myth. As God first pronounces the aardvark's name, He sets in place the classifications, categories, oppositions, metaphors, and metonyms that Tabwa deem necessary to recognize and establish comprehension of an orderly universe. The Tabwa story is similar to that of the Dogon's celestial ark, discussed above, and to all genesis myths. Even as it establishes primordial order,

however, the aardvark also creates a place in human society for aardvark-like ambiguity, ambivalence, and absurdity. The aardvark paradoxically presents too much information (overdeterminacy) and not enough (indeterminacy). Aside from pure entertainment, such a story must stimulate reflection upon the puzzlements of Tabwa society and the universe around it.

Aardvarks appear in the visual and performative arts of a number of African groups. Seth, the ancient Egyptian god of chaos, was sometimes represented theranthropically, and over the years some have speculated that the animal in question is an aardvark.[33] The "maladroit" artistic representation of Seth that has made identification so difficult for Egyptologists may be due as much to the aardvark's "morphological ambiguity as to the Egyptians' imperfect knowledge of the animal."[34] An aardvark culture hero less destructive than the Egyptian Seth but equally enigmatic is said by some to have been responsible for the origin of the Mbudye Society, through which Luba people of Zaire dramatize the essence and anomalies of sacred rule. A like figure is occasionally inscribed as a pictograph on *lukasa* "memory boards," through which sacred tales are recounted.[35] Aardvarks also find a place in the bestiary of the Lega in Zaire, who carve little ivory figures to suggest aphorisms about the animal's relationship to its "senior," the pangolin, in the hierarchical contexts of the Bwami Society.[36] The aardvark can be a political creature, as well. Jean-Claude Muller compares Tabwa aardvark lore with that of Rukuba people of the Jos Plateau (Nigeria), and finds many of the same traits and associations in both systems of thought.[37] The Rukuba chief, considered an "aardvark" in a variety of narrative and performative contexts, is given the perplexing responsibility of maintaining a fragile social order based upon the animal's preposterously mediated oppositions.

It is among Bamana of Mali, however, that the aardvark finds its best-known visual representation in *chiwara* (*tyiwara*) crests worn by young men during harvest and other agrarian rituals and celebrations (cat. nos. 96, 97). The primary zoomorphic reference of *chiwara* is to the sweepingly curved horns of roan antelope (*Hippotragus leucophæus*) or the astoundingly long and straight ones of the oryx (*Oryx gazella*); but these are most often found in composite sculptures with either aardvarks or pangolins or both at the same time. As Dominique Zahan suggests in *Les antilopes du soleil*, his magnificent book on *chiwara*, Bamana consider some animals that dig and "cultivate" to be "human," and some humans who dig and cultivate to be animal. The aardvark (*tímbá*) and the pangolin are the two most important of such "animalhumans," while the young men wearing *chiwara*

crests, as "human-animals," learn how to scratch and scarify the earth, following the aardvark's bestial lessons. Men wear a piece of aardvark tail around their upper right arms, to bring the animal's strength to their agricultural endeavors, but also because the animal is said to know all the "seams and sutures" (*coutures*) of the earth.[38] One can guess that, as an overdetermined animal, the aardvark helps recognize, mediate, and realize the sorts of articulation as well as the resulting order that the word *couture* implies in French.

For Bamana, the earth is female, and cultivation is an almost-erotic penetration of the hoe into soil. The aardvark "animal-human" also scratches and digs the earth, and its phallic snout must reinforce this same sexual imagery, as it plunges into its tunnel. Indeed, *tímbá*, the Bamana word for aardvark, also refers to the "sheet of marriage" onto which the blood of a deflowered woman flows, that is then euphorically exhibited by older women dancing in a style called *tímbá*. The arched back of the aardvark suggests sexual positions, but also the tension of muscles needed for the hard labor of hand-hoe agriculture. Working the earth, the farmer makes something out of nothing, growing crops to feed his family. For this, he relies on his hoe, deemed an object of sorcery, which echoes the snout of the aardvark, a sorcerer in the animal world, archetypal master of transition and transformation.

In a great many *chiwara* headdresses, the lowest animal portrayed is the hump-backed aardvark, but often in an indeterminate form that may provoke reflection for those given to intellectual pursuit. Among the references that such a polythetic symbol encourages is that of sprouting sorghum (*Sorghum guineense*), an important grain staple for Bamana. Sorghum seeds germinate and send down a taproot in a manner reminiscent of the aardvark's muzzle penetrating the earth. *Chiwara* crests, then, and the dances and other performative forms that give them their dramatic context, tell their audiences a great many things about the early manhood of those wearing them. At one level a kind of "ostentatious display of virility," *chiwara* performance also bespeaks the fertile exuberance of youth, linked to that of the animal and plant life upon which Bamana depend and with which they identify so completely. Above all, however, the aardvark's preposterousness must tell audiences something important about what it means to be a young man, coming into form as the rigors of adult life begin.

The King of Beasts Is NOT the Lion

The pangolin (*Manis* spp.) is as bizarre as the aardvark but appears somewhat more frequently in African visual arts.[39] Pangolins have some of the same "human" traits as aardvarks, and according to our objective naturalists, pangolins are otherwise

> among the strangest mammals in the world. They are not unlike reptiles, having large, overlapping, armour-plated scales of dermic origin (resembling those of a pine cone [or artichoke]).... They are elongated in shape, with a small narrow, earless head. They have no teeth, but a long narrow protactile tongue, sticky with saliva, to which adhere the insects (termites, ants) on which they feed. These strong animals move very slowly, often walking on their hind legs (better developed than the forelegs) and using the tail as a counter balance.... They are able to roll themselves up into a ball with only the scales on the outside. This passive attitude is their only defense. However, the cutting action of the scales, worked by powerful muscles, can inflict serious wounds on an enemy getting its fingers or snout between them. The sense of sight is very limited, but ... smell, taste and hearing are very acute. They are solitary animals [and] young are born singly. The scales harden two days after birth. The mother carries its young at the base of its tail, and protects ... [it] by wrapping her body around.[40]

When Tabwa say that "the king of beasts is *not* the lion, but the pangolin," it is hard to think of a less likely candidate for the honor.

Across their wide range in Africa, pangolins provide metaphors important to many contexts of ritual, magic, and sacred rule. Until recently, Lele people of Zaire made the pangolin the subject of a fertility cult for those who had suffered but overcome barrenness. The cult invited its initiates to become aware of and confront the categories of their own culture, and to recognize them for the arbitrary creations that they are. In other words, through the challenge to taxonomic order posited by the pangolin, Lele fertility-cult members were empowered to turn their lives around, and deny that the misfortune of sterility was a necessary and final state of being. Furthermore, because of such behavior as the way it "bows its head like a man avoiding his mother-in-law," the pangolin also helps people think through the perplexities of marriage and inheritance.[41]

For Lega (Zaire), the pangolin is a culture hero who taught people how to roof their houses with large leaves, in a pattern similar to the animal's scales; and "a sacred animal whose accidental death creates ritual disequilibrium, which must be expiated by appropriate rituals and distributions." The animal is such an integral part of the aphoristic art of the

Cape pangolin (Manis temmincki), Zambia. Photo: Manuel Jordân, 1992.

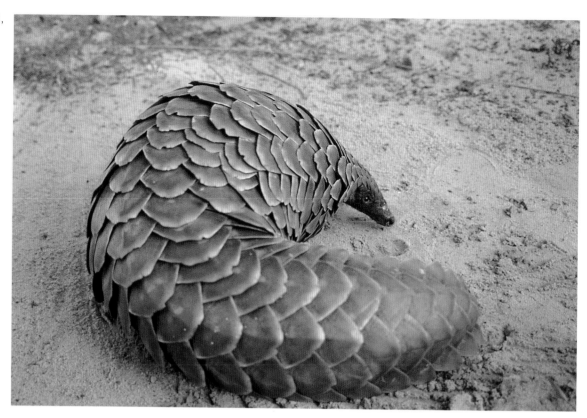

Bwami Society that "any generalized animal carving, with or without suggestive additions such as scales, can be interpreted as a pangolin"—or a dog or antelope,[42] probably depending upon the communicative needs of the circumstance. Again, this is what the polythetic nature of metaphor both permits and encourages. For Lega, the pangolin stands for the continuity of exogamy versus the disruption of incest, and the importance of links to one's maternal kin, and especially one's mother's brothers.[43]

Certain Gelede masks made by Yoruba people in Bénin and Nigeria also portray pangolins (*arika*), often in scenes evocative of hunting. One mask depicts two hunters grasping the back legs of a pangolin that is proceeding down the serene woman's face constituting the helmet of the mask itself.[44] Hunting is celebrated in Gelede, especially during Efe performances at night, for in the forest, men encounter animals as spiritually and magically powerful beings, in a contest of wit and wile.[45] The mask conveys the hunters' mastery of the pangolin and the cooperation necessary for community good. At the same time, no doubt, the image of this unusual animal "provokes [other] ideas and provides lessons useful to humans." The mask also celebrates the powers of Ogun, god of iron and patron of hunters, and the ability to keep oneself safe from harm.[46] The way a pangolin rolls itself in a ball to defend itself, portrayed in a kola nut container from Nigeria, epitomizes a means of defense impervious to more powerful enemies (cat. no. 76).

Reference to another attribute of the pangolin is widely made in African expression: not only is it unusual that an animal should have fish-like scales, but these are roughly triangular, as are the scars left upon the pangolin's skin if the scales are removed. The isoceles triangles of beaded headbands worn by Zairian Tabwa and Luba mediums of the Bulumbu possession cult are called "pangolin" because of such a first-level analogy. Among Luba, "pangolin" is a common triangular pattern used in scarification of women's chests,[47] in incisions along the rims of pottery vessels, and in the carving of all manner of regalia, from stools, to bowstands, to the backs of *lukasa* "memory boards"—each an object "wherein the ruler's possessing spirit resides." The general sense the animal brings to bear is the containment of power through secrecy,[48] but also of solidarity and the rewards of leading a proper life, as defined by tradition.[49]

Tabwa use the same triangular motif in an equally wide range of material culture, and call it "the rising of the new moon" (*balamwezi*). The triangle itself represents the "male" moon standing at a zenith, between his first and second wives (Venus in the east and west, respectively). The overall message of the motif is enlightenment, hope, and courage—just as the new moon rises after a night or two of utter darkness.[50] A Tabwa spirit medium told me that her beaded headband was called "pangolin," both because of the triangular motifs, and because a piece of pangolin scale is sewn into a magical bundle placed over the center of the forehead to protect the "seat of prophesy" located there. The bundle keeps sorcerers and malicious spirits from interfering with divination and, thus, enlightenment.

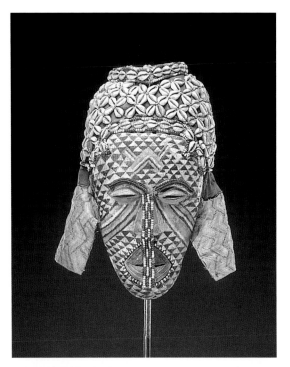

(TOP LEFT) *Luba spirit medium wearing a beaded headband called "pangolin," near Kinkondja, Zaire. Photo: Mary Nooter Roberts, 1990.*

(TOP RIGHT) *Ngady-a-mwash mask of Kuba people, with triangular motif that may suggest pangolin scales. Virginia Museum of Art.*

(CENTER RIGHT) *Gelede costume lappeted as "pangolin," near Porto-Novo, Bénin. Photo: Allen F. Roberts/Mary Kujawski Roberts, 1987.*

(BOTTOM RIGHT) *Bichir "water pangolin." Photo: Allen F. Roberts/Christopher Davis-Roberts, 1977.*

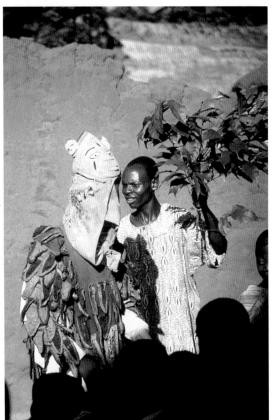

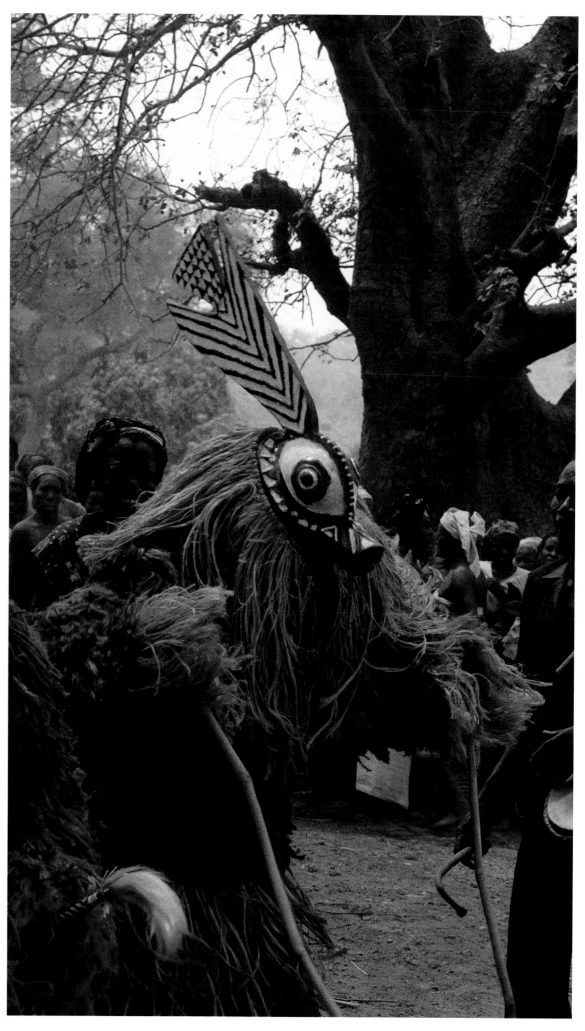

Bwa fish mask danced at market day, Dossi, Burkina Faso (detail). Photo: Christopher D. Roy, 1985.

A great many other African objects decorated with isoceles triangles refer to the pangolin as well, not only from central Africa where Bantu-speaking people culturally related to Luba and Tabwa live, but throughout the pangolin's wide African range.[51] For example, certain clothing worn by chiefs or other parties among Yoruba and related peoples of Bénin and Nigeria is "made of layered lappets to approximate the scales of a pangolin's hide."[52] A lappeted Gelede costume seen in performance near Porto-Novo, Bénin, surely produced just such an effect, keeping at bay the forces that might disrupt and thwart the good intentions of the dancer.[53] There may also be an allusion to triangular pangolin scales in the obscured faces of two Gelede masks at the Virginia Museum of Fine Arts, which represent the open-work beaded veils of certain Yoruba royalty at one level.[54] The top of a Gelede mask in the Stanley Collection at The University of Iowa Museum of Art surely portrays the ridged scales of a giant pangolin (Manis gigantea).[55] A Lega hat in the Stanley Collection, made from the scaly skin of an actual tree pangolin (M. tricuspis), looks remarkably like a Nigerian pangolin headdress with wooden scales and articulated bamboo forelegs (cat. nos. 73, 74).[56]

Other objects decorated with triangular motifs probably also refer to pangolins, such as Tabwa high-backed stools or truly beautiful Bisa leather skirts from the turn of the century, which are completely decorated with painted or stained triangles.

A Few Last Fish
As a last example of preposterous beasts represented in African visual arts and other expressive forms, one may consider several species of "fish" (so-called following Western taxonomy). Polypterus delhezi, called a "bichir" in English, is known by Tabwa as a "water pangolin." The bichir is rare and a relict species, with 25-million-year-old cousins, found as fossils in Kenya. Primitive lungs allow it to gulp air when oxygen is low in turbid water. An alternative Tabwa name for the fish, mushekele, may be derived from the verb "to laugh," perhaps in reference to this gasp. A bichir has a fused sheath of rhomboid-shaped, ganoid scales almost like an exoskeleton, similar to a North American gar, and Tabwa say it has no bones. Furthermore, it can hoist itself out of the water and through marsh grass using its thick, limb-like front fins. Tabwa say the fish can "take chickens" as it slithers about, although a Western ichthyologist I consulted doubted that this would be possible.[57] Whether or not this is true, Tabwa certainly are correct when they say that the fish "has 'things,'" or marvelous attributes.

The fish portrayed in bronze plaques and other royal art forms of the old kingdom of Benin (Nigeria)

may include bichirs. Since Felix von Luschan studied them in the early years of this century, researchers have discovered how notoriously difficult it is to identify such fish with assurance, and it is wisest to conclude, as he did, that a "generic, supernatural 'Royal Fish'" combines attributes of a number of species.[58] Von Luschan called such a metonym "mudfish," and to be included in it are all manner of odd creatures, some of which have primitive lungs as does the bichir, some that are catfish with barbels (Clarius spp.), and others which possess electric organs that are perceptively sensitive in the muddiest waters (Mormyrus spp.) or that can shock an aggressor with enough of a jolt to knock down and even kill a man.[59] This last kind, Malapterurus electricus, lives in Lake Tanganyika, as well. Indeed, during my stay in Zaire, a European teenager was killed by one while bathing in the lake. Tabwa, being great fishermen, know how carefully manikwe, as they call them, must be handled. They use the fish in a variety of magical preparations, not only because of the potency of their "lightning," but also because of what they consider to be the repulsively flaccid nature of manikwe bodies.

Mudfish in Benin art refer to important gods and spirits, such as Olokun, "Lord of the Great Waters." The Oba, or king, mediates between Olokun's watery realm and everyday life on dry land. Plaques sometimes depict the Oba with barbels emerging from the head and legs that terminate in mudfish tails, suggesting the powers associated with his role as intermediary between spirit and human worlds. The primitive lungs of other "mudfish" may contribute their own symbolic sense, for the Oba is master both in water and out. The Oba's fish-legs in some portrayals have been associated more specifically with the electric catfish, Malapterurus, evoking the potential threat should the king's feet touch the ground, as well as the perils to any who test his wrath. The way that he grasps dangerous animals in other depictions emphasizes the point.[60] The monstrous king, then, masters all his various parts, and as Tabwa would say, he, like a bichir, certainly "has 'things.'"

The mudfish as a metaphor also has many layers of meaning. The mudfish-legged king may refer to a particular individual who suffered from paralysis, and through related stories, one can learn of the limits of royal power and prerogative.[61] For this, among other reasons, mudfish are frequently sacrificed in Benin. As Paula Ben-Amos reports, "the mudfish is the freshest, most robust, and most delicious of all fish and is considered very attractive and desirable. It represents prosperity, peace, well-being and fertility."[62] I imagine another remarkable attribute is the oily nature of mudfish meat. Certain catfish (e.g. Dinopterus cunningtoni) have so much oil that in precolonial times, Tabwa and neighboring groups

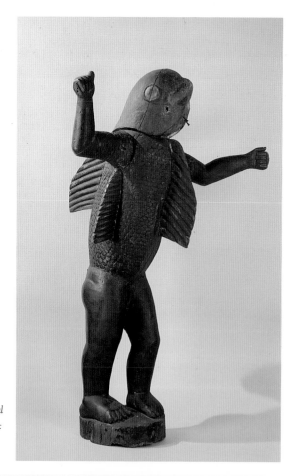

King Behanzin, as a shark. Fon, Republic of Benin. Wood, paint; 5 ft. 4 in. Musée de l'Homme, General Dodds Gift, 1893.

Wall paintings of Dona Fish, rural store in northwest Zambia. Photo: (above) Allen F. Roberts, 1992; (below) Manuel Jordân, 1992.

extracted it to burn for light.[63] Nowadays they joke that one can always tell who has been eating catfish, because of the grease around his or her lips!

Mudfish are associated with royalty elsewhere in west Africa. Depicted in golden pendants, finger rings, and sword ornaments worn by Akan nobles in Ghana, mudfish often suggest proverbs stressing social responsibility. Sometimes the reference is to the junior status of the mudfish vis-à-vis the crocodile, living in the same waters. The proverb associated with one goldweight is "If the mudfish in the stream grows fat, it does so to the advantage of the crocodile who finally eats it."[64] Mudfish symbolism is "rather ambiguous and it may be interpreted in various ways," for it is "not uncommon in Akan art for symbols to give rise . . . to a variety of interpretations, which are sometimes diametrically opposed"[65]—appropriately so for such a preposterous animal.

Finally, let us consider the shark. Americans love the *frisson* of shark movies, the idea that beneath the waves, even in the shallows where you might swim, a monstrous maw gapes, ready to tear you to bits. Judging from the shark masks and figures made by several coastal groups, west Africans recognize the same awesome power, and the potency of its metaphor. Some depictions are very evocative: a Bidjogo mask from Guinea-Bissau in the Mestach collection takes the form of a "surrealistic" shark head with an articulated mouth open and ready to bite.[67] A Nigerian headdress in the Eiteljorg Collection[66] looks frighteningly like a shark slipping through the water, ready to grab someone's leg. It is said that water-spirit masks from the same general area were sometimes performed by dancers submerged in the lagoon in such a way that only the mask showed on the surface; one can imagine the high drama (cat. no. 103).

Most intriguing of all is a sculpture of Béhanzin, the last Fon king of Dahomey prior to French colonial conquest, portrayed as a shark-man.[68] Béhanzin was a ruthless ruler who tried to halt French incursion and so preserve his kingdom, which was based upon the bloody remnants of the slave trade. He failed, was deposed, and sent off to exile by the French colonizers; but despite such ignominy, Béhanzin is being resuscitated as a symbol of resistance that is useful for nation-building in contemporary Bénin. Ironically, at least one great-grandson of the very Yoruba who were frequent targets of slave-raiding by Béhanzin's predecessors has made a Gelede mask celebrating the king's futile gesture to stop the French.[69]

As with von Luschan's "mudfish," the two-legged "shark" of Béhanzin does not fit a Western ichthyologist's taxonomy, for its large scales, four fins, and puckered mouth seem more like those of a barbel, carp, or bottom-feeder—some of the very "mudfish"

Reverse-glass painting by Mor
Gueye of Sheikh Amadou Bamba
praying on the water, Dakar.
Photo: Allen F. Roberts/Mary
Nooter Roberts, 1994.

of Benin lore. Sharks do not have scales, and indeed, are not "fish" at all, but *Elasmobranchii*, a family of cartilaginous creatures whose only other members are skates and rays. In all likelihood, several species of fish are combined in Béhanzin's "shark" to make a more powerful, polythetic symbol. This would certainly be consistent with other constructive sculpture by Fon and related peoples, such as the great figure of Gu (Ogun), god of war,[70] that is made from scrap-iron gleaned from European railroad and shipping vessels.[71] As such, Béhanzin-as-Shark is, as has been suggested, "surrealistic."[72] Indeed, the finny figure foreshadows—if in an inverted manner—the mermaid Mami-Wata.

Convulsive Beauty

Mami Wata (Pidgin English for "Mother of Water"), and her other African incarnations such as Mamba Mutu ("Crocodile-Person") and Dona Feesh (Portuguese/English "Madam Fish") in southeastern Zaire and northwestern Zambia, respectively, are mermaids with human female features above the waist, and fish, crocodile, or occasionally snake parts below. The rapidity with which recognition of Mami Wata has become a pan-African-and-Diaspora religious phenomenon is an example of what Henry Drewal has described as the "ongoing process of creating one's reality, of constructing meaning out of experience," which I would call "culture-building."[73]

Mami Wata is a constructed being, much like Béhanzin-the-Shark and the fish-legged Oba. In other words, Mami Wata does not exist in "nature," as defined by science. Figureheads on early European ships, photographs portraying snake-charmers, chromolithographs portraying mermaids, and other popular or sacred arts are among the sources of Mami Wata imagery, but from such input, Africans have developed their own iconography to make Mami Wata relevant to their religious and cultural needs.[74]

It is the "convulsive beauty" of the mermaid that is so fascinating, quite literally, for those who come under her spell are transfixed and changed forever.[75] From a functionalist perspective, Mami Wata is a religious device that helps explain the nature of capitalism to Africans moving rapidly into the international economy. In places like southeastern Zaire, a person makes a Faustian promise to the mermaid, and Mami Wata brings success in business in return for gifts and perhaps even the sacrifice of one's own children or other kin through sorcery. Why else do some people succeed without really trying, while others work equally hard but fail? Surely those who enjoy the greatest profits must be cheating the most. Or such, at any rate, would be the reasoning, gossip, and accusations of those not doing so well in the heady market economies of contemporary Africa. Elsewhere, loyalty to Mami Wata is proudly proclaimed, rather than whispered about, and wall-paintings and other devices advertise her stewardship of commerce. Mami Wata is between worlds and can be presumed to assist her followers to enjoy the best of the rest of the world, while retaining what is deemed relevant from a "traditional" Africa (itself unceasingly reinvented). Some who openly display their love of the mermaid do so to proclaim their own cosmopolitan sophistication, others to capitalize upon or decry the mermaid's

Religious poster of al-Buraq, Islamic mythical winged creature, from Cairo, Egypt. Paint on paper, H. 40.9 x W. 55.9. cm. UCLA Fowler Museum of Cultural History, Gift of Arnold Rubin (X83.841A).

outrageous eroticism.[76]

Al-Buraq, another constructed being introduced from outside sub-Saharan Africa, has also been converted through African expressive idioms to meet local æsthetics and needs. In some ways and in some places, it seems very likely that al-Buraq is a Muslim version of Mami-Wata, in both image and essence.

Al-Buraq is the winged horse with a woman's head that Muhammed rode on his mystical night journey from Mecca to Jerusalem, and then onward to meet God in the dome of the seven heavens. As René Bravmann explains, the imagery of al-Buraq is suggested by the Koran, but elaborated in popular arts and mystical texts. Muhammed, accompanied by the angel Gabriel (called Djibril in Arabic), rides his winged horse to paradise and to hell, to encounters with earlier prophets, and to a meeting with God Himself. African Muslims see al-Buraq as proof of Allah's miracles, and lithographs, tie-dyed cloths, and three-dimensional works such as carved wooden drums and masks all portray the wondrous steed as "the Noble and Sympathetic friend" of the Prophet.[77] Reverse-glass paintings of al-Buraq, used for private devotion and home decoration in Senegal, have become an item in the international tourist trade.[78]

Apotropaic ink drawings called *hatumere* that portray al-Buraq surrounded by holy Koranic scriptures are made by marabouts as charms among FulBe and Limba peoples in Sierra Leone. Some may be decorated with a menacing "angel snake," and the images are placed above the thresholds of homes to protect the inhabitants from witchcraft and other misfortune. The winged horse, as quick and strong as lightning, will deflect any evil propelled at the house-

hold. In Freetown, Sierra Leone, Temne artists create al-Buraq masks and costumes that are danced in festivals celebrating the end of Ramadan, the Muslim holy month of fasting. These creations present the female face of al-Buraq as the essence of "sultry Semitic" beauty, based upon North African prints widely sold in Muslim sub-Saharan Africa. Baga people of Guinea have recently incorporated the winged horse into their village festivals, some of which are not otherwise Muslim;[79] and while this may reflect the growing influence of Islam in the area, its appeal may lie as much in its "conspicuous newness."[80]

What is most significant about al-Buraq is the *miraculous* nature of the horse and of Muhammed's flight to heaven.[81] This is clear from related imagery concerning Sheikh Amadou Bamba (ca.1853-1927), the sainted man central to the Mouride Way, an Islamic Brotherhood in Senegal. Wall paintings, lithographs, and books concerning Sheikh Bamba show him surrounded by winged angels, with Djibril (Gabriel) often leading the saint's horse or defending him from harassment by wild animals or equally uncouth French colonizers. Other paintings recount the sheikh's miracles, and especially his exile by the French (echoing Muhammed's own flight), when he stopped the colonial ship and knelt on the surface of the ocean to pray, surrounded by fish who had come to be blessed. Mourides (members of the brotherhood) who work in the most physically demanding occupations of the informal economy, such as pounding corrugated metal roofing flat to make into trunks, or melting aluminum engine blocks to recast as kitchen implements, work under the image and ægis of Bamba. His miracles are their miracles. If he could

walk on water, then they can effect miracles too, and make a living, however meager, when all "official" indices shout that they cannot. Al-Buraq, flying to heaven with Muhammed, carries on its strong back the hopes of Muslims working away in the hot sun. Its beautiful face speaks of pride and dignity, but also of Islamic unity. Even the lowliest Muslim working the longest and hardest hours can be transported.

The Horror

The preposterous beasts considered so far in this chapter are oddly "human," despite their bizarre qualities. Several do exist in nature, as that term is defined in the West, and others such as the shark-king Béhanzin or the winged woman-horse al-Buraq incarnate the threshold between humans and animals. For the Africans believing in them, these beings exist in nature, too. From an outsider's perspective, though, they are a pastiche of elements from different domains, drawn together metonymically to produce a master symbol such as the "mudfish," that stands for the ambiguities of human social life.

One last kind of collage, well represented in African art and created through the same representational devices, serves a quite different purpose: to give fear a face. Fear is a physiological event with a genetic pedigree plunging deep into human evolution, and survival responses are instinctual at some level. For both humans and primates, snakes seem to trigger the strongest shivers of any animal in nature. This appears true for all human groups, regardless of culture.[82] However dangerous and fearsome, though, snakes and other strange creatures from nature such as pangolins and aardvarks are still tangible, and they may have positive qualities that balance the bad. Fear can usually be kept in check when one can see what is coming. It is when one cannot that all hell breaks loose.

In such obscure recesses smirks the "Imp of the Perverse," as Edgar Allan Poe called him. For Poe, the Imp is the personification of "that overwhelming tendency to do wrong for the wrong's sake," who appears "when we persist in acts because we feel we should *not* persist in them."[83] The Imp is another designation for Satan in Judeo-Christian thinking, of course, but I am by no means suggesting that Africa is "the Devil's dominion," as so many Christian missionaries have over the years. Rather, for Tabwa and other peoples I have studied closely, there is a recognition that evil lurks in the hearts of men, as "The Shadow" used to say. The Imp is there and must be reckoned with.

People create monsters for just this reason: they *need* the strange. They must confront fear; and so Fear itself is given the face of creatures no one has ever seen or experienced, except well beyond the pale, riding the horses of dream, charismatic prophesy, and the trance-enhanced vision of magic. As Georges Bataille wrote, drawing upon Pierre Boaistuau's *Histoires prodigieuses* of 1561, "'among all things that can be contemplated under the concavity of the heavens, nothing is seen that arouses the human spirit more, that ravishes the senses more, that horrifies more, that provokes more terror or admiration to a greater extent among creatures than the monsters, prodigies, and abominations through which we see the works of nature inverted, mutilated, and truncated.'" As Bataille noted, while such "prodigies and monsters were regarded in the past as presages and, most often, as such, as birds of ill omen; Boaistuau had the merit ... of recognizing to what extent men are *eager* for stupefaction" [my emphasis].[84]

Psychologists may have explanations for such eagerness, based on models of the deep-seated psyche; but here it is more useful to consider the location of fear in religion. Fear results from the evidence of intense or inexorable pain, gross iniquity, and suffering, or the feeling that life simply does not make sense.[85] "All that is ordinary, commonplace, belonging to everyday life, and recognized by all suddenly becomes meaningless, dubious and hostile. Our own world becomes an alien world. Something frightening is revealed in that which was habitual and secure."[86] Such terrors are felt by all people, at some time in life; it is then that masks are worn, to use their "peculiar interrelation of reality and image" to confront paradox.

Fear is given a face so that one can confront the realities of death. But even in ghastly circumstances, there is much to be gained, for the rapturous raw power of death and destruction is creative too, as we have seen repeatedly through examples of African expression, from Gelede masks to an Esan threshold. The face of fear is a collage, a pulsing, erotic storm always on the verge of busting loose to meet the conceptual needs of a savage new world. The African objects to be described below may be thought of as contained potential, to be directed while possible, before the next storm bursts and releases new meaning.

Kifwebe masks made by Songye and other Luba-related people of southern Zaire are a good case in point. As Dunja Hersak explains, *bifwebe* masqueraders are "anonymous agents of the political élite" who "resolve social tensions and ... enforce allegiance to the ruler by exercising malevolent powers of witchcraft and sorcery."[87] These are ambiguous arts, both in intention and performance: people possessing them are suspected of having committed incest or otherwise inverting and so subverting society itself; yet they are informed by the dead and can protect and

Tabwa kalunga medicine horn
protecting spirit medium from
sorcerers, Zaire. Photo: Allen F.
Roberts/Christopher Davis-
Roberts, 1977.

bring great benefit to those who use them "right-
eously"—which is always the most contingent of
terms.

In the politically charged context of *bifwebe* per-
formance, the masks are "perceived as supernatural
creatures from the mountains and the wilderness"
that are "neither exclusively human, animal nor
spirit, yet they embody attributes of all three." In
such transmogrification, the performer "is trans-
formed into something else called *ngulungu*," the
Songye word for bushbuck. "Bushbuck" is a state of
being, for the masks themselves do not directly repre-
sent this animal at all. Rather, the maskers' "power
display which is erratic, fear-inducing and unre-
strained," is achieved through the "petrified light-
ning" that is collage: the right side of the mask is the
sun, the left, the moon. The chin is "the snout of
the crocodile" and its beard of raffia "the mane of the
lion." Its mouth is "the beak of a bird" or "the flame
of the sorcerer," its nostrils are "the openings of a
[iron-smelting] furnace," and its eyes the "swellings of
sorcerers." The striations covering the face of the
mask refer to those of a zebra, in a pattern called
"something transformed." Rooster plumes extend the
head and sagittal crest, introducing the cock-of-
dawn's rhythm and reference to time. The neck of the
performer is associated with bees. The rest of his cos-
tume is important too, for the breast refers to constel-
lations of stars and the skins covering his hips are
leaves of a particular tree, while the cord with which
they are bound around his waist is a "snake." His legs
are a "mortar and pestle" and his leggings the "feet of
an elephant," while their stitching is "fleas." Finally,
the woven coverings of his feet are the dancer's
"roots." The performer's choreography evokes the
ferocity of lions and crocodiles, "the excessive virility
of the elephant and the stinging ... of the porcupine
and insects."

In the flashpoint creation of this collage, every
conceivable power and circumstance is elicited. Woe
to any who challenge the wielding of such awesome
capacity, which threatens to fly off in all directions at
once. To redirect a Surrealist text, the *kifwebe* mask
is "magnificent in its shock and its irreverence," for
its imagery, however terrifying, must convey the fer-
vent hope that "the creation of the world is not yet
finished."[88] Indeed, paradoxically, the mask's
ironic eclecticism triumphs over the stultifying
"single meaning" of established authority,[89] even
as it serves the purposes of those in the community
arrogant enough to presume to define that which
is "righteous."

West Africa also has many well-known examples
of this kind of "synæsthetic totality," as the late
Arnold Rubin might have called it,[90] such as masks
representing wild and menacing nature spirits among

Wee and related peoples of Ivory Coast (cat. nos. 95,
119), the convulsive creations portraying water spirits
among the Ijo, Ekpeye, and Abua peoples of Nigeria
(cat. nos. 102–104), or Sierra Leonean Toma and
Sherbro masks that mix animal and human references
to challenge the boundaries of what is *either* animal or
human.[91] One more case, described in detail, will
illustrate the potency of collage in giving fear a face.

Komo zoomorphic masks, figures, and shrines
made by Bamana people of Mali are terrifying affairs,
and through the physical essence of the dire secrets
they contain, protect, and promulgate, "these objects
symbolize and assemble power" and "portray wisdom
while partaking of it," as Patrick McNaughton has
said.[92] The generic term for the things of Komo is *siri*,
a word referring to "all constructions of supernatural
import" for Bamana, which is directly derived from
an Arabic term meaning "holy mystery" and "secret."
Among these *siri* are *boli* altars, whose animal shapes
are rendered increasingly amorphous by many layers
of sacrificial materials, until they have little distinct
form at all. *Boli* contain "animal bones, vegetable
matter, honey, metal, and rarely, in former times ...
portions of human bodies." Misunderstood as "abomi-
nations" by a writer earlier this century, *boli* represent
"the Bamana conception of the universe."[93] But they
can achieve this essential task of conceptualizing the
universe precisely because they *are* abominations:
they are "loathsome" and "unequivocally detestable,"

as the dictionary defines abomination, because held in the *boli*'s grotesque animal form are bits and pieces of experience that are thrust together and juxtaposed without the slightest regard for the usual order of things.[94] Like other collages, a *boli* is an erotic storm, threatening to let loose.

The sculptures of Komo are "multiple-media constructions that orchestrate materials with secret techniques of assemblage and construction that are believed to generate massive amounts of useful energy" (called *nyama* by Bamana and neighboring Dogon). Their purpose is to affect human emotions through intellect rather than visual metaphors, except insofar as their being "reservoirs of usable energy" is explicit in their very formlessness. Komo masks and the amulet-bedecked costumes accompanying them "do not just carry power; they insinuate it visually (cat. no. 94). They are designed intentionally to be horrific." McNaughton's choice of the verb "insinuate" is apposite, for it suggests a snakey, slow and inexorable conquest by the coils of the mask's thick meanings.[95]

From the dome of the mask, above the dancer's head, large antelope horns project as "archetypal symbols of the power of the bush." They suggest aggression and endurance, and contain magical substances that activate the intentions of the performer and his confederates. Protruding outward from the dome is a long, thin muzzle, sometimes set with zigzagging carved teeth or inset horns of small antelopes and the tushes of wild pigs.[96] Dominique Zahan associated the mouth with the ambiguous attributes of the spotted hyena, while McNaughton suggests that the mouth is long and viciously open to depict the overwhelming powers of the society.[97] Vulture feathers are sometimes attached, to demonstrate the possession of esoteric knowledge and divination that is associated with such birds (probably because they can locate carrion from such astounding heights and distances). Bundles of porcupine quills, alluding to arrows and other projectiles, are bound to the mask in an openly aggressive statement about its capacity for violence. Finally, the masks are coated with resin, mud, and sacrificial materials like a *boli* figure, lending an altogether out-of-the-earth appearance to the mask; as this surface grows in thickness and tactility, so does the mask's power.[98]

The question remains, why does the *komo* mask present such an "indecisive reunion of ... different meanings," to borrow a phrase from Octavio Paz. Why such a "body of visual nonsequiturs," in McNaughton's words? The masks present "generalized animality and stored energy";[99] they are no longer finished forms, for, to paraphrase Mikhail Bakhtin, "the borderlines that divide the kingdoms of nature in the usual picture of the world are boldly infringed."[100]

Drawing of Brachycerus apterus weevil, used as container for Tabwa magical amulets, by Allen F. Roberts.

Instead, the sculptures stand for something that has happened, can happen, may happen, and will happen. "Their energy can influence the world,"[101] for they are the image of everything in a tiny place, a black hole's vortex, into and out of which pass the concept and the power "to be."

A Postscript on Magic and Divination

Even if collage masks and figures are a storm of meaning waiting to burst forth, they are still *objects* to be experienced as consolidated forms. Magic, on the other hand, is a dynamic process of disassembling the fixity of meaning, a manipulation and reconfiguration that helps people achieve defined or implicit goals. A great many elements of African magic come from the same animals portrayed in the masks, figures, and other objects discussed in these pages.

Conceptualizing, creating, and using magic is essentially a synecdochic practice: the totality of, say, a Gaboon adder, is reduced to its fang—all its vibrant colors, its stout form, its age, what it eats, how dangerous it is to those who step on it, the time someone perished from this one's bite, and everything else the snake is, has been, and might be. The fang "is" the adder, just as, for many, a crucifix is Christianity. The power of the objects derives not only from the metaphor they represent—"fang" as what bites and leads to excruciating pain and death—but from the conceptual resolve to reduce all that snakiness to one atom of meaning.

Synecdochically obtained magical elements are combined in a metonymic bundle, to create what Tabwa call a "little world" (*kadunia*) of their own confection. The amuletic little world is to work to the creator's advantage, the way things ought to but rarely do. Once created, such a metonymic bundle is then applied to circumstances metaphorically: a bridge of power is created, linking the totality of

intentions of each and every element combined, to achieve a given purpose. Here is an example from my fieldwork among Tabwa.[102]

A bundle called *mwanzambale* was prepared by an itinerant shamanistic healer (*ng'anga*), to "close" our home to evil. He brought to the confines of our house, darkened to the outside world as though no one were there, a large cloth which he opened to reveal dozens of tiny cloth bundles, each tied separately and each containing an activating agent (*kizimba*) of magic. He extracted a crumb, a tiny shaving, or the merest hint of those he decided we needed to construct our little world. Because the pieces were so small, some were charred, and all were eventually ground together into a paste, no one could identify the particular elements after they were assembled. Only the shaman and his clients can know; any others can only guess. This, of course, is the point: *anything* can be in there. It is what *might* be that is most frightening. Among the several dozen elements he placed in the bundle were:

(a) a dried piece of the honey-guide bird, to lead the magic to its goal;

(b) an artifact of a lightning strike, bringing divine power to bear;

(c) shavings from the dried finger of a chimpanzee, too "human" for comfort;

(d) hairs from the ends of a lion's and a leop-

ard's tail, because "these are animals that are feared, [and] people will look at your face and will fear you;"

(e) skin and esophagus from a python, often used in hunting magic because when the python goes "nyaaa nyaaa nyaaa [a slithering sound], all the animals quickly answer," and so will the other elements of your magic when they are called;

(f) scales and the esophagus of a crocodile because this closes the throat and the animal can travel great distances underwater, and so with this, even if one puts "filth" [evil magic] in your food, it will be "closed" and you will not swallow it;

(g) a piece of a stick that someone has used to knock someone else down and a piece of a hoe handle that has broken while someone was working, for both of these will prevent you from being "struck" by an adversary, and instead, she or he will fall;

(h) a relic from someone who has risen from the dead as an afflicting ghost, for this very powerful agent will awaken your protective magic if someone bad comes in the night [as a sorcerer] and tries to attack you, and she or he will suffer instead;

(i) wood from a tree from which someone has fallen and died, so that the person attacking you will instead have the accident she or he would have inflicted upon you;

(j) fangs from a Gaboon adder and three other snakes called *mpili, mulolo*, and *kapiyono*, all of which make the magic very fierce (*makali*);

(k) hair from the foreheads of a buffalo, a lion, and an elephant, and tendons from the legs of a buffalo and an elephant, because these animals are so strong, but even they will bow to you when you are empowered by this magic;

(l) pebbles from all the great spirit-mountains;

(m) a *kabobo* bee that flies whooooo, another kind of bee called *matembo*, and *shafu* fire ants, so that your aggressors will be stung;

(n) a pangolin scale, for with this, if someone places evil magic in your house, it will sit there as magic, and be powerless to do anything, it can have no effect, nor can anyone who would attack you with a knife or other weapon, they will just stand there and let you pass;

(o) a bat wing, because these are neither birds nor animals and see at night;

(p) the eye of the melanistic serval and of a goat, and the stick of a blind person, so that

you will see evil coming, but the evil-doer will be blind to you;

(q) feathers of a kind of quail often caught in snares; and

(r) the eye of a wily, wild hare.

These and many others still were mixed with leaves and roots from more than a score of medicinal plants. Finally, earth from where we had just stepped and scraped from the wall where our shadows had just fallen, hair from our widow's peaks and napes, and clippings from our fingernails and toenails were taken and mixed with the other ingredients. All were pounded and mashed and placed in an empty penicillin bottle. To keep the bundle alive, a few drops of kerosene might be added once in a while.

Making this bundle was an *event*. Inside the tiny bottle was an erotic storm that would both close us in the safety of its amorphous potential, and reflect back on any aggressor the evil she or he might intend that we suffer. Each element had its explanation, but such particularities were soon lost in the localization of energy. Like a *komo* or *kifwebe* mask, the overall awesome power was far greater than any of its parts. Instead, the bottle "traps forces.... [and] is the place where the visible articulates with the invisible."[103]

Certain forms of African divination work by a related principle. Across south-central Africa, peoples in the Chokwe-Lunda-Luba culture complex use (or once did) baskets full of tiny objects and artifacts, many of them animal parts, some relics of experience, others miniature carvings to represent social relationships.[104] As with the Tabwa talismanic little world, each element has its sense and is synecdochically reduced from a totality of experience; but as opposed to the Tabwa bundle, that remains within its glass bottle as amorphous energy, basket divination is an ever-shifting cognitive kinesis.

A diviner is consulted when something has gone wrong, and an explanation is needed in order to set things right and get on with life.[105] A client often comes one day to ask for help, and that night the diviner dreams about what must be done to help solve the problem; the next day a séance is held, during which the diviner reveals his dreams through performance. One divination method of Chokwe people living in Zambia, Angola, and Zaire, is called *ng'ombo ya kusekula*. As Manuel Jordán describes it, an *ng'ombo* is a basket containing a number of dried animal parts, seeds, minerals, tiny wooden sculptures of animals and humans, and a variety of other artifacts.[106] The diviner shakes his basket and then bases his diagnosis on the juxtapositions and configurations of the objects. Like diviners themselves, who both help but may harm with their powers, most people consider the animals represented in an *ngombo* basket to be highly ambiguous.

Aardvark claws and pangolin scales are often found in *ng'ombo* baskets. Both are bad signs. If an aardvark claw comes to the surface of the objects tossed in the basket, it is suspected that the patient is being afflicted by witchcraft, for aardvarks sometimes dig into graves, seeking termites and ants, and they are considered witches because of this ghoulish activity. If a pangolin scale appears on the top of the heap of things in the *ng'ombo*, an ancestor is probably to blame for whatever misfortune has brought the client to seek the diviner's help. *Nkaka*, the Chokwe/Luvale word for "pangolin," is also a generic term for "grandfather," and reference to such a venerable soul, combined with the fact that pangolins dig into termitaries which are places associated with spirits, suggests that somewhere in the patient's history, some contention with an ancestor needs to be "fixed" though offerings and other palliatives. The contents of the *ng'ombo* basket, then, are a microcosm of memory, intention, and hope, and the product of its reconfiguration is a pregnant hypothesis.

La griffe, voilà le symbole de la volonté pure.
The claw, now <u>that</u> is the symbol of pure will.
Gaston Bachelard, 1939

Bringing It All Back Home

Chokwe/Luvale lion mask, near Chitofu, Zambia. Photo: Manuel Jordân, 1992.

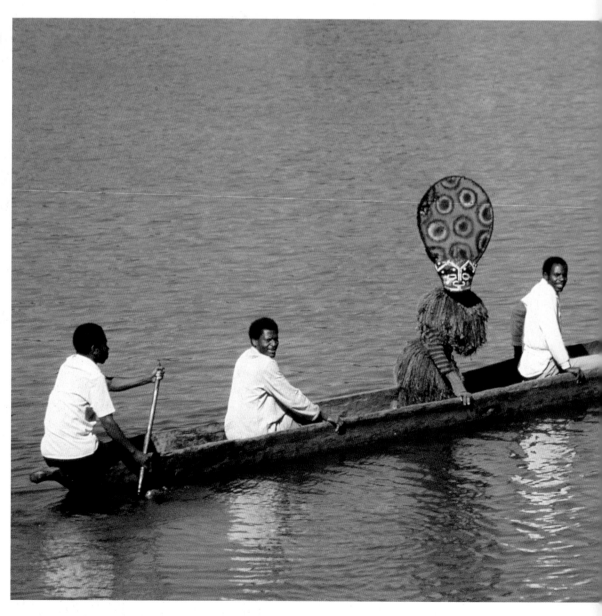

*I*n the preceding chapters, we have followed a passage outward from the security of home and the familiar animals of domesticity, to increasingly distant destinations in physical and social space, inhabited by increasingly preposterous animals. From the beginning, though, it has been stressed that this heuristic device, however African in its inspiration, is only that: it is what people would like to find in the universe around them. The problem is that all too often, the strangest beasts turn up in the shadows of one's own intimacy. A beloved kinsperson or neighbor may be the bloodiest of sorcerers, a "snake" who would gladly devour his fellows' hearts.

You—or even I, for heaven's sake—might be a witch and ride the nightwinds slung under the belly of a hyena. And if that is not enough to make one tremble, the leaders we have chosen may be "leopards." Of the animals represented in African art, the leopard probably appears more frequently and widely than any other, with the elephant as its only possible competitor.[1]

 The lion, largest of cats, is strangely out of the running. True, lions do appear from time to time, notably in royal arts of Fon and Akan peoples, sometimes borrowed from or reinforced by the lions of European heraldry. Elsewhere, they are depicted in the occasional mask, as for Bamana of Mali, or Chokwe/Luvale of northwestern Zambia; or in didactic figures made of clay during Bemba girls' initiation in Zambia and a few other circumstances. Lions are also an indirect

reference in other zoomorphic art, as when the horn-bill makes uncanny lion-like grunts, crocodiles terror-ize as "lions of the water," and hyenas become "lion-robbers."[2]

Still, in African representation, the lion is out-shined by its spotted cousin, which Vansina has called the "king of predators."[3] For each time the lion has been chosen as the direct subject of visual art in Africa, there must be a hundred leopards portrayed in wooden figures and masks, smithing and metal-casting, beading, weaving, dyeing, painting, pottery, and other expressive media (cat. nos. 115–133). As the final issue of this book, let us consider this most magnificent of cats, and speculate as to why it is so widely depicted.

Can the Leopard Change his Spots?[4]

Throughout Africa, the leopard is symbolically asso-ciated with human authority.[5] For Hamba and Tetela of south-central Zaire, for instance, the leopard is "the representative of the elders' power in the animal world" and when a lineage chief is invested, "he looms out of the forest like a leopard." The identifica-tion between the two is such that the chief must not eat leopard meat thereafter, for "'the leopard does not eat the leopard.'"[6] Among Kuba of east-central Zaire, the king is "hot, like the leopard and the sun, and may scorch the earth should he venture across the field. He is able to transform himself into a leop-ard, the sorcerer's familiar, to take revenge on his enemies."[7]

The physiology and behavior of leopards readily lend themselves to the generation of politically useful metaphors. The configuration of their spotted coats (black and white on a rufous field) may represent "the alternation of day and night," and the common use of leopard skins by chiefs throughout Zaire may symbol-ize "the absolute mastery of the light of day by the king."[8] For some groups, the cosmological reference is more complex, for the spots may represent stars as they do for Luba, Zela, northern Tabwa, and some other Luba-influenced peoples. Tabwa say the leopard bears the sun on its forehead, the moon at its nape, and stars spill down its back. For eastern Luba, the leopard shares these cosmogonic attributes and roles with the chthonic spirit that keeps the dead.[9]

From such a view, the leopard is an ambient cos-mological model—rather like the aardvark for Tabwa, but in utterly opposed ways. There may be a further correlation between the play of leopard spots and mnemonic systems used by Luba, Bembe, Tabwa, and other groups of southeastern Zaire to decipher and interpret social circumstances of enduring impor-tance. A semiotics or system of signs is recognized in natural phenomena such as celestial constellations and asterisms, for instance, which are considered to

stellify important relationships or snippets of origin myths.[10] Pecked petroglyphs, scarification patterns, the incising or encrusting of objects of material cul-ture, and perhaps drum rhythms and other music encode information in a related manner.[11] In particu-lar, it is conceivable that at some level, leopard spots may be "read" like the constellations of beads, inci-sions, and raised figures of carved wooden *lukasa* "memory boards," used by Luba to recount their char-ters for sacred royalty and to map out social relation-ships in the court.[12]

The symbolic power of such a strongly "signifying animal" (to use Roy Willis's term) must be related to the contrastive colors of the leopard's black spots "in the form of 'rosettes,' on a buff or yellowish-tawny ground color."[13] Buff or yellowish-tawny colors are glossed as "red" by Bantu-speaking peoples, and to understand the leopard's spots, reference must be made to the red/white/black triad of primary colors recognized by Bantu-speaking peoples and other groups all across Africa.[14] Many African peoples rep-resent the triad as an isoceles triangle.[15] At the apex, white generally represents auspiciousness, enlighten-ment, and a state of grace, often through conjunction with the ancestors and divinity. Red as one basal point of the triangle is violent transformation, which is both destructive and constructive; while black at the other stands for the hidden powers of arcane knowledge, that can transform for good or for ill.[16] Both red and black are highly ambivalent, and can either lead to each other (red-to-black or vice-versa), or to white enlightenment.

For Tabwa, the ferocious leopard is "solar" and "hot," with reference to its reddish coat that stands for "red" blood-letting; but the black spots must add an important, "cooling" mitigation through the insightful secrecy with which black is associated. The white associated with the leopard's black spots must add its calming nuances, as well. John Mack raises an interesting point concerning the simultaneous pres-ence of all three colors of the red-white-black triad in such a representational field. Such imagery raises "an essentially impenetrable problem—a dilemma for the viewer as confused as knowing how to act when all the lights on a set of traffic signals are simultaneously illuminated. Perhaps, however, confusion is precisely the point."[17] Indeed, in the case of the leopard's spots, such confusion may be a visual representation of the cat's limitless powers, and in particular, its utter rapaciousness.

Such speculation is reinforced by the leopard's behavior. Although "smaller than the lion, the leop-ard is incomparably more dangerous, this the more so in that it often climbs trees, from which it can leap upon an antelope, a dog, or even a man passing beneath its hiding place."[18] In this manner, "it is

(TOP) Chokwe/Luvale lion mask, dancing at boys' initiation in Chitofu, Zambia. Photo: Allen F. Roberts, 1992.

(BOTTOM) Chokwe/Luvale lion mask, near Chitofu, Zambia. Photo: Manuel Jordân, 1992.

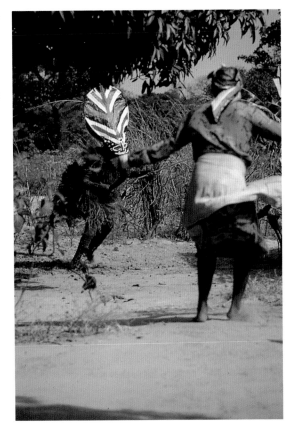
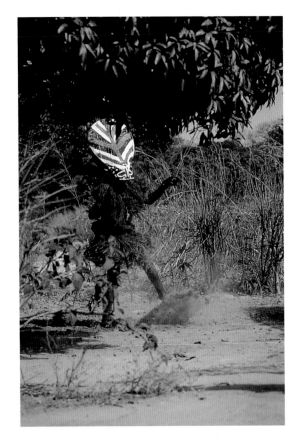
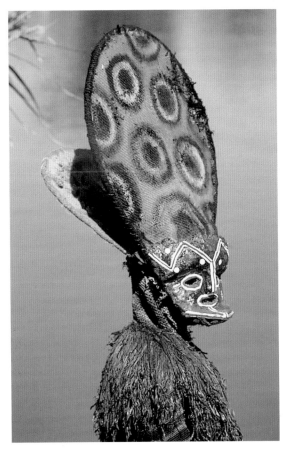
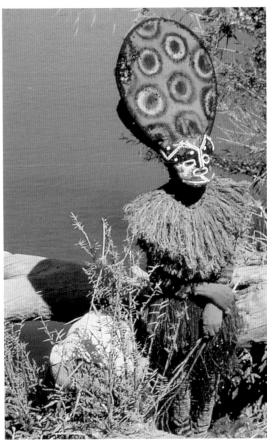

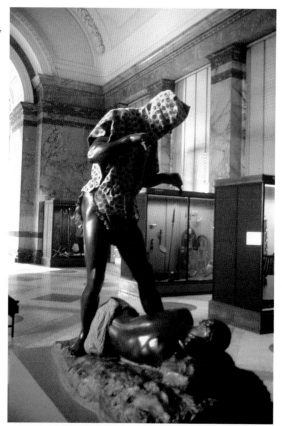

Aniota leopardman diorama, Musée Royal de l'Afrique Centrale, Tervuren. Photograph: Allen F. Roberts.

Leopard emblem of President Mobutu Sese Seko's political party, on long-defunct Zairian currency. Photo: Allen F. Roberts/Christopher Davis-Roberts, 1977.

upon its prey before this latter can, by the least sign, detect its presence. It is extraordinarily audacious, and penetrates not only into villages, but even into houses to take whatever animals are there, the dogs of which it is especially fond, and, very rarely, children."[19] Leopards cause great damage to domestic animals, too, for once having gained entry to a pen or corral, they often slaughter all the livestock they encounter, seemingly in "play," to carry away a single carcass to consume at leisure, high in a tree.[20] Tabwa feel that the leopard attacks "wantonly," "head-on, without shame," and repeatedly, until it has exhausted and dispatched its prey. It is always to be feared.[21] Indeed, for Tabwa the leopard represents limitless aggression.[22]

Leopards intrude into the human sanctum in a most dire and dangerous manner. They lurk and

pounce, squeeze through and seize, slay and lay waste. A favorite prey are villagers' dogs, and sometimes even children may be taken. In the bush, monkeys—another "human" animal[23]—are frequently their victims; but so is virtually any other beast that finds itself in the wrong place at the leopard's right time. No living thing is safe from a leopard, which has no natural enemies of its own. What is more, leopards are active day and night. They climb adroitly, swim well, and hide in otherwise impenetrable thickets along stream bottoms. Leopards go anywhere they wish, and act with abandon. Their vocabulary of spitting "coughs," snarls, growls, and furious "screaming roars" strikes paralyzing terror as a consequence.[24]

Leopard behavior stands in contrast to that of lions, who often inhabit the same territories.[25] If leopards act without measure or control, lions appear "refined." As Tabwa author Stefano Kaoze noted, a lion

> does not always attack animals. There are moments when it knows to show itself indulgent. There are even moments when one might take it for a jackal, and make it flee like a dog. But when there is reason to attack, the lion does so, relying upon more than its own physical strength. It does not take such an action lightly, but goes with patience, painstakingly, as watchful as it is serious, taking all into consideration, everything: the weather, the place, the behavior of its prey, and their number. When all is weighed, the lion leaps, throws down its victim, and rends it asunder. Such attacks are the more awesome for their being so calculated.[26]

A Tabwa adage has it that "to see a lion is to escape from it,"[27] reflecting the fact that the great cats are inactive for twenty or more hours a day. Even when food is scarce, lions lie about, as naturalist George Schaller observes, "utterly relaxed, 'poured out like honey in the sun.'"[28] Schaller notes that "as long as lions are visible to them, prey behave in a remarkably casual manner;" but when they do disappear from sight, lions' hunting skills are such that no beast is safe.

Tabwa use both leopard and lion symbolism in a number of contexts, but following the expectations of their remarkably egalitarian culture, they consider their chiefs to be more "lions" than "leopards."[29] That is, Tabwa chiefs may be ruthless on occasion, but they are also kindly and wise "fathers" of their people. Not so the merciless "leopard" chiefs of other Zairian peoples, and elsewhere in Africa.

Leopardmen and the Politics of Ambiguity

The most instrumental metaphor derived from the leopard concerns its ferocious duplicity and all the double-faced terror so implied. Such is the case among Igbo of Nigeria, who see the leopard as both beautiful and fearful, and who place its images in their Mbari houses precisely because the animal suggests different meanings at the same time. When leopards leave the forest to invade villages, Igbo seek divination to discover the portent of such an anomaly; the response is usually that impending tragedy can only be averted if proper sacrifices are made. If misfortune occurs nonetheless, the offering is deemed to have been incorrect or insufficient. At such a time, an Mbari sculpture is created as "an appropriate memorial to animals owned by the gods and sent by them on evil errands."[30]

The leopard, "king of predators," is always a most paradoxical beast, but then again, so are the African rulers who have reigned under the leopard's sign, for oddly enough, their ruthlessness also leads to community cohesion.[31] It is likely that the leopard-king's rule implied control of violence and capital punishment among Mangbetu as among other politically centralized peoples such as Kongo,[32] for instance. Among peoples of the Cameroon Grasslands, of animals chosen as "interpreters of royal qualities, the leopard heads the list. It is believed that ... [the leopard] sleeps with one eye open lest any movement escape its attention.... [and] the same quality is claimed for sacred kings." The hides and eyes of any leopards slain in a king's lands would be brought to the court for this reason. All manner of houseposts and thresholds, wooden and beaded thrones, pipes and other

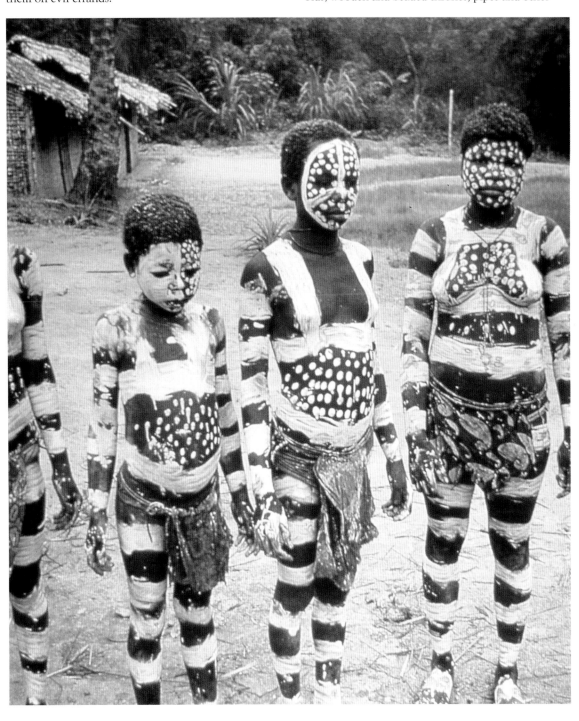

Twa/Mbuti boys in spotted body paint. Photo: Marc Félix.

objects made for royalty in the Grasslands pick up and play off of leopard symbolism (cat. nos. 126, 127).[33]

If African kings and other powerful persons chose the leopard as the emblem of their rule, so did people who would oppose them. In several parts of Africa, in precolonial but also much more recent times, an important guise for terrorism has been that of the leopardman.[34] Terrorism is a political strategy through which random violence brings a halt to any security in expectation. Victims are as often as not—and perhaps even *more* often than not—those who least deserve to be injured or killed, and who, by any definition, are altogether innocent. If children or young mothers are killed in their very own gardens or homes, is anyone safe, anywhere? Panic brings flight, and flight brings down whoever is in authority. As Tabwa say, a chief is like a rooster: his people are his beautiful plumes; plucked, he is not worth much!

Leopardmen have operated in a number of different parts of Africa, such as southern Nigeria, Ghana and Liberia.[35] One particularly bloody arena was in Sierra Leone, where among Mende peoples, men dressed in leopard (or crocodile) skins and armed with iron "claws" or "three-pronged knives" carried out a variety of heinous attacks under the ægis of magic called *bofima*. Measures were taken by British colonial authorities to prohibit any such activity, yet hundreds were allegedly murdered and scores arrested, many of whom were imprisoned or hanged.[36] *Bofima* seems to have been a magical bundle that, among other things, offered the promise of protection from European harassment and insured the society's members' promotion within the colonial hierarchy of clerks and chiefs. There was alleged to be a close association between leopardmen and the Poro Society,[37] and one is left to speculate that the society was, at least in part, a reaction to colonialism itself. This would be consistent with other movements of theriomorphic terrorism in Africa.[38]

In the Belgian Congo (now Zaire), for instance, the furtive Anioto Society of leopardman terrorists was a foil to the rising consolidation of power by both established and would-be Mangbetu kings (cat. nos. 128–130).[39] These were men profiting mightily from ivory-hunting, slaving, and other activities of the economics of predation that characterized the last decades before colonial conquest.[40] People of adjacent groups like Bali resented and feared the rise of the Mangbetu, and sent leopardmen to wreck havoc in their kingdoms; many of the spotted face masks now associated with secret societies from the region may have been used in contexts associated with such activities.[41]

Once the full force of colonial conquest was felt by these same African societies, the focus of leopardman terrorism sometimes shifted. Victims became those profiting most from missionary or administrative programs, or, if not the individuals themselves, then those somehow associated with them.[42] Such violence was in a way mimetic, for as Susan Stewart suggests, "all colonization involves the taming of the beast by bestial methods and hence both the conversion and projection of the animal and human, difference and identity."[43] In other words, in the eye of the most intolerant, Africans were "beasts," and treated as such. Such a view, made painfully evident in the slurs and epithets openly addressed to Africans, was felt to be just cause for resistance and, in rare cases, leopardman terrorism.

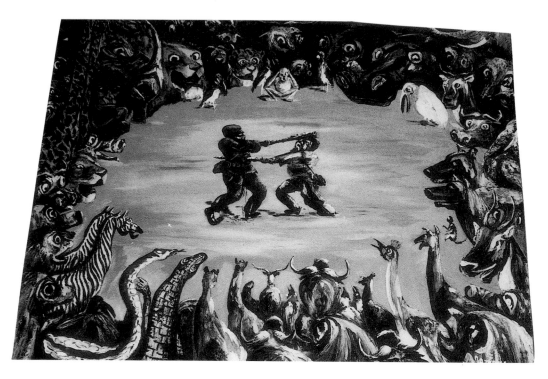

Detail of a popular painting in Virunga National Park, Zaire, portraying animals watching two humans fight with each other. Photo: Allen F. Roberts/ Christopher Davis-Roberts, 1976.

Catalogue

*Animals are metaphors which define essential
humanity through the establishment of its outer limits
— the non-human or uncivilized as well as the more-
than-human or supernatural.*

— Ben-Amos, "Men and Animals in Benin Art."

Although this exhibition focuses on animal imagery in African art, human beings are its main subject. In African cultures animals and their associated qualities provide apt metaphors for human identity and social relationships. African art vividly expresses these complex ideas. In Africa, as everywhere, people use animals as mirrors of humanity.

Organized according to broad African systems of classification, the exhibition moves from the familiar to the marvelous. It begins with the secure environment of domestic space and proceeds outward through the various realms of land, air, water — and beyond.

The exhibition's first section presents images of familiar domestic, sacrificial, and working animals, such as dogs, chickens, roosters, rams, horses, and oxen. These are followed by images of wild animals, with a sub-section devoted to anomalous creatures like chameleons, crocodiles, hyenas, monkeys, and pangolins — beings whose unusual behavior and appearance seem to disrupt the "natural" order. Next are sculptures that combine human and animal or multiple animal images to create other-worldly composites, like Senufo "fire-spitter" masks. Because leopards may be the most commonly portrayed animals in African art, an entire section is devoted to these feline creatures. The last section places an emphasis on human beings, with images of humans and animals interacting with one another in ways that invite more metaphoric interpretations.

By presenting an evocative and richly diverse array of African representations of animals, the exhibition contributes an African perspective to the universal question "What can we learn about humanity by examining our relationship to animals?"

1. Antelope mask; Bozo, Mali. This enormous sculpture was once attached to a cloth body, creating a gigantic animal that served as a mobile stage for performances organized by youth associations. Young men would animate the giant animal from within, while young women and other members of the community would encircle it dancing and singing. This theatrical tradition is known by different names in different regions. One of its names is *sogo bo*, "the animals come forth" (Arnoldi 1981:16). Wood, metal sheeting, cloth, string; H. 9 ft. Farid Tawa Collection [Photographed against tie-dyed cloth from Ivory Coast in the museum's Indigo Room]

Unless otherwise stated, all works date from the 19th or 20th century.

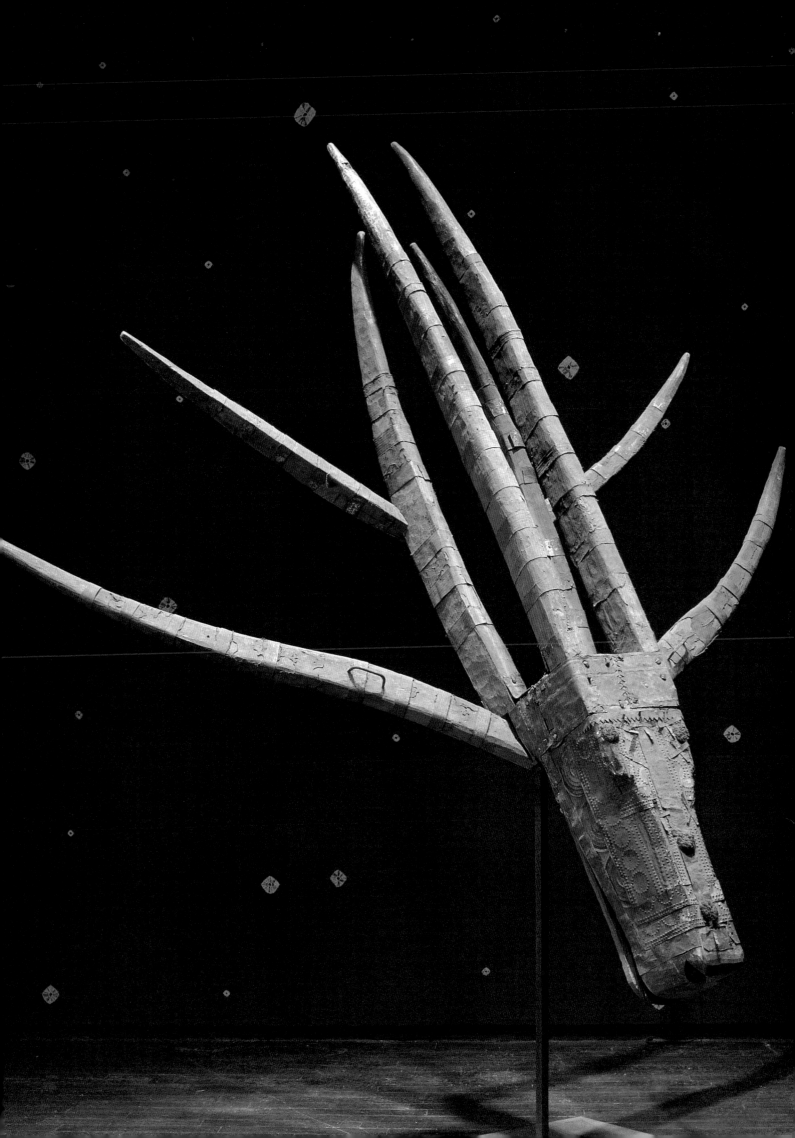

Domestic

The animals that inhabit the secure environment of domestic space in many African societies are generally not treated as pets; instead, these animals earn their keep. Four-legged animals are often described as "meat on feet." The economic value of different animals–from chicken to oxen–structures the hierarchy of religious sacrifice. Sculptural representations of sacrificial animals provide perpetual offerings to serve human needs.

2. Shrine sculpture: woman with sacrificial ram; Yoruba, Nigeria. Painted white, this sculpture embodies the essence of spiritual coolness. It depicts a woman offering a ram to Shango, the Yoruba thunder deity, who uses his fiery tools — lightning, meteorites, and fire — as instruments of moral agency. Her self-composed, regal gesture implores Shango to use his powers to undo injustices and set the world's imbalances aright. She gives with both hands, in a gesture of submission, to emphasize "the act of giving as an embodiment of character and perfect composure, a point given further focus, in both art and life, by the firmness of the facial expression that accompanies the noble act" (Thompson 1983:7). Wood, pigment; H. 35 1/2 in. Nancy and Richard Bloch. Photo: Addison Doty.

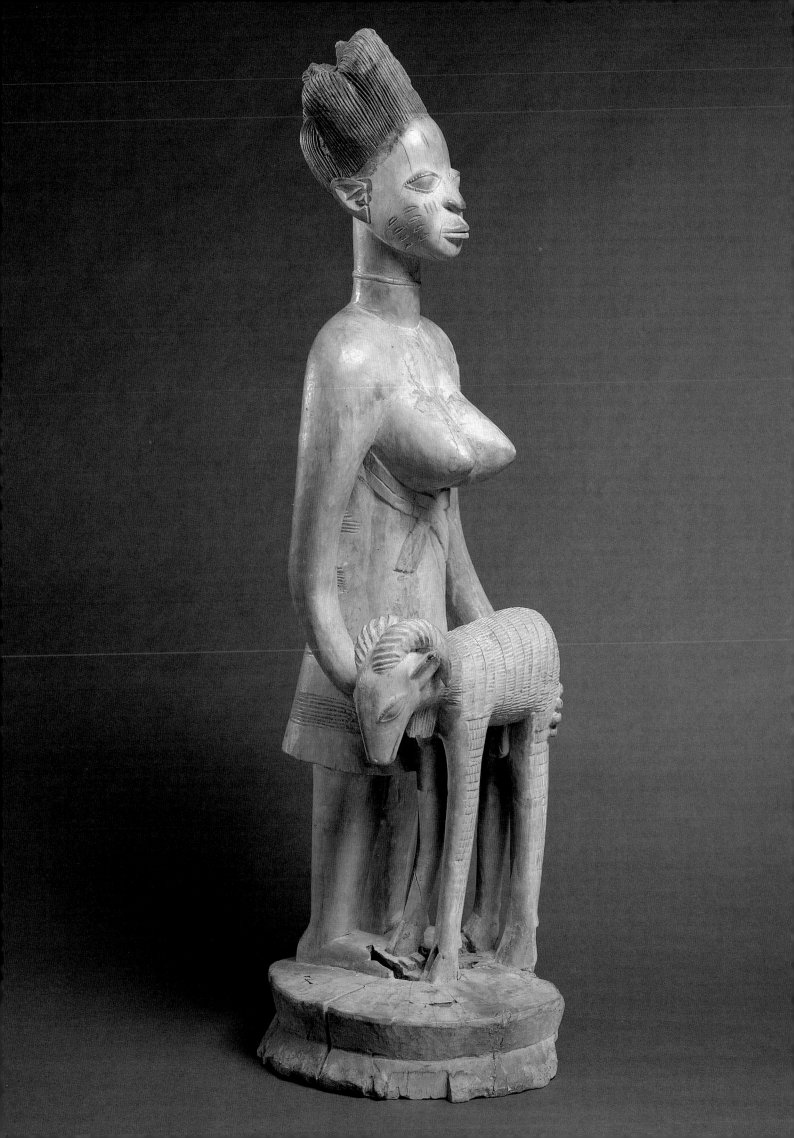

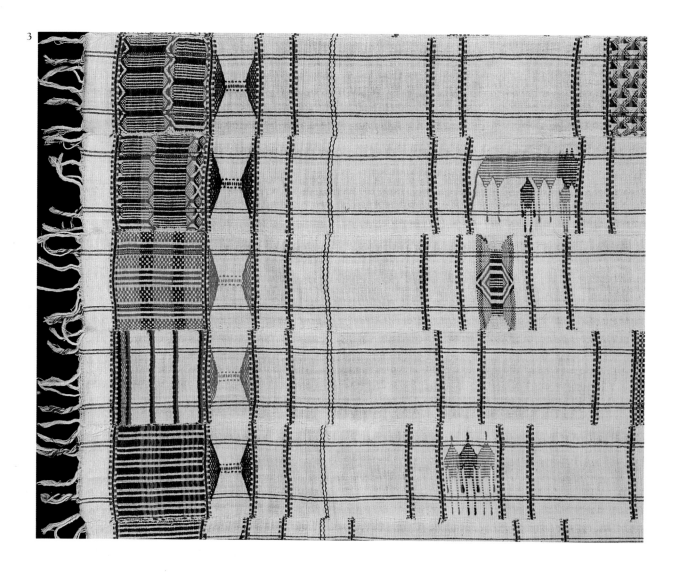

3. Textile (detail); **Djerma, Burkina Faso.** Motifs that float across the surface of this cloth include images of human figures sheltered beneath a four-legged animal, a cow or bull, and figures standing side-by-side. Throughout West Africa, similar cloths, made up of narrow bands sewn together, are woven by men on easily portable, horizontal looms. Such strip-woven cloth, used for burials as early as the 11th to 12th century, has been uncovered by archaeologists in the dry caves of the Bandiagara cliffs in Mali (Bedaux 1988:44). Cotton; Full dim. 88 x 48 1/2 in. The Newark Museum, Purchase 1928. Photo: Sarah Wells.

4. Heddle pulley; Baule, Ivory Coast. Carved as a heddle pulley, this little bird once perched over a weaver at work. Wood; H. 9 1/2 in. Shelly and Norman Dinhofer.

5. Shrine sculpture; Yoruba, Nigeria. With a chicken or guinea hen sitting on its nest, both above and inside, this is a sculpture within a sculpture, doubling its sacrificial offering. With few exceptions, only domestic animals are used in religious sacrifice. Chickens are the most common sacrifice of all. Wood, paint; H. 37 in. The Newark Museum, Walter Dormitzer Collection, Purchase 1924. Photo: Sarah Wells.

4

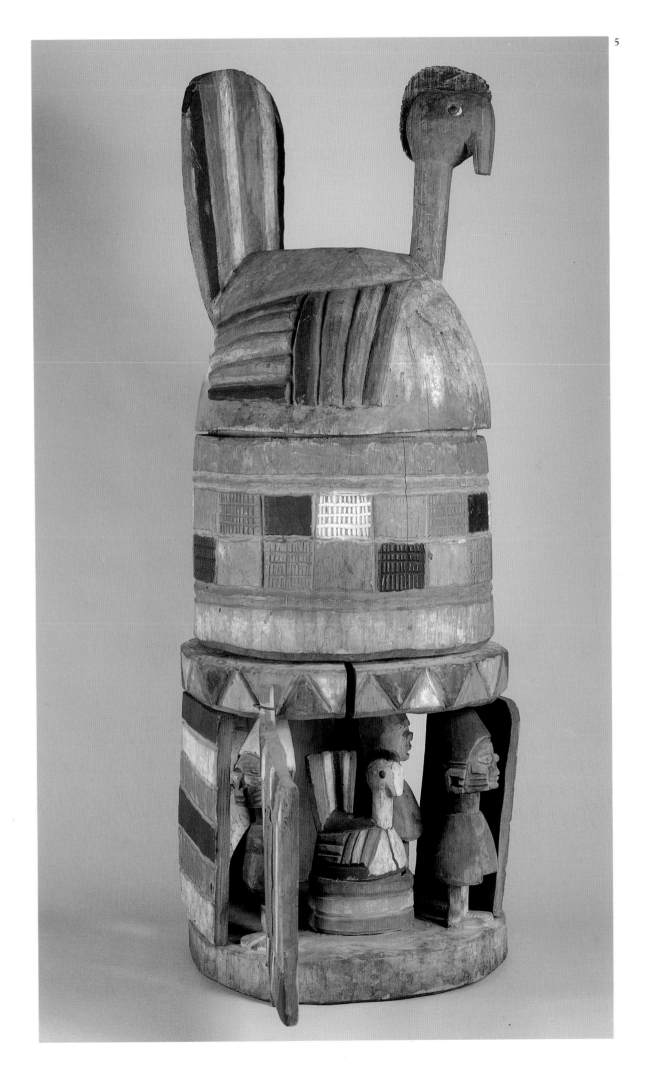

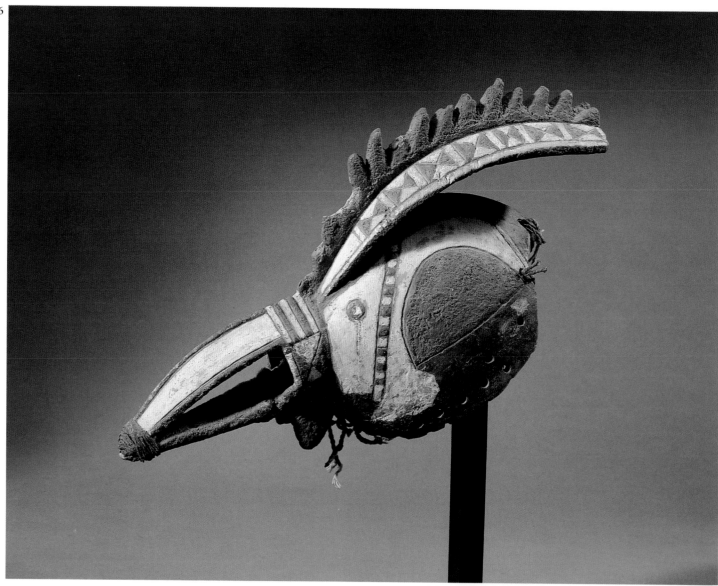

6. Rooster headdress; Mossi, Burkina Faso. Wood, paint, fiber; L. 15 1/2 in. Thomas G.B. Wheelock.

7. Rooster mask; Bobo, Burkina Faso. Wood, pigment; H. 25 in. Robert and Nancy Nooter. Photo: Del Lipp.

Among the Mossi people of Burkina Faso, rooster masks embody the collective spirits of a clan's ancestors and appear at funerals to honor a recently departed family member . Among the neighboring Bobo people, the rooster mask is associated with ancient wisdom (Roy 1979:24, 32).

8. Vessel; Mali, date unknown.
Terracotta; H. 19 in. Maureen Zarember.

9. Sculpture (in the form of a bird). Koma, Ghana, date unknown.
Terracotta; L. 8 in. Drs. Jean and Noble Endicott.

10. Commemorative sculpture: newborn goat(?); Dakakari, Nigeria.
Continuing a tradition established perhaps centuries ago, twentieth century Dakakari women make terracotta sculptures in both human and animal form and place them on the graves of important men and women as offerings to ancestral spirits, along with unornamented household pots (Fitzgerald 1944:43,44; Berns in Ross 1994:95,96). Terracotta; H. 25 in. The May Weber Museum of Cultural Arts. Photo: Gerald Hoffman.

8

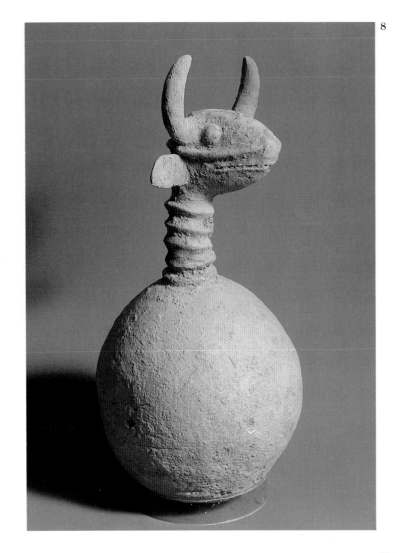

9

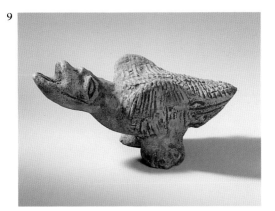

10

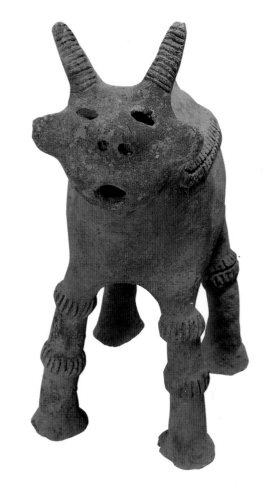

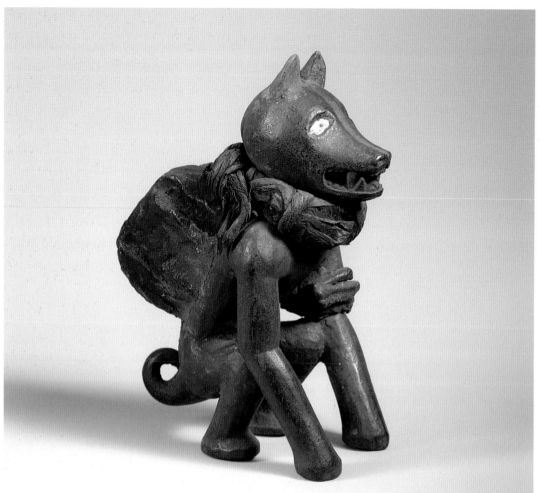

11. Nkisi; Kongo, Zaire. To swiftly track down evil forces, this *nkisi* is made in the shape of a dog. Wood, cloth, monkey's paw, porcelain, fiber, resin, mirror; H. 5 3/4 in. Buffalo Museum of Science.

12. Potlid; Woyo, Zaire. To help resolve marital conflicts, Woyo women use pictographic pot lids to send coded messages to their husbands. This lid refers to the proverb, open to various interpretations, which states that, "those who hitch two goats too close to each other are to blame when the ropes get tangled" (McGuire 1980:54). Wood; diam. 8 in. Mr. and Mrs. Armand Arman.

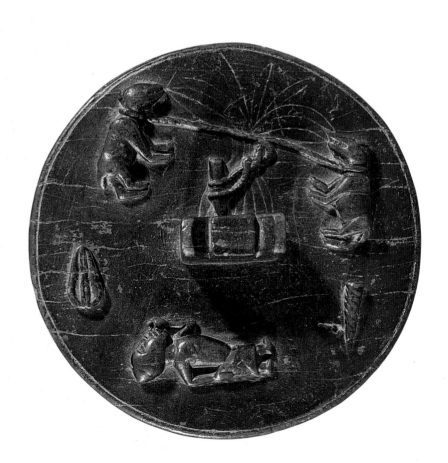

13–15 (Opposite page) **Ox masks; Bidjogo, Guinea Bissau.** Masks representing "*dugn'be*...the ox raised in the village" are used in initiation ceremonies in the Bissagos archipelago of Guinea-Bissau. The cord that runs through the mask's nostrils shows that the initiate is like a tethered ox and "belongs to the preinitiatory class...a being whose strength has just begun to be mastered" (Gallois-Duquette in Vogel 1981: 57). Among domestic animals, cattle are the most efficacious of religious sacrifices. **13.** (Upper left) Wood, paint, cows' horns, glass, nylon rope; H. 15 in. x W. 20 1/2 in. Ernie Wolfe III and Diane Steinmatz Wolfe. Photo: Dennis Nervig. **14.** (Upper right) Wood, glass, fiber, pigment; H. 20 in. Walt Disney's Tishman African Art Collection (1984.AF.051.025). **15.** (Right)Wood, raffia, bone, glass, metal, fur, paint, fiber; W. 20 1/8 in. The Brooklyn Museum, Gift of Mr. and Mrs. Joseph Gerofsky (1992.69.3). Photo: The Brooklyn Museum.

16. Ox; Karagwe, Tanzania. Iron. University of Michigan Museum of Art, Gift of Helmet Stern (1985/2.91). H. 11 7/8 in. Photo: Patrick Young.

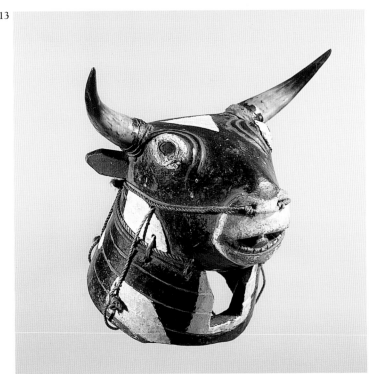

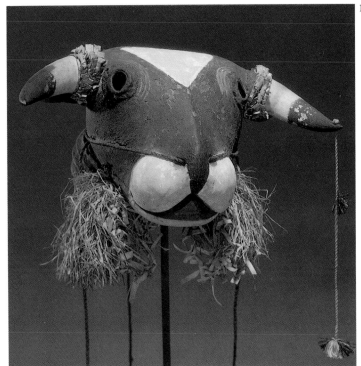

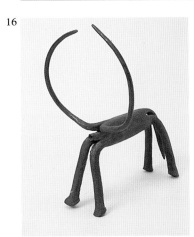

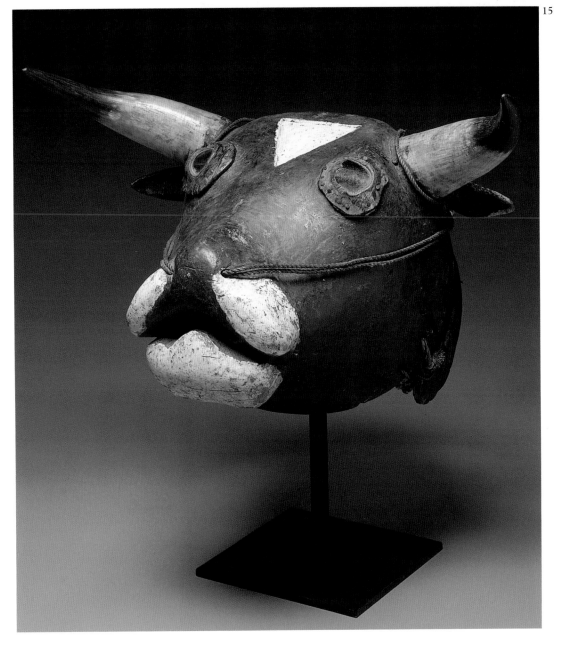

17. Horse and rider; Dogon, Mali.
Wood; H. 10 1/4 in. Cecilia and Irwin Smiley.

18. Ring: Horse and rider; Dogon, Mali. Brass, H. 2 3/8 in. (figure 1 5/8). Private Collection, Chicago.

19a. Left: Mounted warrior; Lake Debu region, Mali, date unknown. Bronze; H. 2 1/4 in. David T. Owsley.

19b. Right: Horse and rider; Lake Debu region, Mali, date unknown. Bronze; H. 2 in. Private collection.

Horses were introduced into the Western Sudan from North Africa sometime before the 10th century (Law 1980:3,4). Across the wide open spaces of the West African savannah, this animal enabled African kings and political leaders from Mansa Musa to Samori Touré to establish broad bases of power. Among the Dogon people of Mali, horse and rider sculptures are associated with powerful, victorious individuals. Rings like this one are worn by the *hogon*, or earth priest. The small bronze horse and rider figures were made centuries ago, although their exact date of production is unknown.

20. (Opposite page) **Horse and rider; Yoruba, Nigeria.** Brass; H. 11 3/4 in. Lucien Van de Velde. Photo: Fotostudio Herrebrugh.

17

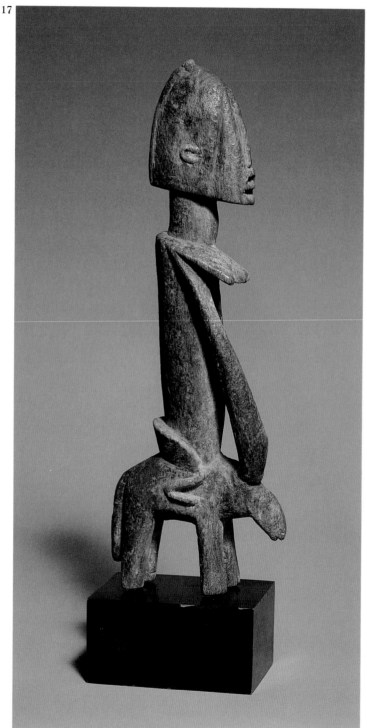

18

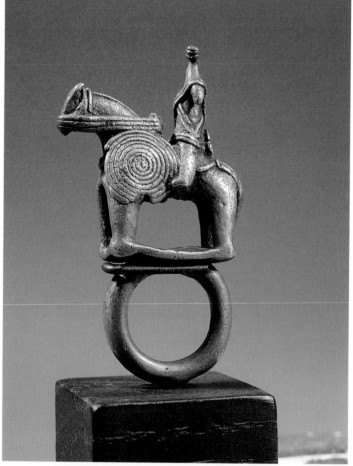

19

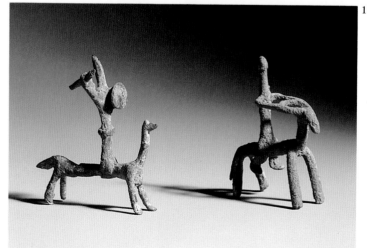

21. Staff with equestrian finial (detail); Yao(?), Mozambique. Wood; H. 49 1/4 in. Cecilia and Irwin Smiley.

22. Comb; Chokwe, Zaire/Zambia/Angola. Wood; H. 7 3/4 in. William W. Brill. In Central and Eastern Africa, horses were also associated with powerful individuals. Both the staff and comb are personal objects that identified their owners as men of influence.

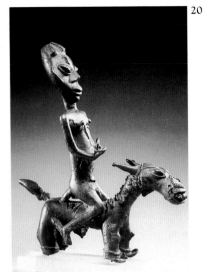

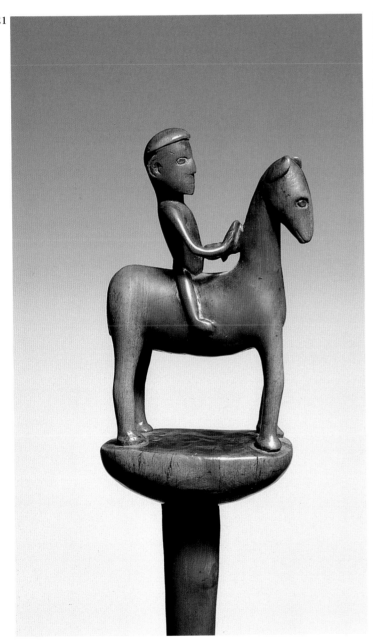

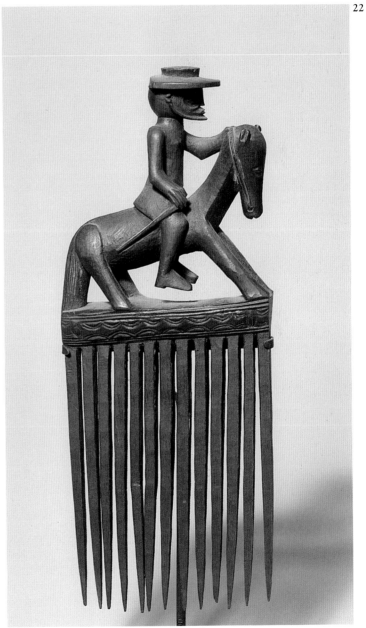

23. Sculpture; Madagascar. In this sculpture a colonial official reading a book flanked by dogs is carried in a litter by four figures. Dominance over animals, nature, and other cultures is a thread that runs through the history of Western culture, as exemplified by this work. Wood; H. approx. 34 in. The Field Museum, acquired in 1926 (cat. #209886, neg. # A109977c). Photo: Ron Testa.

24. Horse and rider; Fante, Ghana. In the dense forest regions of the Guinea Coast, horses do not survive for very long. Attacked by tsetse flies they quickly succumb to sleeping sickness. Their scarcity adds to their value as symbols of authority, often associated with European power, as is doubly conveyed by the top-hat worn by this equestrian figure. Wood, paint. H. 20 in. in. William Wright.

23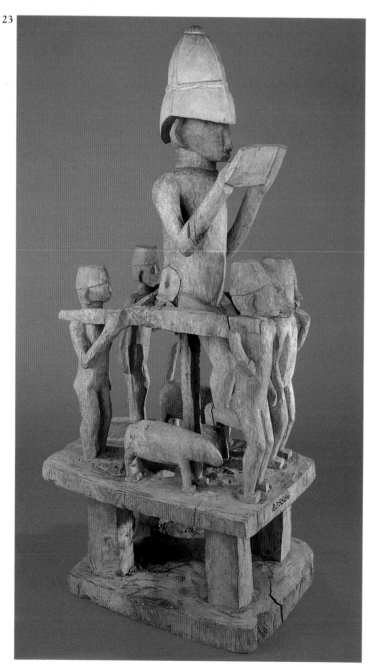

24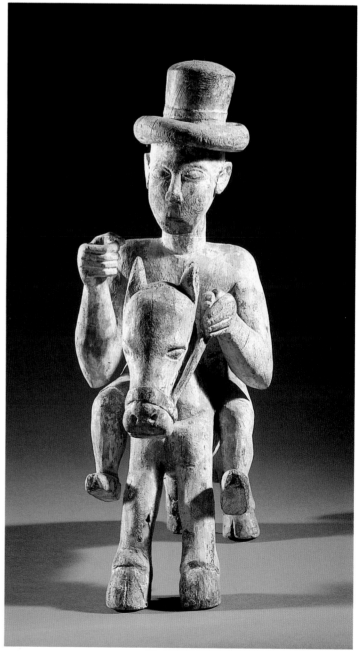

25. Hunting scene; Ethiopia. Pigment on cloth. H. 47 3/4 x W. 29 3/4 in. (framed). Joseph and Margaret Knopfelmacher.

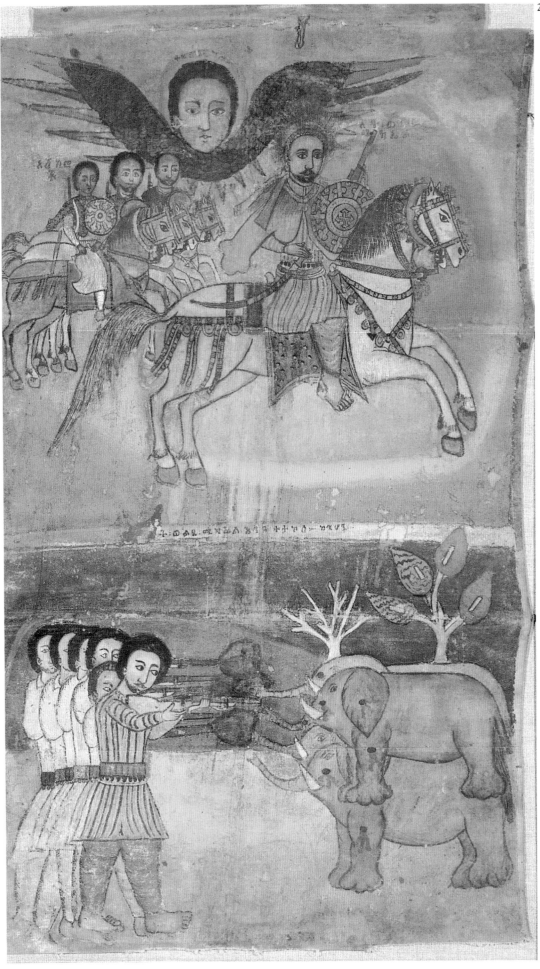

26

Wild

African animal taxonomies often extend outward in conceptual and physical space from relatively secure domestic environments toward the more dangerous and unpredictable regions of the forest or savannah. Transformative powers are usually reserved for animals living farthest from the community's center, for that which is least known often possesses the most creative potential and awesome power.

In African art, wild animals are depicted much more frequently than domestic ones. Contrary to what might be expected, the wild animals most represented are not those people from other parts of the world associate with Africa. The zebras, giraffes, and lions of tourist Africa are almost never depicted in Africa's ancient art traditions. Rather, in African cultural contexts, a more curious menagerie emerges. Artists focus on aardvarks, antelopes, baboons, buffaloes, chameleons, crocodiles, hornbills, hyenas, pangolins, snakes and other animals remarkable for how they look or act. In African cultures it is these and other animals that provide the most useful symbolic expressions of human situations.

26. Figure of a snake; Eton, Cameroon. Of a snake poised as though it is about to strike, this sculpture, almost seven feet long, was once "set up on two forked posts or between tree branches at a height of about two meters in the bush camp of the initiates...as a symbolic bridge between the here and the hereafter, which the candidate had to cross before entering the social world as an adult". For the Eton people, it "recalls the mythical snake of primordial times that placed itself across the border river, enabling the ancestors to immigrate to the present community's area" (Keckési 1987: 250-253). Contrasted with its symbolism in Western art and mythology, where the snake is almost always used as a symbol of evil and of original sin, of Eve tempting Adam with the forbidden fruit, in African art, snakes are almost always associated with positive forces. Wood, paint; L. 7 ft. The Field Museum (cat.#175746, neg.#A109420c). Photo: Diane Alexander White and Ron Testa.

27. Python head; Edo, Kingdom of Benin, Nigeria. This colossal bronze python head was once attached to a long curving body. The entire sculpture was vertically mounted with the python's fangs facing downward, guarding the central doorway of the palace in Benin City. In Benin, the python is thought of as the king of all snakes, playmate and messenger of Olokun, lord of great waters (Ben-Amos 1976:247). Brass; L. 16 1/2 in. University of Pennsylvania Museum (object #AF5106). Photo: Neg.#58-62956.

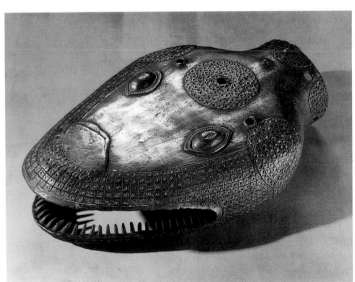

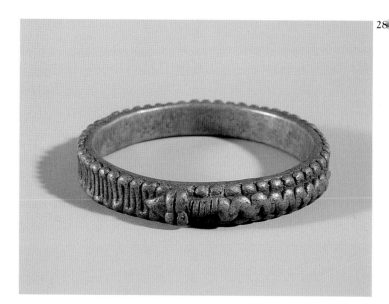

28

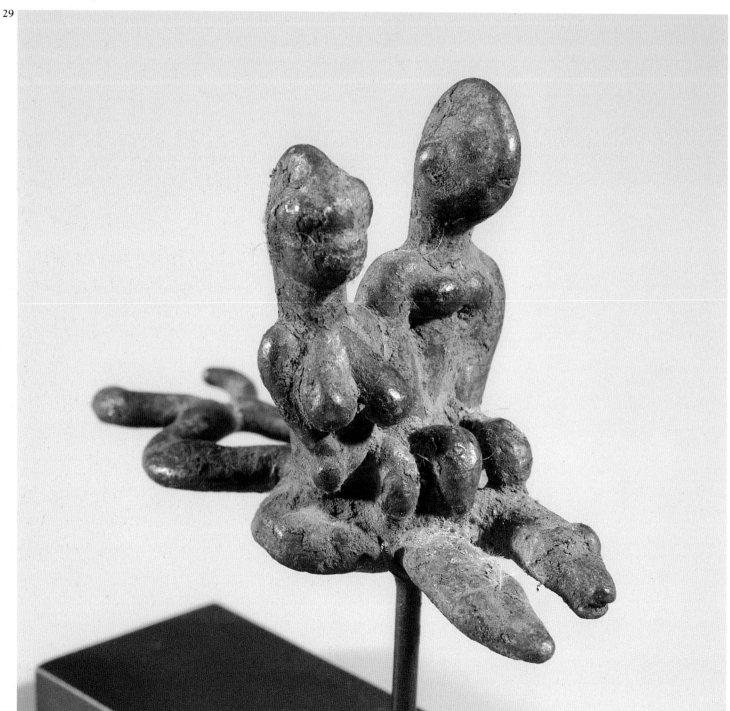

29

28. Child's bracelet (with snakes); Toussian-Syemou(?), Burkina Faso. In southwestern Burkina Faso, bracelets ornamented with pythons are worn by people of all ages as charms or protective medicine. Among the neighboring Senufo people, the python is considered the chief messenger of the bush spirits, capable of taking human form (Glaze 1978:66). Bronze; Diam. 2 1/8 in. Thomas G.B. Wheelock.

29. Pendant (pair of snakes with primordial couple); Bwa(?), Burkina Faso. Bronze; L. 1 11/16 in., Thomas G.B. Wheelock.

30. Snake mask (detail)**; Bwa, Burkina Faso.** Bwa snake masks are among the most spectacular of all African masks. These three range from approximately fourteen to sixteen feet long. Snake masks are worn by strong young men who begin training to perform wearing these difficult-to-maneuver masks at a very young age. The masks are worn with a full fiber costume. To steady the mask the performer grips a wooden brace — whose ends pierce the sides of the mask — between his teeth. Wood, paint, fiber; H. 15 ft.. Thomas G.B. Wheelock.

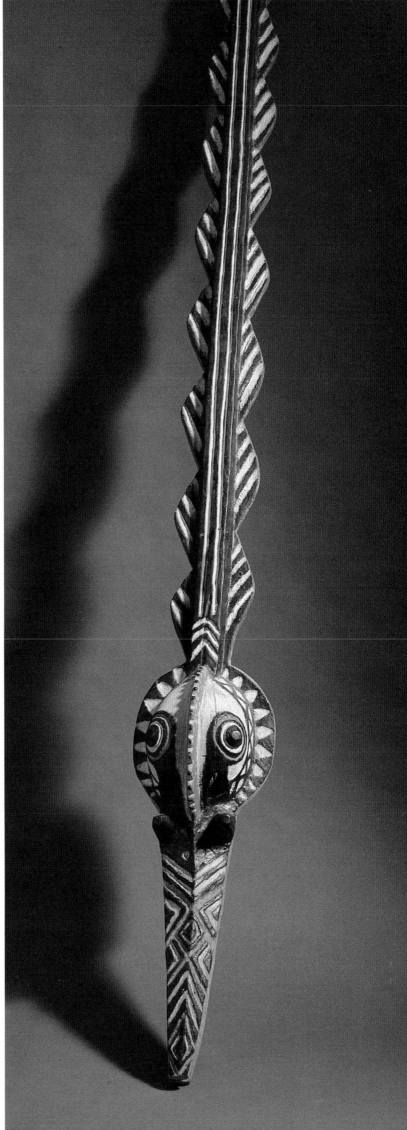

31

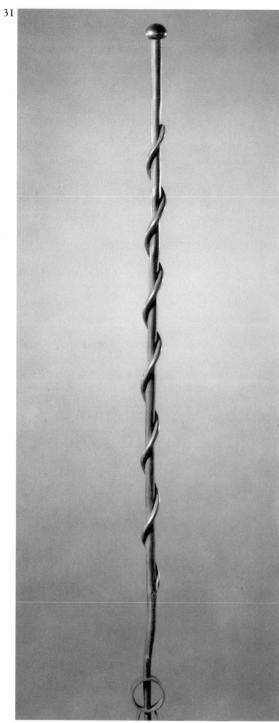

32

33

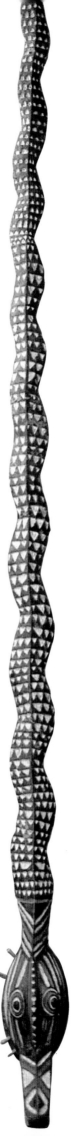

31. (Left, above) **Staff; Malawi.** Wood; Margaret and Al Coudron.

32. (Left, below) **Potlid; Woyo, Zaire.** Wood; Diam. 6 3/4 in. The Studio Museum in Harlem. (acc.#91.16.6). Photograph: Becket Logan.

33. (Left) **Snake mask; Bwa, Burkina Faso.** In the rural villages of Burkina Faso, masks like this appear during celebrations and ceremonies that take place during the dry season. They perform during rites of passage when young men and women are recognized as adult members of society, and at funerals when deceased elders leave this world to join their ancestors. Wood, pigment; L. 16 ft. 2 in. Peter and Nancy Mickelsen.

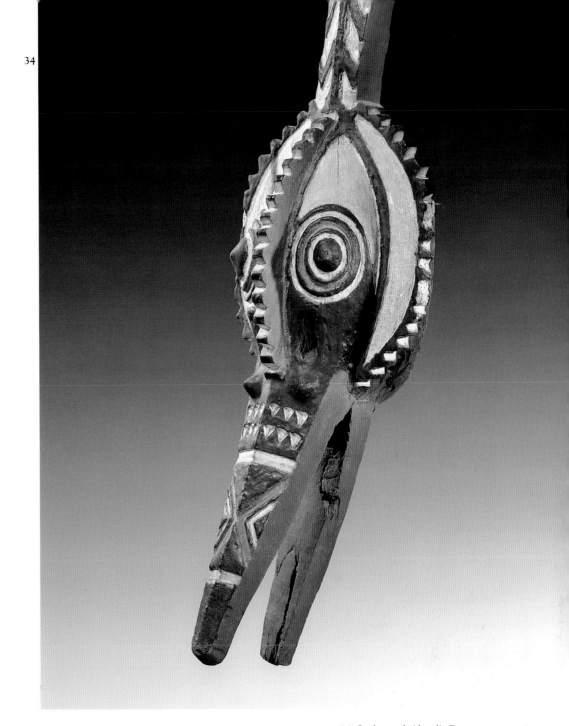

34. Snake mask (detail); **Bwa, Burkina Faso.** On the day of the mask performance, large groups of masks approach the village in procession and dance before animated audiences, accompanied by the music of flutes, drums, balafons, and voices. Their many different shapes and sizes represent a variety of beings, both earthly and supernatural. Wood, pigment; L. 14 ft. 5 in. Lucien Van de Velde, Antwerp. Photo: Fotostudio Herrebrugh.

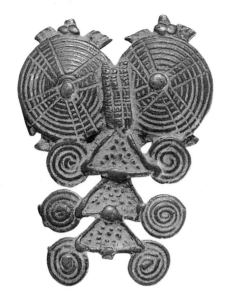

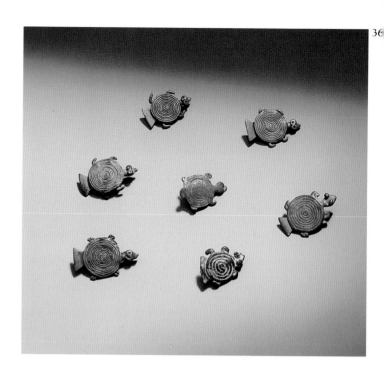

35. Pendant (with pair of turtles and swirling water); Toussian-Syemou(?), Burkina Faso. Bronze, H. 2 1/4 in. Thomas G.B. Wheelock

36. Group of seven turtles; Senufo, Ivory Coast. Small brass turtles are worn as protective amulets or are kept in household altars. Called *yawiige*, these personal adornments are prescribed by a diviner when "there is an imbalance in the relationship between a person and a particular spirit that is causing problems for the person" (Glaze 1981:76-78). They take the form of many different animals, because the Senufo believe that spirits can take any animal form. Brass; Diam. 1 to 1 1/4 in. Private Collection.

37. Sawfish(?) mask; Bidjogo, Guinea Bissau. Wood, pigment, plant leaves; H. 30 in. Pamela and Oliver E. Cobb. Photo: Paul Macapia.

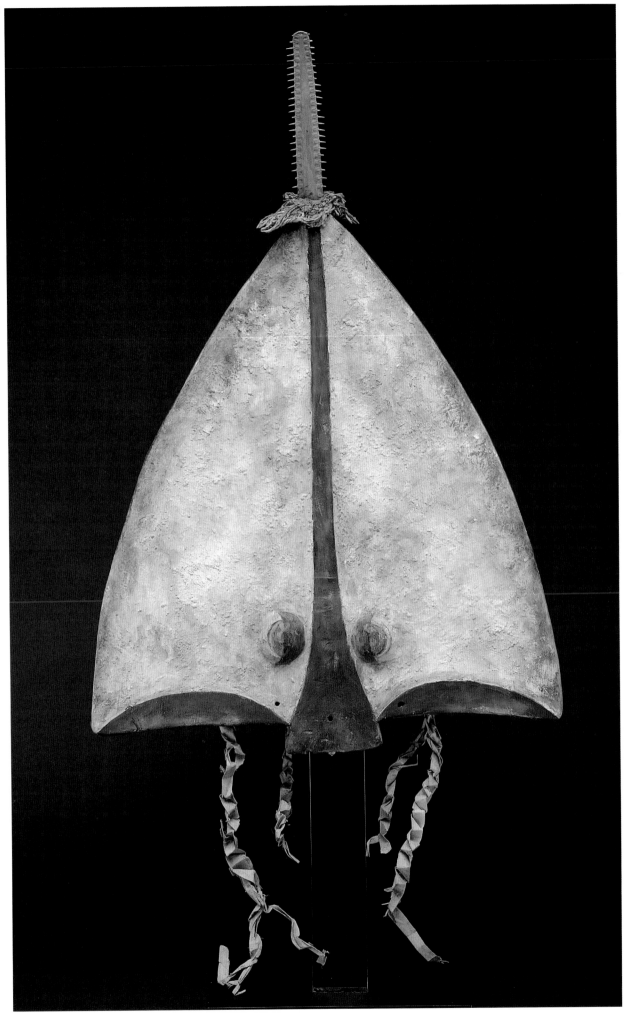

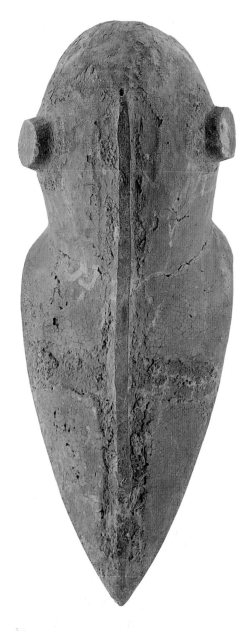

38. Mask; Djibete, Nigeria. Wood, paint; H. 27 7/8 in. Private collection. Photo: Courtesy of the Minneapolis Institute of Arts.

39. Hornbill sculpture; Senufo, Ivory Coast. Wood, paint; H. 6 ft. Walt Disney's Tishman African Art Collection.

40. Stork(?) mask; Dogon, Mali. Wood, paint; H. 3 ft. University of Iowa Museum of Art, Stanley Collection (x1986.460). Photo: UIMA.

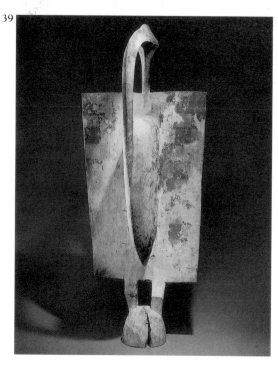

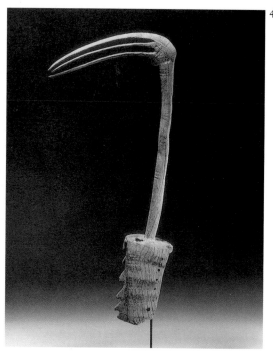

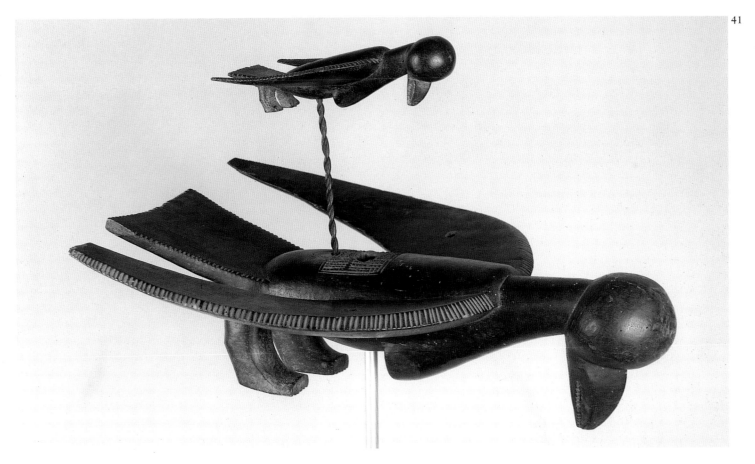

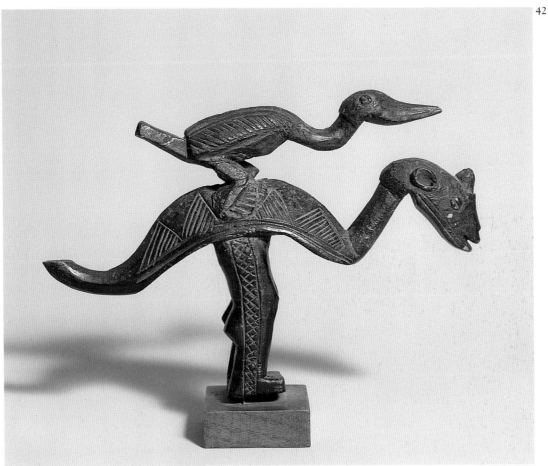

41. Bird finial; Fourou Senufo; Kenedougou region, Ivory Coast. During hoeing competitions, sculptures like this one are mounted on a tall pole erected in the field where the work takes place. At the end of the day elders raise the sculpture in the air and dance as they praise the best workers and invite the young men to join the young women standing at the edge of the field (Förster 1993:32-34). In newer staffs the birds are sometimes replaced by airplanes. Wood, metal; L. 16 5/8 in. x H. 10 in. The Newark Museum, Helena Rubenstein Collection, Purchase 1966, Louisa Bamberger Bequest. Photo: Sarah Wells.

42. Headdress (with birds); Afo(?), Nigeria. Wood; H. 7 1/2 in. William Brill.

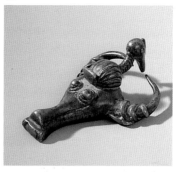

43

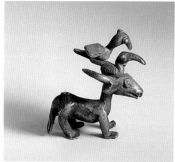

44

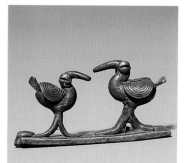

45

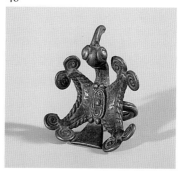

46

43–45 Goldweights; Akan, Ghana.
Brass; Diam. 1–2 in. **43.** Drs. Jean and
Noble Endicott. **44.** Rosemary and
George Lois. **45.** Private collection.

**46. Ring (with bird); Bwa or
Nuna(?), Burkina Faso. Brass.** L. 2 in.
Thomas G.B. Wheelock.

**47. Hairpin (with two birds); Bwa or
Nuna(?), Burkina Faso. Brass.** H. 6 in.
Thomas G.B. Wheelock.

48. Staff; Lobi, Burkina Faso. Iron;
Margaret and Al Coudron. Photo:
David R. Knox.

47

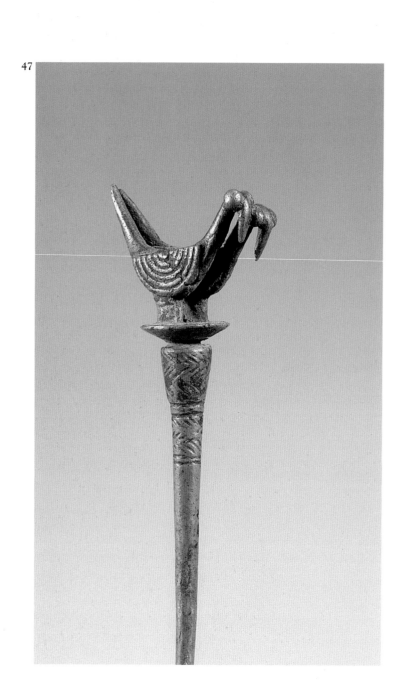

48

49-50. *Chiwara* headdresses; Bamana, Mali. These scultpures represent the female oryx antelope (*oryx beisa*) carrying her young on her back as African women do. Wood, metal, fiber. 49. (Left) H. 21 3/4 in.; Sydney L. Shaper. 50. (Right) H. 23 in.; University of Iowa Museum of Art, Stanley Collection (x1986.492). Photo: UIMA.

49

50

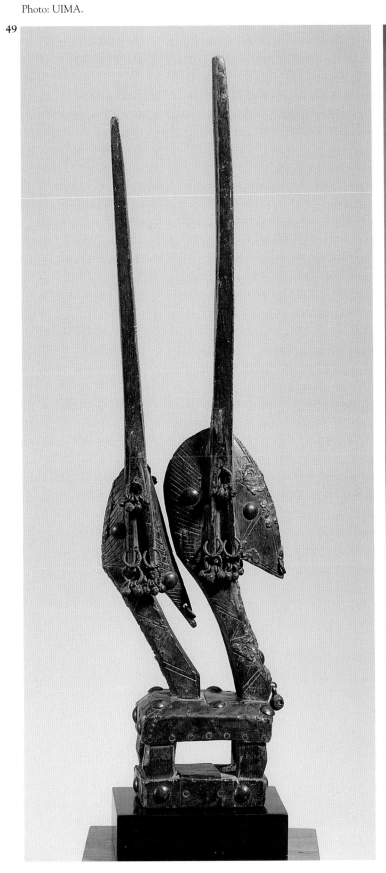

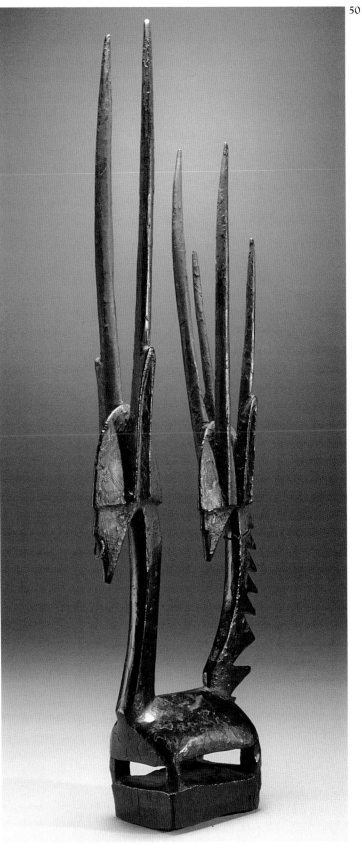

51. Knife with sculpted handle; Bembe, Zaire. Wood, metal; H. 10 1/4 in. Gerald and Lila Dannenberg.

52. Neckrest; Shona(?), Zimbabwe. Wood; L. 6 1/2 in. Carol and Jerome Kenney.

53. Neckrest; Shona(?), Zimbabwe. Wood; H. 6 1/2 in. Pamela and Oliver E. Cobb. Photo: Paul Macapia.

54. Horned cap; Zaire. Raffia palm fiber, medicine-filled antelope horns. The Field Museum, acquired in 1903 (cat.#34017, neg.#A112631c). Photo: Diane Alexander White.

51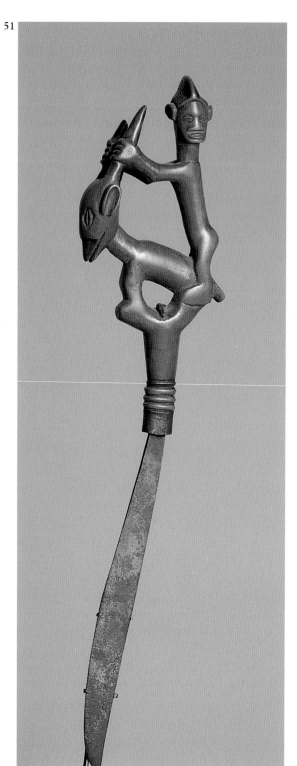

52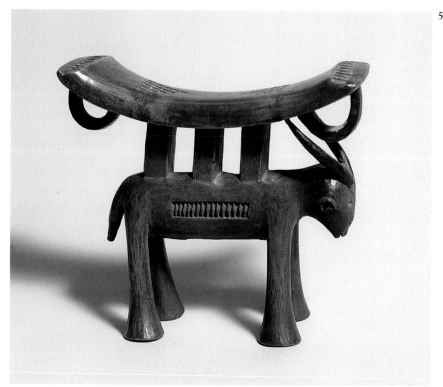

53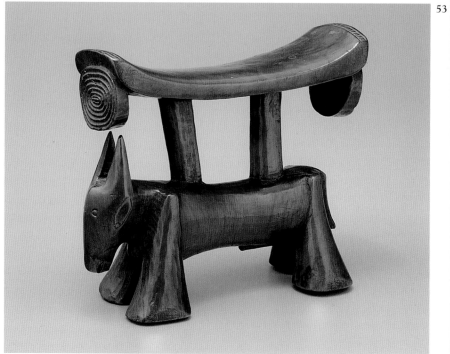

54

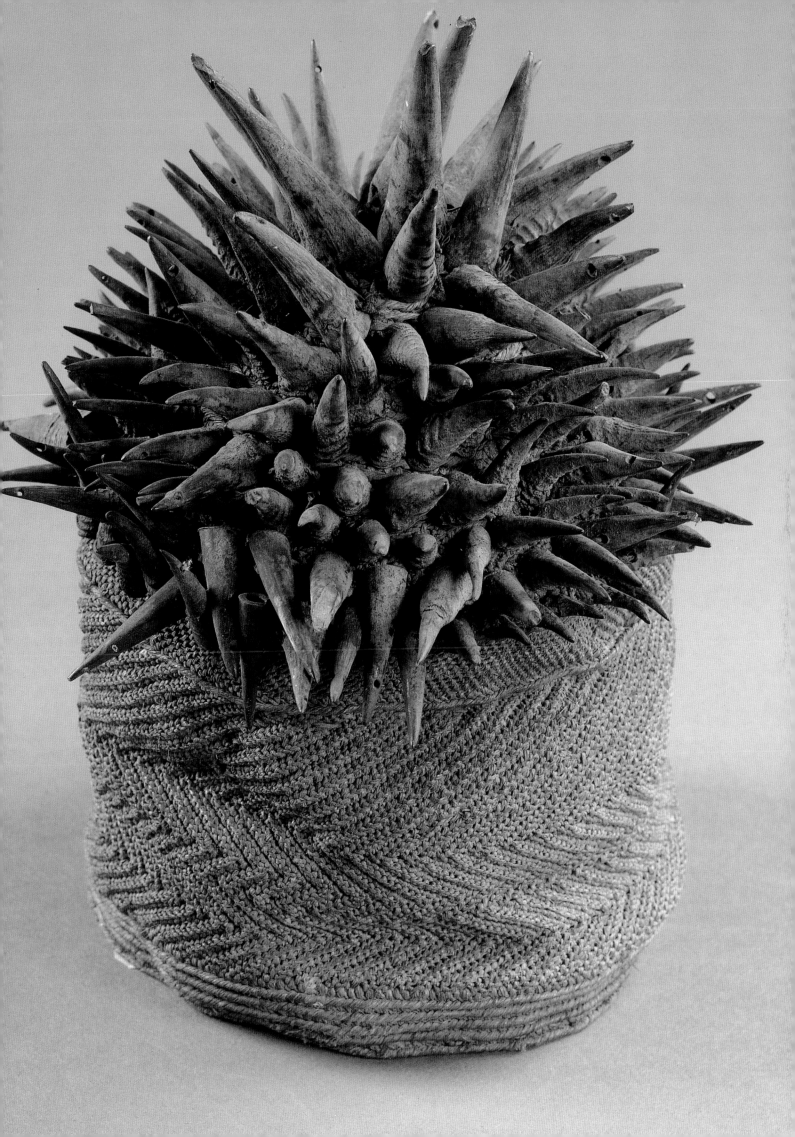

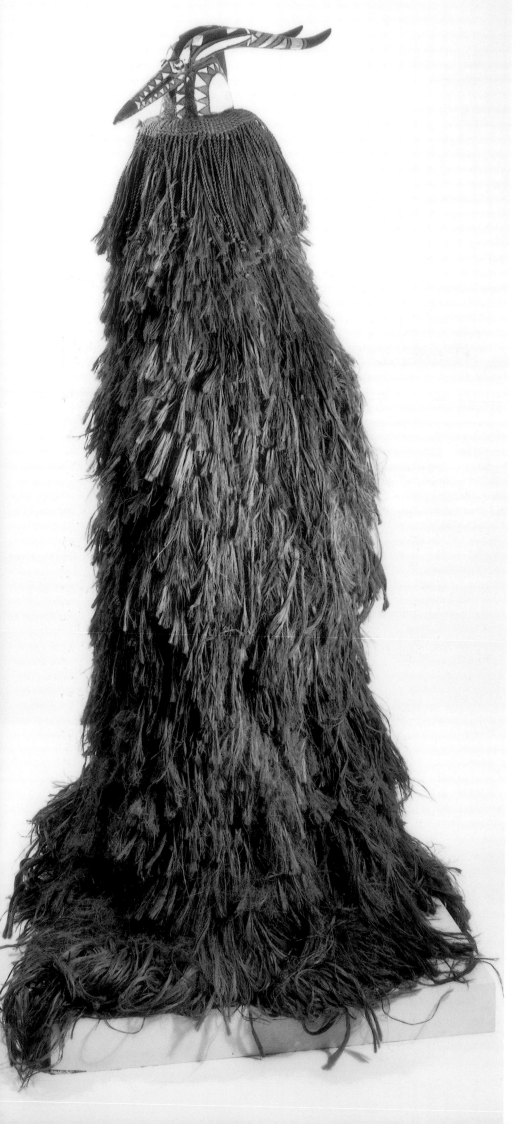

55

55. Antelope mask with costume; Mossi, Burkina Faso. Wood, paint, fiber; H. 78 in. University of Iowa Museum of Art, The Stanley Collection (1979.43). Photo: UIMA.

56. Pig or aardvark mask; Chokwe; Zaire/Angola/Zambia. Wood, paint, fiber; H. 10 5/8 in. Marc Felix. Photo: Dick Beaulieux.

57. Animal sculpture, okapi(?); Pere, Zaire. Wood, paint; L. 28 in. Marc Felix. Photo: Dick Beaulieux.

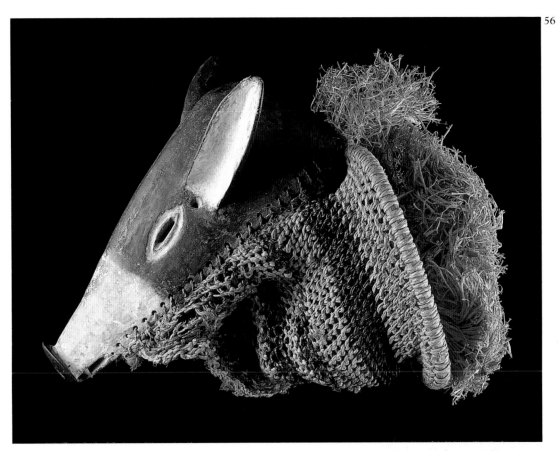

56

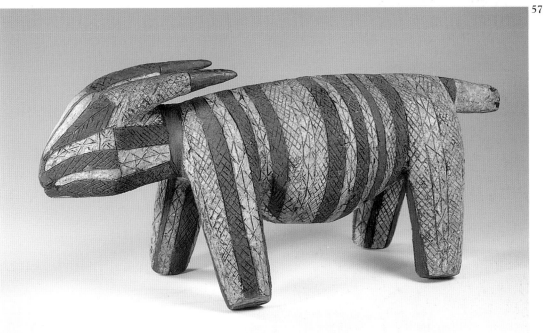

57

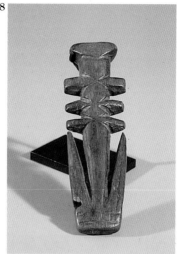

58

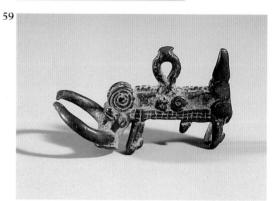

59

58. Flute; Mossi, Burkina Faso.
Wood; H. 5 1/4 in. Thomas G.B.
Wheelock.

**59. Pendant (warthog); Burkina
Faso.** Brass; L. 1 5/8 in. Thomas G.B.
Wheelock.

**60. Pair of warthog masks; Nuna (?),
Burkina Faso.** Wood, paint;
L. 12 1/2 in. Thomas G.B. Wheelock.

**61. Warthog mask; Mossi, Burkina
Faso.** Wood, paint; H. 23 1/4 in.
Thomas G.B. Wheelock.

60

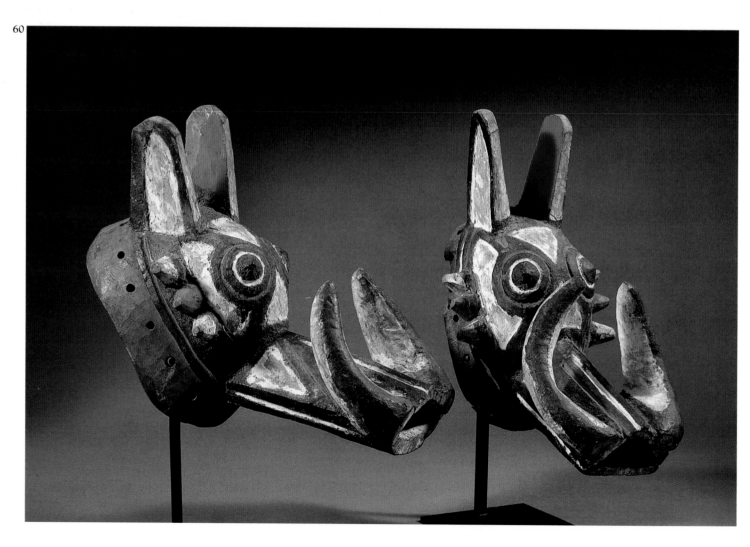

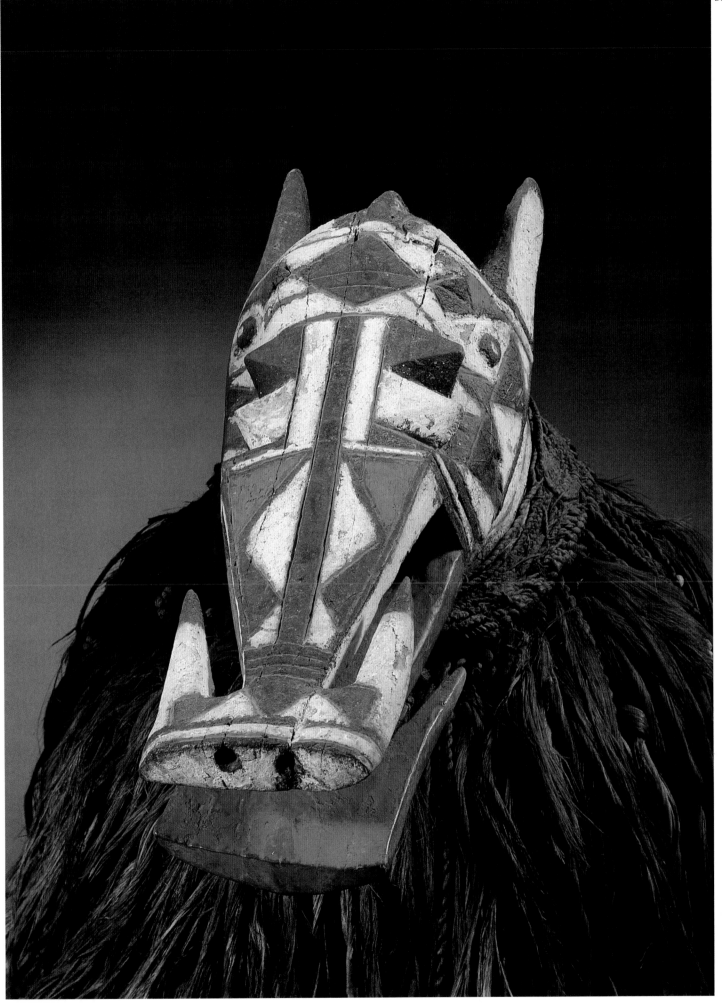

62. Wild bush pig mask (*ngulu*); Chokwe, Zaire/Angola/Zambia. Used in *mukanda* initiations, this mask appeared in performances with human characters, both male and female. The performer wearing this mask danced on all fours mimicking the animal's uncontrollable nature. "Among Bantu-speaking peoples the unpredictable and wild behavior of the bush pig is associated with females of all species, and the mask is said to reflect the difficulties men have controlling women" (Jordân in Roy 1992:225). Wood, beads, fiber; H. 9 1/2 in. The University of Iowa Museum of Art, The Stanley Collection (x1990.705). Photo: UIMA.

63. Drum; Lobala, Zaire. This enormous slit-gong, shaped like a charging buffalo, was used to send messages across long distances, calling people together and conveying other important news. Writing in 1911, a European visitor described how in the quiet of dusk the sound of such drums echoed across many miles (Roy 1992:209). Wood; L. 8 3/4 ft. The University of Iowa Museum of Art, The Stanley Collection (x1990.688) Photo: UIMA.

64. Buffalo mask; Tabwa, Zaire and Zambia. The Tabwa associate buffaloes with chiefs and culture heros. Both are "seen as sources of wisdom, nurturance, and protection, but they are also feared" (Roberts in Roy 1992:244). Buffaloes are crepuscular, most active during the magical hours of dusk and dawn. During the day they stand motionless behind undergrowth and virtually disappear. When encroached upon or hurt buffaloes become extremely dangerous animals. Wood, cowrie shells; H. 29 in. The University of Iowa Museum of Art, The Stanley Collection (x1990.690). Photo: UIMA.

62

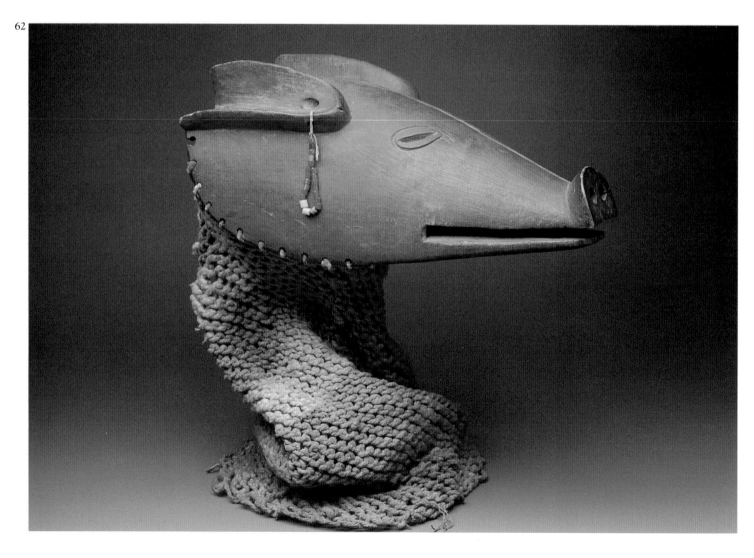

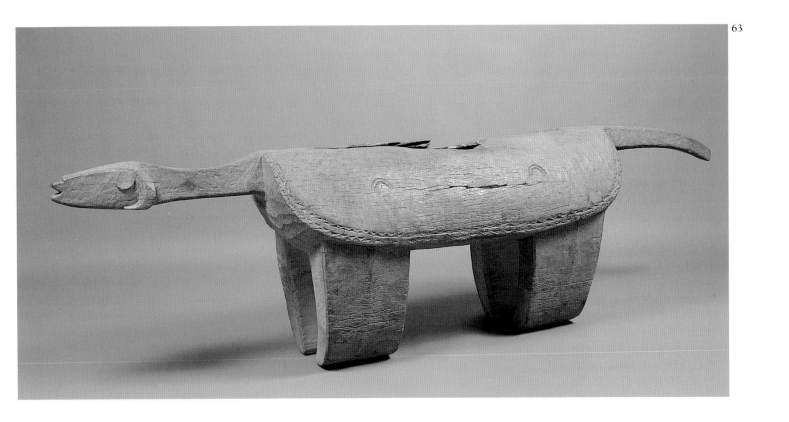

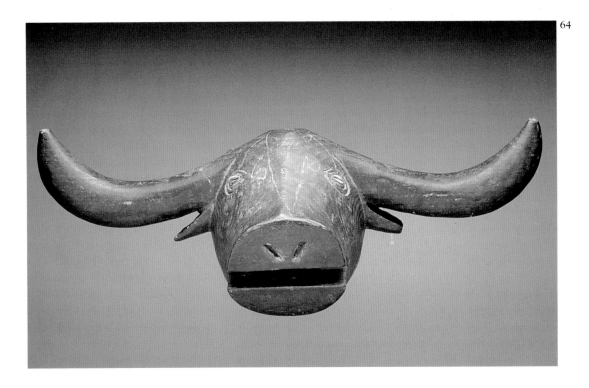

Anomalous

Often, the more anomalous the beast, the more essential its role in African systems of thought, the more closely it is associated with spiritual forces, and the more conspicuously it appears in visual arts. Creatures that cross categories figure prominently in African symbolic systems—"fish" that climb trees (pangolins), animals apparently capable of magical transformation (chameleons), creatures able to move about both in and out of water (crocodiles), animals that are too close to human (baboons and chimpanzees), and other anomalous animals.

The contradictory ways anomalous animals behave defy all expectations. It is especially these unpredictable animals that inspire artworks "made by human hands, for spirit eyes" (Poynor 1995). In the cultures where these objects were made, people rely on animals and spirits alike for their survival, drawing prosperity, health, and fecundity from them. But, as anthropologist Mary Douglas has noted, "animals and spirits characteristically are shy of humans and do not come out spontaneously into the human world" (1966). Animal masks and other objects used in rituals of healing, hunting, initiation, and divination are often created to coax nature spirits to come close to people and act on their behalf. These spirits have aesthetic preferences that inspire artistic creativity, imagination, and invention. Among the Senufo people of the Ivory Coast, for example, "bush spirits are thought to have some human qualities . . . to enjoy music, dance, sculpture, and ornament" (Glaze 1978:65).

65. Nkisi nkondi (in the form of a monkey); Kongo, Zaire. This sculpture, used to heal and protect, has recessed areas where medicines were inserted, at the top of the head, in the center of the stomach, and at the bottom of the spine. "An *nkisi* that lacks medicines can accomplish nothing; they are its being, its hands, its feet, its eyes. Medicines are all these, so an *nkisi* that lacks medicines is dead and has no life" (MacGaffey 1993:43). In addition, the nails were inserted to bind oaths, land contracts, peace treaties and other important agreements. Wood, pig hide, red cloth, glass, iron, paint; H. 14 3/4 in. Rijksmuseum voor Volkenkunde, Leiden (497.89). Photo: B. Grishaaver.

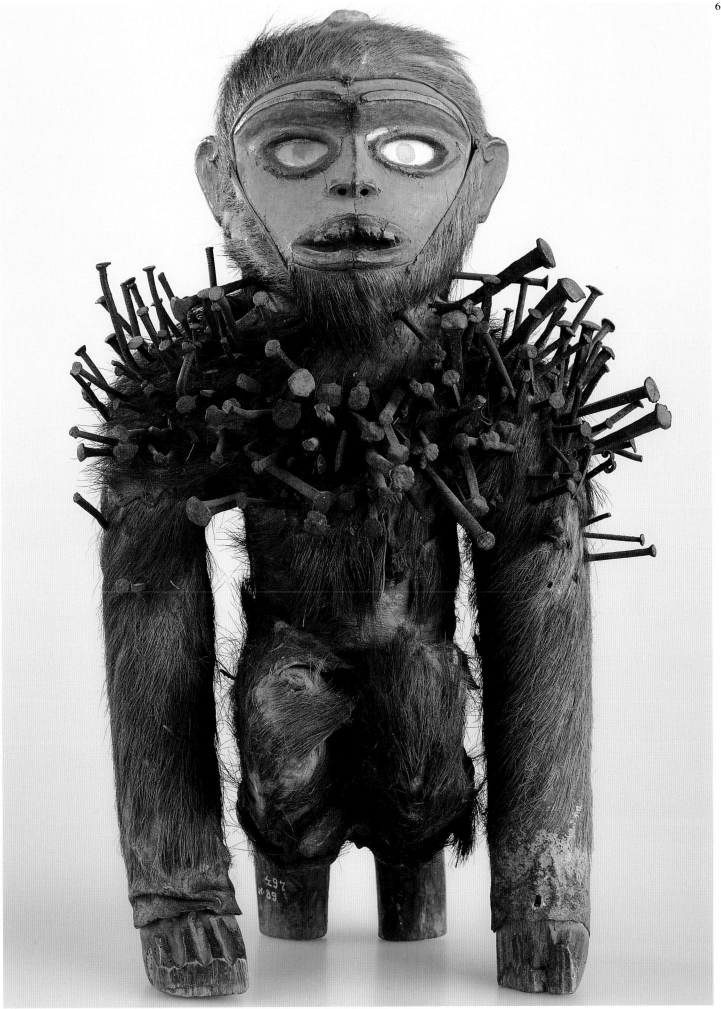

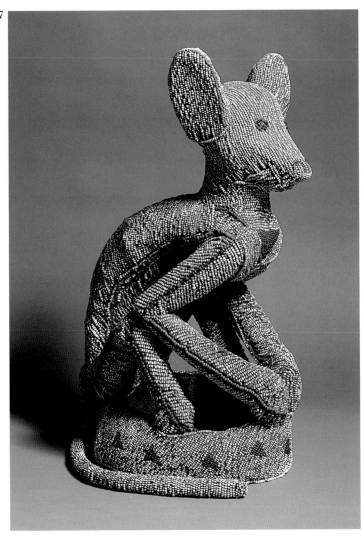

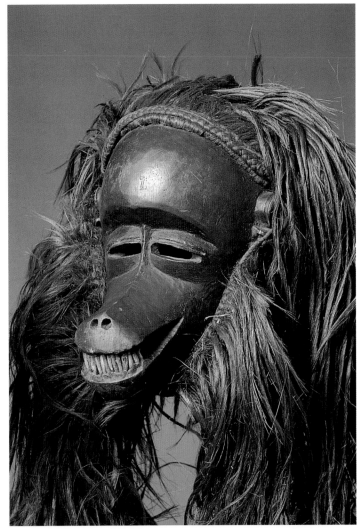

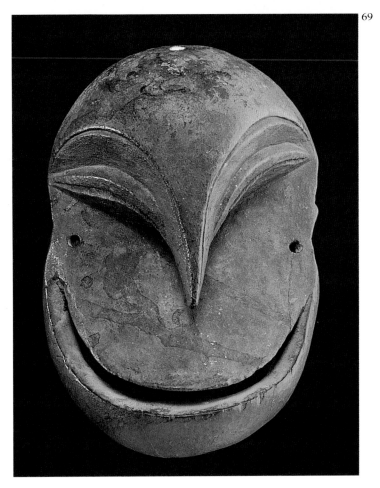

66. Heddle pulley (of a fruit bat?); Guro, Ivory Coast. Wood; H. 5 3/8 in. Drs. Jean and Noble Endicott.

67. Headdress; Bamileke, Cameroon. Wood, beads, cloth; H. 17 in. Phyllis and Stuart Plattner. Photo: Courtesy Thomas Alexander.

68. Baboon mask; Bobo, Burkina Faso. Wood, fiber; H. 24 in. Peter and Nancy Mickelson.

69. Chimpanzee-human mask; Hemba, Zaire. Masks like this one are called *mwisi gwa so'o* or "spirit-invested object of the chimpanzee human." They appear at funerals wearing Black and White Colobus monkey hair and pelts from both domestic and wild animals. "Like death, the *so'o* is a disturber of the order of the system. Anomalous, category-confusing charac-teristics of the *so'o* parallel Hemba conceptions of the afterworld, where categories of things that are clearly distinct in the world of the living become muddled and mixed" (Blakely and Blakely 1987:36). Wood; H. 8 1/2 in. The University of Iowa Museum of Art, The Stanley Collection (x1986.402). Photo: Mark Tade.

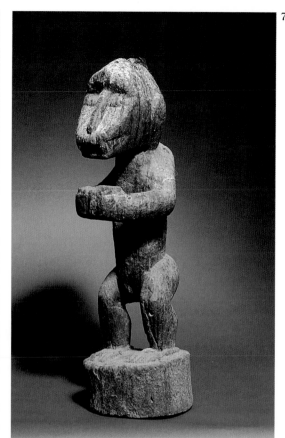

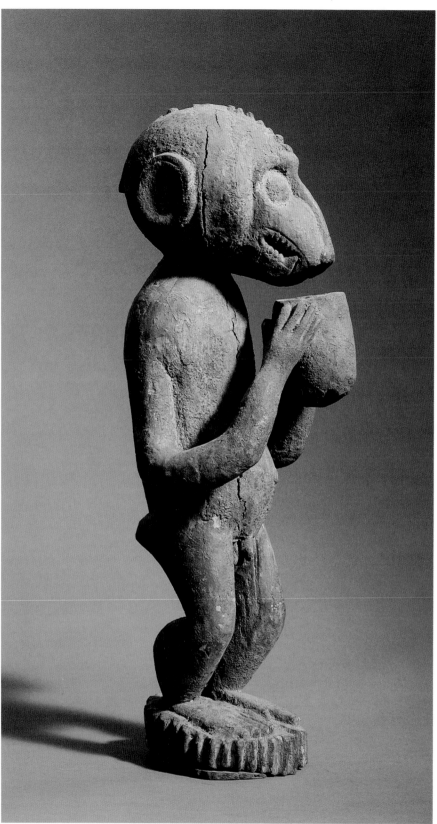

70. Baboon figure (*gbekre*); Baule, Ivory Coast. Wood, sacrificial material; H. 20 1/2 in. Ernst Anspach.

71. Baboon figure (*gbekre*); Baule, Ivory Coast. Wood, sacrificial material; H. 25 in. Private collection.

72. Baboon figure (*gbekre*); Baule, Ivory Coast. Wood, sacrificial material; H. 24 1/4 in. Private collection. Photo: Dirk Bakker.

Baule monkey figures have open hands or hold small cups for sacrificial offerings. Sacrifices are also poured directly over the figures.

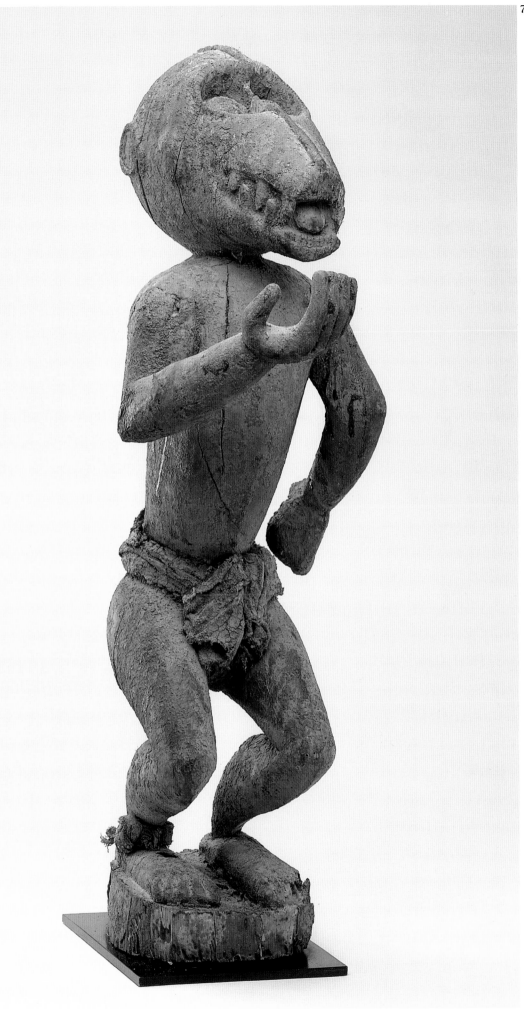

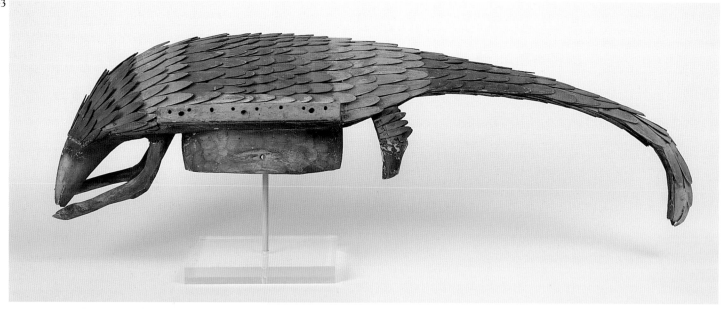

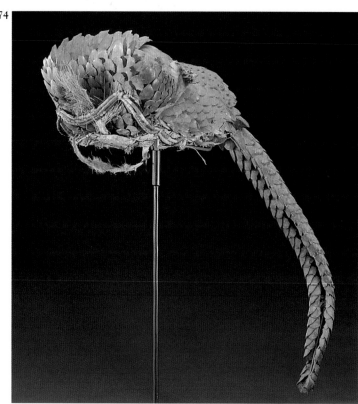

73. Pangolin headdress; Ekpeye, Nigeria. The pangolin headdress is called the blacksmith of the animal world, described as "both mammal and reptile and at the same time neither one" (Picton 1988:48). The Egbukere celebration, in which the pangolin appears, is thought of as a time in between, a time of renewal and transformation. Wood, paint; L. 3 ft. 4 in. Des Moines Art Center Permanent Collection (1978.27), Gift of Julian and Irma Brody. Photo: Craig Anderson, Des Moines, Iowa.

74. Hat; Bangandu-Mongo, Zaire. Pangolin skin, fiber, fur, beads; H. 19 1/2 in. University of Iowa Museum of Art (x1986.90). Photo: UIMA.

75. Slippers, pair (in the form of scorpions); Asante, Ghana. Leather; L. 12 3/4 in. The Metropolitan Museum of Art, Gift of Bryce Holcombe Collection of African Decorative Arts (1982.485.19-20).

76. Kola nut container (in the form of a pangolin); Yoruba, Nigeria. Preeminent among liminal animals in African art is the pangolin. When it encounters a human, it plays dead, curled in a ball easily captured, as shown here. Wood, diam. 10 in. Private collection.

77. Hat (with three frogs); Bamileke, Cameroon. Fiber, felt, beads, shell; 9 1/2 in. Minneapolis Institute of Arts. Photo: Courtesy of the Minneapolis Institute of Arts.

78. Lidded box; Edo; Kingdom of Benin, Nigeria. Ivory; L. 6 3/8 in. University of Pennsylvania Museum, Philadelphia (object#29-93-6). Photo: Neg.#58-62573.

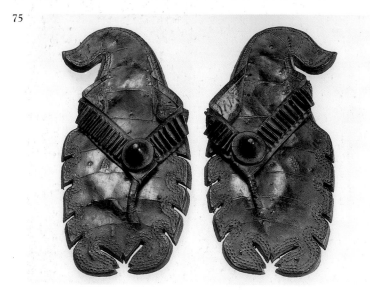

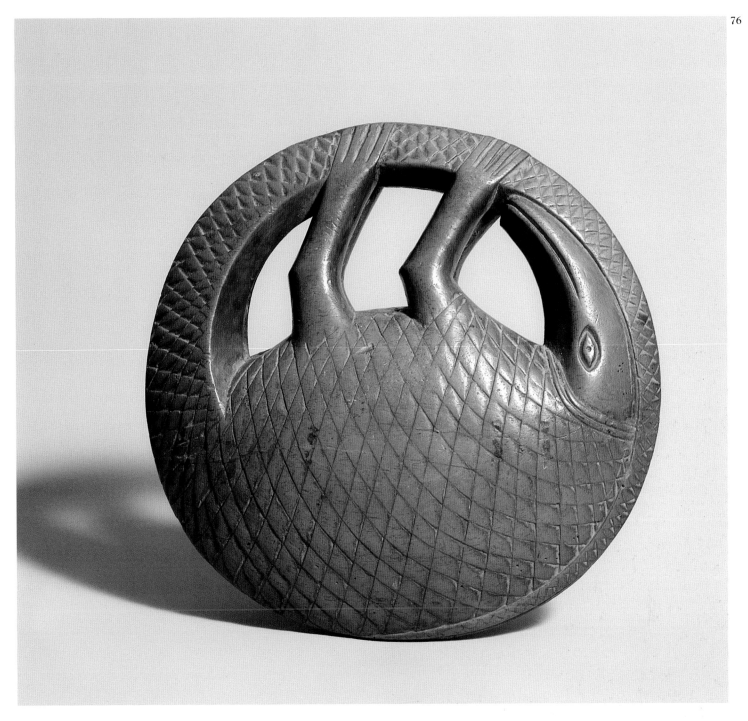

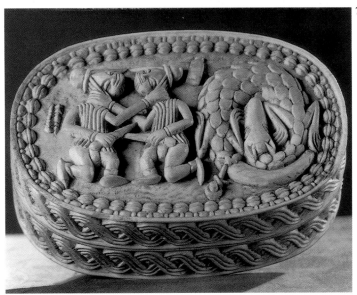

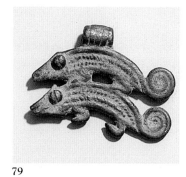

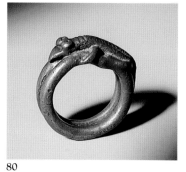

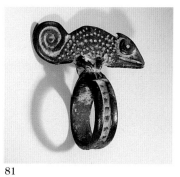

79

80

81

79. **Pendant (with pair of chameleons); Burkina Faso.** Bronze, W. 1 11/16 in. Thomas G.B. Wheelock.

80. **Ring; Burkina Faso(?).** Brass; Diam. 1 1/4 in. David T. Owsley.

81. **Ring; Senufo(?); Ivory Coast, Mali, or Burkina Faso.** Senufo people say the chameleon has both "knowledge that reaches back to the mysterious beginnings of the world and an awareness of unpredictable and malevolent forces at work in the present" (Glaze 1978:67). Brass; H. 1 5/8 in. Drs. Jean and Noble Endicott.

82. **Headdress (with pair of chameleons); Bwa, Burkina Faso.** Wood, paint; L. 19 in. Thomas G.B. Wheelock.

83. **Chameleon mask; Nuna(?), Burkina Faso.** Wood, paint; H. 26 in. UCLA Fowler Museum of Cultural History, Gift of George Frelinghuysen. Photo: Courtesy of UCLA Fowler Museum of Cultural History.

84. **Stencil (for textile printing); Yoruba, Nigeria.** Zinc; 18 1/2 in. Susan and John Picton. Photo: John Picton.

82

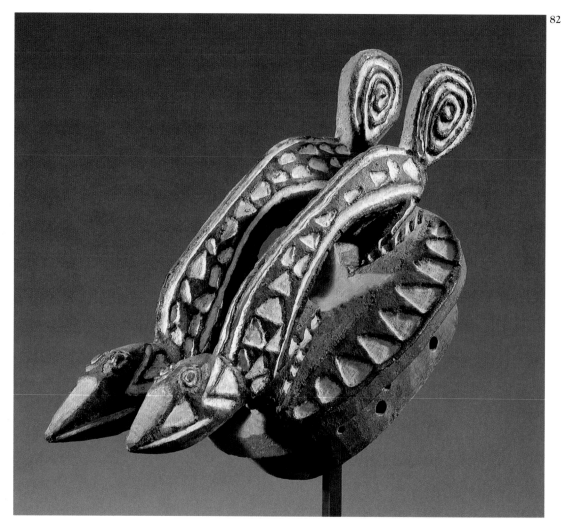

83

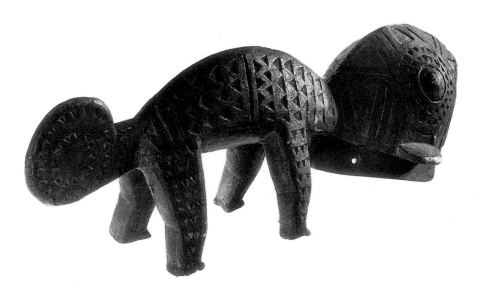

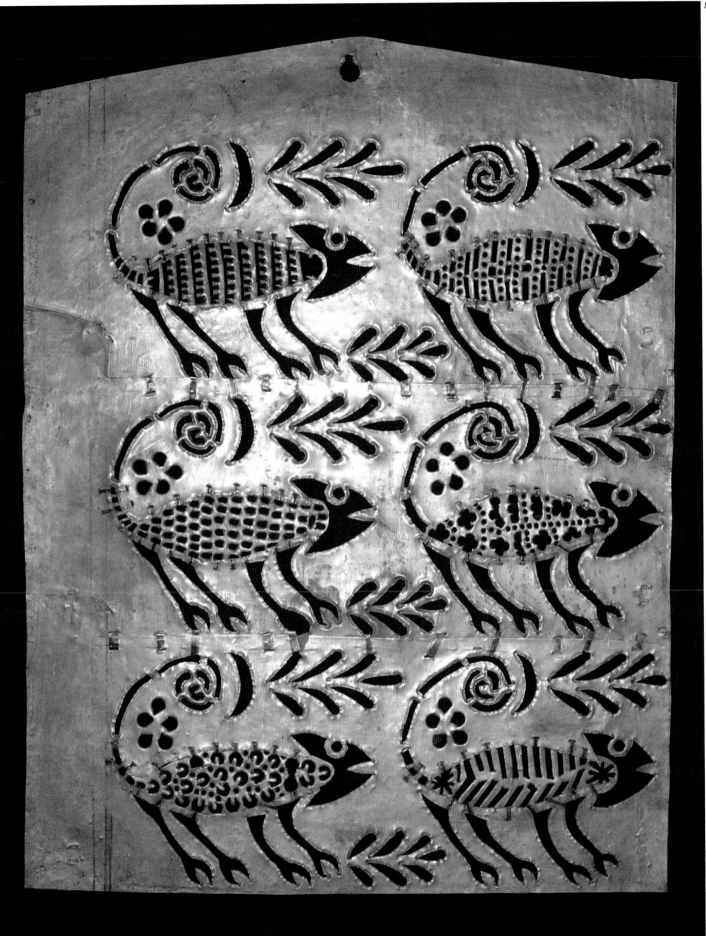

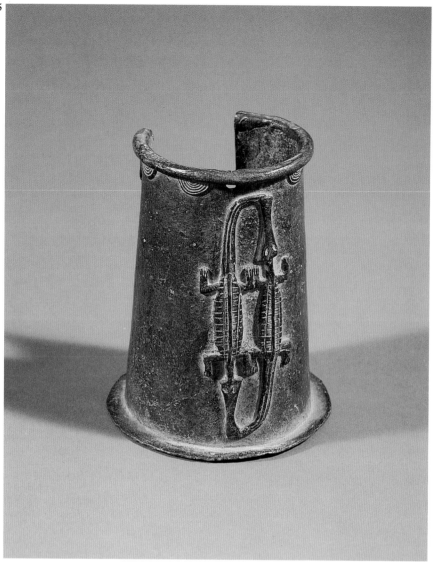

85. Anklet (with crocodiles); Kasena, Burkina Faso. Brass, H. 5 1/2 in. Thomas G.B. Wheelock.

86. Box; Akan, Ghana. The motif of two crocodiles with a common stomach on the lid of this box refers to the proverb "*funtum frafu denkyem frafu*," literally, "bellies mixed up, crocodiles mixed up" (Cole and Ross 1977:10). The image is intended to discourage greediness and egoism since no matter which crocodile eats the food it still goes to the same stomach. Alternatively, the crocodiles argue that the pleasure of tasting the food is part of its enjoyment (Kyerematen 1964:48). Brass, L. 2 3/4 in. Ernst Anspach.

86

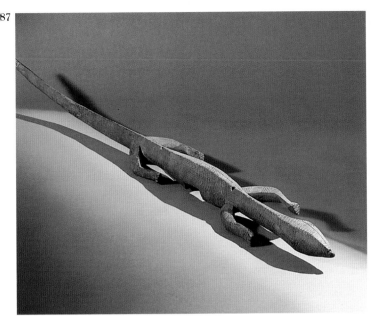

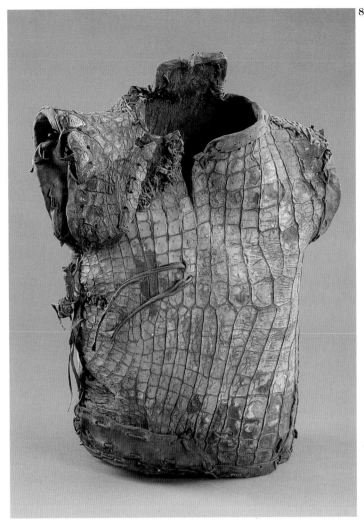

87. Doorlock handle (with monitor lizard); Samo(?), Burkina Faso. Wood; L. 52 3/4 in. Thomas G.B. Wheelock.

88. Skin vestment; Cameroon. Crocodile hide; H. 22 in. The Field Museum, purchased August 7, 1925. (cat.#175394, neg.#A112630C). Photo: Diane Alexander White.

89. Divination tool; Kuba, Zaire. Wood, H. 3 in. Pamela and Oliver Cobb. Photo: Paul Macapia.

89

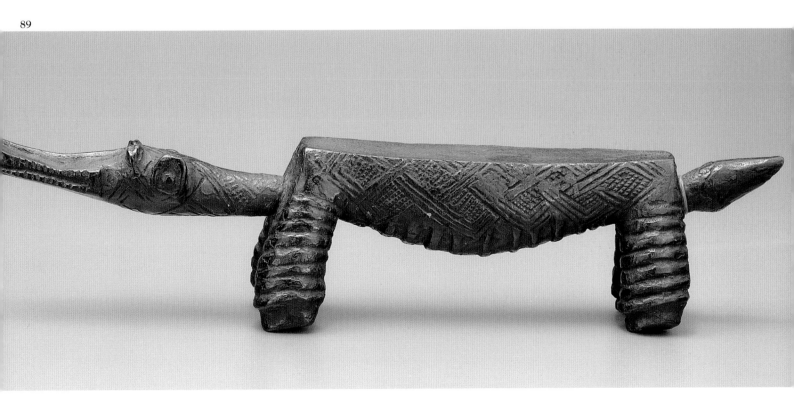

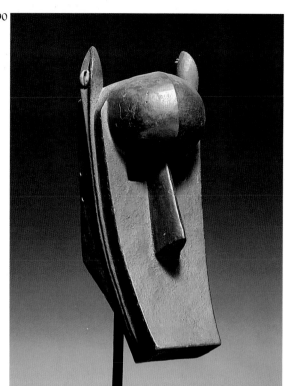

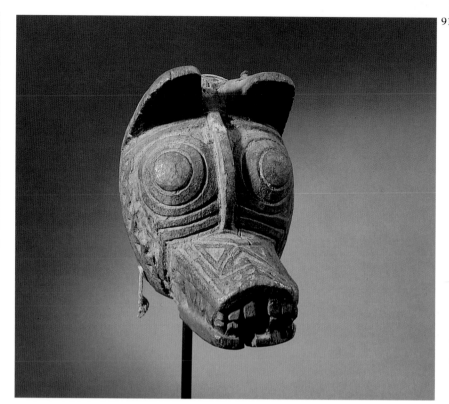

90. Hyena mask; Bamana, Mali.
Wood, cowrie shells, fiber; H. 17 1/4
in. Rosemary and George Lois.

Bamana hyena masks are worn by
junior members of the men's *kore*
society in a performance which
through negative example shows
inititiates how not to behave. The
hyena mask, with its bulging forehead
and gaping mouth, represents
insatiable, reckless behavior, "a
symbol of human folly and imperfect
knowledge" (Roy 1979:35).

**91. Hyena mask; Nunuma, Burkina
Faso.** Wood; H. 11 1/4 in. Thomas
G.B. Wheelock.

**92. Hyena mask; Zaramo(?),
Tanzania.** Wood, paint;
H. 15 in. Dr. Michael Berger.

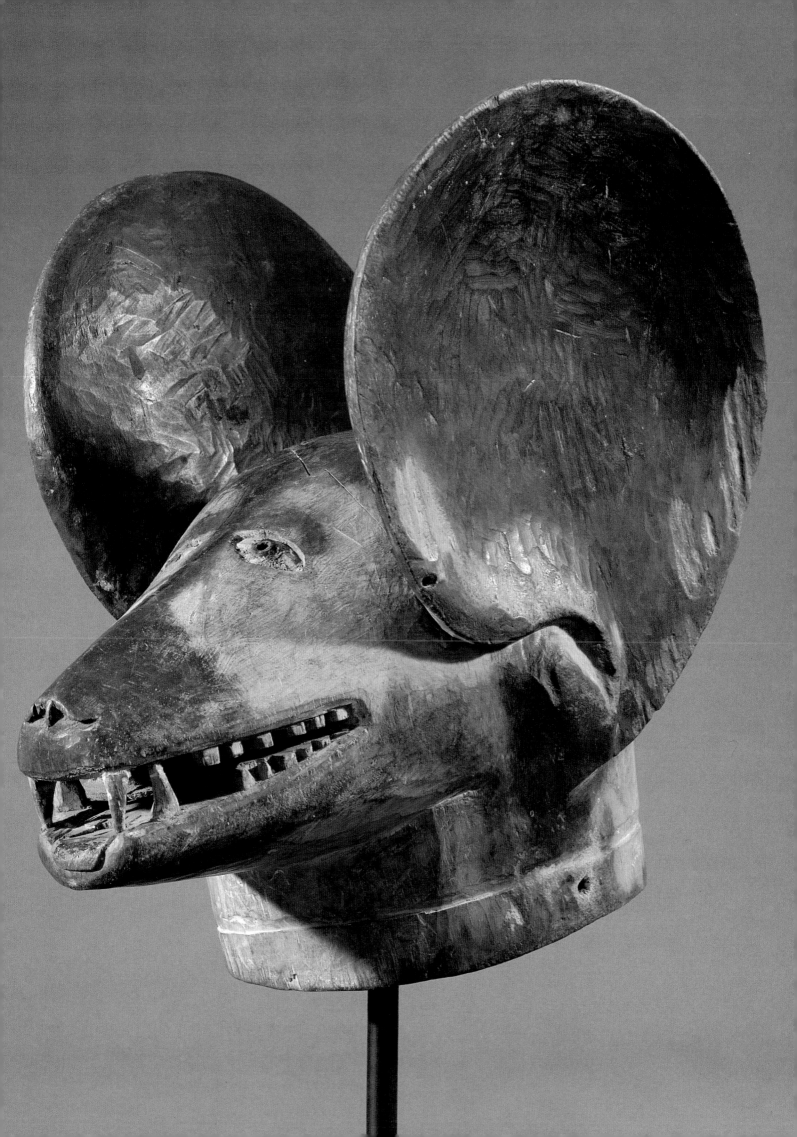

Composite

Composite masks and sculptures merge diverse human and animal features to present creatures that are not part of the visible, everyday world. These chimera-like creations especially "define essential humanity through the establishment of its outer limits — the non-human or uncivilized as well as the more-than-human or supernatural" (Ben-Amos 1976:243). Their shape-shifting forms serve socially therapeutic functions.

Often, at times of social crisis or momentous change, elements from the most remote realms of the animal world are brought into the normally secure environment of village life to serve a transformative purpose. For example, as Allen Roberts has noted, "the transformations that masked performances assist people to undergo are not limited to those of individual actors' changes of state and their assumption of spiritual form. Rather, all of society may be experiencing radical transformation, and this dynamic process may be conceptualized, dramatized, and made more broadly accessible through the use of masks" (1990:38). As beings that exist outside the familiar, everyday world, composite creatures offer a sense of "pure possibility" with unlimited potential to move the world in directions no one could have imagined.

93. Scorpion mask; Bwa or Nunuma(?), Burkina Faso. With eyes of poisonous red seeds (*Abrus precatorius*) and a single red horn projecting forward as the insect's tail, this mask is the embodiment of one of the most dangerous and unpredictable but potentially most beneficent of all bush spirits. Wood, paint, seeds; H. 17 1/4 in. Thomas G. B. Wheelock.

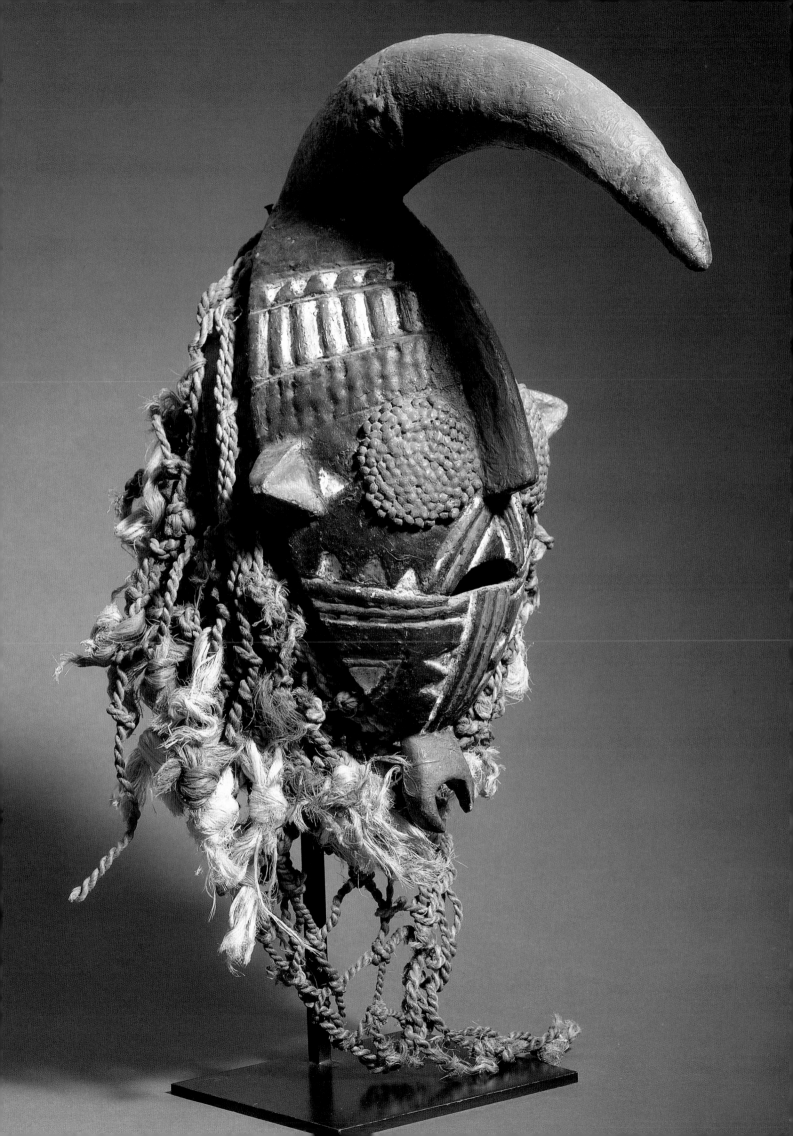

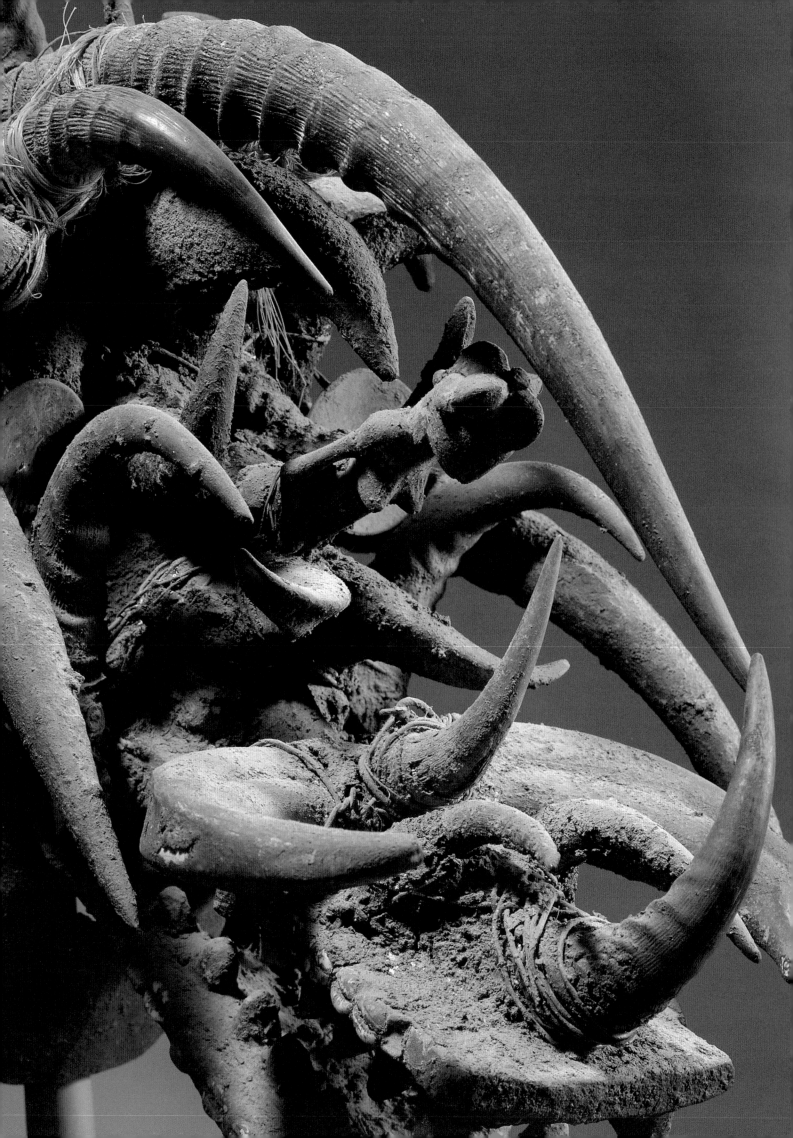

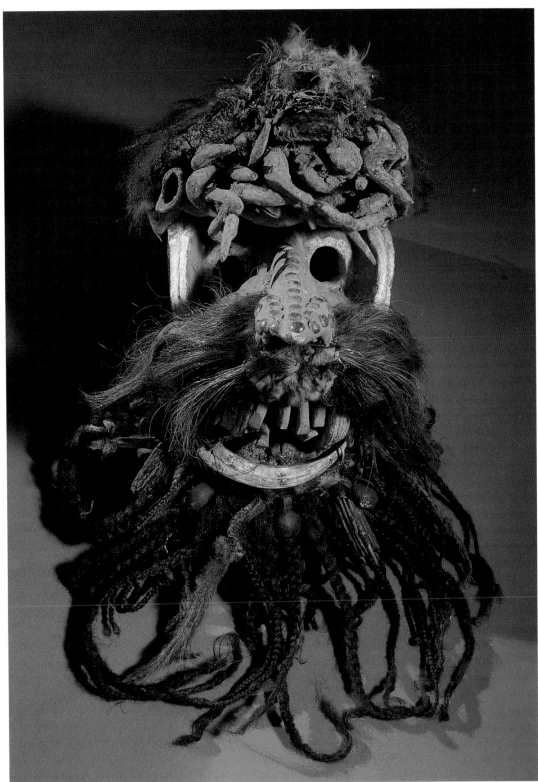

94. Helmet mask (*Kponyungo*) (detail); Senufo; Ivory Coast, Mali, or Burkina Faso. This mask's eyes are made of the circular bases of stemmed wine glasses, turned upside-down, in a hallucinatory combination with horns and tusks of all shapes and sizes and a small, finely carved, neatly coiffured, female figure inserted into the center of it all. This mask, perhaps more than any other in the exhibition, "gives fear a face." Wood, animal horns, fiber; L. 27 in. David T. Owsley.

95. Mask; Sapo, Liberia. Sapo masks join multiple ferocious animal parts and other materials, including human hair, to become fearsome symbols of civilizing, moral forces and agents of social control. Wood, metal, cloth, paint, tusks, fur, roots, human hair, man-made fiber, leather amulets, bundles of vegetable matter; H. 17 1/4 in. Merton D. Simpson Gallery.

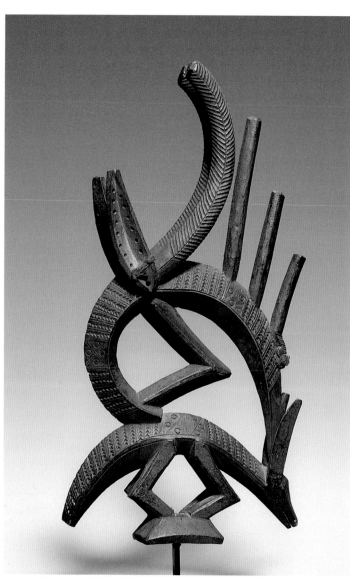

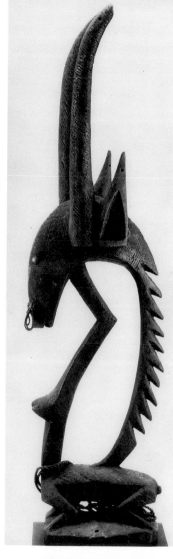

96. *Chiwara* dance crest; Bamana, Mali. Wood, paint; H. 15 1/4 in. Regina and Stephen Humanitski.

97. *Chiwara* dance crest; Bamana, Mali. Wood; H. 25 1/2 in. Lucien Van de Velde, Antwerp. Photo: Dubois, Brussels.

The well-known *chiwara* headdresses, danced by the Bamana people of Mali during planting and harvest celebrations, combine the humped back of a pangolin, the phallic snout and tall ears of an aardvark, and the horns of a roan antelope — all animals associated with the generative powers of the earth, and, by extension, with human agriculture and fertility. As here, sometimes *chiwara* are also given human attributes, male or female.

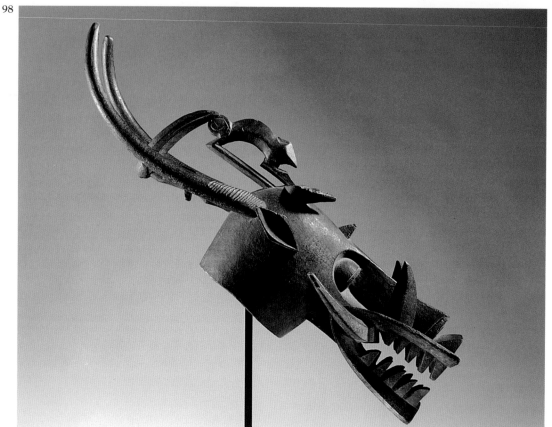

98. Helmet mask *(Kponyungo)*; Senufo, Ivory Coast, Mali, or Burkina Faso. Senufo *Kponyungo* masks incorporate the features of many different animals to become "a condensed visual statement acknowledging the reality of evil and at the same time providing a means to deal with it" (Glaze 1981:137). Wood, L. 41 in. The University of Iowa Museum of Art, The Stanley Collection (x1986.533). Photo: Mark Tade.

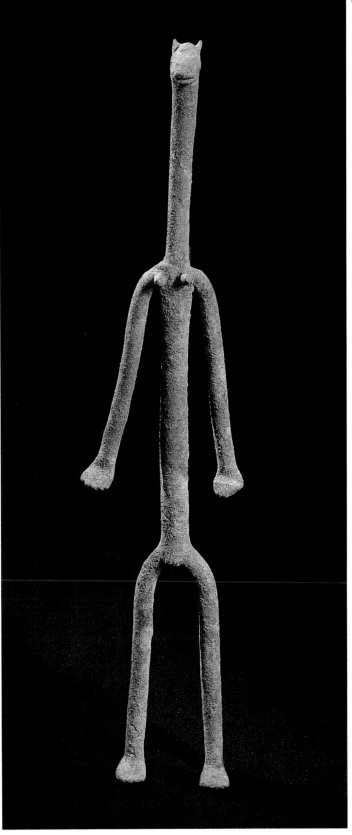

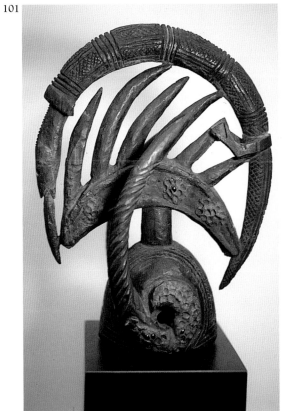

99. Fragment of a bell(?); Lower
Niger region, Nigeria, date unknown.
Bronze, glass beads, H. 7 in. Toby and
Barry Hecht. Photo: Toby T. Hecht.

100. Composite figure; Mali, date
unknown. Bronze, H. 11 3/8 in.
Private collection, Chicago.

101. Drummer's headdress; Afo,
Nigeria. This headdress combines a
chameleon-and-cocks-comb superstruc-
ture with antelope horns in an elegant
spiral of dynamically curving forms
that insinuate movement even when
static. Wood, H. 11 1/4 in. Toby and
Barry Hecht. Photo: Toby T. Hecht.

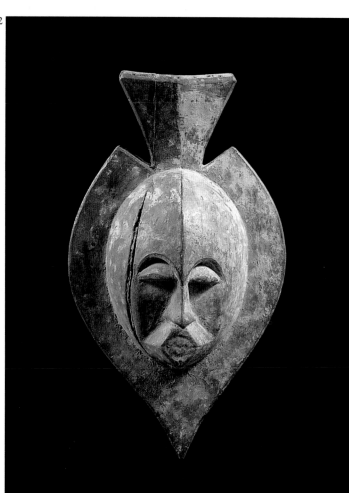

102. Headdress; Ijo, Nigeria; Wood, paint; H. 18 1/2 in. Ernst Anspach. Created for a benevolent water spirit, this mask combines the face of a human with the body of a fish.

103. Headdress; Ekpeye, Nigeria. Wood, paint, mirrors; L. 80 in. Private collection.

104. Headdress; Abua, Nigeria. Wood, paint; H. 20 1/2 in. Donald Morris Gallery. Photo: Courtesy Donald Morris Gallery.

103

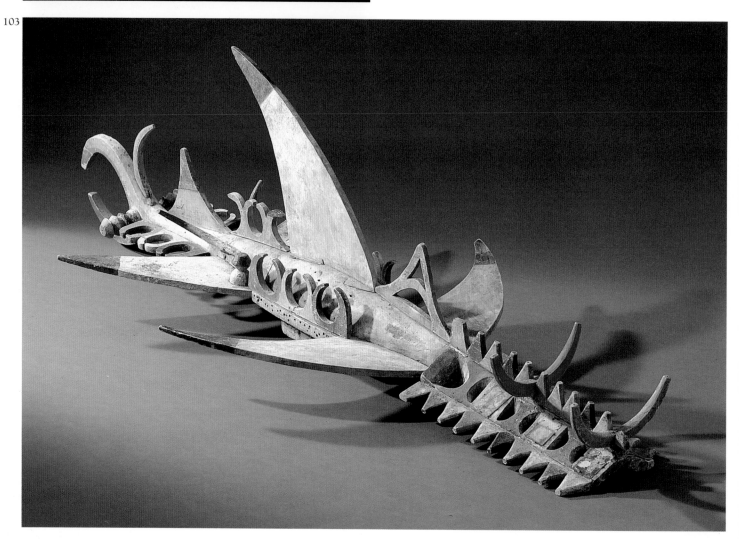

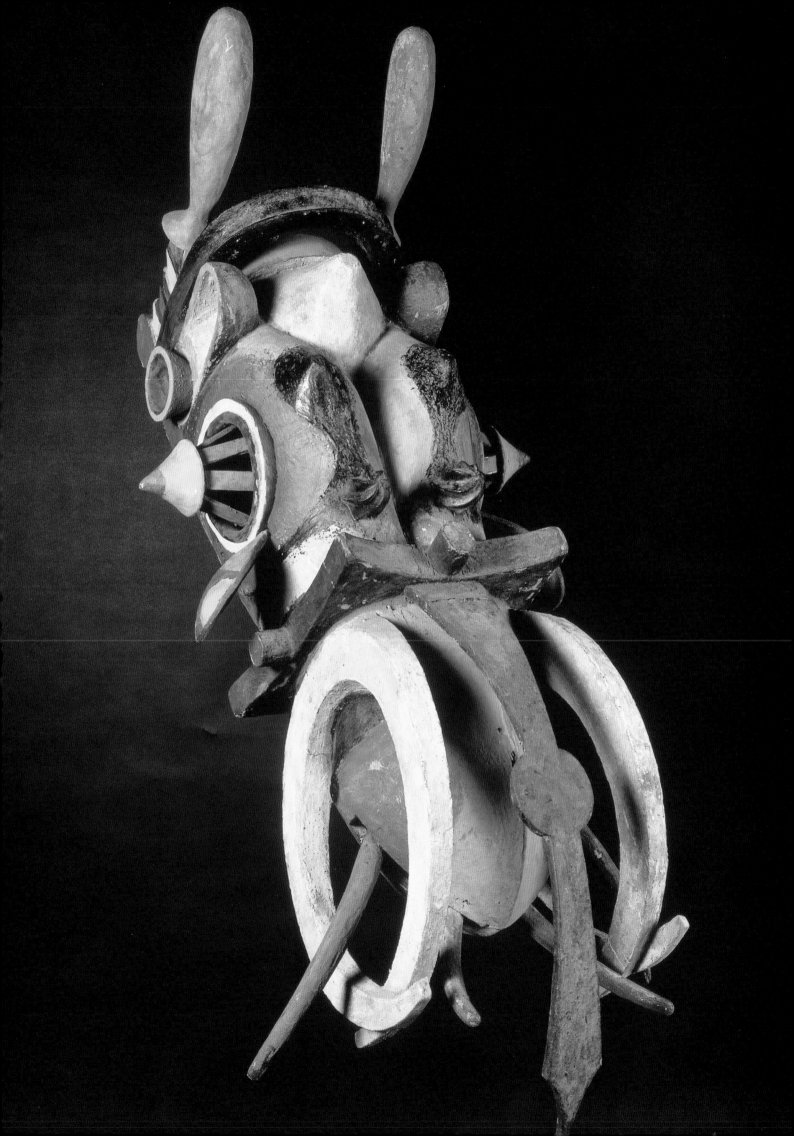

**105. Two-headed animal; Mambila,
Nigeria.** Wood, paint; L. 11 in. Nancy
and Robert Nooter.
Photo: Robert Nooter.

106. Headdress; Mambila, Nigeria.
Wood, paint; L. 15 in.
William W. Brill.

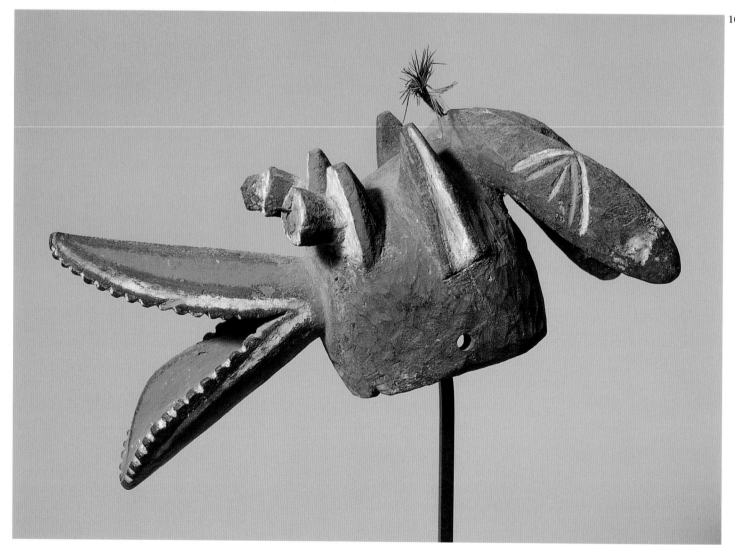

107. Figure (*ivri*); Isoko, Nigeria.
Isoko people of the northwestern
region of the Niger Delta use the
word *ivri* to describe both sculptures
like this one and aggressive personality
traits. Such sculptures, both large and
small, harness violently destructive,
agressive behavior and give it
constructive purpose, transforming for
example, stubbornness or truculence
into tenacity (Peek in Vogel
1981:141-143). Wood; H. 28 in.
Walt Disney's Tishman African
Art Collection.

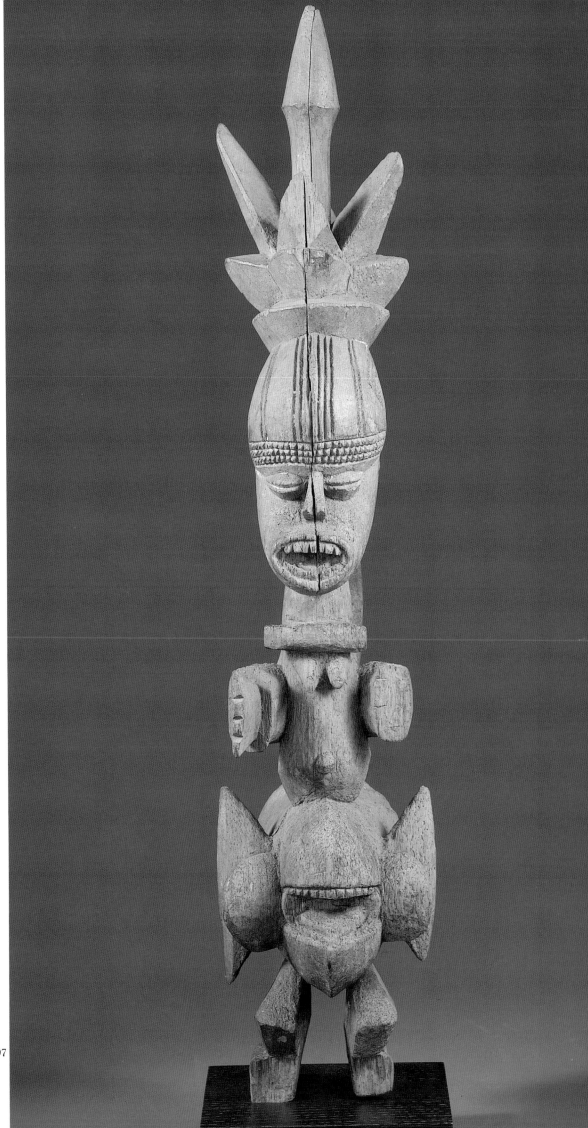

107

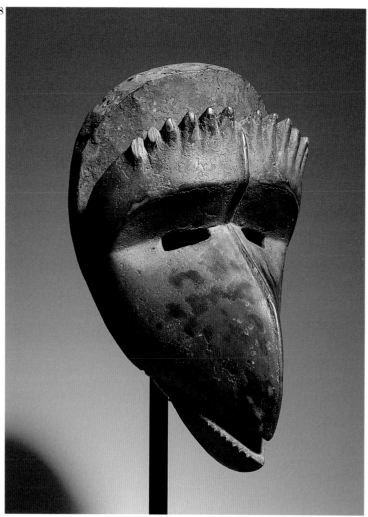

108. Mask; Dan, Ivory Coast. Wood; H. 10 in. Private collection.

109. Mask; Ibibio, Nigeria. Masks personifying ancestral spirits enforced laws made by Ekpo, the society which governed Ibibioland before the advent of British colonial rule in 1903 (Ekpe Akpabot 1975:25-27). These societies were known as *Mbre Idem*, music of the spirits. Masks like this one were called *inuen ekpo*, or bird ekpo. Wood, paint, cloth; H. 12 in. Margaret H. Demant. Photo: Dirk Bakker.

110. Mask; Ogoni, Nigeria. Wood, paint, fiber; H. 7 1/2 in. Mauricio and Emilia B. Lasansky. Photo: Mark Tade.

111. Mask; Ogoni, Nigeria. Wood; H. 8 in. Toby and Barry Hecht. Photo: Toby T. Hecht.

112. Helmet mask; Bembe, Zaire. With the eyes of an owl on all sides, this mask has "panoramic vision and keeps the opposing powers of nature (male/female, night/day etc.) in balance and thus preserves harmony" (Felix 1989:166). Wood, paint; H. 19 3/8 in. Stewart J. Warkow.

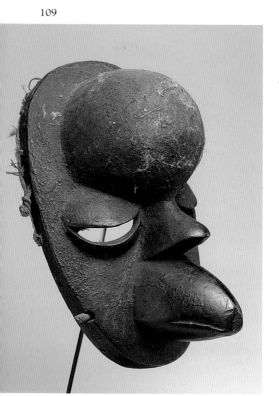

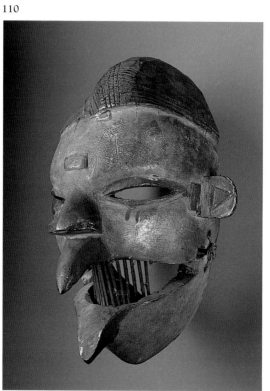

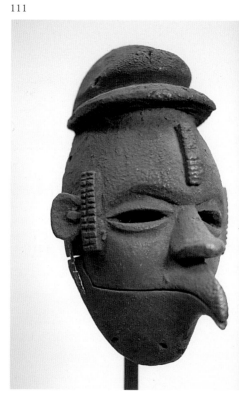

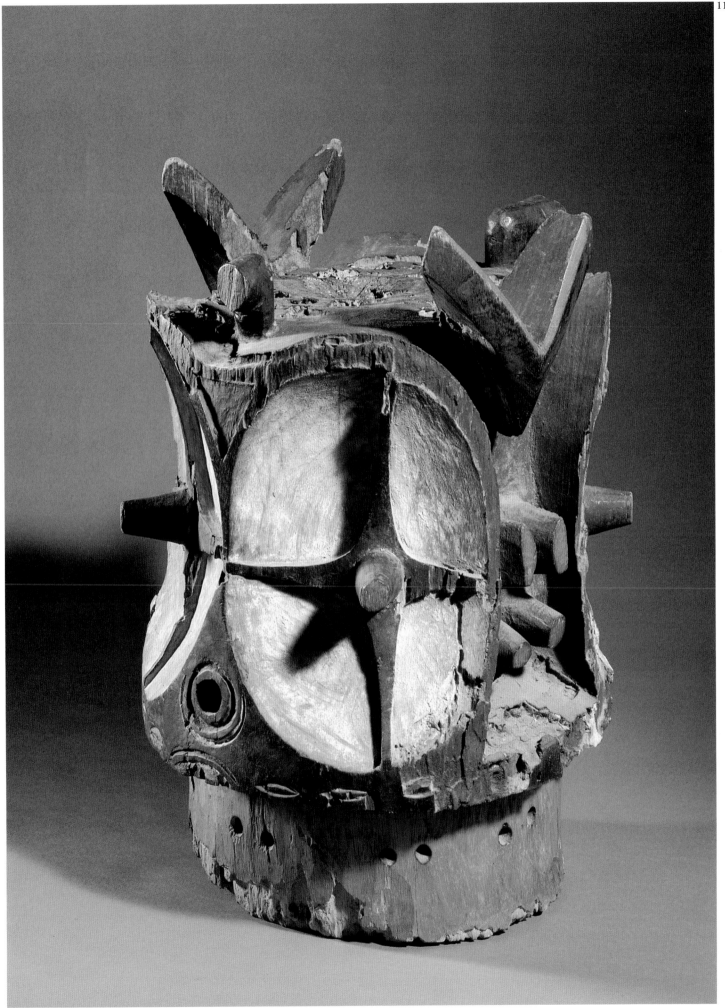

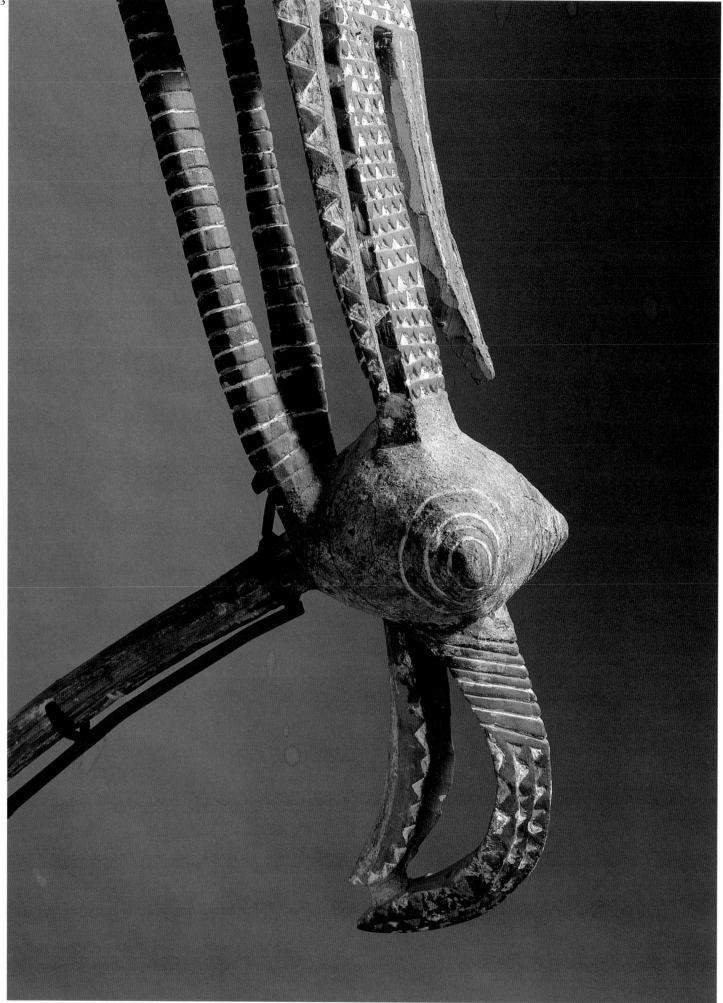

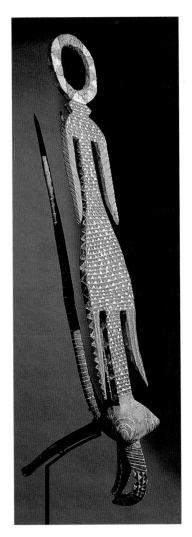

113. Staff; Samo, Burkina Faso.
Wood, paint; H. 5 ft. 4 in. Thomas
G.B. Wheelock.

**114. Janus figure with panther
above; Kuyu, Congo.** "Western
Kuyu liken the chief to a panther, and
initiation ceremonies teach the secrets
of this animal's powers" (Ezra in Vogel
1981:196-198). Wood, paint; H. 32
1/4 in. Walt Disney's Tishman African
Art Collection.

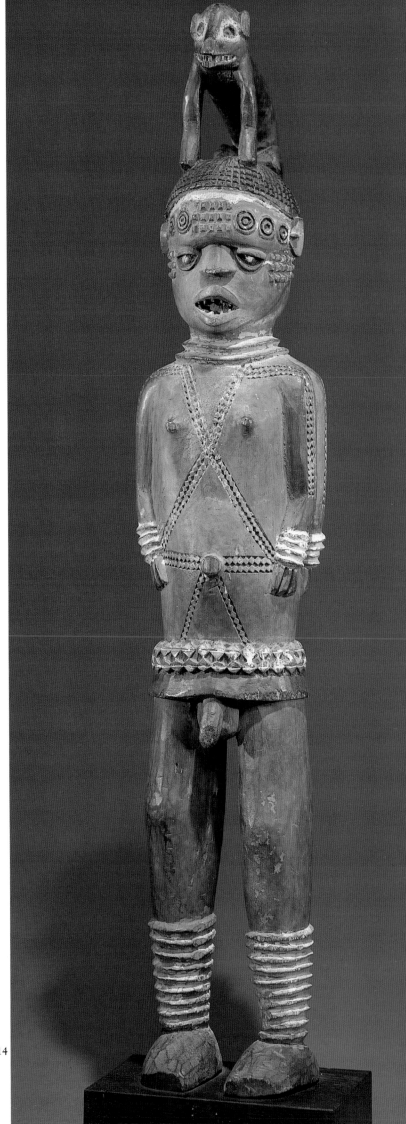

114

Leopards

Gentle hunter
his tail plays on the ground
while he crushes the skull.
Beautiful death
who puts on a spotted robe
when he goes to his victim.
Playful killer
whose loving embrace splits the antelope's heart.

— Yoruba praise poem for leopards (Gleason 1994:129).

Leopards are one of the most commonly portrayed animals in African art. Throughout Africa, the leopard is symbolically associated with political authority. As extraordinarily intelligent and courageous animals, leopards readily lend themselves to the production of politically useful metaphors. As predators of humans, leopards are associated with individuals and organizations that have the authority to take human life. Leopards are often considered the animal-others of chiefs, kings, and members of the governing bodies charged with maintaining law and order.

115. Mat; Yombe or Sundi; Lower Kongo, Zaire. Pandanus leaves, L. 27 3/4 in. x W. 23 in. Newark Museum, Josephine Harris Collection, Gift of William D. Hoppock, 1948. Photo: Sarah Wells.

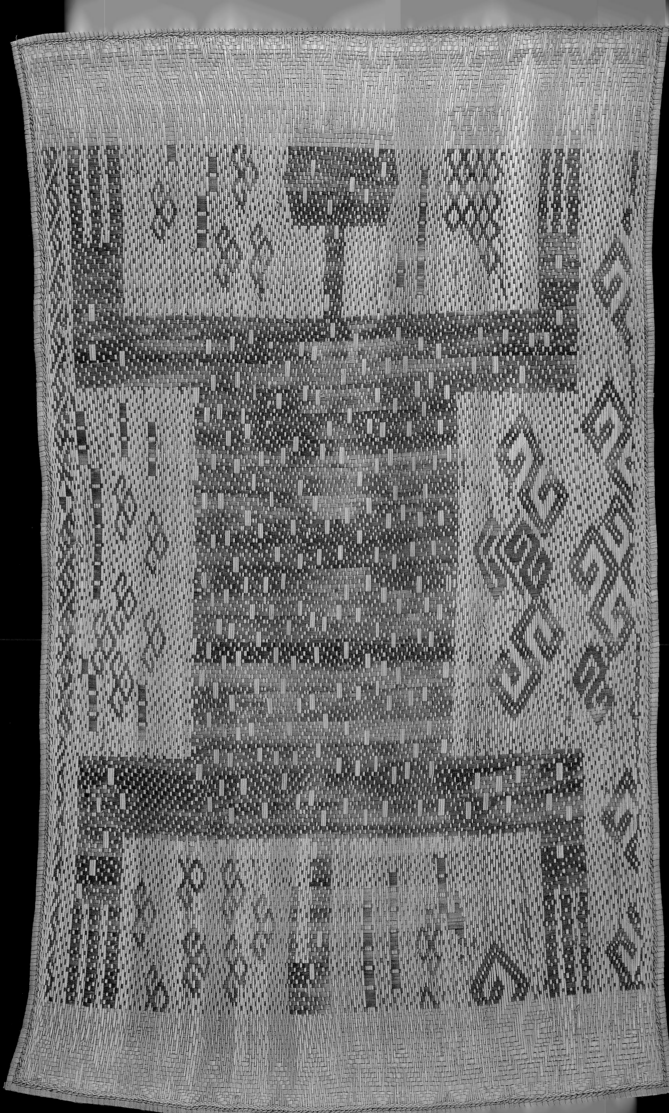

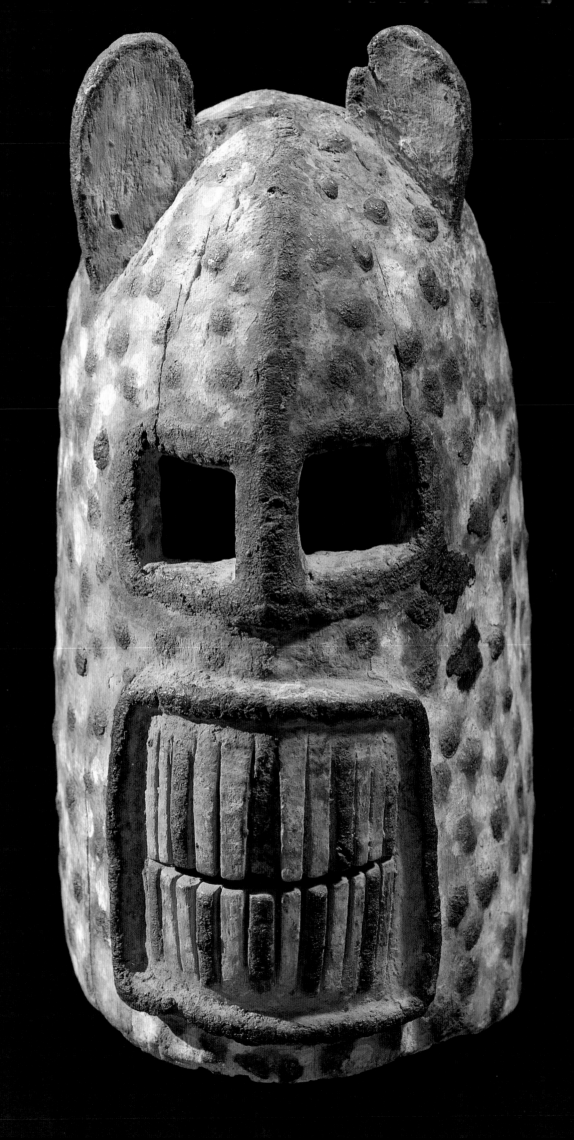

116. Mask (leopard or hyena); Dogon, Mali. Wood, paint; H. 11 3/4 in. The Graham Collection.

117. Leopard claw necklace; South Africa(?). Leopard claws, beads, fiber; H. 20 in. The Field Museum (cat.#210736, neg.#A112627C). Photo: Diane Alexander White.

118. Leopard tooth necklace; South Africa(?). The Field Museum Leopard teeth, fiber; H. 19 5/8 in. (cat. #28382, neg.#A112632C). Photo: Diane Alexander White.

119. Mask; Wee, Ivory Coast or Liberia. Wood, ivory, cartridge shells, studs, fur, hair, feathers, brass bells, cloth, kaolin, metal, nails, raffia; H. 15 in. Joyce Marie Sims. Photo: Dirk Bakker.

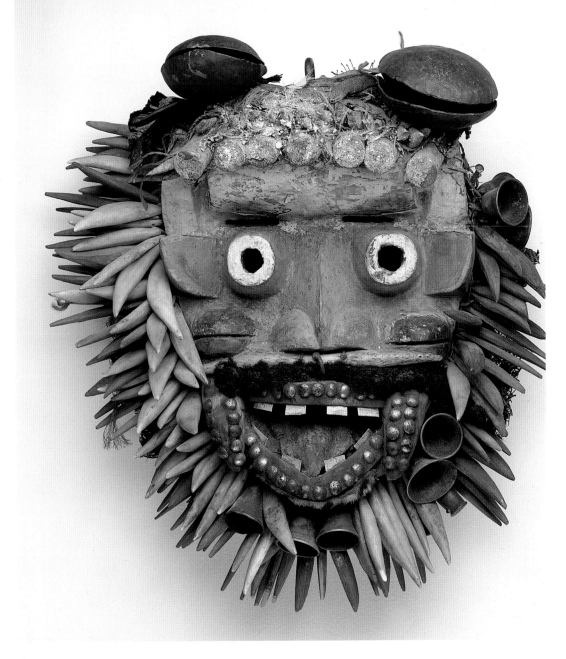

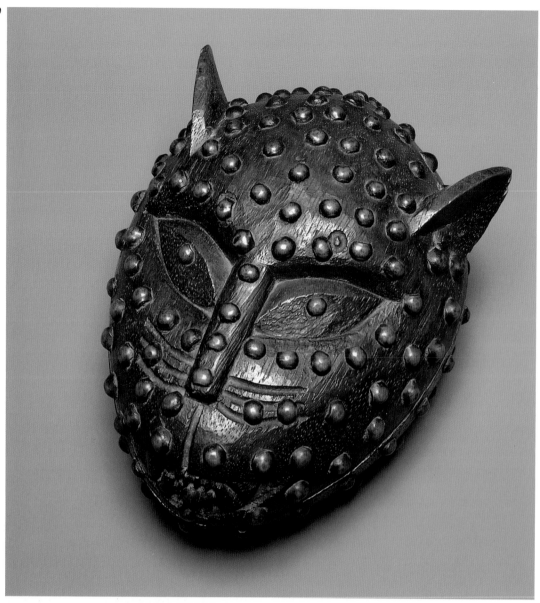

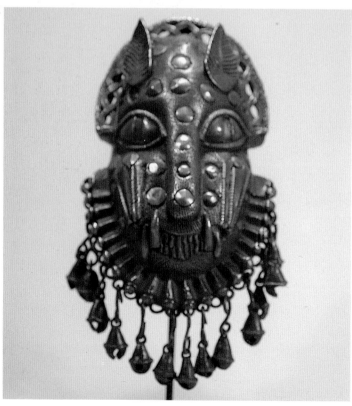

120. Kola-nut box in the form of a leopard head; Edo; Kingdom of Benin, Nigeria. Wood, metal tacks; L. 6 3/4 in. The Brooklyn Museum, Gift of Arturo and Paul Peralta-Ramos (56.6.31a-b). Photo: The Brooklyn Museum.

121. Hip mask; Edo; Kingdom of Benin, Nigeria. Brass, copper; H. 9 1/2 in. Margaret H. Demant. Photo: Ellen Kahan.

122. Pendant (with leopard attacking antelope); Toussian-Syemou(?), Burkina Faso. Metal, animal hide, fur; H. 4 1/4 in. Thomas G.B. Wheelock.

123.Leopard; Edo; Kingdom of Benin, Nigeria. Ivory; H. 9 3/4 in. Lucille and Arnold J. Alderman. Photo: Courtesy of Sotheby's, Inc.

124. Linguist staff finial; Fante, Ghana. Wood, gold leaf; H. (full staff) 60 in. Doris Rief. Photo: Jeffrey Ploskonka.

125. Stool; Baule, Ivory Coast. Wood, metal; H. 16 1/2 in. William W. Brill.

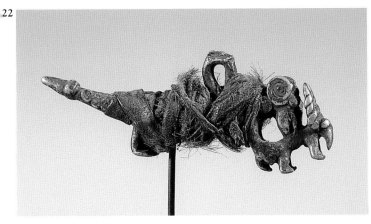

22

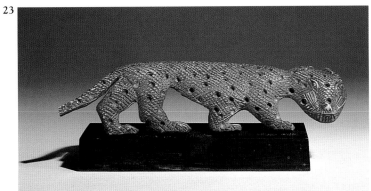

23

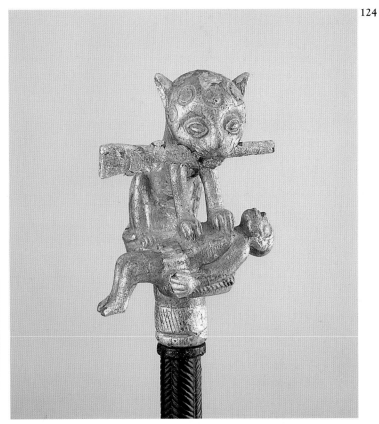

124

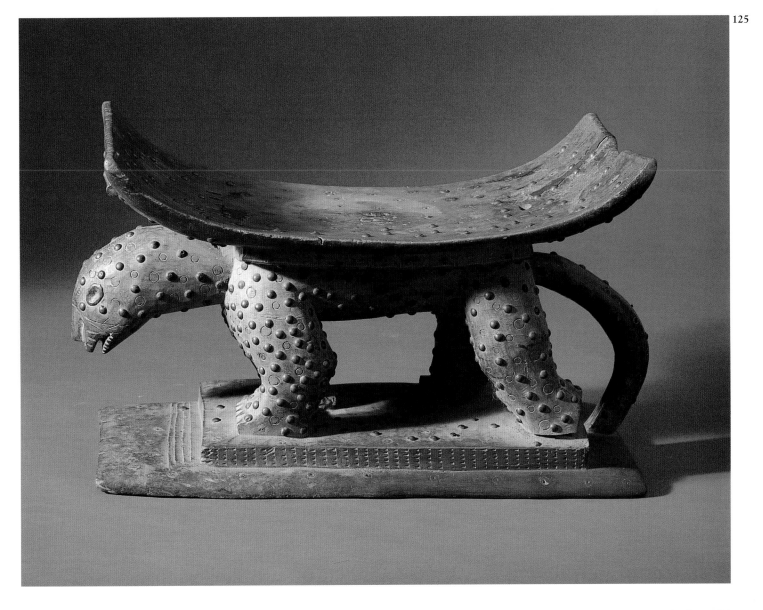

125

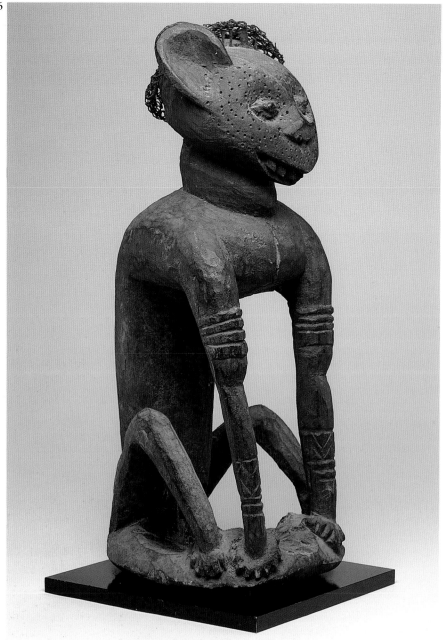

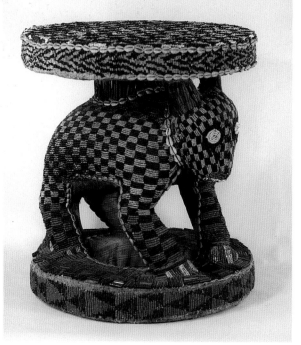

126. Leopard sculpture; Bamileke, Cameroon. Wood, fiber; H. 23 in. Florence and Donald Morris. Photo: Dirk Bakker.

127. Leopard stool; Bamileke, Cameroon. In the Bamileke city-states of the Cameroon grasslands, as elsewhere in Africa, the leopard is one of the most important symbols of traditional power and authority, alter-ego of the king. Wood, beads; Dr. Michael Berger. Photo: Michael Berger.

128. Leopard mask; Zaire. Wood, paint, fiber; H. 13 in. Mei Li Dong.

129. Mask (leopard); Twa(?); Zaire. Fiber, paint; mask H. 15 1/2 in, costume H. 34 in. Marc Felix.

130. Leopard claws; Twa(?), Ituri, Zaire. Iron, Marc Felix. Photo: Courtesy of The University of Iowa Museum of Art.

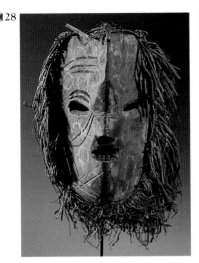

130

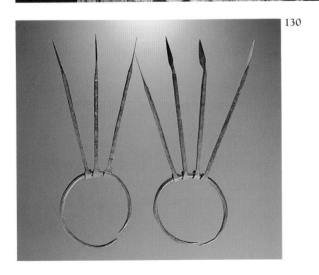

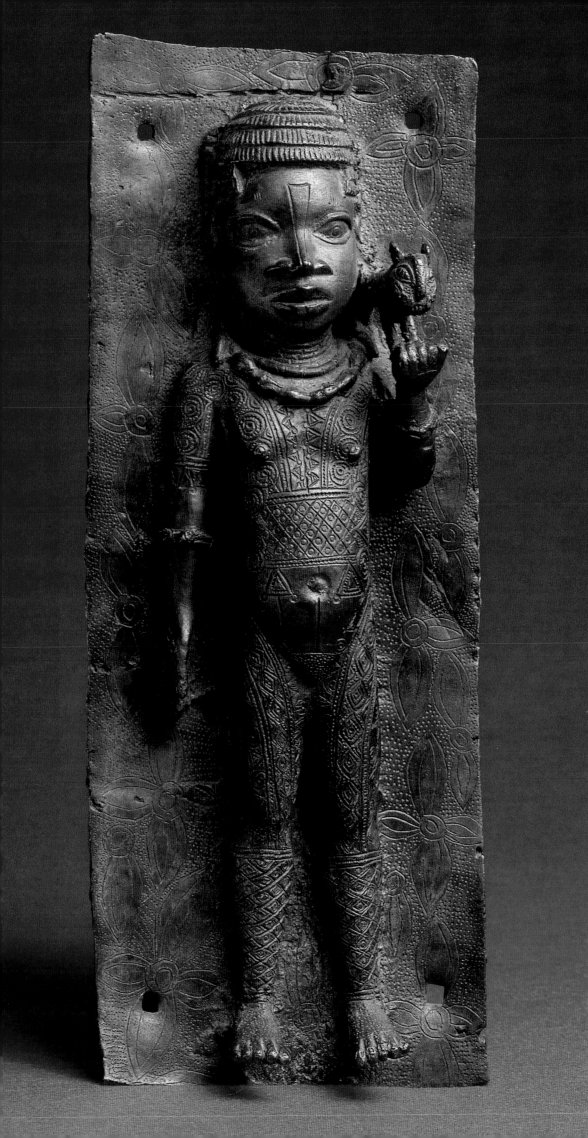

131. Plaque (young girl with leopard aquamanile), c. 1600; Edo, Kingdom of Benin, Nigeria. Bronze; H. 17 3/4 in. The Fine Arts Museum of San Francisco, Museum Purchase, William H. Noble Bequest Fund (1980.31). Photo: Fine Arts Museum of San Francisco.

In the art of the Kingdom of Benin, animals are everywhere. Birds, roosters, hens, mudfish, crocodiles, pythons, horses, and other creatures appear prominently, but the leopard, king of the forest and animal-other of the king, is preeminent, mirroring the king as symbol of royal authority. Leopards appear in many of the bronze plaques that once lined the palace walls in Benin City. Their spots and whiskers are ever-present in regalia and as incised dots in the plaques' textured surfaces and background patterns. In this plaque, a young girl carries a baby leopard or leopard-shaped aquamanile on her shoulder.

131

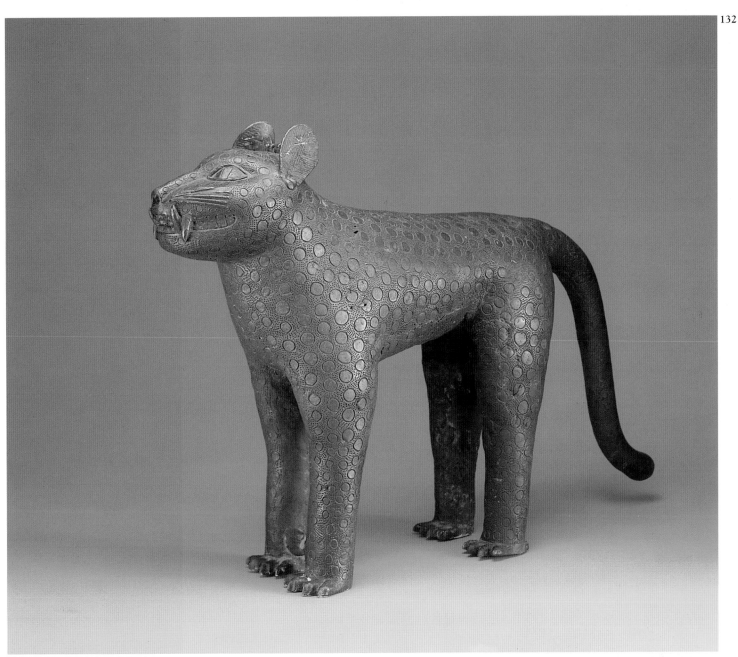

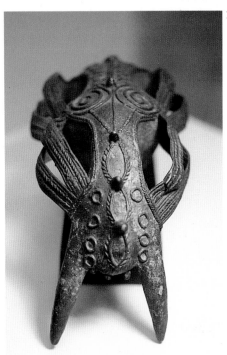

132. Aquamanile (in the form of a leopard); Edo; Kingdom of Benin, Nigeria. Late 16th to the 18th century. Bronze; H. 17 in. L. 26 in. Minneapolis Institute of Arts (acc.#58.9). Photo: The Minneapolis Institute of Arts.

133. Leopard skull; Lower Niger River region, Nigeria, date unknown. Similar lost-wax cast, metal objects, shaped like leopard skulls, have been found buried as part of chiefly regalia in the area between the Niger Delta and the Cross River estuary of southern Nigeria, dating from the 17th century. Another similar example was excavated at Igbo Ukwu, dating from the 9th or 10th century (Shaw 1970). Bronze, L. 7 in. Toby and Barry Hecht. Photo: Toby T. Hecht.

ANIMALS AND HUMANS

This section of the exhibition shifts the emphasis from animals to humans with works of art that invite metaphoric interpretations.

In African cultures, verbal and visual arts reinforce and enrich one another. Proverbs, songs, and spoken narratives, in unison with visual art forms, provide complex multisensory systems of communication. Animals are common subjects of both verbal and visual arts, often portrayed in dynamic interaction as a comment on the nature of social relationships.

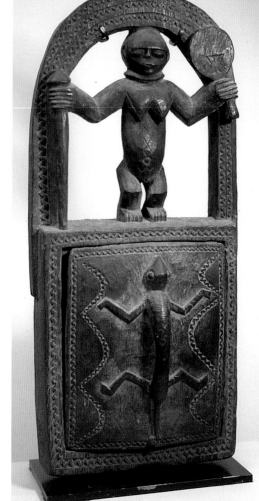

134

134. Mirror case; Ishan, Nigeria. In this mirror case, the human figure and the animal below are similarly conceived as parallel visual expressions reflecting the human tendency to describe and classify animals in ways that parallel human social organization. In art and life, we understand animals as we understand ourselves. Wood, mirror; H. 17 in. Toby and Barry Hecht. Photo: Toby T. Hecht.

135. Torso with snakes; Djenne region, Mali, c. 11th to the 14th century. Terracotta, H. 9 1/2 in. Private collection.

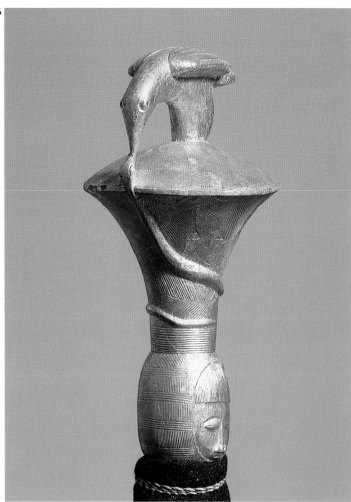

136

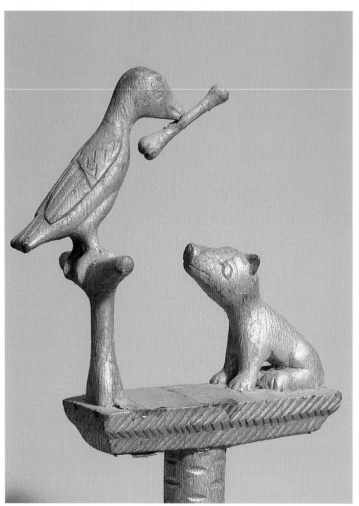

137

136. Flywhisk; Baule, Ivory Coast. Wood, goldleaf, cloth, horse hair; H. 40 in. Private collection.

137. Linguist staff finial; Asante, Ghana. "This staff depicts the enigmatic saying, 'The owner of a thing collects it with his left hand' (*Nyimpa a ödze nadze ödze nebenkum gye*). The Akan consider the left hand unclean. It is never used in gesturing or eating, or put in physical contact with another person. Even in the Western world, the left is considered sinister while the right is dexterous (from the Latin *sinistre* and *dexter*). Nevertheless, among the Akan, property rights seem to take precedence over good manners. The bone, of course, belongs to the dog rather than the bird, and the insult of retrieving it with the left hand is appropriate in difficult situations when trying to recover goods left behind, loaned, or stolen" (Ross 1982:66). Wood, gold leaf; H. 13 in. Carol and Jerome Kenney.

138. Linguist staff finial; Asante, Ghana. This staff depicts an equally enigmatic saying, "Even though the bird is such a small animal, you can't swallow everything because you can't eat feathers," which has been interpreted by George Preston to mean "To bite a small thing is nonetheless potentially to bite off more than you can chew" (Ross 1982:66). Wood, gold leaf; Private collection.

Counselors and messengers to Akan paramount chiefs carry staffs like these as their badge of office. The imagery of the gold-covered staff finials refers to proverbs that can be interpreted in many different ways. These counselors are skilled public speakers. They use their staffs to inspire discussion of political issues and judicial matters and to present multiple perspectives, subtly conveying various messages.

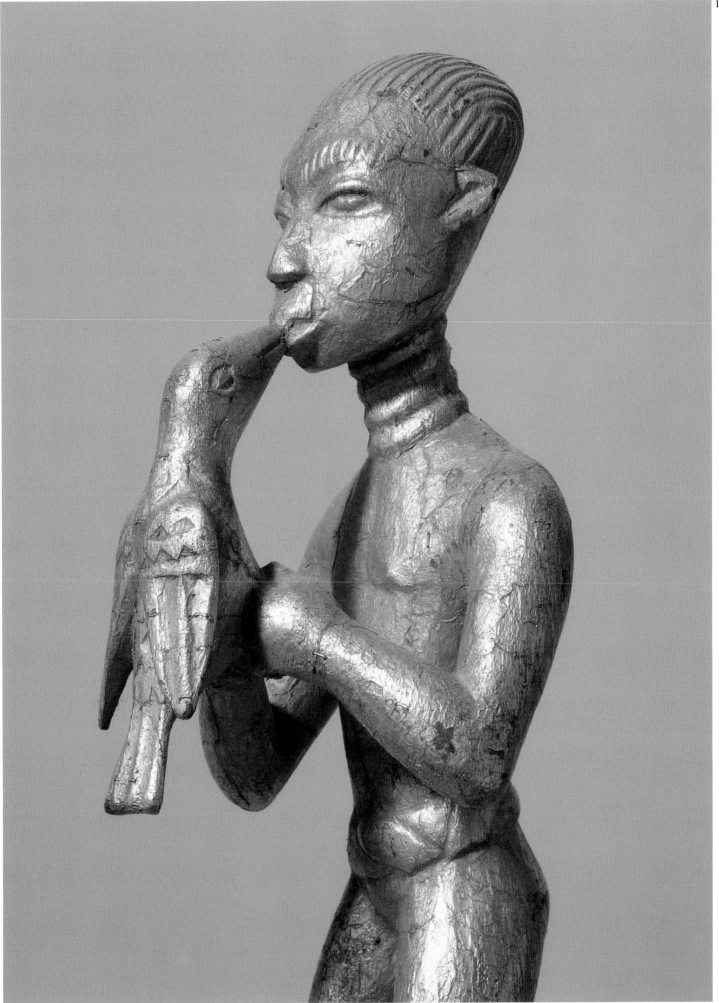

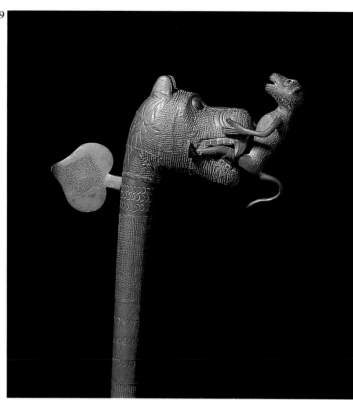

139. Scepter; Fon, Republic of Benin. The lion is the symbol of Glele, a 19th century king of Dahomey. The imagery of this scepter corresponds to the one of his "strong names," (a phrase used to describe the king's power): "I am the lion who sows terror as soon as its teeth are grown" (Adams 1980:40). Wood, brass; H. 21 in. Shelly and Norman Dinhofer.

140. Commemorative sculpture: man riding lion; Fon; Dahomey, Republic of Benin. Silver; H. 7 1/2 in. Private collection.

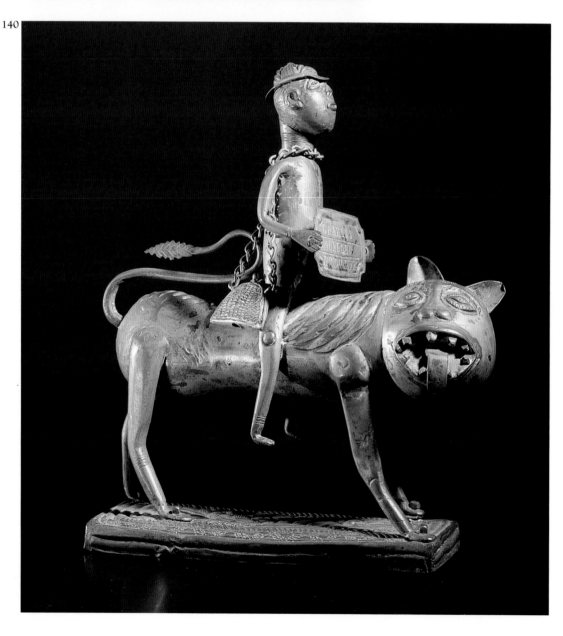

141

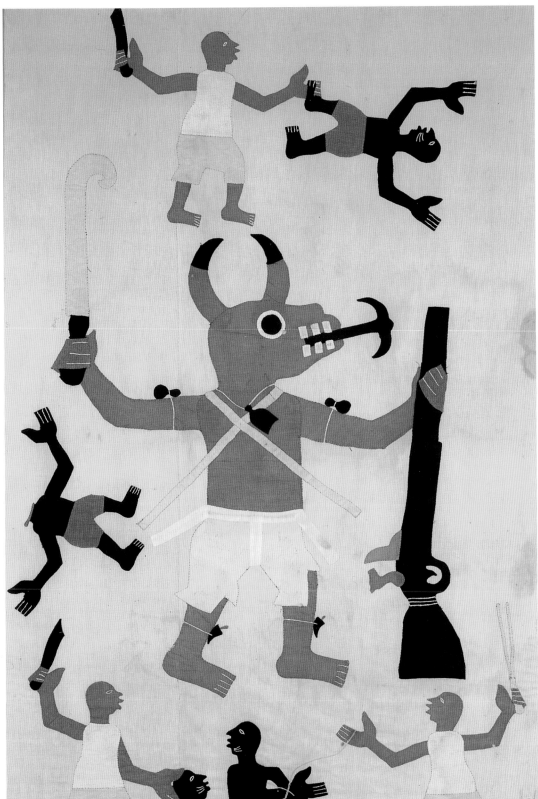

141. Appliqued textile; Fon; Dahomey, Republic of Benin. Cloth; H. 70 in. The Regis Collection, Minneapolis. Photo: Courtesy The Regis Collection, Inc.

142. Heddle pulley; Baule, Ivory Coast. This heddle pulley shows a Baule man wearing a helmet mask. Such masks have the horns of dangerous buffaloes, the jaws of crocodiles and the faces and scarifications of humans — because they bring the power of the wild to bear on human problems. Wood, 7 in. Donald Morris Gallery. Photo: Dirk Bakker.

143. Goldweight; Akan, Ghana. Brass, L. 2 1/4 in. Private collection.

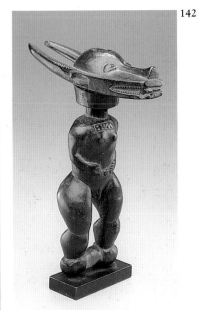

142

143

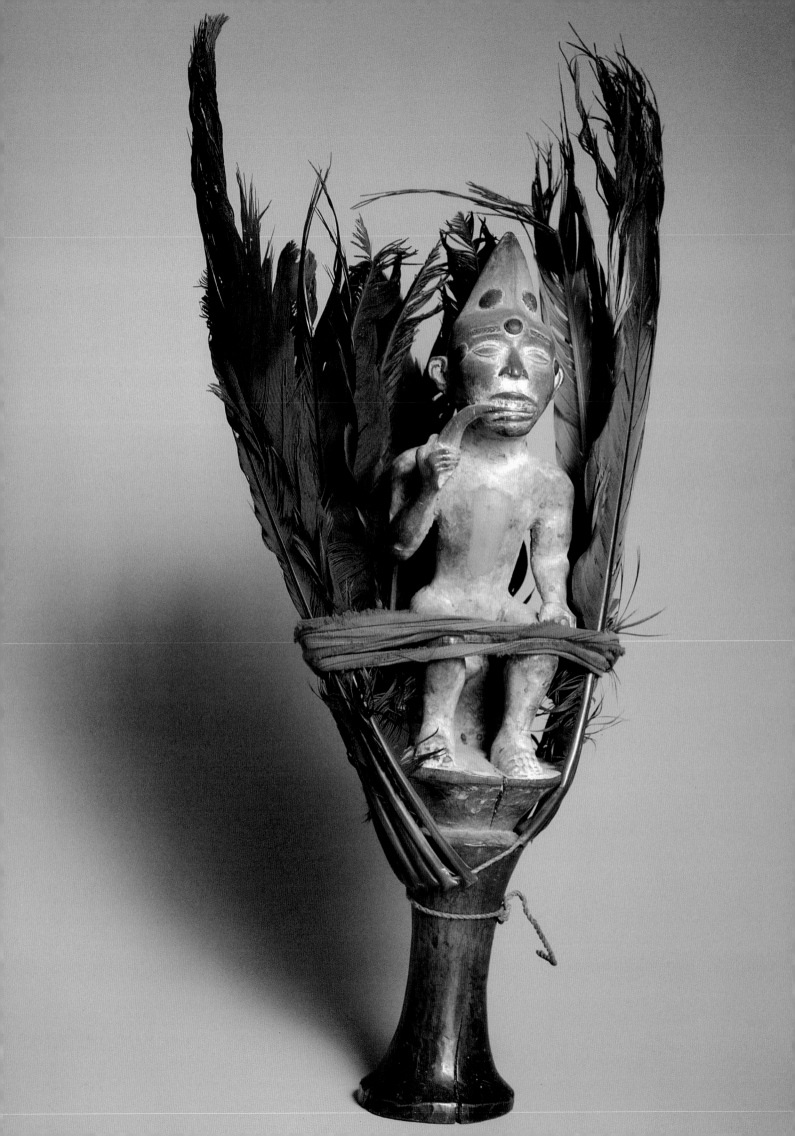

144. Scepter; Yombe, Zaire. The feathers that surround this *nkisi* indicate that it concerns itself with things of "the above." The figure holds *munkwisa,* a plant used in the investiture of chiefs and in *minkisi* which serve judicial purposes (MacGaffey 1993:72,96). Wood, feathers, paint, metal, cloth; H. 18 3/4 in. Gerald and Lila Dannenberg.

145. Staff finial (*sankofa*); Akan, Ghana. Sankofa means "return to the past and fortify yourself in order to go forward." It is a term used in planning military stategies as well as in everyday conversation to remind someone to go back and get something left behind. Wood, paint; H. 7 1/2 in. Eric D. Robertson.

146. Whistle (*nsiba*); Kongo, Zaire. Small antelope horn whistles like this one were considered the "children" of *nkisi.* "Only men initiated in the *nkisi-*cult were allowed to possess and use the sculpture-adorned whistles, that is socially prominent people such as the...*banganga* and possibly the village chiefs. They were not carried by ordinary people" (Soderberg 1966:7,32). Wood, antelope horn; H. 4 3/4 in. Mr. and Mrs. Armand Arman.

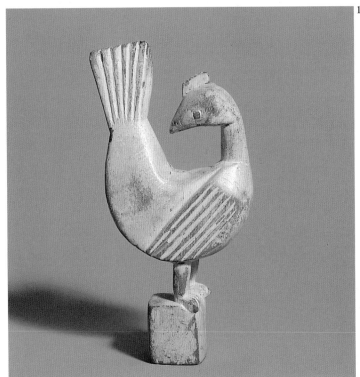

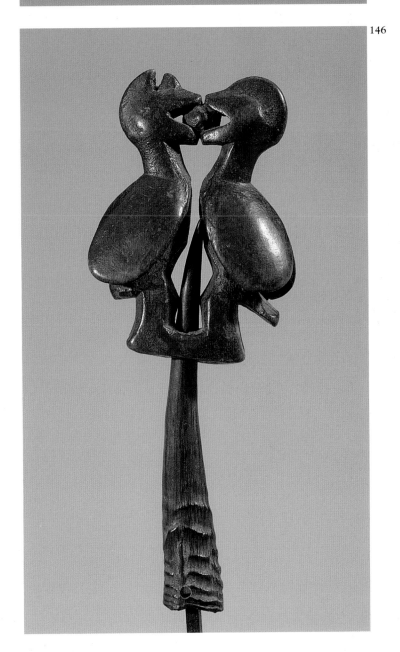

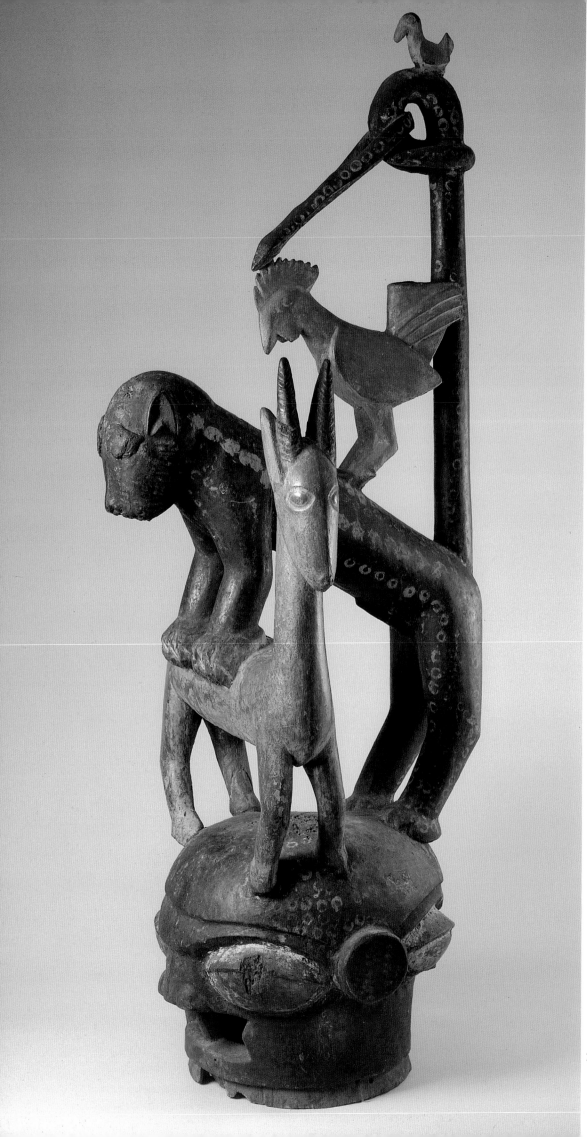

147. Helmet mask (*epa*); Yoruba, Nigeria. This type of *epa* mask is called *Oloko*, the leopard, thought of as both "Lord-of-the-Bush" and "Lord-of-the-Farm" as animal-other of the King. Its performance celebrates great warriors. Wood, paint; H. 56 in. Dr. and Mrs. Bernard Wagner. Photo: Courtesy Eric Robertson.

148. Shrine sculpture (*izemize*); Ishan, Nigeria. With snakes on either side and a leopard attacking an antelope overhead, this sculpture of a human figure framed within an intricate network of animals refers to the competing forces — physical, social, and spiritual — of the Ishan world. In it animals are on the same plane as people, and all the sculpture's parts link together to form a stable, almost architectural structure. Such sculptures are called *izemize*, or human figures who cannot talk (Picton in Ross 1994:85). Wood, paint, cloth, string, fiber; H. 6 ft. 7 1/4 in. UCLA Fowler Museum of Cultural History, Gift of Jerome L. Joss (x92.78). Photo: Courtesy of UCLA Fowler Museum of Cultural History.

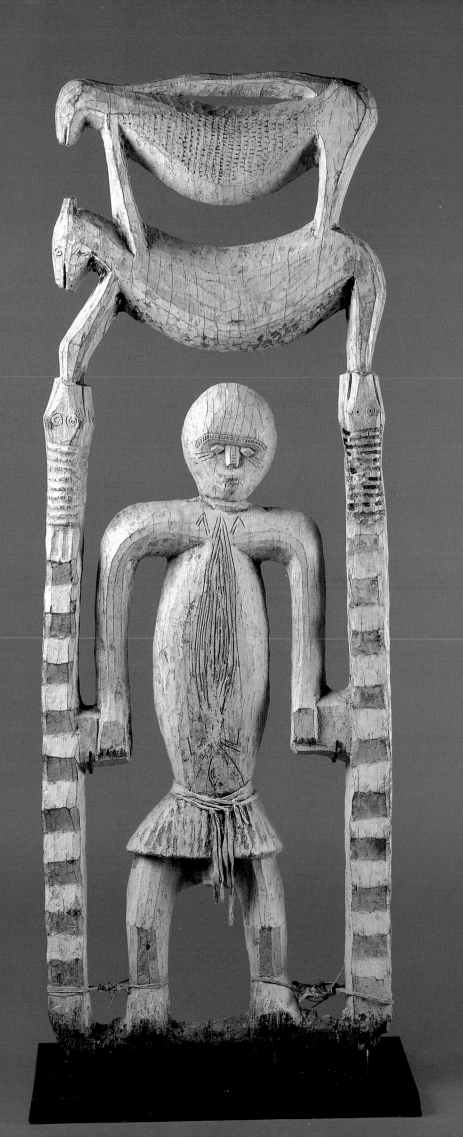

Introduction: Hitching Up the Horse

1. Steve Baker's *Picturing the Beast: Animals, Identity and Representation* (1993) is a useful study of contemporary Western use of animal imagery. Taking off from Africanist anthropologist Roy Willis's *Man and Beast* (1974), Baker reviews contemporary writing on human/animal relations by John Berger, Robert Darnton, Harriet Ritvo, and others and then asks the question that is central to the present study, as well: "Why is it that our ideas of the animal —perhaps more than any other set of ideas—are the ones which enable us to frame and express ideas about *human identity?*" (Baker 1993: 6).
2. Centner's book is a compendium of children's games and toys, but all are from southern Zaire rather than throughout Africa as her title would suggest. She sometimes confuses adult or sacred activities with child's play, and the book has an underlying ideological message strongly supporting Katangan secession. African children's toys and games have received very little study, with a few exceptions like Griaule 1938 and Fernandez 1986b.
3. As John Reinhardt (1982: 1) has noted in the context of an exhibition of zoomorphic objects at the National Museum of African Art, "the abundance of animals in African art is no unmixed blessing for museums.... The museum could continually exhibit objects inspired by animals without exhausting the patience or credibility of its patrons. Animals in African art are a Beethoven symphony awaiting the next production of a fine orchestra." To extend his metaphor, each "conductor" of the symphony comes to the task with specific abilities and goals, so that each "concert" is different while the musical score remains the same. In the present writing, I make no claim to have the final word on why, how, or when Africans have made, make, or will make zoomorphic objects.
4. Fernandez 1986b: 32. For examples from elsewhere in the world, one might consider the "animal style" represented in a great many objects produced by the "barbarian hordes" of northern Europe and Asia during the first millennium, B.C. Such art is thought to have been associated with shamanism, and has been described as "vigorous, intriguing, and, at times, even beautiful, but it is never monumental or intellectual" (Bunker et al. 1970: 13–5). Such ludicrously arrogant descriptions should be revised, and are certainly not applicable to African zoomorphic art that is distinctly vigorous, intriguing, *and* intellectual.
5. For a richly detailed description of the importance of hunting and animal symbolism to people living in lands long over-hunted and game-scarce, see René Devisch's study of Yaka people of Zaire (1993: 74–9).
6. Mirrors, attendant theory concerning the transformative paradoxes of mimesis and reflection, and the many manifestations of these principles in African expressive culture are discussed at length in my forthcoming book, *THRESHOLD: African Art on the Verge.*
7. Fernandez 1986b: 35.
8. Cf. Lifschitz 1982.
9. In the early 1980s, I attended a lecture by Professor David Wiley, director of the African Studies Program at Michigan State University, on the importance of such imagery to a very particular Africa invented from without; cf. Reinhardt 1982: 1, Mudimbe 1988 and 1994.
10. See for example Baker 1993, Ingold 1988b, Morphy 1989, Ross 1992, Willis 1990.
11. Berger 1980: 9.
12. Baker 1993: 12. Baker presents a much more detailed discussion of these shifts, drawing upon Foucault's sense of changes incurred as the "Classical Western episteme" gave way to "the distinctly modern 'empiricities' of economics, biology, and linguistics" (p. 20 and passim).
13. Ingold 1988: 1.
14. Tapper 1988: 49.
15. Baker 1993: 26.
16. Ingold 1988: 1.
17. Clark 1988: 31.
18. Ingold 1988: 3.
19. Midgley 1988: 35, 37.
20. Stephen Clark (1988: 3) discusses the way that these essential Western stances are derived from Christian ideas that the immortal soul can be possessed only by those God made in His image (i.e. humans); and the "further oddity" of liberal humanists who do not espouse such a view of the soul, but who still assume that the human species is a "natural kind." As Clark notes, this allows them to distinguish between "domestication [of animals] and slavery, flesh-eating and cannibalism, the killing of an ox and the slaying of a man," and the like. Clark exhorts them to think again. Keith Thomas (1983) offers a more detailed discussion of the philosophical underpinnings of English attitudes toward the natural world; and Paula Ben-Amos (1976: 246) describes an African echo from Bini people in the Kingdom of Benin (Nigeria), where "in the ideal order of things ... man dominates animals as his god-given right."
21. This may sound like a rephrasing of Freudian theory, with the "animal" the unacceptably wild "id" that we all try and all occasionally fail to suppress. Cf. Midgley 1988: 35.
22. One might contend that this is because of ecological differences, and that people living in southern Kenya and other areas of great game, simply do not produce sculpture and other visual arts. Such thinking would be anachronistic, for before the introduction of high-powered, repeating rifles brought eradication of big game, giraffe, zebra, and other animals abounded in the central African lands of sculpture-producing peoples like Luba and Tabwa; and yet very few zoomorphic objects were made, and fewer still represent big game.
23. See Willis 1990, Lévi-Strauss 1963a: 89.
24. Cancel 1981: 84.
25. Cf. Lifschitz 1982.
26. The useful discussions in David Sapir's "The Anatomy of Metaphor" (1977); James Fernandez's "Persuasions and Performances: Of the Beast in Every Body and the Metaphors of Everyman" and "The Mission of Metaphor in Expressive Culture" (1986a and 1986b)—despite his horrible pun (1986b: 30) suggesting that anthropology should become "an-trope-ology"!—and the particularly straightforward presentation on "The Role of Metaphor, Metonymy, and Symbol" in Schultz and Lavenda's *Cultural Anthropology* (1990: 189–93) form the basis for my discussion here. More recent debate appears in the essays of *Beyond Metaphor: The Theory of Tropes in Anthropology* (Fernandez 1991). The reader is referred to these works for more complete consideration of intellec-

tual and historical contexts of master tropes than is possible here.
27. Cole 1985: 16.
28. I am grateful to Professor John Pemberton III (personal communication 1994) for discussing the difference between identity and predication as expressed by the verb "to be," in the context of a different writing project (Roberts 1996). His suggestion then, that "perhaps the point is that for the Yoruba the ontological distinction between physical reality and its representation is not as severely drawn as in Western (modern) culture," is certainly relevant here as well. It should be understood here and throughout the text, that when I speak of "master tropes" and other features and devices of representation, it is as an outsider to the African cultures I am discussing: insiders ordinarily have little or no reason to consider their own ontology in such ways (although there are certainly many excellent studies of African thought by African scholars). Rather, their view is that of living the lives that we outsiders seek to understand better and appreciate more through our inquiry.
29. Napier 1986; Roberts 1990a: 37–8.
30. Sapir 1972: 20.
31. Biebuyck 1973: 179. The "constrained diversity" and "semantic equivalence" of objects are discussed in Layton 1992: 33–4 and applied to the study of *yo domolo* "robbers' crooks" made by Dogon people of Mali, in Roberts 1988a.
32. Sapir 1977: 16.
33. This is especially true as art objects are removed from their original settings and taken to new lives in private or museum collections. An object may be identified as a "masterpiece" thereafter, and may stand for all others of its type, or, indeed, for a much broader metonymy such as "African art." The "classic" *chiwara*, with its tall, curved horns and "elegant" stance, has become a design element (e.g. the logo for Air Afrique, appearing on the tail sections of all airplanes as well as on other promotional materials) and has been reproduced in many parts of Africa by artists working for the tourist market, as *the* archetypal African sculpture.
34. The word "know" is placed in quotation marks in this sentence to suggest that such identifications may be far fuzzier than we might expect, with several possibilities for the same feature. Multiple meanings are not a "mistake," but an artistic achievement consonant with the polythetic nature of symbols common to African expression, as will be discussed in chapter two.
35. Fernandez (1986b: 32 & 1986a: 8, 24.
36. Fernandez 1986b: 32.
37. Soukhanov 1992: 912.
38. The word "inchoate" is itself a metaphor, when one considers its root's imagery of a farmer hitching up his horse, as described here.
39. Drewal, Pemberton & Abiodun 1989: 33.
40. Sapir 1977: 3.
41. OED 1982: 1779, 1781.
42. Tapper 1988: 56. Furthermore, as a gauge of the social intent and impact of animal metaphors, it is worth noting that "the marginalization of animals is today being followed by the marginalization and disposal of the only class [i.e., farmers] who, throughout history, has remained familiar with animals and maintained the wisdom which accompanies that familiarity" (Tapper 1988: 56 citing J. Berger).
43. Choice of animals for verbal abuse may be based on reasons other than unfamiliarity, and will be discussed further in chapter one. As Edmund Leach (1979: 155) has suggested, "when an animal name is used ... as an imprecation, it indicates that the name itself is credited with potency."
44. "Luck" is placed in quotation marks here because there is no such thing for Tabwa; instead, ability to hunt successfully results from secret knowledge and what we would call "magic." While something may be secret and so unknown to a given individual, all events occur for reasons that can eventually be determined, often using divination; see Roberts 1988b and 1993. I should add that I understand and accept the caveats of Arnold Rubin (1974: 13) and Suzanne Blier (1993a: 147–52) about use of the term "magic," so often used as a distancing device to refer to chicanery and the "irrational" "religion of the other"; I find it impossible to avoid the word, given the lack of a suitable alternative. In the present text, "magic" refers to the instrumentality of metaphysics—making things happen. I may add that while I do not personally believe in everything my African friends have told me over the years, about some of their magical abilities (e.g. flying through the air), I certainly do believe *they* believe, have, and act upon such intentions. It is this insider's view of the way the world works that I aspire to convey here.
45. Cf. Fernandez 1986c.
46. Cf. Nooter 1993.
47. Cf. Cole 1985. Inability to "remove the mask" results in what, at least from the outside, may be defined as "insanity." Some masking involves spirit-possession, through which one "is" what the mask represents; but again, if one cannot divest oneself of the spirit once the ritual is completed, then the resulting alienation may be defined as insanity. "Insanity," it may be added, is a culturally as well as physiologically defined state.
48. Fernandez 1986b: 36.
49. As Ted Cohen has put it, metaphor implies "the achievement of intimacy," for "the maker and the appreciator of a metaphor are drawn closer to one another. Three aspects are involved: (1) the speaker issues a kind of concealed invitation; (2) the hearer expends a special effort to accept the invitation; and (3) this transaction constitutes the acknowledgement of the community" between proposer and appreciator (1979: 6).
50. Metaphors have a "shelf life" and a "sunset rule": if they are appropriate in some circumstances, they are not in others, or if they are appropriate now, they may not be as effective even in similar circumstances, at some later date. A case in point is the Tabwa aardvark-as-culture-hero: although this was a story recorded at the turn of the century, and its tales are structurally consistent with stories told nowadays to explain the origins of human culture, the aardvark is being replaced by other heroes in the kind of shift in dramatis personæ that one must expect, as new metaphors are invented to explain changing circumstances; see Roberts 1990a & 1992a.
51. Consentino 1984.
52. Serrano's piece was seized upon as a useful "last straw" in the course of a long battle between conservatives and what they feel to be the "Liberal Establishment" evidenced in the arts community. Metaphor always has a

political dimension available to those on both sides of its "bridge."
53. Rosen 1984.
54. T. Turner 1991: 123.
55. E.g. Fernandez 1986b: 30.
56. Here it is useful to stress that most of the African art referred to in the present discussion was created shortly before, during, or since the colonial period, when missionaries and other agents of socio-political change were actively trying to suppress African religion and its artistic vehicles. In many cases, then, the perplexing obscurity that Western observers may feel has been purposefully created by African artists; see Roberts 1985: 21–3 for further discussion of this point.
57. Use of animal imagery has often seemed so "readily accessible" and self-evident that many writers merely mention and do not explain it.
58. Buffalo and other Tabwa masks, figures, and related expressive culture are presented in Roberts & Maurer 1985:162–3, Maurer 1985: 252–3, and Roberts 1990a. Marc Félix (1989: 218–9) illustrates a wooden "anthropo-zoomorphic" mask—a human face surmounted by carved antelope horns—that he collected among northern Tabwa (whom he calls "Tumbwe," after the name of a particular chief) and states that "no other examples are known at present." Contemporary Tabwa sometimes represent other animals in wall paintings, the pictographs with which they pyroengrave gourds, or in sculptures representing personal or hunting spirits; but these are very rare: I remember seeing only two examples of zoomorphic sculpture in the nearly four years I lived among Tabwa, and only two others brought into Tabwa lands from outside their culture area.
59. Dorst & Dandelot 1969: 276–7.
60. Hallet 1967: 70.
61. Bourgeois 1991: 19.
62. Leakey 1969: 48.
63. Hallet 1967: 66, 81.
64. Dorst & Dandelot 1969: 276–7.
65. A photo of this is in Leakey 1969: 47.
66. Hallet 1967: 66.
67. Bourgeois 1991: 21, 29.
68. IAAPB 1892: 11.
69. Roberts 1986.c
70. Roberts & Maurer 1985: 176–7.
71. Giraud 1890: 522.
72. Colle 1913: 275.
73. Bourgeois 1991.
74. Womersley 1984: 7.
75. The collectors are a Belgian art dealer who visited the Tabwa area in the 1970s, and an American who hunts for and raises exotic snakes to sell to zoos, who chanced upon a Tabwa mask during an expedition to southeastern Zaire in the early 1990s. Their accounts of the names for the buffalo mask and its pairing in dance with a female mask are virtually identical. My thanks are extended to both gentlemen for sharing this information with me. The etymology in the next sentence is from Van Acker 1907: 71, White Fathers 1954: 821–2, and Van Avermaet & Mbuya 1954: 780–1.
76. Roberts 1995.
77. Reefe 1981.
78. Burton 1961: 159–60; Nooter 1990: 65–71. The second part of the name, "Inang'ombe," means "mother-of-the-cow." Cattle have been introduced to highlands in the Luba/Tabwa area only recently, and it is likely that the "cow" in question is a buffalo. The same heroine is associated with land tortoises important to Mbudye ritual, that may, in turn, refer to the moon via the 13 scutes of the shell that stand for the 13 lunar months in a solar year, and eventually back to Mbidi Kiluwe, a lunar hero; see Roberts 1980, chaps. 12 & 13; and Heusch 1980: chap. 1. Nooter (1990: 65–71) reports that the use of the word "buffalo" here may be a clandestine reference to "tortoise" from the secret language of Mbudye. One can surmise that even if this is the case, the choice of secret terms is the proposal of yet another metaphor, bridging away from still linking buffaloes and tortoises.
79. Burton 1961: 163, 167.
80. With a few notable exceptions in the late l9th-century, Tabwa chiefs were leaders rather than rulers; that is, they could suggest and persuade, but did not have absolute authority to coerce people to obey them (see Roberts 1985: 14–6).
81. Tabwa make the same metaphorical analogy of light (hence enlightenment) and wisdom as is made in English, and use the key metaphor of the moon's phases to contemplate the perplexities of their own politics (see Roberts 1985: 1–3 & 1991).
82. Cf. Turner 1970.
83. Tabwa, Luba, and many other Bantu-speaking peoples of central Africa recognize a genre of culture heroes that are divided vertically down the body midline; some are half-human, some half-beeswax, some are only half-beings, and others reflect dichotomous symbolism in their bearing or body arts. Such a hero assists people to think about the paradoxes of social life, in which people are "two-faced," offering generous warmth while ruthlessly seeing to their own selfish interests; see Roberts 1986a, 1986d, 1988c, and especially 1991.
84. "Creature" is used deliberately in this sentence, because in their enthronement rituals, chiefs among Tabwa and related peoples are moved from the realm of humanity to that of beasts: chiefs are "lions," feared for their ruthlessness. See Roberts 1983, 1991, and forthcoming B.
85. De Heusch 1991. The term "dilemma," from the Greek for "ambiguous proposition" (Soukhanov 1993: 523), is especially appropriate here; Tabwa "dilemma tales" (cf. Bascom 1975) are commonly told to children as a means of discussing the ambiguities of social life, especially through use of the trickster Kalulu, the wily hare; see Roberts forthcoming A.

Chapter 1: Familiar Friends

1. Cited in Morris 1987: 111.
2. Hurston 1990: 219. Anthropology is based upon the principle of cultural relativism and the comparative method. As such, it contests the dogmatism of any given religion or positivist philosophy and contends, as did Durkheim, that "there are no religions which are false. All are true in their own fashion, all answer, though in differ-

ent ways, to the given conditions of human existence" (1966: 15).
3. Lessa & Vogt 1979: 151.
4. Fernandez 1986b: 11.
5. OED 1982: 568.
6. See Durkheim 1966: 103. Cf. Geertz 1979.
7. See James Fernandez 1986a. In Swahili, "recognize" is *kutambua*.
8. I use "social process" as Victor Turner (1970) used the term.
9. The languages of animals as interpreted by Africans and other world peoples have been an occasional object of ethnography (Guss 1985). Of interest is the suggestion that secret languages of shamans and other mystics are sometimes said to be "animal" in origin (M. Eliade, cited in Guss 1985: 76–8).
10. Leach 1979: 157–8. Vast literatures of psychology concern this issue, of course, as does a growing one in the anthropology of "personhood"; see, for example, the essays and bibliography of Jacobson-Widding 1983, many/much of which concern African peoples.
11. In our own contemporary educational culture, vocabulary acquisition and correct usage are understood to reflect or to be synonymous with intelligence itself, witness the importance of verbal portions of various college-entrance exams.
12. Leach 1979: 157–8.
13. Roberts forthcoming A.
14. Leach 1979: 158.
15. The definition of taxonomy is from Soukhanov 1993: 1840. While Ellen (1979) would distinguish "classification" from the more specific "taxonomy," I shall use the two words as synonyms in this text. The point throughout the book is that there is little or nothing "natural" about the "natural relationships" upon which taxonomies are based. Instead, they are cultural products, defined for particular people at particular moments in their history for particular reasons based upon political economy and other social factors.
16. Griaule 1980: 31–46.
17. If this "long-tailed star" is a comet, it would lend the Dogon sense of the portentousness of these rare celestial events to the wildness of animals. Throughout Africa and the rest of the world, the apparition of comets is associated with disquieting change of time and state; see Roberts 1982.
18. Cf. Heusch 1985: 137–8, 215.
19. Ogotemmeli's and other versions of Dogon cosmogony are discussed in Roberts 1988a, with a detailed description of the iconography and use of *yo domolo* "robbers' crooks." The animal head of the shoulder crook has been variously described as that of a horse, dog, aardvark, rabbit, or hyena; my guess is that it may be all of them at once.
20. Griaule & Dieterlen 1986. A Dogon sculpture seen in a private collection portrays the torso of a Nommo upon a four-pillared platform representing the universe, its head that of a catfish. Re the attachment of all but the Bozo woman to the navel, see Griaule 1980: 36.
21. Quotes taken from Bachelard 1969: 6–7, 14, 17. "Closed" is a key word here, for in many African cultures, magic is placed in the thresholds and around the perimeters of houses to "close" them from misfortune and agents of evil; see Roberts forthcoming A.
22. Fernandez 1982: 101.
23. On household layout among Dogon and Mousgoum people, see Denyer 1982: 25, 14, 132. Examples of the ways that house layout can reflect human social relations and human/animal interaction among Berber people of north Africa and among people living along the Thai-Loatian border, are presented and analyzed brilliantly by Pierre Bourdieu (1973) and Stanley Tambiah (1973), respectively. The anthropomorphism of African architecture is nicely described for Batammaliba (Betammaribé) people of northern Togo and Bénin in Blier 1989: 202.
24. Domestic cats are kept in some parts of Africa, and they appear in the Dogon taxonomy of domestic animals reported by Ogotemmeli, as discussed above; yet I know of no case in which cats are kept as "pets" as African dogs sometimes are, nor are they looked to as helpmates. Instead, they are expected to hunt mice and other vermin for their sustenance, and seem tolerated rather than nurtured. Similarly, whereas dogs appear quite frequently in African visual arts, are sacrificed in some societies, and are widely employed as an element of magic, I know of no similar representation or use of cats.
25. On the early domestication of dogs and other animals in Africa, see Clutton-Brock 1981.
26. Ojoade 1990: 221.
27. MacGaffey 1993: 43.
28. Jespers 1983: 68.
29. Roberts 1993.
30. Roberts 1986a: 32–5.
31. Peek 1991: 198.
32. Cornet 1982: 91–2.
33. Koloss 1990: 49.
34. Ojoade 1990: 219.
35. MacGaffey 1993: 42–3.
36. The expression "seer extraordinaires" comes from Thompson 1983: 121. Peek (1991: 198) discusses dogs as messengers between living and dead.
37. See MacGaffey 1993: 40–1; Nooter 1993: 107. Janus figures with two faces or heads are discussed at length in Roberts 1986a and are one of the primary subjects of Roberts forthcoming A.
38. On the mirror as reflective division see Thompson 1983: 109. On the piercing gaze that traverses them see Roberts forthcoming A.
39. Bunseki is cited in Thompson 1983: 121. One can suppose that the doubled syllables of the Kongo word for "mirror," *talatala*, are a play on reflection, the more so since -*tala* is probably a form of the common Bantu noun *taa*, "lamp" or light source. Dualism in the arts of related central African peoples is discussed in Roberts 1986c and 1991.
40. Biebuyck 1973: plate 88.
41. Meurant 1994: 221.
42. Laude 1973: fig. 52 and caption.
43. A solid ethnography of the ambivalence of Beng people (Ivory Coast) to dogs is provided by Alma Gottlieb (1992: 98–107. "What makes dogs resonate so strongly for the Beng, .. is that in myth as well as daily life, dogs act both as Self and Other to humans."
44. On dogs among Nigerian people, see Ojoade 1990: 216.
45. Douglas 1979a: 10.
46. Heard while I was a secondary school teacher on contract to the Chadian Ministry of Education, 1965–6.
47. MacGaffey 1991: 54–5.

48. My first fieldwork—as rudimentary as it admittedly was—was conducted among Kabré of Tchitchao village during the summer of 1969, while a participant of an Operation Crossroads Africa project. Data on Kabré age-grade initiation was the basis for my honors' thesis in anthropology at Amherst College in 1968. The term "iniatiand" was coined by Victor Turner (1970) to refer to those undergoing initiation.
49. Ojoade 1990: 219–20.
50. Lonsdale 1981: 129–30.
51. Ojoade 1990.
52. A dog's ears are "headlights," head a "gearbox," throat a "telephone line" and tail the "telephone," legs "wheels" and feet "tires," and intestines a "roundabout." The water in which a dog is cooked is called "penicillin" (Ojoade 1990: 218), completing the contemporary satire.
53. Jespers 1983: 65–6.
54. Jespers 1983: 68–71, 84–5; cf. Heusch 1985: 174–83.
55. On Ogun as "Lord of the Cutting Edge" see Thompson 1983: 53. On further aspects of his role in recycling scrap metal, see Roberts 1996. On the "enraged orisa..." see Pemberton 1989: 106. The story of the dog that bit off Ogun's penis comes from Ojoade 1990: 220. Re new car protection see Apter 1992: plates 16–7. On the dog's decapitation and hanging at the shrine, see Pemberton 1989: 109–10.
56. Wyckaert 1913: 9.
57. Cf. Sperber 1975.
58. Douglas 1979b.
59. Douglas 1979a: 13.
60. In his brilliant analysis of English animal, food, and kinship categories, Leach (1979: 161) notes that most familiar animals have monosyllabic names; and that while many of these can be abusively extended to humans (bitch, cat, pig, swine, goat, cur, dog), others are "friendly, even affectionate" to the point of obscenity (lamb, duck[y], ass, pussy, cock).
61. Leach 1979: 155.
62. Cole 1989: 116.
63. On their association with African royalty, see Roberts & Roy 1993: 341. The citation is from Cole 1989: 116.
64. Hurston 1990.
65. Cole 1989: 121.
66. Donkeys are far more numerous and more frequently used than horses for all aspects of daily work by people across the Sahel and in other areas where tsetse-fly infestation does not preclude keeping livestock. Donkeys rarely if ever appear in African art, however, and one can guess that they are just too "common" for such recognition. Camels, used for some of the same chores in more arid lands, on the other hand, are occasionally represented in a number of visual media.
67. Evans-Pritchard 1969, 1977. The ethnographic present of Evans-Pritchard's research is the 1930s. A great deal has changed since then, due to natural and managed ecological change, and especially the protracted civil wars pitting non-Muslim southern Sudanese people against the Islamic fundamentalism of their central government.
68. Evans-Pritchard 1969: 16.
69. Evans-Pritchard 1969: 16–50 & 1977: 4.
70. Mack 1989: 51, 66.
71. Sassoon 1983: 96, 100; Bruyninx 1988: 311; cf. Maret 1985.
72. Sassoon 1983: 102–5; Roy 1992: 246–7.
73. Evans-Pritchard 1977: 202–3; cf. Kurimoto 1992.
74. Soukhanov 1993: 1585.
75. Luc de Heusch (1985: 4–6) discusses the pitfalls of applying words such as "sacred" and "sacrifice" from our Indo-European heritage, to the religious practices of Africans and others whose logic and thought are organized very differently. The Latin root sacer is rife with ambiguity, for it refers to something both "worthy of veneration" and "inciting horror," "majestic and cursed." African sacrifice (of necessity called that for want of another term in English) may not be based upon such ambiguity.
76. Mack 1989: 32, 62–6; Vogel 1981: 242–3.
77. Prussin 1986: 78–80, 100.
78. Bohannan 1965: 248–53.
79. Jacobson 1967. Nowadays, Western-style general-purpose currencies replace earlier bridewealth goods in many African societies, and some Africans no longer practice the exchange due to Western religious influences. A further change has occurred due to the slow shift of African political economies to capitalism. Young wage-earning men may save sufficient cash to pay their own bridewealth, thus rendering obsolete the network of economic and social debts incurred in the old days; see Bloch 1989 for a fascinating study of these changes in Madagascar. Tabwa elders bemoan such changes, and point to the arrogance and self-destructive behavior of young men (especially those associated with national-party politics) that result; see Roberts 1986b.
80. Håkansson 1988: 42–8.
81. J. W. Williams 1994: 45.
82. Abiodun 1989: 98, 102, 108–9.
83. Ezra 1992: 1158–60.
84. Robbins & Nooter 1989: 226.
85. Cole & Aniakor 1984: 24–34.
86. On ram masks see Félix 1992a: 12.
87. Weghsteen 1953: 22. Alternatively, Nkuba may be a billy-goat, a fire-red ram, or a ram with the head of a rooster and the feet of a kite Milvus migrans. Nkuba is the subject of a chapter of Roberts 1980 and much of one in Heusch 1982.
88. "Kalulu" is a pseudonym, named after the trickster hare of Tabwa tales. Kalulu was a true friend and the most masterful storyteller I knew during my fieldwork among Tabwa in the mid-1970s. In this tale, he included hilariously animated facial and hand expressions to indicate the terror of those in the house, and danced about to suggest the movement of his dramas; Roberts 1980: 185.
89. Van Avermaet & Mbuya 1954: 550.
90. Moore 1940: 227.
91. One day in 1976, a Tabwa chief agreed to show me his ancestral shrine—a rare honor indeed. The door stuck, and when he kicked it, a medicine bundle fell at my feet from where it had been tucked in the roofing thatch above the door, much to the chief's chagrin. The bundle consisted of a tiny bow with a duiker horn full of medicine twisted in its string. The chief quickly pushed it aside with his foot, making clear that the matter was none of my business. Without identifying the chief, I later described the incident to a renowned practitioner of magic who laughed uproariously and said that in all likelihood this was lightning medicine (dawa ya radii). Such magic is said to protect the chief and to see that his peo-

ple are not harassed or harmed by outsiders; see Roberts 1986b. The relationship between Nkuba and culture heroes is discussed extensively in Roberts 1980 and Heusch 1982.
92. Waterlot 1926: plate 8.
93. Cf. Roberts 1992a, 1996.
94. Adande 1977: 192–4.
95. OED 1982: 198.
96. Thompson 1983: 10–1.
97. Lewis 1980: 71. Labelle Prussin (1986: 79–80) illustrates an amulet from Sierra Leone consisting of a sacrificed ram's horn wrapped in a page of Arabic script empowered by a schematic centering device of crossed axes.
98. Roy 1979: 103.
99. Cissé 1983: 156.
100. Roy 1979: 95.
101. Arnoldi 1988: 79.
102. Middleton 1960: 109–16.
103. Roberts 1987a: 297–8.
104. Contemporary Christian art in Africa also plays on animal metaphors with the Bible, as illustrated by an "anecdotal crucifix" carved by Brother Yumba of the Monastère Notre-Dame-des-Sources in southern Zaire. The crucifix presents Biblical stories presented as though they were African folktales, with figures carved along three horizontal beams on a single vertical support. The photograph published by Badi-Banga Ne-Mwine (1982: 156) is difficult to "read," but its animal and human forms remind me of the decoration of Chokwe chairs.
105. Mercier 1979: 15–9; Sobania & Silverman 1992: 26 –30.
106. Roberts 1992c.
107. The rest of this paragraph relies of information about Kwele from Leon Siroto 1972: 70, 58, 60–62. Dr. Siroto states that the Kwele term for these is paazong (singular)/mezong (plural), and that mezong were only used by eastern Kwele (in what is now the Congo Republic), while western Kwele (in Gabon) used other measures of wealth; my thanks for this personal communication in 1991. I accept and am grateful for Dr. Siroto's assertion that the associations I suggest here are "rather risky." In offering this speculation, I acknowledge both the need to verify my educated guesses, and the need to take intellectual risks if we are to generate new hypotheses. Anthropologist Georges Dupré has conducted field research in the Kwele area, and will discuss mezong currency tokens in a forthcoming publication.
108. Roy 1992: 102.
109. L. Siroto, personal communication 1991.
110. Fernandez 1982: 99–125.
111. Turkeys may appear in Yoruba art, among the forms of a kola nut bowl; and ducks or other waterfowl decorate the covers of some Lozi Zambia food dishes, as illustrated in Robbins & Nooter (1989: 241, 533); guinea fowl and other domestic birds and animals are represented occasionally too, but still, these are relatively rare subjects of African art.
112. Pemberton 1989: 200–2.
113. Douglas 1979a: 15–6.
114. Fraser 1972: 148.
115. This mask was one of five chosen for an educational program based on the museum's permanent collection and devised by museum staff with guidance from my late wife, Mary Kujawski Roberts, under a U.S. Information Agency Academic Specialist Grant (Roberts 1992: 56–8). Children were urged to explain and then assume the posture of the hen, and many did, even down to the comical grin of the chicken's beak. Reference to the mask's use to curb or criticize promiscuity were not a part of the children's program.
116. Dark 1962: 34–5; Roy 1979: 92–3.
117. Ezra 1992: 86.
118. Zahan 1979: 34.
119. Heusch 1985: 174–5.
120. Cf. Ellen 1979: 8–12.
121. McLeod 1984: 100.
122. Roy 1979: 32, citing personal communication from René Bravmann.
123. Roy 1987: 273, 340–5.
124. Adler & Barnard 1992: plates 96–7.
125. Zahan 1979: 34–5.
126. Roberts & Roy 1993: 339.
127. Mudiji 1989: 238–9.
128. Roberts 1990a: 42.
129. Roberts 1981: 1–3 & 1992: 66–71.
130. Chicken feet are anisodactylous: three toes in front, one in back (Zahan 1979: 26). In a thematically related article on southwestern Native American rock art, Polly Schaafsma (1980) notes the zygodactylous foot of the roadrunner—two toes forward, two back—which is a form shared by cuckoos, woodpeckers, and some owls. The resultant X-shaped footprint appears in many petroglyphs and other expressive forms produced by Pueblo peoples. Its play is upon the "ability to confuse" of the crossroad-like X: is the bird going forward or back? In funereal art, the track motif may misdirect a vengeful ghost, for instance.
131. Zahan 1979: 26–7.
132. Zahan 1989: 355, original emphasis.
133. Roberts forthcoming A & forthcoming B.
134. See Zahan 1989, the last paper to be published before his untimely death. Dominique Zahan was a Stanley Fellow of the Project for Advanced Study of Art and Life in Africa at The University of Iowa in the winter of 1990–91, and he left Iowa City to go almost directly to his native Romania, to teach at the University of Kluj. His stay there was interrupted by virulent cancer, that took him within a very few months. Professor Zahan died young in his mid 70s, and it is ironic that his piece on crossroads should be his last work published before his death—something that ideally should not have happened to one yet so vital of mind and spirit.
135. The following paragraphs are inspired by Luc de Heusch's masterful book, Sacrifice in Africa (1985). Francophone authors have studied sacrifice more extensively than their anglophone counterparts. See the excellent case studies in the first five volumes of Systèmes de Pensées en Afrique noire (summarized in English in Mellott 1983) and in Cartry 1987.
136. Hubert & Mauss (1968 [1899]).
137. Indeed, the Latin root sacer is rife with ambiguity, for it refers to something both "worthy of veneration" and "inciting horror," "majestic and cursed." African "sacrifice" (for want of another term in English) may not be based upon such ambiguity.
138. See Heusch (1985: 4–17). My sense is that for both de Heusch and the Africans whose systems of thought are

understands so profoundly, the "game of death" is one of some ambiguity, uncertainty, and "play."
139. Such as those of René Girard in his Violence and the Sacred (1977).
140. William Murphy's recent adaptation of philosophical discourse on the sublime to explain a Mende (Sierra Leone) æsthetics of power is apposite here (1993 and forthcoming).
141. The citations in this paragraph come from de Heusch 1985: 214–5.
142. Zahan 1979: 34–5.

Chapter 2: Into the Garden

1. As taught to me by my great aunt, Rose Losee: "What a wonderful bird, the frog are. When he sit he stand almost; when he hop, he fly almost. He ain't got no sense hardly; he ain't got no tail hardly, either. When he sit, he sit on what he ain't got almost."
2. Soukhanov 1993: 302.
3. Bohannan & Dalton 1962.
4. Ellen 1979: 1. Lamarck (1744–1829) cautioned against confusing culturally constructed with "natural" distinctions among animals and other phenomena. British anthropologists such as Radcliffe-Brown did not pay heed, and the sense that they could discern "correct descriptions and arrange them in valid typological relations" was mocked as "butterfly-collecting" by Edmund Leach: expected in a dusty Victorian cabinet, perhaps, but hardly a way to portray the vagaries of human experience. See Ellen 1979 for an excellent review of this intellectual history.
5. Foucault 1970: xv.
6. Ellen 1979: 8.
7. Fungo is from the verb kufunga, "to close"; bundugu from ndugu, literally "the state of being brother (ndugu),"
8. Terms like these are found in the thought systems of other Bantu-speaking people such as Lunda people of Zaire, who "knot" and so bind together the categories of experience (De Boeck 1991); as well as in west African societies such as Kpelle of Liberia, who "create a fence" around relating health practices, and for whom "fence" is the word one may translate as "ritual" (Stone 1994: 394).
9. Such a formal exercise is obviously foreign to Tabwa experience. The late Luvunzo wa Musongo, one of the three men participating, was fully literate, and helped Kalulu and Mumbyoto (who could read a bit but not too well) place the animal cards in piles. This experiment was conducted in 1977, after having spent more than three years in the same village working closely with these three friends on all manner of research activities, some of which were novel to them, to say the least. These and a few other close friends joined in what, in similar circumstances, Victor Turner (1970: 138) called a "seminar in religion." They were used to my asking them to help with peculiar tasks, then; but I see no reason to believe that their choice of distinctive features or categories was influenced by my own sense of how the world works, or by the circumstances of working with me more generally. Furthermore, as noted below, Tabwa often argue about animal classification (is a bat a bird or an animal?) to wile away the hours.
10. It is possible that mbulu, the "water" monitor, is Varanus niloticus, and that kenge, its dry-land cousin, is V. griseus. The two are difficult to distinguish, and it seems that V. griseus is more a sahelian animal, while V. niloticus is given to inhabiting the edges of lakes and rivers; see Cloudsley-Thompson 1969: 73, 275.
11. In Swahili and other languages of the Bantu family, nouns are divided into a number of classes, each with its own singular and plural prefixes. The class mu-/wa- is generally that of people and other animate beings, while ki-/vi- usually suggests inanimate things. There are interesting exceptions, however, as when animate beings can be shifted to this class to suggest lack of the "civilizing" qualities shared by most animate beings; this is the case, for instance, of terrorist lionmen, called visanguka by Tabwa (see Roberts 1986c). When Kalulu called the sokosoko lizard a kidudu, he was stressing that these are not "animals" (nyama), but something altogether different. His use of the ki- prefix may have been a debater's ploy, to stress a difference that Luvunzo was questioning. On another occasion, he referred to a snake as a mududu, using the more usual prefix for animate beings.
12. Tabwa live along Lake Tanganyika, one of the longest, deepest, and most ancient lakes in the world. The fauna of the lake is of remarkable diversity, and in addition to myriad fishes (especially the scores of different Cichlidae or tilapia), its own peculiar life forms have evolved, such as Gastropod snails (Ampullaria spp.), crabs, and medusoid jellyfish (Limnocnida tanganjicae) so similar to marine species that it was once thought that the lake must be an ancient arm of the sea, long isolated by tectonic movements. See Cloudsley-Thompson 1969: 140–3; and Roberts 1984.
13. Distinctions such as these are made by other central African peoples. In a pathbreaking exposition, Kenji Yoshida (1992: 210–11) discusses Chewa (Zambia/Malawi) animal categories and, in particular, the Chewa concept of nyama, which can refer to "wild quadruped mammals" but also means "flesh," or potential meat. Domestic animals are never called nyama when alive, but are, after they are butchered. Birds and bats have their own category (mbalani), as do lizards and thunder (buluzi), snakes (njoka), fish (nsomba), and "small creatures that bite" (kalombo: insects, annelids, and arthropods). Tortoises, crocodiles, and snails do not belong to any categories but their own.
14. This may or may not be more true of men than women; there is gender segregation during the sorts of activities described here, and because I would accompany men, I know less of women's views. Nor was this an explicit research interest of Christopher Davis-Roberts, my former spouse, who studied Tabwa medicines and related matters, primarily among women (Davis-Roberts 1980).
15. One man said that a crocodile is a fish-animal, rather like a crocodile-person (mamba-mutu)—the local version of the Mami Wata mermaid, but with the lower half of the being a crocodile rather than a fish.
16. Bascom 1975. For example, if you were in a capsizing canoe with your sister, your wife, and your mother-in-law, and could only save the life of one, which would it be? Tabwa observe matrilineal descent, and so one's heirs are one's sister's children; yet one is equally bonded emotion-

all with one's own birth children, and woe be it should one abandon one's mother-in-law! This and other equally perplexing but hilarious (as long as it happens to someone else) double-binds of social structure are debated by Tabwa for hours at a time.
17. See Hegel cited in Llewelyn (1986: 8); see also Bachelard 1969: 39. Cf. Roberts 1992.
18. Ellen 1979: 8.
19. Roberts 1983. Mary Douglas (1979c: 296) mentions but does not elaborate upon Durkheim's question, "how fuzzy are the boundaries of the categories" of classification systems? The application of a sense of what "fuzzy sets" are, to African social identity, was first suggested to me by linguistic anthropologist Hoyt Alverson (see Roberts 1989: 193–4). There is healthy debate in African art studies as to the appropriateness of such approaches to African symbolism. On the "other side" are materialist Positivists, who cautiously hope to find the enduring explanation for expression; see, for example, Ezra 1988.
20. Needham 1981: 25 and passim. Indeterminacy and the polythetic appear in many other aspects of African culture, as when they characterize Yoruba gods and the art forms that both represent them and are their vehicles for action (Barnes 1989: 2–12). Andrew Apter finds that "the apparent inconsistency of the Yoruba pantheon—the flexibility and indeterminacy of its centering and decentering deities—supports shifting political relations and expresses rival political claims. Properly conceived, the Yoruba pantheon exists as a practical calculus of differential, substitutable, and integral relations which can be variously interpreted according to changing contexts and situations" (1992: 155–6).
21. Fernandez 1986c.
22. Cf. Ben-Amos 1976: 243–5.
23. Cartry 1979: 265–9. Cartry's work nicely counters the "smug incuriosity" of some, who might be "content to analyse a symbolic system until it is phrased in terms of a universal contrast between nature and culture without specifying the particularities of the case in hand" (Douglas 1979c: 286–7). Both the delineation and the fuzziness of a "village/wilderness dichotomy" are discussed at length in Anderson and Kraemer 1989; see also McNaughton 1990.
24. See Fernandez 1982: 100–110. One is reminded of Marlow's sense of suffocation as he traveled into the "heart of darkness," through the luguhrious rainforest bordering the Congo River: "Trees, trees, millions of trees, massive, immense, running up high; and at their foot, hugging the bank against the stream, crept the little begrimed steamboat, like a sluggish beetle crawling on the floor of a lofty portico" (Conrad 1983: 538). This particular passage echoes Coleridge ("Water, water, everywhere"), and one must take care not to project a Western sense of anxiety and futility onto African landscapes and cultures, thereby inventing the continent anew; cf. Mudime 1988 and idem, 1994. Rather than falling into such a trap, Fernandez captures Fang ambivalence to the forest, as both frightening and exhilarating; cf. Fernandez 1982: 3–4.
25. Middleton 1960: 237–8.
26. On the normal and its inversions, see Leach 1979: 160. Social distance may be but is not necessarily the same as physical distance. In urban Africa and other places where ethnic groups are mixed, ethnic lines may be equally strongly drawn. As Fredrik Barth (1969: 15) has written, "the identification of another person as a fellow member of an ethnic group implies a sharing of criteria for evaluation and judgement. It thus entails the assumption that the two are fundamentally 'playing the same game,' and this means that there is between them a potential for diversification and expansion of their social relationship to cover eventually all different sectors and domains of activity. On the other hand, a dichotomization of others as strangers, as members of another ethnic group, implies a recognition of limitations on shared understandings, differences in criteria for judgement of value and performance, and a restriction of interaction to sectors of assumed common understanding and mutual interest." On issues of central African ethnicity, see Roberts 1989 for a Tabwa case study and more general bibliography.
27. Cf. Douglas 1979c: 289.
28. Fortier 1967: 161. The myths in question are either from Fortier (1967) or from my own research while a Peace Corps Volunteer in Baïbokoum, Chad (1968–70), as analyzed in Roberts 1972: 78–120.
29. "Stations" is my allusion to Christian cosmology, as Christ passed through the Stations of the Cross leading progressively to His crucifixion. With regard to Sara reference to disease, Lévi-Strauss notes that "we imagine infirmity and sickness to be deprivations of being and therefore evil. However, if death is as real as life, and if therefore everything is being, all states, even pathological ones, are positive in their own way. 'Negativized being' is entitled to occupy a whole place within the system, since it is the only conceivable means of transition between two states" (1969: 53). Such insight is applicable to the discussion of sacrifice at the end of our previous chapter, and responds to (and in a sense contradicts) Leach's sense of "taboo" introduced earlier and again below.
30. Following Lévi-Strauss (1963b: 224), one can also discern distinctions and "resolutions" as one moves upward, from the Earth through a first level associated with hunting (hawks and kites), on to others marked by death and dissolution (carrion-eating crows and vultures), and finally to heaven where God fosters animal husbandry and agriculture (Roberts 1972: 93).
31. Other taxonomies overlap and intersect these strictly linear ones. Categories are established drawing distinctions between terrestrial and airborn animals, those on land and others inhabiting waters, and between those active in daylight and their counterparts lurking in darkness. While I shall concentrate on a linear model as a means to organize an immense body of information, it must be understood that it is very unlikely that things are ever so simple as such a model would suggest. Rather, in the same way that symbols may be polythetic (as discussed in the preceding section of the previous chapter), so entire classification systems may be shot through with alternative organizational modes. As people live their lives, these seeming contradictions or alternative systems are understood, accepted, and employed in everyday affairs; I have written elsewhere about how such fuzziness characterizes African ethnic identity (Roberts 1985, 1989). In writing a book such as this one, however, the need to choose one of the many competing organizational schemes imposes itself, if the book is to have any order at all!
32. Sahlins 1969: 147–9.
33. Middleton 1960: 230–8.

187

34. Evans-Pritchard 1977: 89.
35. Douglas 1979c: 285, my emphasis.
36. Cf. Geertz 1979: 81, Douglas 1990.
37. There appears to be a significant difference between the relatively short list of animals that are portrayed in African visual arts, and the longer one of animals that may appear in proverbs, just-so stories, and other narrative forms. It is not that these latter escape African notice, are insignificant, or lack potential as sources of metaphor; rather, despite being the subject of oral expression, they are rarely if ever represented visually. I doubt that there is any explanation of this puzzle that fits all cases, and it is quite likely that interest in animals is a matter of degree: some are more evocative than others, and given the limited needs for visual materials, it is they that are chosen. Those not represented now or in the past, may be in future, however, if needs are such that a mole or mouse proves more metaphorically apposite than other animals that may have been used in past visual metaphors.
38. Douglas 1979c: 282 & 1990: 25.
39. See Douglas 1979c: 282. Douglas herself has demonstrated remarkable courage in working through her position, and modifying her own earlier arguments; see Douglas 1990 for a discussion of her own intellectual history, as well as for a series of caveats about the nature of symbolic analysis for which she might take me to task concerning certain speculative points in the present book, as she has on earlier occasions—always in the spirit of genially constructive criticism, I might add! Dan Sperber (1975) has asserted that a classification system has no necessary rigidity, and can include whatever. Roy Ellen (1979:14–5), too, cautions that "it is important to distinguish genuine anomalies from those produced by careless use of the taxonomic method," and that "we must be careful not to invent anomalies where they do not exist." He further suggests that rather than being "negatively anomalous," the peculiar beasts in question may be "positively singular." I generally take Ellen's point that "whereas the inbuilt, rigorous logic of ethnographic method easily gives rise to anomalies"; however I disagree with the latter half of the same sentence, that "the informal logics of folk systems permit its avoidance" (1979: 14). In my opinion, "folk systems" are not any more or less "informal" than Western ones, although I agree that it is heuristic to define "folk models" as those "practised in a spirit of community and mutual respect, rather than when being preached by those [outside the culture] who think they know best" (Jacobson-Widding 1991: 12). Furthermore, as suggested above, my sense of African polythetic representation is that African people do not avoid contradiction and paradox, but instead they allow and even thrive on it.
40. Douglas 1979d: 95–6.
41. T. Turner 1969: 49–65.
42. Lévi-Strauss 1963b: 226.
43. From a lecture by Victor Turner at The University of Chicago, 1971. The discussion of Su is based upon my MA paper (Roberts 1972) for which Professor Turner was principal reader.
44. "Spinner of doubleness" is from Pelton, who also describes the spider as a "personified limen" (1989: 24, 58). "Neither this nor that..." comes from Turner 1970: 99. Trickster tales, middle speech, dilemma tales, and parables are among the topics of "THRESHOLD Narrated," the second chapter of Roberts forthcoming A.
45. My thanks to then-three-and-a-half-year-old Seth Roberts for suggesting this description of Ananse (personal communication, 1993).
46. Roberts 1992a: 49–65.
47. Griaule & Dieterlen 1986: 235–47.
48. Cited in Detienne 1986: 114.
49. Gebauer 1979: 24, 58, 86–9, 93, 103.
50. Peek 1991: 197–8.
51. Gebauer 1979: 375.
52. Roy 1987: 76, 78, 223.
53. Glaze 1981a: 76 and passim.
54. Personal communication, 1994.
55. MacGaffey 1983: 128–9.
56. Roberts 1990: 40–1. Cone shells (Conus leopardus or C. imperialis) appear in the Ocean from far-off islands in the Indian Ocean. Disks were cut from the ends of the shells and traded inland from the east African coast, and were used throughout central Africa as symbols of social status (Roberts 1990: 40–1). Gastropods (snails and other mollusks like cone shells) are usually "right-handed," with their whorls turning counterclockwise when viewed from the outside; but a few sport individuals are left-handed, with the opposite turning about the spire (Gosner 1978: 124).
57. Useful essays on the meanings of death for African peoples are found in Bloch & Parry 1982, and Cederroth et al. 1988.
58. Roberts 1984.
59. For the first quote, see Thompson 1974: 133. For the second, see James 1990: 196–7.
60. Other small antelopes such as sunis and oribis have localized populations, and in some cases may be glossed with duikers in African classification systems. On these and other African mammals, most useful reference works are Dorst & Dandelot (1969) and Haltenorth & Diller (1988).
61. Dorst & Dandelot 1969: 249–50.
62. Ibid.: 259–60.
63. E.g. Devisch 1993: 74.
64. On the Tabwa masks in question see Félix 1989: 218 –9. On the Baro and Nyindu masks, see Vogel 1986: 116 & 98–9.
65. Biebuyck 1973: 164, 214, plate 37; Roy 1992: 111; Anderson & Kreamer 1989: 107.
66. Cf. Savary 1992: 11.
67. E.g. Maurer 1985: 232, 241.
68. Mato 1990: 26.
69. Maurer 1985: 225, 227, 233, 235.
70. Dorst & Dandelot 1969: 198–9.
71. Maberly 1963: 80–1.
72. Bouillon 1953: 590.
73. Tabwa have a sense of the effects of cannibis that differs from how the drug is usually viewed in the United States: rather than making one "mellow," it brings on and releases aggression, and those few who smoke it are both scorned and feared.
74. Roberts 1980: 148–9.
75. Roberts 1980: 147; cf. Bouillon 1954: 587–8, 590; and Moore 1940: 225–6.
76. Roberts 1980: 147; Marks 1976: 100.
77. De Boeck 1991: 41; Roberts 1992b.
78. Nooter 1990: 97, 106.

79. Roberts & Maurer 1985: 149; cf. Lambo 1947 and Richards 1935.
80. Hersak 1986: 164–5; Roy 1992: 160–1.
81. Christopher Roy (1992: 55) reports seeing such a mask danced in a Mossi village in Burkina Faso. A young man had purchased it from a Guro carver while working in Ivory Coast, and when he brought it back home, the mask was repainted in the distinctively Mossi red-white-and-black patterns, a new fiber costume was attached to it, and it was renamed katré, "Hyena." As Professor Roy suggests, this is a brilliant example of the reinvention of objects through the course of their "lives."
82. Deluz 1989: 130.
83. Robbins & Nooter 1992: 275.
84. Dorst & Dandelot 1969: 197–8.
85. "Shrewdness" is a 15th-century English term of venery, used to refer to a troop of apes (Lipton 1977: 54). Most African animals were unknown to English-speakers centuries ago when such terms were being generated, often by adopting a poetic reference to an aspect or attribute of the animal and applying it to a company of same (e.g. a "murder" of crows or a "skulk" of foxes). Because no term exists to specifically describe baboons, one is left to extend words used for related animals. Certainly the term "shrewdness" captures the fascination and frustration of Tabwa farmers watching their fields be destroyed by baboons more clever than they. Indeed, in his entertaining compendium An Exaltation of Larks (1977), James Lipton encourages such extension and the invention of new collective terms to meet our contemporary needs; perhaps in my own field, a "bicker" of anthropologists would be appropriate!
86. Dorst & Dandelot 1969: 46.
87. Susan Vogel (1985: 125) notes that these figures have different names and purposes among the subgroups of the region, and that as a corpus, they range from "vaguely simian to fully human." Diane Pelrine (1988: 54–5) notes that the names given these figures may refer to particular objects or styles than a broad category of figures.
88. Féau 1989: 74–5; Pelgrine 1988: 54.
89. N'Diaye & Vogel 1985: 135; Pelrine 1988: 54.
90. Waterlot 1926: plate 9b.
91. Drewal & Drewal 1990: 200.
92. Cole 1982: 61.
93. Bastin 1982: 92–3.
94. M. Jordán, personal communication 1994.
95. Goldwater 1964: 18–9.
96. Johnson 1991: 29, 32, 61. Thanks are extended to Nancy Ingram Nooter for bringing this book to my attention.
97. Such tusks are more properly called "tushes."
98. Material in this paragraph thanks to Dorst & Dandelot 1969: 174, 178.
99. Roy 1987: 99–111, 217–8, 288 and passim.
100. Pelrine 1988: 38.
101. Silverman 1994: 41–3.
102. Brelsford 1941: 10.
103. Because no term exists in English (see footnote 85, above), one has a choice of words to describe a group of bushpigs: "sounder," as used to refer to some wild pigs (Soukhanov 1993: 697) and which seems usefully applied to a bunch of grunting warthogs, or "singular." As James Lipton (1977: 45) explains this last, 15th-century collective term, "singular" is derived from the extraordinary nature of the wild boar, called Singularis porcus in Latin. The bushpig, too, especially from a Tabwa viewpoint, is nothing if not singular!
104. Kaoze 1947: 98.
105. Ruel 1970: 339, 341.
106. "Luba-ized" refers to those who have adopted some prestigious aspects of Luba political culture, as did western and northern Tabwa chiefs in the 19th century, when they sought to consolidate their political powers following a Luba model of sacred kingship. It was among these Luba-ized Tabwa chiefs that Pierre Colle served as a Catholic missionary and conducted the research leading to his important work, Les Baluba (1913). These and related issues of political economy and history are discussed in Roberts 1985 and 1989.
107. Although the possession of Bulumbu mediums is assisted by the ancestors, it is not they who "mount" the person in trance; rather, they summon earth spirits to speak through their loved one. Bulumbu as a religious form was adopted by Tabwa from neighboring Luba in the 1930s, at a time of great social change. Capitalism, Catholicism, and other social forces were transforming Tabwa society, and earlier, collective practices such as observation of "ecological cults" dedicated to earth spirits, were becoming obsolete. Instead, what was needed was personal catharsis, stressing the same individualism fostered by capitalism and Catholic salvation. The earth spirits now reside in the cavern described in this account, along with the ancestors presided over by Kibawa, the most important spirit which Tabwa and Luba associate with their culture heroes. They can be summoned from Kibawa's cavern to possess Bulumbu adepts. This is not the last word of Tabwa religion, however, as it continues to evolve (as do all religions), to meet new circumstances; these and related developments are discussed in Roberts 1984, 1985, 1988b, 1989, and 1990.
108. Colle 1913: 542–8.
109. Nooter 1990.
110. Recall that the word "sinister" in English is derived from the Latin word for "left," and that if one attends a Christian wedding as guest of the bride, one is directed to a seat on the lefthand side of the church, facing the altar. Dichotomous representation in Tabwa art and narrative is discussed in Roberts 1985, 1986a, 1986c, 1991, and 1993, and is a topic of a book, Roberts forthcoming A.
111. Hata & Yoshida 1986.
112. Drewal & Drewal 1990: 207–9.
113. Thompson 1974: 205–6.
114. It is not altogether clear whether these depict bushpigs or domestic swine, despite their frequent identification as "bushpigs" in the literature (cf. Gwete 1982: 52); my thanks to Manuel Jordán for discussion of this and related points, based upon his own recent fieldwork among Chokwe and other peoples of northwestern Zambia.
115. Gwete 1982: 59.
116. Bastin 1982: 92–3.
117. Jordán 1993: 51–2; Roy 1992: 142–3.
118. M. Jordán, personal communication 1994.
119. Roy 1992: 225.
120. Cited in Roy 1992: 225.
121. Roy 1992: 142, 225; Heusch 1988a: 20.
122. Cf. Roberts 1980.

Chapter 3: Out on the Edge

1. From Schneider & Schneider 1994: 13, reworded.
2. As Clifford Geertz (1979: 85) has written so eloquently, "the strange opacity of certain empirical events, the dumb senselessness of intense or inexorable pain, and the enigmatic unaccountability of gross iniquity all raise the uncomfortable suspicion that perhaps the world, and hence man's life in the world, has no genuine order at all —no empirical regularity, no emotional form, no moral coherence. And the religious response to this suspicion is in each case the same: the formulation, by means of symbols, of an image of such a genuine order of the world which will account for, and even celebrate, the perceived ambiguities, puzzles and paradoxes in human experience." Religion does not deny pain, fear, and misery; rather, it explains how and why one must endure such travails.
3. The Tabwa saying comes from Kaoze & Nagant 1973.
4. On the Fang, see Fernandez 1982.
5. Willis 1990: 247. Recent authors have modified or rejected Freudian and Jungian hypotheses concerning the snake as necessarily "phallic," regardless of culture, and have argued for a more relativist approach; see Willis 1990, and Mundkur 1983, 1988. The subtitle of this section is drawn from Milton's "Paradise Lost." Parts of this section will be developed further in a forthcoming book on Tabwa cosmology.
6. Gougaud 1973: 125.
7. Eliade 1959: 48.
8. Often, snakes are represented generically as zigzags or linear forms, and cannot be visually identified by species except by context or association with proverbs or other narrative contingencies; see, for instance, the ophidian scarification patterns illustrated in Faïk-Nzuji 1992: 108). Pythons are often represented as having backs decorated with zigzags or diamonds, when the patterning of the animal in nature is far less regular than this. African artists often represent the Gaboon adder in a similar fashion when they, too, have a far more complex patterning than this suggests, and it is difficult to distinguish pythons from Gaboon adders in many of them, except by length: the largest pythons may attain 15–18 feet, while Gaboon adders only reach 4–5 feet.
9. On Tabwa serpents associated with earth spirits see Roberts 1984. Re snake cults in central African in general, see J. M. Schoffeleers 1978: 12.
10. On Igbo relations with pythons, see Cole 1982: 61. A series of remarkable photographs of ritual snake-handling among Sukuma people of Tanzania is offered in Hendriks 1988: 106–8. My thanks to Father Max Terrais for making this book available to me.
11. On Zairian snake staffs, see Roberts 1994a. On Benin regalia, see Duchâteau 1990: 63.
12. Thompson 1974. On the balamwezi pattern, see Maurer 1985: 261–2. Also see Roberts & Maurer 1985: 188–9. The artist's treatment of "motion" in this object is reminiscent of another Tabwa creation: a male figure with a pendant coiffure carved to imitate the weaving of dreadlocks, prompts what Susan Vogel (1986: 176–8) describes as a "jazz riff."
13. The Baule version is found in Roy 1979: 84–5. The Fante version is in Adler & Barnard 1992: 49.
14. Drewal & Drewal 1990: 206.
15. Thompson 1974: 142–3.
16. On the palace bas-relief, see Bay 1985: 18–9. On the snakes made for family shrines, see Blier 1990: 43.
17. Griaule 1980: 48–9.
18. Yoshida 1992: 249. Yoshida suggests that the figure and a song he recorded refer to sexual intercourse, with, presumably, the "python" the male member. Based upon exegeses of Tabwa (who live in the same general culture area), my guess is that Chewa consider a woman's fertility to be generated and controlled by a "snake" living inside her body, to which these objects and performances refer. See Roberts 1995 for an explanation of relevant ethnography.
19. Roy (1979: 54) states that such sculptures represent "a hooded serpent," and the spots on either side of the blunted top suggest the "eye-spots" of a cobra (Naja spp.). The pattern on the back is similar to that of the python, however, and it is possible that reference to several serpents is made through the same object. Other snakes are alleged to stand on the tips of their tails too; see Roberts 1980.
20. On bansonyi and the mock combat, see Roy 1979: 54– 5. Robbins and Nooter's illustrations are in Robbins & Nooter 1989: 142–3.
21. Roy 1987: 263, 268.
22. On Gelede, snakes, and the power of women see H. Drewal 1981: 114–5; Drewal & Drewal 1990: 74, 183, 206.
23. Hambly 1921, Loewenstein 1961.
24. Drewal & Drewal 1990: 186.
25. Roy Picton 1994: 84–5. My speculation about the Esan gender symbolism associated with bilateral symmetry is based on the overwhelming preponderance of world populations that see things this way—with a few interesting exceptions, of course; see Needham 1973.
26. Heusch 1982: 54, citing Jean Feytaud. Nfwimina finds its homologues in the cosmologies of neighboring central African peoples. See also Roberts 1995.
27. Colle 1913: 353.
28. Rainbows are created when light strikes spherical drops of airborne rain and is refracted inside the drop. When light strikes from a slightly different angle, it is refracted a second time within the raindrop, reversing the spectrum. "Violet," from the rainbow's spectrum recognized in the West as (from the top of the rainbow downward) red-orange-yellow-green-blue-indigo-violet, is a culturally specific term foreign to the usual triad of primary colors recognized across most of Africa. "Violet" would probably be glossed as "black" in an African spectrum; see Roberts 1993. See also Turner 1970: 93, 97, 98.
29. Cloudsley-Thompson 1969: 73. The subhead is from a song in the Walt Disney™ movie, "Peter Pan."
30. Marks 1976: 102.
31. Cf. Gansemans 1980: 51 and passim.
32. I worked with Tohoessou Sourou in March, 1994, in the course of research for a book and exhibition entitled "Recycled, Reseen: Folk Art from the Global Scrap Heap," organized by the Museum for International Folk Art in Santa Fe, New Mexico, that opens in 1996. Thanks are extended to the museum and to the Project for Advanced Study of Art and Life in Africa (PASALA) at The University of Iowa, for supporting my field research, and to Dr. Joseph Adande, professor of African

art history at the National University of Bénin, for acting as my collaborator and guide. See Roberts 1996.
33. The passage was translated and to some extent adapted from Mr. Tohoessou's Aja into French by Augustin Ahouanvoedo, an uncle of Professor Joseph Adande and retired civil servant, who had introduced us to the blacksmiths. My hearty thanks for Mr. Ahouanvoedo's help. Mr. Ahouanvoedo used the word "sign," and described the monitor as a "reptile"; his term "bizarrerie" is perhaps a local Béninois idiomatic expression in French, meaning "something bizarre." The reference to the assanyin as a "face" is to an altar where offerings may be made and "eaten" by the ancestor so honored; on related Yoruba use of the concept of a "face of the gods," see Thompson 1993.
34. Roy (1987: 223) identifies it as a crocodile but Woodward (1994: 64–5) suggests it may be a lizard. Another Nuna mask, a plank mask illustrated by Roy (p. 215), is surmounted by a reptile with the tipped-up nose, alternating sharp teeth, and serrated tail that are clear diagnostic traits of a crocodile. The "monitor" mask lacks these and has a diamond-shaped head, regular teeth, and a longer, smoother tail like those of a lizard, not a crocodile; it still might be one, of course, and without explicit exegesis, my identification remains speculative.
35. For further discussion of this particular mask see Roy 1987: 218–34.
36. Roy 1970: 162–3.
37. On this door in the Wunderman collection, see Ezra 1988: 93. Also see Jean Laude (1973: catalog fig. 73), who identifies this as a crocodile. I believe his identification can be challenged in the same way as the Nuna mask at the Virginia Museum of Fine Arts, discussed above. The configuration of the limbs of the lizard on the granary door also echoes that of the legged figures on the upper portions of kanaga masks, sometimes identified as lizards (among other animals). The agile dancing of kanaga masks, through which the young man swings his head about to touch the upper "limbs" to the ground (see the cover of Laude's book for a photograph), may enact the descent of a "flying" monitor to earth.
38. Foester 1988.
39. On the Tabwa stool, see Maurer 1985: 262. On the hunting cult, see Neyt 1977: 495–6.
40. See Burton 1981: fig. 14. The references made by these clay figures seem to be to several different animals, probably at once, including leopards and hippos; see Nettleton 1992: 32, 33, 130–1.
41. Mbote are a "Pygmoid" people who live by hunting and gathering in the mountains in territories otherwise inhabited by Tabwa, eastern Luba, and other groups. They are distantly related to Mbuti and other groups of the Ituri forest, but left the forest so long ago and have intermarried and lived among Bantu-speaking peoples for so many generations that they do not maintain a "Pygmy" culture (nor are they "little," as "Pygmies" are expected to be). Rather, their way of life is distinct from but complementary to that of the Bantu-speaking people with whom they live and interact. Mbote and related hunter-gatherer peoples outside the rainforest have been studied very little; see Terashima 1980 and Roberts 1987b.
42. Laude 1973: catalog fig. 6.
43. Thompson 1974: 98–9.
44. Duchâteau 1990: 56, 63.
45. Brain 1980: 53.
46. Biebuyck 1973: plate 90.
47. Adler & Barnard 1992: 58. Akan goldweights may portray this last proverb, and were used mnemonically but also in circumstances when only a visual code known to some but not others, could be shared. Barbara Thompson (1994) recounts how a 15th-century king trading gold dust for firearms with a European merchant, measured the dust against a weight portraying a crocodile seizing a mudfish, to warn his people that they should know that the European would resort to violence and use his guns against them if he did not receive the gold he desired. My thanks to Ms. Thompson for sending me a copy of her excellent paper.
48. Authors sometimes mistakenly call hornbills "toucans" (a central American bird), because of the supposed resemblance of their large beaks. Because of the wide range of styles and uses of hornbill imagery, the bird has often been a focus of exhibitions of African art, e.g. Kuchta 1973 and Lifschitz 1982. On hornbill iconography, see McCall 1975.
49. Williams 1964: 146.
50. Lifschitz 1982: 4.
51. Williams 1964: 146, 150. Bemba people of Zambia "hear" the ground hornbill's call as "Where do you keep the food for the children?" (kambala ka mwana mubikile kwi, kali kuntambalilo), as they also "hear" other birds to "say things" (Brelsford 1945: 31).
52. On initiation societies imitating the hornbill, see Roberts 1994b. On the leopard's growl effect, see Heusch 1982: 138.
53. Roy 1987: 350–2.
54. Bravmann 1983: 44.
55. De Boeck 1991.
56. Heusch 1982: 189, citing de Sousberghe. See de Heusch, chap. 6, for more on Mungonge initiation.
57. Goldwater 1964: 28.
58. Roy 1979: 44–5.
59. See Glaze 1981b: 36 and (re the wing patterns) Roy 1979: 45.
60. Goldwater 1964: 28.
61. Glaze 1981b: 36.
62. Roy 1992: 26–8; Glaze 1981b: 207–8, 127–32.
63. Williams 1963: 146.
64. Brelsford 1941: 11.
65. Roy 1987: 305–6.
66. Roy 1987: 169.
67. Robbins & Nooter 1989: 283.
68. Davis 1981: 60–1.
69. Goldwater 1964: 28.
70. Brelsford 1945: 32.
71. Williams 1964: 155.
72. Lipton 1977: 57.
73. Simmons 1971: 96–7, 109.
74. Ruel 1970: 340.
75. Biebuyck 1972: 77.
76. Roy 1992: 116.
77. Biebuyck 1972: 78.
78. Félix 1992a: 14–5.
79. A photograph of such a figure appears in Schneider & Schneider 1994: 6; my thanks to Gilbert and Evan Schneider for discussing Mambila owl imagery, based upon their long residence in the area as missionaries and teachers.

80. See Simmons 1971.
81. Dorst & Dandelot 1969: 100.
82. Blakely & Blakely 1987: 32–3.
83. Blakely & Blakely 1987: 85.
84. E.g. Neyt 1977: 502–3.
85. Such an inappropriate opening as a sign of crude excess is found elsewhere in the mythical logic of Hemba, Luba, Tabwa, and other closely related people of southern Zaire; see Heusch 1982: 158.
86. Blakely & Blakely 1987: 31–2.
87. Cornet 1975: 123.
88. Blakely & Blakely 1987: 33–4.
89. Blakely & Blakely 1987: 36. My own feeling is that there is more to be said about these masks and their performance, for the ethnography of Tabwa, Luba, and other peoples of the region suggests that for these neighbors of the Hemba at least, the mimesis of the chimpanzee may be horrifying in some ways, but it is also distinctly—though uncomfortably—humorous. Most funerals, too, are not the sorts of "serious" events Western observers might expect; rather, they include story-telling, joking, teasing, and outright taunting between clans and other factions. From a functionalist perspective, the laughter associated with such devices helps people to "let off steam" and contextualize their grief, while from a more cognitive viewpoint, it provides comedic inversion that allows people to conceptualize the passage of the spirit to and across the threshold of "ancestorhood." My guess is that the so'o masquerade for Hemba serves some of these same purposes.
90. Roy 1979: 73.
91. Lifschitz 1982: 7.
92. Bravmann 1983: 33.
93. Cf. Ross 1979. See also Siroto 1972.
94. Siroto 1972.
95. See Fernande 1986a: 24.
96. Drewal & Drewal 1990: 209–10.
97. For extended case studies of African shape-shifting and relevant bibliography, see Roberts 1983 and forthcoming D.
98. The spotted hyena's characteristics have been reviewed and discussed by David Sapir (1981) for Diola of Sénégal, Alma Gottlieb (1992) for Beng of Ivory Coast, Allen Roberts for Tabwa and related peoples of Zaire/Zambia (1980: 265–74, 1992d), David Parkin for Giriama of Kenya (1991:151–6), and Thomas Beidelman (1975) for Kaguru of Tanzania.
99. Beidelman 1975: 190.
100. Kruuk 1974. The collective term "skulk" is a 15th-century term of venery that refers to foxes and thieves (Lipton 1977: 37); given what many Africans think of the animals, it seems appropriate to extend the term to hyenas, as well.
101. Moss 1978: 65–7, 89–90.
102. Hans Kruuk 1974: 210–1.
103. White 1960: 3.
104. Roosevelt & Heller 1914: 257.
105. The Tabwa example is from Roberts 1980: 270, the Giriama from Parkin 1991: 151–6.
106. Roberts 1992d.
107. Goldwater 1964: 19.
108. Roberts 1988a.
109. Gottlieb 1992: 108–18.
110. Beidelman 1975: 190; 1963: 64–5.
111. Zahan 1960.
112. McNaughton 1994: 34.
113. Brain 1980: 80–1, based upon Zahan 1960.
114. Roy 1987: 221–2, 266–8, 273.
115. Heusch 1982: 8–9; 1988a: 30.
116. Drewal & Drewal 1990: 27, 29, 103.
117. The ethnic term "Bushmen" is problematic, for in South Africa it has been used as a derogatory, racist epithet. Alternative terms, chosen to avoid such connotations, include "!Kung" and "San," which often appear in scholarly literature. !Kung do not call themselves "!Kung," however, but Zu/'hoasi; and "San" is an inter-ethnic slur, used by Nama people to refer to "any impoverished, cattleless people." There seems no easy solution, and archæologists David Lewis-Williams and Thomas Dowson (1989: 8–9) have chosen to use "Bushmen," with a sensitive explanation of what they mean by the term. I shall follow their lead.
118. Dorst & Dandelot 1969: 190.
119. The following account is digested from Lewis-Williams and Dowson 1989, and Dowson 1992. Readers are encouraged to consult the original texts for deep detail, insightful explanations, and wonderful illustrations. I am grateful to my colleague, William Dewey, for introducing me to this important writing—and for loaning me his books!
120. "Shamanism" is a much-used and frequently misunderstood term. "Shaman" is derived from Siberian Inuit languages and now correctly extended to similar worldwide religious structures to identify a practitioner "whose powers come from direct contact with the supernatural, rather than from inheritance of memorized ritual." Trance is often the vehicle of the shaman's passage to the other world, where s/he contacts spirits directly, interacting and sometimes fighting with them to wrest control of the soul of someone they are afflicting. Useful essays on shamanism by Knud Rasmussen, Claude Lévi-Strauss, and several other authors are reproduced in Lessa & Vogt 1979, chapter 6.
121. Dowson 1992: 52–5.

Chapter 4: Beyond the Pale

1. "Pale" is the term for a picket, "a fence enclosing an area," or the area so enclosed; and "The Pale" in particular meant the English dominions in Ireland. See Soukhanov 1993: 1302.
2. "Pastiche" is "a dramatic, literary, or musical piece openly imitating the previous works of other artists, often with satirical intent," and a "borrowing of incongruous parts, a hodgepodge." Soukhanov 1993: 1325.
3. Clifford 1988: 118–9. "Instability of appearances" is from a wall text at the Wadsworth Atheneum in Hartford, Connecticut, referring to a painting by Salvador Dali. "Aggressive incongruity" is a politically tinged phrase from Georges Bataille (1991: 54). Surrealist theory has been discussed and applied to African culture-building in Roberts 1992a and 1996.
4. F. Johnson 1988: 6, 116.
5. Roberts 1993.
6. Murphy 1993 & forthcoming.
7. Mabille 1962: 32.
8. Max Ernst cited in Clifford 1988.
9. Geertz 1979: 85.
10. Geertz 1979: 158.
11. Bataille 1991: 54.
12. See Turner 1970: 103–5.
13. Hart & Hart 1992.
14. Dorst & Dandelot 1969: 184–6.
15. Schildkrout & Keim 1990: 58–61 and passim.
16. Mary Douglas 1979e.
17. E.g. Brett 1987.
18. Brody 1994: C1.
19. On Kongamato, see Heuvelmans 1958; on Mokele-Mbembe, see Nugent 1993.
20. Bataille 1991: 53–4, original emphasis.
21. Stewart 1993: 132–3.
22. OED l982: 2282. The adjective "preposterous" is especially appropriate, for the juxtaposition of its particles pre- ("before"), -poster- ("coming after"), and -ous ("characterized by"), are preposterous themselves: "before-coming-after-ness" makes little sense. Little wonder that the word is used to refer to something that "places last that which should be first" and so is "contrary to the order of nature, or to reason or common sense." The aardvark is sometimes called "antbear," especially in older British writing, or an "anteater"; but such names are confusing, as several other local animals eat ants (e.g. pangolins and aardwolves), and the aardvark is not related to anteaters of the Americas.
The aardvark has been taken up as an emblem of Western counter-culture, probably because it is so absurdly obscure an animal, more than any other reason. It was the subject of a short-lived animated cartoon by Hanna-Barbara™, and is the protagonist of the independent comic book "Cerebus" by Dave Sim (published monthly by Aardvark-Vanahem Inc. of Kitchener, Ontario). Mattel™ made a toy aardvark named "Alvin" sometime in the early 1980s: pushed around by an infant, it went oing-ge-ge-oing-ge-ge and when a bulb in the handle was squeezed, its velcroed tongue would extend to "catch" cloth "ants." "Aardvark" is the name of companies seeking the name's alphabetical aadvantage in phonebooks, and in a related sense, can also provide poignant political imagery: Malcolm X saw such an early word in the dictionary as a message about all he did not know about Africa, and as a reason to begin a self-education that would take him so far and make him so important to world history (Gates 1993).
23. IAAPB 1892: 73.
24. Cf. Kingdon 1974: 385.
25. Dorst & Dandelot 1969: 150, 185.
26. Crawford 1914: 357. The Reverend Crawford's love of alliteration gets the best of him here, for surely there is little in common between an aardvark and a sloth, literally or figuratively: the aardvark is neither a slow nor deliberate animal unlike the sloth, a denizen of South America and not Africa.
27. Crawford 1914: 357.
28. Dorst & Dandelot 1969: 150.
29. Dorst & Dandelot 1969: 150; Kingdon 1974: 384.
30. Heusch 1971: 12.
31. Cf. Willis 1967.
32. See Douglas 1979e, 1979a: 234; Sperber l975: 30, 31.
33. Frechkop 1946; Keimer 1944.
34. Zahan 1980: 116.
35. Faïk-Nzuji 1993: 158; Nooter 1990.
36. Biebuyck 1973: pl. 93.
37. Muller 1991.
38. Material in this and the following two paragraphs about Dogon cultivation and chiwara comes from Zahan 1980: 36–41, 69–74, 77.
39. In the literature of animal classification, the pangolin has become the archetypal anomalous animal, for the perplexities the pangolin brings to taxonomies and other systematics. Mary Douglas's studies of pangolin symbolism have set the scene for a great deal of debate about classification and symbols more generally, but what is as remarkable is her ability and willingness to develop and rethink her own positions through the course of her long and brilliant career. See Douglas 1990 for her latest thoughts, but not her last ones, we trust.
40. The passage is from Dorst & Dandelot 1969: 35.
41. Douglas 1979c: 299, 302 & 1990: 30.
42. Biebuyck 1973: figs. 88 and 91, and passim.
43. My thanks to Father Max Tertrais, a Catholic missionary who served among Lega and made a particular study of their pangolin lore. Private communication, 1982.
44. Maurer 1984: fig. 14.
45. Drewal & Drewal 1990: 179–80.
46. Pemberton 1989b: 216, 221–3.
47. E.g. Roy 1992: 236.
48. Nooter 1990: 255–61 & 1993: 49–52.
49. Stappers 1962: 43–7; Bouillon 1953: 575–6.
50. Roberts 1985.
51. The four species of pangolin found in Africa overlap in some areas but generally speaking cover the continent, south of the Sahara, with the apparent exception of extreme southern Africa (Dorst & Dandelot 1969: 39).
52. Pemberton 1989b: FN 14.
53. Roberts 1992a: 55.
54. Thanks are extended to Dr. Henry Drewal for discussion of these points, October 1994.
55. See Roy 1992: 64.
56. See Von Rosen 1916: plates 40–8. See also Robbins & Nooter 1989: 264.
57. My thanks to Emeritus Professor Reeve Bailey of The University of Michigan for this private communication in 1986.
58. Gallagher 1983: 89, 93.
59. Gallagher 1983: 89–91.
60. Gallagher 1983.
61. Ezra 1992: 131. The "icon" of a fish-legged monarch may be of great antiquity, and it is conceivable that these Nigerian images reflect a commerce of ideas and forms leading all the way back to the eastern Roman empire and more particularly to Afghanistan, where strikingly similar images were produced from 100 B.C to 300 A.D. (Fraser 1972b, Vansina 1984: 119).
62. Ben-Amos 1976: 245.
63. Cf. Kakeya 1976.
64. Robbins & Nooter 1989: 198.
65. Garrard 1989: 227, 233–4.
66. Robbins & Nooter 1989: 266.
67. Bastin 1988: 270.
68. Waterlot 1926: pl. 4.
69. Roberts 1992a: 57.
70. N'Diaye & Vogel 1985: 137.
71. Roberts 1996.
72. N'Diaye & Vogel 1985: 138. I disagree with Francine N'Diaye and Susan Vogel when they assert that the sculptor of this "un-African" figure "is literal-minded," in the way that fish-features have been "grafted onto a man's body without suggesting a new kind of being." Nor do I find details like its toenails "banal" and "lacking transcendence." Rather, it seems to me that closer investigation of the mix of attributes from different fish, and the situation of the object in the context of Dahomean culture-building during the 19th century, suggest just how pertinent such representation must have been to a sense of the king's "partake[ing] of another reality." Cf. Blier 1993b: 430–1 and Roberts 1996.
73. Drewal 1988: 160. Roberts 1992a. There is a growing literature on Mami Wata imagery and religious practice in Africa and the African Americas. Henry Drewal, whose early writing (1988) represents a magnificent piece of detective work as well as a good source of bibliography, plans an exhibition and book in the near future. "Culture-building" is an expression borrowed from the work of Robert Blauner; see Roberts 1992a and 1996 for an explanation, case studies, and relevant bibliography.
74. Drewal 1988. African manatees (Trichechus senegalensis) inhabit some lakes and broad rivers, and it is possible that earlier African ideas about them are now complemented by those concerning Mami Wata. In Chad, for instance, manatees are found in a number of lakes. Sara peoples believe in an inverted underwater world where they reign, and ancient Sao peoples created clay figures in their image, as seen at the National Museum in N'Djamena, before it was sacked by Libyan soldiers, see Lebeuf and Lebeuf 1977.
75. See Rush 1992, from whose title come the words "convulsive beauty," with reference to Surrealist literature.
76. For speculations on sorcery and Mami Wata, see Jewsiewicki 1991: 132–3.
77. See René Bravmann 1983: 74–85.
78. Renaudeau & Strobel 1984.
79. Bravmann 1983: 74–85.
80. Vogel 1991: 43–5, citing field research by Fredrick Lamp.
81. My speculation here is based upon research which Mary Nooter Roberts and I conducted in Dakar in 1994, in an ongoing project that concerns expressive culture associated with the Mouride Way. A first discussion of this material is reported in Roberts 1996.
82. Mundkur 1983 & 1988: 148–9, 159. Studies suggest that even urban American children are more afraid of snakes and other "wild animals" they will never meet on the mean streets of New York, than of the very real human dangers their parents and teachers must preach about to them every day of their lives.
83. Poe 1944: 439.
84. Bataille 1991: 53.
85. Geertz 1979: 85.
86. Bakhtin 1984: 39.
87. Information on kifwebe/bifwebe in this and the next two paragraphs is drawn from Hersak 1990: 141, 144 & 1986: 46.
88. Simic 1993: 30.
89. Cf. Bakhtin 1984: 123.
90. Rubin 1974: 6.
91. On Ijo water spirits, see Anderson & Kraemer 1989: 87, 112–3. On Toma and Sherbro masks, see Nooter 1985: 38–9.
92. McNaughton 1979: 1, 14. These same passages are repeated and in some cases elaborated upon in McNaughton 1988. Rather than double-referencing the same quotations, I shall locate them in the first of the two that I consulted.
93. Nooter 1993: 58–9. Youssouf Cissé (1985) offers a discussion of boli ingredients, stressing that all boli represent placentas: something "living and intangible," and "the 'quintessence' (kèno or nènò) of the being or object" portrayed by the object.On the misinterpretation of boli by an earlier writer, see McNaughton 1979: 26.
94. The definition of abomination comes from Soukhanov 1993: 5.
95. Quotes in this paragraph come from McNaughton 1979: 14, 23, 31. The description "reservoirs of usable energy" may also be applied to shrines for Ogun, the god of iron and, nowadays, recycling, among Yoruba and related peoples of Bénin and adjacent countries; see Roberts 1996 for a preliminary discussion of recent fieldwork on these and other "synæsthetic totalities."
96. McNaughton 1979: 31–2; Davis 1981: 8–11.
97. Zahan 1960: 80; McNaughton 1979: 31–2.
98. McNaughton 1979: 33–4.
99. See Paz 1973: 145; McNaughton 1979: 35.
100. Bakhtin 1984: 32.
101. McNaughton 1979: 35.
102. The following account is from my transcription and translation of taped interviews held in late October, 1975, with a shamanistic healer. The interviews were jointly conducted with Dr. Christopher Davis-Roberts, to whom I was married at the time; the "we" of the account refers to the two of us. We commissioned the bundle as a consequence of a number of mishaps to us and the people working most closely with us, that led some of our friends to feel that we needed to "close" our home and ourselves to evil people in our community; see Roberts forthcoming C. Similar magic as practiced by peoples adjacent to Tabwa has been discussed by Biebuyck (1981: 23) and Hersak (1986:121).
103. Heusch 1988b: 15.
104. Nooter 1985: 3, 79.
105. Although African divination is sometimes referred to as "fortune-telling," it is very rare for African diviners to "tell the future." When they do, there is a possibility that this is evidence of a synthesis of African and non-African diagnosis. There are a great many different forms of African divination, and a useful collection of essays focusing on a few of them is presented in Peek 1991. Sincere thanks are extended to Dr. Manuel Jordán for discussion of basket divination among Chokwe of northwestern Zambia, and for taking me to observe a renowned diviner using such a method, during a visit with Dr. Jordán at his field site in 1992.
106. Manuel Jordán 1994.

Epilogue: Bringing It All Back Home

1. Ross 1992.
2. On royal arts of Fon, see Blier 1990. On Akan art, see Ross and Garrard 1983. On Bamana, see Robbins & Nooter 1992: 80 and Davis 1981:48. On Chokwe/Luvale, see Jordán 1993. On Bemba, see Hoch 1964.
3. Vansina 1990: 81.
4. The subheading here is a paraphrase of Jeremiah XIII/23. The following paragraphs on leopard behavior and symbolism are adapted from earlier writing about terrorist lionmen among Tabwa (Roberts 1986c) and the Aniota Society of leopardmen among peoples bordering the Mangbetu (Roberts 1994b). See Roberts 1983 and Marks n.d.
5. Jewsiewicki 1988: vi; Ruel 1969.
6. Heusch 1985: 32–3.
7. Vansina 1964: 98–116.
8. Heusch 1982: 139–40.
9. Ferber 1931, Schmitz 1912: 260, Van Avermaet & Mbuya 1954: 431–2
10. Roberts 1981.
11. Roberts 1986d, 1988c.
12. Such matters will be a principal focus of an exhibition program tentatively entitled "Memory: Luba Art and the Making of History" that is being organized by art historian Mary Nooter Roberts at the Museum for African Art in New York City; see also Nooter 1993.
13. Dorst & Dandelot 1969: 144. The phrase "signifying animal" comes from Willis 1990.
14. Jacobson-Widding 1979. It is not that people cannot recognize different hues, but rather that the three primary colors (red/white/black) are primary chromatic metonyms. Secondary colors are given descriptive terms, and it is likely that the list of these is expanding as Western color symbolism is adopted and adapted to local circumstances. Tabwa call yellow "turmeric" (manjano) and green "leaves" (majani), while blue is given a Swahilized French term, ki-bleu.
15. Willis 1985.
16. Roberts 1993.
17. Mack 1994: 15.
18. CAPIRSNB 1953: 33.
19. Bourgoin 1955: 159.
20. Dorst & Dandelot 1969: 145.
21. Kaoze 1947: 95.
22. Roberts 1980: 406.
23. Segrer 1975.
24. Haltenorth & Diller 1988: 223.
25. Lion and leopard behavior and symbolism are contrasted for Tabwa people of southeastern Zaire in Roberts 1980: 404–8 and 1983; and for Bisa of Zambia in Marks n.d.
26. Kaoze 1947: 3.
27. Roberts 1983: 102)
28. See Schaller 1972: 120–2, including his citation of Anne Morrow Lindbergh ("poured out like honey...").
29. Roberts 1983. As seen in the previous chapter another Tabwa adage, however, proposes that "the king of beasts is not the lion, but the pangolin."
30. Cole 1982: 199–200.
31. It is Vansina (1990: 81) who characterizes the leopard as king of predators. A contemporary example of the manipulation of leopard symbolism is that of President Mobutu Sese Seko of Zaire, whose leopard-skin cap is meant to be "authentic" by the local political definition of that term, as a "recourse, but not a return to tradition." As the years of his reign have gone by, President Mobutu has increasingly lived up to the leopard's rapacity and scorn for life. See Donald Cosentino's brilliant piece, "Afrokitsch" (1991) and the paintings of Mobutu by Zairian artists Tshibumba Kanda-Matulu and Moke accompanying Jewsiewicki 1991.
32. MacGaffey forthcoming.
33. Gebauer 1979: 93 and passim.
34. In some African societies, leopards may be were-animals—that is, a person may shape-shift to a leopard, or may have a leopard familiar that is intimately associated with him or her. On Banyang (Cameroon) shape-shifting, see Ruel 1970: 341–2. On other forms of shape-shifting in Africa, see Roberts forthcoming D.
35. Joset 1955.
36. Beatty 1915: 3–6 and passim; cf. Little 1967. See also Richard Dooling's new novel, White Man's Grave (1994), about shape-shifting, leopardmen and bofima in Sierra Leone.
37. Joset 1955: 145–54.
38. Cf. Roberts 1986c.
39. Vansina 1990: 81.
40. Anioto is still often ignored by scholars, and curiously enough, even the writing on the society that does exist, is frequently overlooked, despite two synoptic works on the society and others like it (Joset 1955, Lindskog 1954). It is quite likely that being overlooked was the point of Anioto itself; that is, leopardman terrorism was based upon "hiding in plain sight," a ruse maintained by strict secrecy.
41. On spotted face masks associated with secret societies in Zaire, see Félix 1992b. Re their possible contexts, see also Roberts 1994b.
42. Roberts 1986c.
43. Stewart 1993: 110.

Bibliography

ABIODUN, ROLAND
1989 "The Kingdom of Owo," pp. 91-116 in YORUBA: Nine Centuries of African Art and Thought, H. Drewal, J. Pemberton III, and R. Abiodun, eds. New York: The Center for African Art/Harry N. Abrams.

ADAMS, MONNI
1980 "Fon Appliqued Cloths," African Arts 13(2):28–41, 87, 88.

ADANDE, C. JOSEPH
1977 "Les grandes tentures et les bas-reliefs du Musée d'Agbome," unpublished Master's thesis in History, Université Nationale du Bénin.

ADLER, PETER, AND NICHOLAS BARNARD
1992 ASAFO! African Flags of the Fante. London: Thames and Hudson.

ANDERSON, MARTHA, AND CHRISTINE KRAEMER
1989 Wild Spirits, Strong Medicine: African Art and the Wilderness. New York: The Center for African Art.

APTER, ANDREW
1992 Black Critics and Kings: The Hermeneutics of Power in Yoruba Society. Chicago: University of Chicago Press.

ARNOLDI, MARY JO
1981 "Regional Puppet Theatre in Segon, Mali," The Puppet Journal 32(4):14–19.
1988 "Playing the Puppets: Innovation and Rivalry in Bamana Youth Theatre of Mali," TDR, The Drama Review 32(2):65-82.

AULAIRE, EMILY D' AND PER D'AULAIRE
1983 "Pangolins Are All the Rage," International Wildlife 13(1):14-16.

BACHELARD, GASTON
1939 "Le bestiaire de Lautréamont," pp. 29-78 in Lautréamont, by G. Bachelard. Paris: Librairie José Corti.
1969 The Poetics of Space. Boston: Beacon Press.

BADI-BANGA, NE-MWINE
1982 "Expression de la foi chrétienne dans l'art plastique zairois," Cahiers des religions africaines 16(31-2):135-67.

BAKER, STEVE
1993 Picturing the Beast: Animals, Identity and Representation. New York: St. Martin's for Manchester University Press.

BAKHTIN, MIKHAIL
1984 Rabelais and his World. Bloomington: Indiana University Press.

BARNES, SANDRA
1989 "Introduction: The Many Faces of Ogun," pp. 1-26 in Africa's Ogun, Old World and New. Bloomington: Indiana University Press.

BARTH, FREDRIK
1969 Ethnic Groups and Boundaries: The Social Organization of Cultural Difference. Boston: Little, Brown.

BASCOM, W.
1975 African Dilemma Tales. The Hague: Mouton.

BASTIN, MARIE-LOUISE
1982 La Sculpture Tshokwe. Meudon (France): Alain et Françoise Chaffin.
1988 "Bidjogo, Archipel des Bissagos," p. 270 in Utotombo: L'Art d'Afrique noire dans les collections privées belges. Brussels: Palais des Beaux-Arts.

BATAILLE, GEORGES
1991 "The Deviations of Nature," (originally published in 1930), pp. 53-8 in Visions of Excess: Selected Writings, 1927-1939. A. Stoekl, ed. and translator. Theory and History of Literature, 14. Minneapolis: University of Minnesota Press.

BAY, EDNA
1985 Asen: Iron Altars of the Fon People of Bénin. Atlanta: Emory University.

BEATTY, KENNETH
1915 Human Leopards: An Account of the Trials … [in] Sierra Leone. London: Hugh Rees, Ltd.

BEDAUX, R.M.A.
1988 "Tellem and Dogon Material Culture," African Arts 21(4):38–45, 91.

BEIDELMAN, THOMAS
1963 "Witchcraft in Ukaguru," pp. 57-98 in Witchcraft and Sorcery in East Africa, J.Middleton and E. Winter, eds. London: Routledge and Kegan Paul.
1975 "Ambiguous Animals: Two Theriomorphic Metaphors in Kaguru Folklore," Africa 45(2):183-96.

BEN-AMOS, PAULA
1976 "Men and Animals in Benin Art," Man (N.S.) 2, 243-52.

BERGER, JOHN
1980 "Why Look at Animals?" in About Looking. London: Writers & Readers.

BIEBUYCK, DANIEL
1972 "Bembe Art," African Arts 5(3):12-19, 75-84.
1973 Lega Culture: Art, Initiation, and Moral Philosophy Among a Central African People. Berkeley: University of California Press.
1981 "Buhabo Statues from the Benembaho (Bohoma)," Africa-Tervuren 1, 18-30.

BLAKELY, THOMAS AND PAMELA
1987 "So'o Masks and Hemba Funerary Festival," African Arts 21(1):30-37, 84-6.

BLIER, SUZANNE
1989 The Anatomy of Architecture: Ontology and Metaphor in Batammaliba Architectural Expression. New York: Cambridge University Press.
1990 "King Glele of Danhomè, Part One: Divination Portraits of a Lion King and Man of Iron," African Arts 23(4):42-53, 93-4.
1993a "Truth and Seeing: Magic, Custom, and Fetish in Art History," pp. 139-66 in Africa and the Disciplines, R. Bates, V. Mudimbe, and J. O'Barr, eds. Chicago: University of Chicago Press.
1993b "Melville J. Herskovits and the Arts of Ancient Dahomey," pp. 425-44 in Art in Small-Scale Societies: Contemporary Readings, R. Anderson and K. Fields, eds. Englewood Cliffs (NJ): Prentice Hall.

BLOCH, MAURICE
1989 "The Symbolism of Money in Imerina," pp. 165-90 in Money and the Morality of Exchange, J. Parry and M. Bloch, eds. New York: Cambridge University Press.

BLOCH, M. AND J. PARRY, eds.
1982 Death and the Regeneration of Life. New York: Cambridge University Press.

BOHANNAN, PAUL, AND GEORGE DALTON, eds.
1962 Markets in Africa, Evanston: Northwestern University Press.

1965 Social Anthropology. New York: Holt, Rhinehart & Winston.

BOUILLON, A.
1953 "Les mammifères dans le folklore luba," Zaïre 7, 563-601.
1954 "La corporation des chasseurs Baluba," Zaïre 8, 563-94.

BOURDIEU, PIERRE
1973 "The Berber House or the World Reversed," pp. 98-110 in Rules and Meanings, M. Douglas, ed. Baltimore: Penguin Books.

BOURGEOIS, ARTHUr
1991 "Mbawa-Pakasa: L'Image du buffle chez les Yaka et leurs voisins/Buffalo Imagery Among Yaka and Their Neighbors," Arts d'Afrique Noire 77(1):19-32.

BOURGOIN, P.
1955 Animaux de chasse d'Afrique. Paris: Nouvelles Editions de la Toison d'Or.

BRAIN, ROBERT
Art and Society in Africa. New York: Longman.

BRAVMANN, RENé
1983 African Islam. Washington, D.C.: Smithsonian Institution Press.

BRELSFORD, VERNON
1941 "Babemba Animal Medicines," Native Administration Department Annual, (Rhodesia), 18, 8-11.
1945 "Bird Lore of the Babemba in Northern Rhodesia," Southern Rhodesia Native Affairs Department Annual (Rhodesia) 22, 28-35.

BRETT, ROB
1987 "Romancing the Naked Mole Rat," Swara, Magazine of the East African Wildlife Society 10(2):9-11.

BRODY, JANE
1994 "The Strange, Dark World of the Naked Mole Rat," New York Times 12 April, pp. C1, C13.

BROWN, J.
1972 African Birds of Prey. London: Collins.

BRUYNINX, ELZE
1988 "Karagwe (Banyambo?), Tanzanie," p.311 in Utotombo: L'Art d'Afrique noire dans les collections privées belges. Brussels: Palais des Beaux-Arts.

BUNKER, EMMA, C. CHATWIN, AND ANN FARKAS
1970 "Animal Style" Art from East to West. New York: New York Graphic Society for the Asia Society.

BURTON, W.F.P.
1961 Luba Religion and Magic in Custom and Belief. Tervuren: Musée Royal de l'Afrique Centrale.

CANCEL, ROBERT
1981 "Inshimi Structure and Theme: The Tabwa Oral Narrative Tradition," unpublished PhD dissertation, The University of Wisconsin at Madison.

CAPIRSNB = Commission Administrative du Patrimoine de l'Institut Royal des Sciences Naturelles de Belgique
1953 Manuel de Zoologie à l'usage des écoles du Congo Belge et du Ruanda-Urundi. Brussels: Fons du Bien-Etre Indigène.

CARTRY, MICHEL
1979 "Du village à la brousse ou le retour de la question: À propos des Gourmantché du Gabnangou (Haute-Volta)," pp. 265-88 in La fonction symbolique, essais d'anthropologie, M. Izard et P. Smith, eds. Paris: Gallimard.

CEDERROTH, C., C. CORLIN AND J. LINDSTRÖM, eds.
1988 On the Meaning of Death: Essays on Mortuary Rituals and Eschatological Beliefs. Uppsala Studies in Cultural Anthropology, 8. Stockholm: Almqvist and Wiksell International.

CENTNER, T. H.
1963 "L'Enfant africain et ses jeux," Mémoires du CEPSI 17, Elisabethville (Lubumbashi, Zaire).

CISSÉ, YOUSSOUF
1983 "Le sacrifice chez les Bambara et les Malinke," pp. 156-7 in "Summaries of Sacrificial Rites Described in the Preceding Four Issues," N. Mellott ed. Systèmes de pensée en Afrique noire 6, 149-83.
1985 "Les nains et l'origine des bolis de chasse chez les Malinke," Systèmes de pensée en Afrique noire 8, 13–24.

CLARK, STEPHEN
1988 "Is Humanity a Natural Kind?" pp. 17-34 in What is an Animal?, T. Ingold, ed. Vol. 1, proceedings of the World Archaeological Congress, Southampton, UK, 1986. London: Unwin Hyman.

CLIFFORD, JAMES
1988 The Predicament of Culture. Cambridge: Harvard University Press.

CLOUDSLEY-THOMPSON, J.
1969 The Zoology of Tropical Africa. New York: Norton.

CLUTTON-BROCK, JULIET
1981 Domesticated Animals from Early Times. Austin: University of Texas Press.

COHEN, TED
1979 "Metaphor and the Cultivation of Intimacy," pp. 1-10 in On Metaphor, S. Sacks, ed. Chicago: University of Chicago Press.

COLE, HERBERT
1982 Mbari: Art and Life Among the Owerri Igbo. Bloomington: Indiana University Press.
1985 "Introduction: The Mask, Masking, and Masquerade Arts in Africa," pp. 15-27 in I Am Not Myself: The Art of African Masquerade, H. Cole, ed. Los Angeles: UCLA Museum of Cultural History.
1989 ICONS: Ideals and Power in the Art of Africa. Washington, D.C.: Smithsonian Institution Press.

COLE, HERBERT, AND CHIKE ANIAKOR
1984 Igbo Arts, Community and Cosmos. Los Angeles: UCLA Museum of Cultural History.

COLE, HERBERT, AND DORAN ROSS
1977 The Arts of Ghana. Los Angeles: UCLA Fowler Museum of Cultural History.

COLLE, PIERRE
1913 Les Baluba. 2 vols. Anvers: Albert Dewit.

CONRAD, JOSEPH
1983 "Heart of Darkness," pp. 490-603 in The Portable Conrad, M. Zabel, ed. 1st ed. 1896. New York: Viking Press.

CORNET, JOSEPH
1975 Art from Zaire: 100 Masterworks from the National Collection. New York: African-American Institute.
1982a "Art royal kuba," pp. 78-95 in Sura dji: Visages et racines du Zaïre. Paris: Musée des arts décoratifs.
1982b Art Royal Kuba. Milan: Edizioni Sipiel.

COSENTINO, DONALD
1990 Exhibition review: "Andres Serrano, Photographs," African Arts 23(4):84-5.
1991 "Afrokitsch," pp. 240-55 in Africa Explores: 20th

Century African Art, S. Vogel, ed. New York: The Center for African Art and Munich: Prestel.

CRAWFORD, DAN
1914 Thinking Black: 22 Years Without a Break in the Long Grass of Central Africa. London: Morgan and Scott.

DARK, PHILIP
1962 The Art of Benin. Chicago: Chicago Natural History Museum.

DAVIS, CHARLES
1981 The Animal Motif in Bamana Art. New Orleans: Davis Gallery.

DAVIS-ROBERTS, C.
1980 "Mungu na Mitishamba: Illness and Medicine Among the BaTabwa of Zaire." Unpublished PhD dissertation, University of Chicago Department of Anthropology.
1981 "Kutambuwa Ugonjuwa: Concepts of Illness and Transformation Among the Tabwa," Social Science and Medicine 15B, 309-16.

DE BOECK, FILIP
1991 "Of Bushbucks Without Horns: Male and Female Initiation Among the Aluund of Southwest Zaïre," Journal des africanistes 61(1):37-72.

DELUZ, ARIANE
1989 "Masque Zamblé," p. 130 in Corps sculptés, corps parés, corps masqués: Chefs-d'oeuvre de Côte d'Ivoire. Tours: MAME Imprimeurs for the Association Française d'Action Artistique.

DENYER, SUSAN
1982 African Traditional Architecture. New York: Africana Publishing Co.

DETIENNE, MARCEL
1986 The Creation of Mythology. Chicago: University of Chicago Press.

DEVISCH, RENÉ
1993 Weaving the Threads of Life: The Khita Gyn-Eco-Logical Healing Cult Among the Yaka. Chicago: University of Chicago Press.

DEWEY, WILLIAM
1993 Sleeping Beauties: The Jerome L. Joss collection of African Headrests at UCLA. Los Angeles: UCLA Fowler Museum of Cultural History.

DOOLING, RICHARD
1994 White Man's Grave. New York: Farrar, Strauss and Giroux.

DORST, JEAN AND PIERRE DANDELOT
1969 A Field Guide to the Larger Mammals of Africa. Boston: Houghton Mifflin.

DOUGLAS, MARY
1966 Purity and Danger: An Analysis of Concepts of Pollution and Taboo. London: Routledge and Kegan Paul.
1970 Natural Symbols, Explorations in Cosmology. London: Barrie and Rockliff.
1979a "Social and Religious Symbolism of the Lele," pp.9-26 in Implicit Meanings, Essays in Anthropology. London: Routledge & Kegan Paul.
1979b "Do Dogs Laugh?" pp. 83-9 in Implicit Meanings, Essays in Anthropology. London: Routledge & Kegan Paul.
1979c "Self-Evidence," pp. 276-318 in Implicit Meanings, Essays in Anthropology. London: Routledge & Kegan Paul.
1979d "Jokes," pp. 90-114 in Implicit Meanings, Essays in Anthropology. London: Routledge & Kegan Paul.
1979e "Animals in Lele Religious Symbolism," pp. 27-46 in Implicit Meanings, Essays in Anthropology. London: Routledge & Kegan Paul.
1990 "The Pangolin Revisited: A New Approach to Animal Symbolism," pp. 25-36 in Signifying Animals, Human Meaning in the Natural World, R. Willis, ed. Vol. 16, proceedings of the World Archaeology Congress, Southampton, UK, 1986. London: Unwin Hyman.

DOWSON, THOMAS
1992 Rock Engravings of Southern Africa. Bloomington: Indiana University Press for the University of Witwatersrand.

DREWAL, HENRY
1981 "Mask (Gelede)," pp. 114-6 in For Spirits and Kings: African Art from the Tishman Collection, S. Vogel, ed. New York: Harry N. Abrams for The Metropolitan Museum of Art.
1988 "Performing the Other: Mami Wata Worship in Africa," TDR, The Drama Review 32(2):160-85.

DREWAL, HENRY AND MARGARET
1990 Gelede: Art and Female Power Among the Yoruba. Bloomington: Indiana University Press.

DREWAL, HENRY, JOHN PEMBERTON III, AND ROLAND ABIODUN
1989 "The Yoruba World," pp. 13-43 in YORUBA: Nine Centuries of African Art. New York: The Center for African Art/Harry N. Abrams.

DUCHÂTEAU, ARMAND
1990 Benin, Trésor royal: Collection du Museum für Völkerkunde, Vienne. Paris: Éditions Dapper.

DURKHEIM, ÉMILE
1966 The Elementary Forms of the Religious Life. 1st ed. 1915. New York: Free Press.

EKPE AKPABOT, SAMUEL
1975 Ibibio Music in Nigerian Culture. East Lansing: Michigan State Press.

ELLEN, ROY
1979 "Introductory Essay," pp. 1-32 in Classifications in Their Social Context, R. Ellen, ed. New York: Academic Press.

ELIADE, MERCEA
1959 The Sacred and the Profane. New York: Harcourt Brace.

ETIENNE, LOUIS
1937-8 "Coutumes indigènes observées chez les Babemba et les tribus limitrophes," mimeographed ms #803/113, Central Archives of the Missionaries of Our Lady of Africa (The White Fathers), Rome.

EVANS-PRITCHARD, EDWARD
1969 The Nuer: A Description of the Modes of Livelihood and Political Institutions of a Nilotic People. 1st ed. 1940. New York: Oxford University Press.
1977 Nuer Religion. New York: Oxford University Press.

EZRA, KATE
1988 Art of the Dogon: Selections from the Lester Wunderman Collection. New York: Harry N. Abrams for The Metropolitan Museum of Art.
1992 Royal Art of Benin: The Perls Collection. New York: Harry N. Abrams for The Metropolitan Museum of Art.

FAÏK-NZUJI, CLÉMENTINE
1992 Symboles graphiques en Afrique noire. Paris: Éditions Karthala for CILTADE, Louvain (Belgium).
1993 La puissance du sacré: L'homme, la nature et l'art en Afrique noire. Brussels: La Renaissance du Livre.

FÉAU, ÉTIENNE
1989 "Baoulé. Statue de singe porteur de coupe," pp. 74-5 in Corps sculptés, corps parés, corps masqués: Chefs-d'oeuvre de Côte d'Ivoire. Tours: MAME Imprimeurs for the Association Française d'Action Artistique.

FÉLIX, MARC
1989 Maniema: An Essay on the Distribution of the Symbols and Myths as Depicted in the Masks of Greater Maniema. Munich: Verlag Fred Jahn.
1992a "Luba Zoo: Kifwebe and Other Striped Masks," occasional paper, Zaïre Basin Art History Research Center, Brussels.
1992b Ituri: The Distribution of Polychrome Masks in Northeast Zaire. Munich: Verlag Fred Jahn.

FERBER, N.
1932 "Rapport de sortie de charge de l'Administrateur territorial," copy of an unpublished manuscript, collection of Dr. G. Nagant, Kalemie, Zaire.

FERNANDEZ, JAMES
1982 Bwiti: An Ethnography of the Religious Imagination in Africa. Princeton: Princeton University Press.
1986a "Persuasions and Performances: Of the Beast in Every Body and the Metaphors of Everyman," pp. 3-27 in Persuasions and Performances: The Play of Tropes in Culture. Bloomington: Indiana University Press.
1986b "The Mission of Metaphor in Expressive Culture," pp. 28-70 in Persuasions and Performances: The Play of Tropes in Culture. Bloomington: Indiana University Press.
1986c "Edification by Puzzlement," pp. 172-87 in Persuasions and Performances: The Play of Tropes in Culture. Bloomington: Indiana University Press.

FERNANDEZ, JAMES, ed.
1991 Beyond Metaphor: The Theory of Tropes in Anthropology. Stanford: Stanford University Press.

FITZGERALD, R.T.D.
1944 "Dakakari Grave Pottery," Journal of the Royal Anthropological Institute 74:43–57.

FITZSIMONS, V.
1970 A Field Guide to the Snakes of Southern Africa. London: Collins.

FÖRSTER, TILL
1988 Art of the Senufo. Zurich: Rietberg Museum. Unpaginated English translation from the German for use in teaching at The University of Iowa, 1994.
1993 "Senufo Masking and the Art of Poro," African Arts 26(1):30–41, 101.

FLEXNER, STUART, ed.
1987 The Random House Dictionary of the English Language, 2nd ed. New York: Random House.

FORTIER, JOSEPH
1967 Le mythe et les contes de Sou en pays Mbaï-Moïssala. Paris: Juillard.

FRASER, DOUGLAS
1972a "The Symbols of Ashanti Kingship," pp. 137-52 in African Art and Leadership, D. Fraser and H. Cole, eds. Madison: The University of Wisconsin Press.
1972b "The Fish-Legged Figure in Benin and Yoruba Art," pp. 261-74 in African Art and Leadership, D. Fraser and H. Cole, eds. Madison: The University of Wisconsin Press.

FRECHKOP, S.
1946 "L'Oryctérope ne serait-il pas le prototype de l'incarnation de Seth-Typhon?" Chronique de l'Egypte 21(41):91-2.

GALLAGHER, JACKI
1983 "'Fetish Belong King': Fish in the Art on Benin," pp. 89-93 in The Art of Power, The Power of Art: Studies in Benin Iconography, P. Ben-Amos and A. Rubin, eds. Monograph 19. Los Angeles: UCLA Museum of Cultural History.

GANSEMANS, JOS
1980 "Les instruments de musique luba (Shaba, Zaïre)," Annales 103. Tervuren (Belgium): Musée Royal de l'Afrique Centrale.

GARRARD, TIMOTHY
1989 Gold of Africa: Jewellery and Ornaments from Ghana, Côte d'Ivoire, Mali and Senegal. Munich: Prestel for the Barbier-Mueller Museum, Geneva.

GATES, HENRY
1993 "Malcolm, the Aardvark and Me," New York Times Book Review, 21 February, p.11.

GEBAUER, PAUL
1979 Art of Cameroon. Portland (OR): Portland Art Museum.

GEERTZ, CLIFFORD
1979 "Religion as a Cultural System," 78-89 in Reader in Comparative Religion, 4th ed., W. Lessa and E. Vogt, eds. New York: Harper & Row.

GIRARD, RENÉ
1977 Violence and the Sacred. Baltimore: Johns Hopkins University Press.

GIRAUD, VICTOR
1890 Les lacs de l'Afrique centrale, voyage d'exploration exécuté de 1883 à 1885. Paris: Hachette.

GLAZE, ANITA
1978 "Senufo Ornament and Decorative Arts," African Arts 12(1):63–71, 107, 108.
1981a Art and Death in a Senufo Village. Bloomington: Indiana University Press.
1981b "Hornbill (Gahariga)," pp. 36-7 in For Spirits and Kings: African Art from the Tishman Collection, S. Vogel, ed. New York: Harry N. Abrams for The Metropolitan Museum of Art.

GLEASON, JUDITH
1994 Leaf and Bone: African Praise-poems. 1st edition 1980. New York: Penguin.

GOLDWATER, ROBERT
1964 Senufo Sculpture from West Africa. Greenwich (CT): New York Graphic Society for the Museum of Primitive Art, New York.

GOSNER, KENNETH
1978 A Field Guide to the Atlantic Seashore. Boston: Houghton Mifflin.

GOTTLIEB, ALMA
1992 Under the Kapok Tree: Identity and Difference in Beng Thought. Bloomington: Indiana University Press.

GOUGAUD, HENRI
1973 Les animaux magiques de notre univers. Paris: Solar.

GRIAULE, MARCEL
1938 "Jeux dogons," Travaux et mémoires de l'Institut d'Ethnologie, 32.

1980 *Conversations with Ogotemmeli, An Introduction to Dogon Religious Ideas.* 1st ed. 1948. New York: Oxford University Press.
GRIAULE, MARCEL, AND GERMAINE DIETERLEN
1986 *The Pale Fox.* 1st ed.1965. Chino Valley (Arizona): Continuum Foundation.
GUSS, DAVID, ed.
1985 *The Language of the Birds: Tales, Texts, and Poems of Interspecies Communication.* San Francisco: North Point Press.
GWETE, LEMA
1982 "Art populaire Bandundu," pp. 51-77 in *Sura dji: Visages et racines du Zaire.* Paris: Musée des arts décoratifs.
HÅKANSSON, THOMAS
1988 "Bridewealth, Women, and Land: Social Change Among the Gusii of Kenya," *Uppsala Studies in Cultural Anthropology* 10.
HALLET, JEAN-PIERRE
1967 *Animal Kitabu.* New York: Random House.
HALTENORTH, THEODOR, AND HELMUT DILLER
1988 *The Collins Field Guide to the Mammals of Africa, Including Madagascar.* Lexington (MA): Stephen Greene.
HAMBLY, W.
1921 "Serpent Worship in Africa" *Anthropology Series* 289, Field Museum of Natural History (Chicago).
HART, TERESE AND JOHN
1992 "Between Sun and Shadow," *Natural History* 101 (11):29-35.
HATA, NOBUYUKI, AND KENJI YOSHIDA, eds.
1990 *Masks of Equatorial Africa.* Text in Japanese. Osaka: National Museum of Ethnology.
HENDRIKS, JAN, ed.
1988 *Imani za jadi za kisukuma.* Text in Kisukuma. Bujora (Tanzania): Kamati ya utafiti wa utamaduni.
HERSAK, DUNJA
1986 *Songye Masks and Figure Sculpture.* London: Ethnographica.
1990 "Powers and Perceptions of the Bifwebe," *Iowa Studies in African Art* 3, 139-54.
HEUSCH, LUC DE
1971 *Pourquoi l'épouser? et autres essais.* Paris: Eds. Gallimard.
1982 *The Drunken King, or, The Origin of the State.* Bloomington: Indiana University Press.
1985 *Sacrifice in Africa, a Structuralist Approach.* Manchester (UK): Manchester University Press.
1988a "La vipère et la cigogne: Notes sur le symbolisme tshokwe," pp. 19-47 in *Art et Mythologie: Figures tshokwe,* C. Falgayrettes, ed. Paris: Eds. Dapper.
1988b "Arts d'Afrique: une approache esthétique," pp. 11-18 in *Utotombo: L'Art d'Afrique noire dans les collections privées belges.* Brussels: Palais des Beaux-Arts.
1991 "The King Comes from Elsewhere," pp. 109-17 in *Body and Space: Symbolic Models of Unity and Division in African Cosmology and Experience,* A. Jacobson-Widding, editor. *Uppsala Studies in Cultural Anthropology,* 16.
HEUVELMANS, BERNARD
1958 *On the Track of Unknown Animals.* New York: Hill and Wang.
HOCH, E.
1964 *Mbusa: The Emblems of Initiation.* Ilondola (Zambia): The Language Center.
HUBERT, H. AND M. MAUSS
1968 "Essai sur la nature et les fonctions du sacrifice," in *Oeuvres* by M. Mauss, vol. 1. 1st ed. 1899. Paris.
HURSTON, ZORA NEALE
1978 *Mules and Men.* Bloomington: Indiana University Press.
1990 *Tell My Horse: Voodoo and Life in Haiti and Jamaica.* 1st ed. 1938. New York: Harper & Row.
IAAPB = Institut Apostolique Africaine des Pères Blancs
1892 *Près du Tanganika par les Missionnaires de Son Eminence le Cardinal Lavigerie.* Anvers: Imp. H. Majoor.
INGOLD, TIM
1988a "Introduction," pp. 1-16 in *What Is an Animal?,* T. Ingold, ed. Vol. 1, proceedings of the World Archaeology Congress, Southampton, UK, 1986. London: Unwin Hyman.
INGOLD, TIM
1988b *What Is an Animal?* Vol. 1, proceedings of the World Archaeology Congress, Southampton, UK, 1986. London: Unwin Hyman.
JACOBSON, ANITA
1967 *Marriage and Money.* Uppsala: Studia Ethnographica Upsaliensis.
JACOBSON-WIDDING, ANITA
1979 *Red-White-Black as a Mode of Thought.* Uppsala, Sweden: *Uppsala Studies in Cultural Anthropology,* 1.
1991 "General Editor's Preface," pp. 9-13 in *Body and Space: Symbolic Models of Unity and Division in African Cosmology and Experience,* A. Jacobson-Widding, editor. *Uppsala Studies in Cultural Anthropology,* 16.
JACOBSON-WIDDING, ANITA, ed.
1983 "Identity: Personal and Socio-Cultural," *Uppsala Studies in Cultural Anthropology* 3.
JAMES, WENDY
1990 "Antelope as Self-Image Among the Uduk," pp. 196-214 in *Signifying Animals, Human Meaning in the Natural World,* R. Willis, ed. Vol. 16, proceedings of the World Archaeology Congress, Southampton, UK, 1986. London: Unwin Hyman.
JESPERS, PHILIPPE
1983 "L'Arc et le sang des chiens," *Systèmes de pensée en Afrique noire* 6, 65-102.
JEWSIEWICKI, BOGUMIL
1988 "Présentation," pp. iii-xvi in *Dialoguer avec le léopard? Pratiques, savoirs et actes du peuple face au politique en Afrique noire contemporaine,* B. Jewsiewicki and H. Moniot, eds. Groupe "Afrique noire" Cahier no. 10. Paris: L'Harmattan for Eds. SAFI.
1991 "Painting in Zaire: From the Invention of the West to the Representation of Social Self," pp. 130-75 in *Africa Explores: 20th Century African Art,* S. Vogel, ed. New York: The Center for African Art and Munich: Prestel.
JOHNSON, FREDERICK
1988 *A Standard Swahili-English Dictionary.* 1st ed. 1939. New York: Oxford University Press.

JOHNSON, R.
1991 *Major Rock Paintings of Southern Africa.* Cape Town: David Philip.
JORDÁN, MANUEL
1993 "Le masque comme processus ironique: Les makishi du nord-ouest de la Zambie," *Anthropologie et Sociétés* 17(3):41-61.
1994 "Heavy Stuff and Heavy Staffs from Chokwe and Related Peoples of Angola, Zaire, and Zambia," in *Staffs of Life: Rods, Staffs, Scepters, and Wands from the Coudron Collection of African Art,* A. Roberts, ed. Iowa City: University of Iowa Museum of Art.
JOSET, P. E.
1955 *Les sociétés secrètes des hommes-léopards en Afrique noire.* Paris: Payot.
KAKEYA, MAKOTO
1976 "Subsistence Ecology of the Tongwe," *Kyoto University African Studies* 10, 143-212.
KAOZE, STEFANO
1942 "Culte et superstitions des Batabwa." Unpublished MS notebooks I and II, Archives of the Kalemie-Moba Diocese, Kalemie (Zaire).
1947 "Les mikoa ou clans chez les Batabwa," unpublished manuscript abridged and reproduced in G. Nagant "Famille, histoire, religion chez les Tumbwe du Zaire," unpublished *thèse du 3e cycle,* Anthropology, École Pratique des Hautes Études (Paris), 1976: II, annex III.
KAOZE, STEFANO, AND GENEVIÈVE NAGANT
1973 "Proverbes tabwa," *Cahiers d'Études africaines* 13(4):744-68.
KECSKÉSI, MARIA
1987 *African Masterpieces and Selected Works from Munich: The Staatliches Museum für Völkerkunde.* New York: The Center for African Art.
KEIMER, L.
1944 "L'Oryctérope dans l'Égypte ancienne," *Études d'Égyptologie* 6, 1-20.
KINGDON, JONATHAN
1974 *East African Mammals: An Atlas of Evolution in Africa,* vol. 1. Chicago: University of Chicago Press.
KOLOSS, HANS-JOACHIM
1990 *Art of Central Africa: Masterpieces from the Berlin Museum für Völkerkunde.* New York: Harry N. Abrams for The Metropolitan Museum of Art.
KRUUK, HANS
1974 *The Spotted Hyena: A Study of Predation and Social Behavior.* Chicago: University of Chicago Press.
KUCHTA, RONALD
1973 "Antelopes and Elephants, Hornbills and Hyenas: Animals in African Art," exhibition brochure, the Santa Barbara (CA) Museum of Art.
KURIMOTO, EISEI
1992 "An Ethnography of 'Bitterness': Cucumber and Sacrifice Reconsidered," *Journal of Religion in Africa* 22(1):47-65.
KUJAWSKI, MARY, ed.
1986 *Signs and Seats of Power.* Ann Arbor: The University of Michigan Museum of Art.
KYEREMATEN, A.A.Y.
1964 *Panoply of Ghana.* London: Longmans.
LAMBO, L.
1947 "Étude sur les devins et sorciers, District du Tanganika, Territoire d'Alertville," *Bulletin des Juridictions indigènes et du Droit coutumier congolais* 15(5):133-43.
LAUDE, JEAN
1973 *African Art of the Dogon.* New York: Viking Press for The Brooklyn Museum.
LAW, ROBIN
1976 "Horses, Firearms, and Political Power in Pre-Colonial West Africa," *Past and Present* 72.
1980 *The Horse in West African History.* New York: Oxford University Press.
LAYTON, ROBERT
1992 *The Anthropology of Art.* 2nd ed. New York: Cambridge University Press.
LEACH, EDMUND
1979 "Anthropological Aspects of Language: Animal Categories and Verbal Abuse," pp. 153-66 in *Reader in Comparative Religion,* 4th ed., W. Lessa and E. Vogt, eds. New York: Harper & Row.
LEAKEY, LOUIS
1969 *The Wild Realm: Animals of East Africa.* Washington: National Geographic Society.
LEBEUF, JEAN-PAUL AND ANNIE
1977 *Les arts des Sao.* Paris: Éditions du Chône.
LESSA, WILLIAM, AND EVON VOGT, editor/commentators
1979 *Reader in Comparative Religion,* 4th ed. New York: Harper & Row.
LEVINE, ROBERT
1963 "Witchcraft and Sorcery in a Gusii Community," pp. 221-55 in *Witchcraft and Sorcery in East Africa,* J. Middleton and E. Winter, eds. London: Routledge and Kegan Paul.
LÉVI-STRAUSS, CLAUDE
1963a *Totemism.* Boston: Beacon Press.
1963b *Structural Anthropology.* New York: Basic Books.
1969 *The Raw and the Cooked.* New York: Harper Row.
LEWIS, IOAN
1980 "Islam and Traditional Belief and Ritual," pp. 58-75 in *Islam in Tropical Africa,* I. Lewis, ed. Bloomington: Indiana University Press for the International African Institute.
LEWIS-WILLIAMS, DAVID, AND THOMAS DOWSON
1989 *Images of Power: Understanding Bushman Rock Art.* Johannesburg: Southern Book Publishers.
LIFSCHITZ, EDWARD
1982 "Thinking with Animals: African Images and Perceptions," exhibition gallery brochure. Washington, D.C.: National Museum of African Art, Smithsonian Institution.
LINDSKOG, BIRGER
1954 "African Leopard Men," *Studia Ethnographica Upsaliensia* 7.
LIPTON, JAMES
1977 *An Exaltation of Larks, or, The Venereal Game.* New York: Penguin Books.
LLEWELYN, JOHN
1986 *Derrida on the Threshold of Sense.* New York: St. Martin's Press.
LOEWENSTEIN, J.
1961 "Rainbow and Serpent," *Anthropos* 56(1-2): 31-40.

LONSDALE, STEVEN
1981 *Animals and the Origins of Dance.* London: Thames and Hudson.
MABERLY, A.
1963 *Animals of Rhodesia.* Cape Town: Howard Timmons.
MABILLE, PIERRE
1962 *Le Miroir du Merveilleux.* Paris: Eds. de Minuit.
MACGAFFEY, WYATT
1983 *Modern Kongo Prophets.* Bloomington: Indiana University Press.
1991 *Art and Healing of the Bakongo: Minkisi from the Laman Collection.* Bloomington: Indiana University Press for the Folkens Museum-Etnografiska, Stockholm.
1993 "The Eyes of Understanding: Kongo Minkisi," pp. 18-103 in *Astonishment and Power.* Washington, D.C.: Smithsonian Institution Press.
forthcoming "The Eyes of the Leopard: Violence and Social Control in Central Africa."
MACK, JOHN
1989 *Madagascar, Island of the Ancestors.* London: British Museum Publications.
1994 Review, "SECRECY: African Art that Conceals and Reveals," *African Arts* 27(1):14–18.
MARET, PIERRE DE
1985 "The Smith's Myth and the Origin of Leadership in Central Africa," pp. 73-87 in *African Iron Working, Ancient and Traditional,* R. Haaland and P. Shinnie, eds. Oslo: Norwegian University Press.
MARKS, STEVEN
n.d. *The Imperial Lion: Human Dimensions of Wildlife Management in Central Africa.* Boulder (CO): Westview Press.
1976 *Large Mammals and a Brave People: Subsistence Hunters in Zambia.* Seattle: University of Washington Press.
MATO, DANIEL
1990 "The Sande Society," pp. 14-29 in *Sande: Masks and Statues from Liberia and Sierra Leone,* D. Mato and C. Miller, eds. Amsterdam: Galerie Balolu.
MAURER, EVAN
1984 *Sculpture of Africa: Selections from a Private Collection.* Ann Arbor: University of Michigan Museum of Art.
1985 "Catalogue Raisonné," pp. 219-78 in *The Rising of a New Moon: A Century of Tabwa Art,* A. Roberts and E. Maurer, eds. Seattle: University of Washington Press for The University of Michigan Museum of Art.
MCCALL, DANIEL
1973-4 "The Prevalence of Lions: Kings, Deities, and Feline Symbolism in Africa and Elsewhere," *Paideuma* 19-20, 130-45.
1975 "The Hornbill and Analogous Forms in West African Sculpture," pp. 268–324 in *African Images: Essays in African Iconology.* D. McCall and E. Bay, eds. New York: Africana.
MCGUIRE, HARRIET
1980 "Woyo Potlids," *African Arts* 13(2):54–56, 88.
MCLEOD, MALCOLM
1984 *The Asante.* London: British Museum Publications.
MCNAUGHTON, PATRICK
1979 "Secret Sculptures of Komo: Art and Power in Bamana (Bambara) Initiation Associations," *Working Papers in the Traditional Arts* 4. Philadelphia: Institute for the Study of Human Issues.
1988 *The Mande Blacksmiths: Knowledge, Power, and Art in West Africa.* Bloomington: Indiana University Press.
1990 Review of *Wild Spirits, Strong Medicine* by Martha Anderson and Christine Kraemer, *African Arts* 23(3):22-32.
1994 "Kore Mask, Bamana, Mali or Côte d'Ivoire," pp. 33-4 in *Visions of Africa: The Jerome L. Joss Collection of African Art at UCLA,* D. Ross, ed. Los Angeles: UCLA Fowler Museum of Cultural History.
MERCIER, JACQUES
1979 *Ethiopian Magic Scrolls.* New York: George Braziller.
MEURANT, GEORGES
1994 "Die Bildhauerkunst der Nyamwezi," pp. 217-93 in *Tanzania: Meisterwerke Afrikanischer Skulptur/ Sanaa za mabingwa wa kiafrika,* J. Jahn, ed. Munchen: Kunstbau Lenbachhaus.
MIDGLEY, MARY
1988 "Beasts, Brutes and Monsters," pp. 35-46 in *What Is an Animal?,* T. Ingold, ed. Vol. 1, proceedings of the World Archaeology Congress, Southampton, UK, 1986. London: Unwin Hyman.
MIDDLETON, JOHN
1960 *Lugbara Religion: Ritual and Authority Among an East African People.* New York: Oxford University Press for the International African Institute.
MOORE, C.
1940 "Bwanga Among the Bemba," *Africa* 13(3): 211-33.
MORPHY, HOWARD, ed.
1989 *Animals into Art.* Vol. 7, proceedings of the World Archaeology Congress, Southampton, UK, 1986. London: Unwin Hyman.
MORRIS, BRIAN
1987 *Anthropological Studies of Religion.* New York: Cambridge University Press.
MOSS, C.
1978 "Law of the Jungle (Revisited)," *Ms. Magazine,* Jan., 65-7, 89-90.
MUDIJI, MALAMBA
1989 *Le langage des masques africains: Étude des formes et fonctions symboliques des Mbuya des Phende.* Kinshasa: Imp. St. Paul for the Facultés Catholiques de Kinshasa.
MUDIMBE, V.
1988 *The Invention of Africa: Gnosis, Philosophy, and the Order of Knowledge.* Bloomington: Indiana University Press.
1994 *The Idea of Africa.* Bloomington: Indiana University Press.
MULLER, JEAN-CLAUDE
1991 "Entre mythe et réalité, ou pourquoi le chef rukuba est un oryctérope," *L'Homme* 118, 31(2):67-78.
MUNDKUR, B.
1983 *The Cult of the Serpent: An Interdisciplinary Survey of Its Manifestations and Origins.* Albany: SUNY Press.
1988 "Human Animality, The Mental Imagery of Fear, and Religiosity," pp. 141-84 in *What Is an*

Animal?, T. Ingold, ed. Vol. 1, proceedings of the World Archaeology Congress, Southampton, UK, 1986. London: Unwin Hyman.
MURPHY, WILLIAM
1993 Presentation introducing the notion of the sublime presented at a symposium celebrating the opening of the exhibition "SECRECY: African Art that Conceals and Reveals" at The Museum for African Art, New York.
forthcoming "Mende Aesthetics of Politics: Public Wonder and Secret Tricks," in *African Aesthetics,* K. Hardin and D. Ben-Amos, eds.
MUTIS, ALVARO
1991 "Ludwig Zeller 'In the Shipwreck's Mirror,'" pp. 9-11 in *Zeller Free Dream /Zeller Sueño Libre,* L. Zeller, E. Brittan, S. Wald, and J. Wheeler, eds. Oakville (Ontario): Mosaic Press.
NAPIER, DAVID
1986 *Masks, Transformation and Paradox.* Berkeley: University of California Press.
N'DIAYE, FRANCINE, AND SUSAN VOGEL
1985 *African Masterpieces from the Musée de L'Homme.* New York: The Center for African Art/Harry N. Abrams.
NEEDHAM, RODNEY
1973 *Right and Left: Essays on Dual Symbolic Classification.* Chicago: University of Chicago Press.
1981 *Circumstantial Deliveries.* Berkeley: University of California Press.
NETTLETON, ANITRA, ed.
1992 *"Of Course You Would Not Want a Canoe": The Collection of W. F. P. Burton.* Johannesburg: University of Witwatersrand Art Galleries.
NEYT, FRANÇOIS
1977 *Le grande statuaire hemba du Zaïre.* Louvain-la-Neuve (Belgium): l'Université Catholique de Louvain.
NOOTER, MARY
1985 Catalog entries for *Sets, Series and Ensembles in African Art,* S. Vogel, ed. New York: The Center for African Art/Harry N. Abrams.
1990 "Luba Art and Government: Creating Power in a Central African Kingdom," unpublished PhD dissertation, Columbia University Dept. of Art History.
1993 *SECRECY: African Art that Conceals and Reveals.* Editing and commentary by M. Nooter. New York: The Museum for African Art and Munich: Prestel.
NORTHERN, TAMARA
1984 *The Art of Cameroon.* Washington, D.C.: Smithsonian Institution.
NUGENT, RORY
1993 *Drums Along the Congo: On the Trail of Mokele-Mbembe, the Last Living Dinosaur.* Boston & New York: Houghton Mifflin.
OED = Oxford English Dictionary
1982 *The Compact Edition of the Oxford English Dictionary.* 2 vols. New York: Oxford University Press.
OJO, J.R.O.
1978 "The Symbolism and Significance of Epa-type Masquerade Headpieces," *Man* 12(3):455–470.
OJOADE, J. OLOWO
1990 "Nigerian Cultural Attitudes to the Dog," pp. 215-21 in *Signifying Animals, Human Meaning in the Natural World,* R. Willis, ed. Vol. 16, proceedings of the World Archaeology Congress, Southampton, UK, 1986. London: Unwin Hyman.
PARKIN, DAVID
1991 *Sacred Void: Spatial Images of Work and Ritual Among the Giriama of Kenya.* New York: Cambridge University Press.
PAZ, OCTAVIO
1973 "*water always writes in * plural," pp. 143–58 in *Marcel Duchamp,* A. D'Harnoncourt and K. McShine, ed. New York: Museum of Modern Art with Philadelphia Museum of Art.
PEEK, PHILIP
1991 "African Divination Systems: Non-Normal Modes of Cognition," pp. 193-212 in *African Divination Systems: Ways of Knowing.* P. Peek, ed. Bloomington: Indiana University Press.
PELRINE, DIANE
1988 *African Art from the Rita and John Grunwald Collection.* Bloomington: Indiana University Press for the Indiana University Art Museum.
PELTON, ROBERT
1989 *The Trickster in West Africa: A Study of Mythic Irony and Sacred Delight.* Berkeley: University of California Press.
PEMBERTON, JOHN III
1989a "The Dreadful God and the Divine King," pp. 105-46 in *Africa's Ogun, Old World and New,* S. Barnes, ed. Bloomington: Indiana University Press.
1989b "The Carvers of the Northeast," pp. 188-211 in *YORUBA: Nine Centuries of African Art and Thought,* H. Drewal, J. Pemberton III, and R. Abiodun, eds. New York: The Center for African Art/Harry N. Abrams.
PICTON, JOHN
1988 "Ekpeye Masks and Masking," *African Arts* 21(2):46–53, 94–95.
1994"Figure Group, Esan (?), Nigeria," pp. 84-5 in *Visions of Africa: The Jerome L. Joss Collection of African Art at UCLA,* D. Ross, ed. Los Angeles: UCLA Fowler Museum of Cultural History.
PITMAN, C.
1974 *A Guide to the Snakes of Uganda.* London: Codicote, Wheldon and Wesley.
POE, EDGAR
1944 "The Imp of the Perverse," pp. 437-44 in *Tales of Edgar Allan Poe.* New York: Random House.
POYNOR, ROBIN
1995 *Spirit Eyes, Human Hands: African Art at the Harn Museum.* Gainesville: University Press of Florida.
PRUSSIN, LABELLE
1986 "Hatumere": *Islamic Design in West Africa.* Berkeley: University of California Press.
RATTRAY, R.
1969 *Religion and Art in Ashanti.* New York: Oxford University Press.
REEFE, THOMAS
1981 *The Rainbow and the Kings: A History of the Luba Empire to c. 1891.* Berkeley: University of California Press.
REINHARDT, JOHN
1982 "Preface," "Thinking with Animals: African Images and Perceptions," exhibition gallery brochure by E. Lifschitz. Washington, D.C.: National Museum of African Art, Smithsonian Institution.

RENAUDEAU, MICHEL, AND MICHÈLE STROBEL
1984 *Peinture sous verre de Sénégal*. Paris: Eds. Fernand Nathan.
RICHARDS, AUDREY
1935 "A Modern Movement of Witchfinders," *Africa* 8, 448-61.
ROBBINS, WARREN, AND NANCY NOOTER
1989 *African Art in American Collections*. Washington, D.C.: Smithsonian Institution Press.
ROBERTS, ALLEN
1972 "The Myths of Sou, The Sara Trickster: Structure and Anti-Structure in Prose Narratives," unpublished MA paper, The University of Chicago Department of Anthropology.
1980 "Heroic Beasts, Beastly Heroes: Cosmology and Chiefship Among the Lakeside Batabwa of Zaire," unpublished PhD dissertation, The University of Chicago Department of Anthropology.
1981 "Passage Stellified: Speculation upon Archaeoastronomy in Southeastern Zaire," *Archaeoastronomy* 4, 27-37.
1982 "'Comets Importing Change of Times and States': Ephemerae and Process Among the Tabwa of Zaire," *American Ethnologist* 9(4):712-29.
1983 "'Perfect' Lions, 'Perfect' Leaders: A Metaphor for Tabwa Chiefship," *Journal des Africanistes* 53 (1-2):93-105.
1984 "Fishers of Men': Religion and Political Economy Among Colonized Tabwa," *Africa* 54(2):49-70.
1985 "Social and Historical Contexts of Tabwa Art," pp. 1-48 in *The Rising of a New Moon: A Century of Tabwa Art*, A. Roberts and E. Maurer, eds. Seattle: University of Washington Press for The University of Michigan Museum of Art.
1986a "Duality in Tabwa Art," *African Arts* 19(4): 26-35, 86-7.
1986b "The Comeuppance of 'Mr. Snake' and Other Tales of Survival from Contemporary Rural Zaire," pp. 113-21 in *Crisis in Zaire: Myths and Realities*, Nzongola-Ntalaja, ed. Trenton: Africa World Press.
1986c "'Like a Roaring Lion': Late 19th Century Tabwa Terrorism," pp. 65-86 in *Banditry, Rebellion and Social Protest in Africa*, D. Crummey, ed. Portsmouth: Heinemann Educational Books.
1986d "Les arts du corps chez les Tabwa," *Arts d'Afrique Noire* 59, 15-20.
1987a "An Eye in the Sky, One Deep in the Earth: Elements of Zaose Religion," pp. 291-306 in *Ethnologiques: Hommages à Marcel Griaule*, S. de Ganay et al., eds. Paris: Hermann.
1987b "Mbote 'Pygmoid' Art," presentation at the African Studies Association annual meetings, Denver.
1988a "Of Dogon Crooks and Thieves," *African Arts* 21(4):70-5, 91-2.
1988b "Through the Bamboo Thicket: The Social Process of Tabwa Ritual Performance." *TDR, The Drama Review* 32(2):l23-38.
1988c "Tabwa Tegumentary Inscription," pp. 41-56 in *Marks of Civilization: Artistic Transformation of the Human Body*, A. Rubin, ed. Los Angeles: UCLA Museum of Cultural History.
1989 "History, Ethnicity and Change in the 'Christian Kingdom' of Southeastern Zaire," pp. 193-214 in *The Creation of Tribalism in Southern Africa*, L. Vail, ed. Berkeley: University of California Press.
1990a "Tabwa Masks, 'An Old Trick of the Human Race,'" *African Arts* 23(2): cover, 36-47, 101-3.
1990b "Initiation, Art and Ideology in Southeastern Zaire," *Iowa Studies in African Art* 3, 7-34.
1991 "Where the King is Coming From," pp. 249-69 in *Body and Space: Symbolic Models of Unity and Division in African Cosmology and Experience*, A. Jacobson-Widding, editor. Uppsala Studies in Cultural Anthropology, 16.
1992a "Chance Encounters, Ironic Collage," *African Arts* 25(2):54-63, 97-8.
1992b "Bugabo: Arts, Ambiguity and Transformation in Southeastern Zaire," unpublished paper for "Power Figures in Central Africa: Transition, Transversion and Process," at l'Université Libre de Bruxelles.
1992c "The Uncommon Currency of Masks," paper presented at the 9th Triennial Symposium on African Art, at The University of Iowa.
1992d "Anarchy, Abjection and Absurdity: A Case of Metaphoric Medicine Among the Tabwa of Zaire," pp. 113-28 in *The Anthropology of Medicine: From Theory to Method*, 2nd ed. L. Romanucci-Ross, D. Moerman and L. Tancredi, eds. New York and Amherst: Bergin for Praeger Scientific.
1993 "Insight, or, NOT Seeing is Believing," pp. 64-79 in *SECRECY: African Art that Conceals and Reveals*, M. Nooter, ed. New York: The Museum for African Art and Munich: Prestel.
1994a "Swing the Ramrod Pivot': Staffs of Tabwa Shamans, Herbalists, Hunters, and Chiefs," in *Staffs of Life: Rods, Staffs, Scepters, and Wands from the Coudron Collection of African Art*, A. Roberts. Iowa City: University of Iowa Museum of Art.
1994b "Arts of Terror and Resistance in Eastern Zaire," special issue of *Elvehjem Museum Studies* (University of Wisconsin) commemorating the "African Reflections" exhibition, H. Drewal, ed.
1994c "Sinister Caricatures,' 'Mimetic Competition': European Cannibalism in the Latter Years of the Belgian Congo," *Ethnos*.
1995 "Smelting Ironies: The Performance of a Tabwa Technology," in *African Arts of Iron and Clay*, papers from the 5th and 6th Stanley Conferences on African Art at The University of Iowa, W. Dewey, A. Roberts, and C. Roy, eds.
1996 "The Ironies of 'System D'," in *Recycled, Reseen: Folk Art from the Global Scrap Heap*, C. Cerny and S. Seriff, eds. New York: Harry N. Abrams for the Museum of International Folk Art, Santa Fe.
forthcoming A: "THRESHOLD: African Art on the Verge." Book manuscript, first draft completed 1993.
forthcoming B: "A Tabwa Chief's Last Crossroads," for *A festschrift in memory of Dominique Zahan* edited by P. Erny; manuscript completed 1992.
forthcoming C: "Snipe Hunts and Errant Bats, or, Will the Anthropologist EVER Learn?" for *Night Talk, A Festschrift in Honor of Anita Jacobson-Widding's Sixtieth Birthday*, B. Helander, ed. Uppsala Studies in Cultural Anthropology.
forthcoming D: "'Strong Misreadings': 'Shape-Shifting' Among Tabwa, Anthropologists, and American

University Students," in *Texts and Contexts: Models, Metaphors, and Meanings in African Symbolism*, J. Ovesen, ed. Uppsala Studies in Cultural Anthropology, 17. Stockholm: Almqvist and Wiksell.
ROBERTS, ALLEN, AND EVAN MAURER
1985 "Catalogue of the Exhibition," pp. 97-218 in *The Rising of a New Moon: A Century of Tabwa Art*, A. Roberts and E. Maurer, eds. Seattle: University of Washington Press for The University of Michigan Museum of Art.
ROBERTS, ALLEN, AND CHRISTOPHER ROY
1993 "The Ambivalent Sun of Sub-Saharan Africa," pp. 334-45 in *The Sun, Symbol of Power and Life*, M. Singh, ed. New York: Harry N. Abrams for UNESCO.
ROOSEVELT, THEODORE, AND E. HELLER
1914 *Life-Histories of African Game Animals*. 2 vols. New York: Charles Scribners.
ROSEN, LAWRENCE
1984 *Bargaining for Reality: The Construction of Social Relations in a Muslim Community*. Chicago: University of Chicago Press.
ROSS, DORAN
1979 "Fighting with Art: Appliquéd Flags of the Fante Asafo," UCLA *Museum of Cultural History Pamphlet Series* 1(5).
1982 "The Verbal Art of Akan Linguist Staffs," *African Arts* 16(1):56-67, 95-96.
ROSS, DORAN, ed.
1992 *ELEPHANT: The Animal and Its Ivory in African Culture*. Los Angeles: UCLA Fowler Museum of Cultural History.
1994 *Visions of Africa*. Los Angeles: UCLA Fowler Museum of Cultural History.
ROSS, DORAN, AND TIMOTHY GARRARD, eds.
1983 *Akan Transformations: Problems in Ghanaian Art History*. Los Angeles: UCLA Museum of Cultural History.
ROY, CHRISTOPHER
1979 *African Sculpture: The Stanley Collection*. Iowa City: The University of Iowa Museum of Art.
1987a *Art of the Upper Volta Rivers*. Meudon (France): Alain et Françoise Chaffin.
1987b "The Spread of Mask Styles in the Black Volta Basin," *African Arts* 20(4):40-47, 89-90.
1992 *Art and Life in Africa: Selections from the Stanley Collection, Exhibitions of 1985 and 1992*. Iowa City: The University of Iowa Museum of Art.
RUBIN, ARNOLD
1974 *African Accumulative Sculpture: Power and Display*. New York: Pace Gallery.
RUEL, MALCOLM
1969 *Leopards and Leaders: Constitutional Politics Among a Cross River People*. London: Tavistock.
1970 "Were-Animals and the Introverted Witch," pp. 333-50 in *Witchcraft Confessions and Accusations*, M. Douglas, ed. ASA Monograph 9. London: Tavistock.
RUSH, DANA
1992 "The Convulsive Beauty of Mami Wata," unpublished Master's thesis, The University of Iowa School of Art and Art History.
SAHLINS, MARSHALL
1969 "On the Sociology of Primitive Exchange," pp. 139-236 in *The Relevance of Models for Social Anthropology*, M. Banton, ed. Association of Social Anthropologists of the Commonwealth, Monograph 1. London' Tavistock.
SAPIR, J. DAVID
1977 "The Anatomy of Metaphor," pp. 3-32 in *The Social Use of Metaphor: Essays on the Anthropology of Rhetoric*, J. D. Sapir and C. Crocker, eds. Philadelphia: University of Pennsylvania Press.
1981 "Leper, Hyena, and Blacksmith in Kujamaat Diola Thought, *American Ethnologist* 8(3):526-41.
SASSON, HAMO
1983 "Kings, Cattle and Blacksmiths: Royal Insignia and Religious Symbolism in the Interlacustrine States," *Azania* 18, 93-106.
SAVARY, CLAUDE
1992 *Objets de pouvoir: Ancienne magie bantou en Afrique centrale*. Torino (Italy): Priuli and Verlucca, for the Musée d'Ethnographie de Genève.
SCHAAFSMA, POLLY
1989 "Supper or Symbol: Roadrunner Tracks in Southwest Art and Ritual," pp. 253-69 in *Animals into Art*, H. Morphy, ed. Vol. 7, proceedings of the World Archaeology Congress, Southampton, UK, 1986. London: Unwin Hyman.
SCHALLER, GEORGE
1972 *The Serengeti Lion: A Study in Predator-Prey Relations*. Chicago: University of Chicago Press.
SCHILDKROUT, ENID, AND CURTIS KEIM
1990 *African Reflections: Art from Northeastern Zaire*. Seattle: University of Washington Press for the American Museum of Natural History, New York.
SCHMITZ, ROBERT
1912 *Les Baholoholo*. Brussels: Albert Dewit.
SCHNEIDER, GILBERT, AND EVAN SCHNEIDER
1994 *Celebrating Cameroon*. 1995 engagement calendar. Portland (OR): Intercultural Education Services.
SCHOFFELEERS, J.
1978 "Introduction," pp. 1-46 in *Guardians of the Land: Essays on Central African Territorial Cults*, J. Schoffeleers, ed. Gwelo (Zimbabwe): Mambo Press.
SCHULTZ, EMILY, AND ROBERT LAVENDA
1990 *Cultural Anthropology: A Perspective on the Human Condition*. 2nd ed. St. Paul: West Publishing Co.
SHAW, THURSTON
1970 "An Analysis of West African Bronzes: A Summary of the Evidence," *Ibadan* 28:80-89.
SILVERMAN, RAYMOND
1994 "Do Mask Representing a Wart Hog," pp. 41-3 in *Visions of Africa: The Jerome L. Joss Collection of African Art at UCLA*, D. Ross, ed. Los Angeles: UCLA Fowler Museum of Cultural History.
SIMIC, CHARLES
1993 "The Little Venus of Eskimos," pp. 24-31 in *The Return of the Cadavre Exquis*, A. Philbin, ed. New York: The Drawing Center.
SIMMONS, WILLIAM
1971 *Eyes of the Night: Witchcraft Among a Senegalese People*. Boston: Little, Brown.
SIROTO, LEON
1972 "Gon: A Mask Used in Competition for Leadership Among the Bakwele," in *African Art and

Leadership*, D. Fraser and H. Cole, eds. Madison: University of Wisconsin Press.
SKOUGSTAD, NORMAN
1979 *Traditional Sculpture from Upper Volta*. New York: African-American Institute.
SOBANIA, NEIL, AND RAYMOND SILVERMAN
1992 "History and Art in Ethiopia," pp. 12-31 in *Art and Everyday Life in Ethiopia and Northern Kenya*, J. Wilson, ed. Holland (MI): Depree Art Center, Hope College.
SÖDERBERG, BERTIL
1966 "Antelope Horn Whistles with Sculptures from the Lower Congo," *Ethnos* 31:5-33.
SOUKHANOV, ANNE, ed.
1992 *The American Heritage Dictionary of the English Language*. 3rd ed. Boston: Houghton Mifflin.
SPERBER, DAN
1975 "Pourquoi les animaux parfaits, hybrides, et les monstres sont-ils bons à penser symboliquement?," *L'Homme* 15(2):5-33.
STAPPERS, LEO
1962 "Textes luba: contes d'animaux," *Annales du Musée Royal de l'Afrique Centrale, sciences humaines* 41.
STEWART, SUSAN
1993 *On Longing: Narratives of the Miniature, the Gigantic, the Souvenir, the Collection*. Durham (NC): Duke University Press.
STONE, RUTH
1994 "Bringing the Extraordinary into the Ordinary: Music Performance Among the Kpelle of Liberia," pp. 388-97 in *Religion in Africa*, T. Blakely et al., eds. Portsmouth (NH): Heinemann, and James Currey, London, for the David Kennedy Center for International Studies, Brigham Young University.
TAMBIAH, STANLEY
1973 "Animals Are Good to Think and Good to Prohibit," pp. 127-66 in *Rules and Meanings*, M. Douglas, ed. Baltimore: Penguin Books.
TAPPER, RICHARD
1988 "Animality, Humanity, Morality, Society," pp. 47-62 in *What Is an Animal?*, T. Ingold, ed. Vol. 1, proceedings of the World Archaeology Congress, Southampton, UK, 1986. London: Unwin Hyman.
TERASHIMA, HIDEAKI
1980 "Hunting Life of the Bambote: An Anthropological Study of Hunter-gatherers in a Wooded Savanna," pp. 223-68 in *Africa 2, SENRI Ethnological Studies* 6, S. Wada and P. Eguchi, eds. Osaka: National Museum of Ethnology.
THOMAS, KEITH
1983 *Man and the Natural World: Changing Attitudes in England 1500-1800*. London: Allen Lane.
THOMPSON, BARBARA
1994 "'We Speak to the Wise': Akan Figurative Gold Weights as Devices of Communication, Arbitration, and Confrontation." Unpublished term paper, University of Florida Department of Art.
THOMPSON, ROBERT
1974 *African Art in Motion*. Los Angeles: University of California Press.
1983 *Flash of the Spirit: African and Afro-American Art and Philosophy*. New York: Random House.
1993 *Face of the Gods: Art and Altars of Africa and the African Americas*. New York: The Museum for African Art and Munich: Prestel.
TURNER, TERENCE
1969 "Oedipus: Time and Structure in Narrative Form," in *Forms of Symbolic Action*, Proceedings of the American Ethnological Society. Seattle: University of Washington Press.
1991 "'We Are Parrots,' 'Twins Are Birds': Play of Tropes as Operational Structure," pp. 121-58 in *Beyond Metaphor: The Theory of Tropes in Anthropology*, J. Fernandez, ed. Stanford: Stanford University Press.
TURNER, VICTOR
1970 *The Forest of Symbols*. Ithaca: Cornell University Press.
VAN ACKER, AUGUSTE
1907 *Dictionnaire kitabwa-français, français-kitabwa*. Tervuren: Musée Royal du Congo Belge.
VAN AVERMAET, E. AND B. MBUYA
1954 *Dictionnaire kiluba-français*. Tervuren: Musée Royal de l'Afrique Centrale.
VANDER HEYDEN, MARSHA
1977 "The epa Mask and Ceremony," *African Arts* 10(2):14-21, 91.
VANSINA, JAN
1964 *Le royaume kuba*. Tervuren: Musée Royal de l'Afrique Centrale.
1984 *Art History in Africa: An Introduction to Method*. New York: Longman.
1990 "Reconstructing the Past," pp. 69-87 in *African Reflections*, E. Schildkrout and C. Keim, eds. Seattle: University of Washington Press for the American Museum of Natural History.
VAN WING, J.
1938 "Etudes Bakongo: I, religion et magie," *Mémoires de l'Institut Royal Colonial Belge*, tome 9, fasc. 1.
VINCENT, JEANNE-FRANÇOISE
1963 "Dot et monnaie de fer chez les Bakwele et les Djem," *Objets et Mondes* 3(4):273-92.
VOGEL, SUSAN
1981 "Gravepost, Malagasy Republic, Bara or Antanusi," pp. 242-3 in *For Spirits and Kings: African Art from the Tishman Collection*, S. Vogel, ed. New York: Harry N. Abrams for The Metropolitan Museum of Art.
1986 *African Aesthetics: The Carl Monzino Collection*. New York: The Center for African Art.
1991 "Traditional Art: Elastic Continuum," pp. 32-55 in *Africa Explores: 20th Century African Art*, S. Vogel, ed. New York: The Center for African Art and Munich: Prestel.
VON ROSEN, ERIC
1916 *Trènskfolket: Svenska Rhodesia-Kongo Expeditionens Etnografiska Forskningsresultat*. Stockholm: Albert Bonniers Förlag.
WATERLOT, E.
1926 *Les Bas-Reliefs des Bàtiments royaux d'Abomey (Dahomey)*. Université de Paris, Travaux et Mémoires de l'Institut d'Ethnologie, 1. Paris: Institut d'Ethnologie.
WEGHSTEEN, JOSEPH
1953 "Haut-Congo: Foudre et faiseurs de pluie," *Grands Lacs* 3(167):22.
WHITE, T.
1960 *The Bestiary*. New York: Putnam.

WHITE FATHERS
1954 *The White Fathers' Bemba-English Dictionary*. London: Longmans, Green.
WILLIAMS, J. W.
1994 "Caryatid Container with Lid, Bidjogo," p. 45 in *Visions of Africa: The Jerome L. Joss Collection of African Art at UCLA*, D. Ross, ed. Los Angeles: UCLA Fowler Museum of Cultural History.
WILLIAMS, JOHN
1963 *A Field Guide to the Birds of East and Central Africa*. Boston: Houghton Mifflin.
WILLIS, ROY
1967 "The Head and the Loins: Lévi-Strauss and Beyond," *Man* 2, 519-534.
1974 *Man and Beast*. London: Hart-Davis, MacGibbon.
1985 "Do the Fipa Have a Word for It?" in *The Anthropology of Evil*, D. Parkin, ed. New York: Oxford University Press.
1990 "The Meaning of the Snake," pp. 246-52 in *Signifying Animals, Human Meaning in the Natural World*, R. Willis, ed. Vol. 16, proceedings of the World Archaeology Congress, Southampton, UK, 1986. London: Unwin Hyman.
WILLIS, ROY, ed.
1990 *Signifying Animals: Human Meaning in the Natural World*. Vol. 16, proceedings of the World Archaeology Congress, Southampton, UK, 1986. London: Unwin Hyman.
WOMERSLEY, H.
1984 *Legends and History of the Luba*. Los Angeles: Crossroads Press.
WOODWARD, RICHARD
1994 *African Art: Virginia Museum of Fine Arts*. Richmond: Virginia Museum of Fine Arts.
WYCKAERT, A.
1913 "Forgerons païens et forgerons chrétiens," doc. 854/32, Central Archives of the Missionaries of Our Lady of Africa (The White Fathers), Rome.
YOSHIDA, KENJI
1992 "Masks and Transformation Among the Chewa of Eastern Zambia," in "Africa 4," *Senri Ethological Studies* 31, S. Wada and P. Eguchi, eds. Osaka: National Museum of Ethnology.
ZAHAN, DOMINIQUE
1960 *Sociétés d'initiation bambara, le N'domo, le Korè*. Paris: Mouton.
1979 *The Religion, Spirituality, and Thought of Traditional Africa*. Chicago: University of Chicago Press.
1980 *Les antilopes du soleil: Arts et rites agraires d'Afrique noire*. Vienna: Eds. A. Schendl.
1989 "Carrefour de l'être, carrefour de la vie," *Eranos* 56, 1987, "La croisée des chemins," pp. 353-84.